INSURGENT
AESTHETICS

Art History Publication Initiative

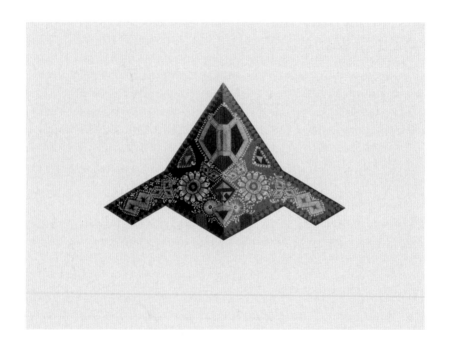

INSURGENT AESTHETICS

SECURITY AND
THE QUEER LIFE OF
THE FOREVER WAR

Ronak K. Kapadia

Duke University Press Durham and London 2019

© 2019 Duke University Press
All rights reserved
Printed in the United States of America
on acid-free paper ∞
Designed by Courtney Leigh Baker
Typeset in Knockout and Minion Pro
by Copperline Book Services

Cataloging-in-Publication Data is available at the
Library of Congress.
ISBN 9781478004639 (ebook)
ISBN 9781478003717 (hardcover)
ISBN 9781478004011 (paperback)

Cover art: (front) *Untitled*, 2015. © Mahwish Chishty.

ART HISTORY
PUBLICATION INITIATIVE

This book is made possible by a
collaborative grant from the
Andrew W. Mellon Foundation.

This book has also received a publication subsidy from
Duke University Press's First Book Fund, a fund estab-
lished by Press authors who donated their book royalties
to help support innovative work by junior scholars.

This book is, first and foremost, about the limitless search for more life-affirming and imaginative alternatives to the here and now. It gives me great pleasure, and so much life, to account for the multitudes—past, present, and emerging—who have helped bring this sustained project to fruition. I am endlessly grateful for the many expansive models of intellectual clarity, political praxis, and creative rebellion that surround me. First to the artist-activist-scholars who generously shared their insurgent aesthetics with me over many years: Wafaa Bilal, Mahwish Chishty, Chitra Ganesh, Mariam Ghani, Rajkamal Kahlon, Søren Lind, Naeem Mohaiemen, Larissa Sansour, and elin slavick—thank you for your world-making knowledge, craft, and critique.

I have been privileged to work with many distinguished mentors throughout my scholarly life. This book began as a doctoral dissertation, and my thanks go to my stellar committee at New York University: Gayatri Gopinath, Nikhil Pal Singh, Lisa Duggan, Crystal Parikh, and the late, great José Esteban Muñoz. I am grateful for their genius, advocacy, humor, and generosity of spirit and intellect over many years, and especially to Gayatri and Crystal, who continue to be wonderful interlocutors. José's trailblazing work in queer of color performance directly inspired me to go to graduate school and to become a writer and scholar. His untimely death in 2013, just as I was finishing my first semester on the tenure clock, sent shockwaves through our shared relational orbits. I continue to mourn his passing and regularly wonder how he would interpret the wildness of our historical present—probably with his brilliant and singular crankiness. His distinctive presence looms large over the pages ahead, and I hope this book will nurture at least some part of the queer lifeworlds he cracked open for so many of us. At NYU, I also had the good fortune of learning from cherished professors such as Jennifer Morgan, Jack Tchen, Phil Harper, Rajeswari Sunder Rajan, Robert Young, Jasbir Puar, and Josie Saldaña. I send equal amounts of love and praise to my esteemed undergraduate mentors at Stanford—Harry J. Elam, Jr. and Cherríe L. Moraga—as well as my high school mentors, Timothy Ortmann and Ann Goethals. Each of these extraordinary teachers played a formative

role in cultivating my intellectual and creative life as an energetic and overly rambunctious young man. I carry their lessons of patience, imagination, and care with me into every classroom space I now inhabit as a professor.

At Duke University Press, all praise and exaltation goes to my dream editor Ken Wissoker. Ken is a shining example of caring and careful leadership, and his encouragement and poise at every turn has made for a supremely better book. Thanks also to the marvelous editorial assistants and project editors who expertly steered my work through the publishing pipeline: Jade Brooks, Nicole Campbell, Maryam Arain, and especially Olivia Polk, Josh Tranen, and Sara Leone. This book benefited immensely from its several anonymous readers, most principally those at Duke, whose challenging and beautifully rendered reports yielded a much finer product. I cannot thank them enough for their steadfast insistence that this book rise to meet its ambitious aspirations. I am grateful as well to Dani Kasprzak, Junaid Rana, and Sohail Daulatzai at the University of Minnesota Press and Eric Zinner at NYU Press for their support of this project in its earliest stages.

After many years of coastal living, the stars aligned to bring me back home to Chicago for my first academic job. My colleagues at the University of Illinois at Chicago in Gender and Women's Studies, Global Asian Studies, and affiliated interdisciplinary units offer exemplary models of scholar activist praxis (not to mention kindness, collegiality, and good humor, too!). My supreme affection and appreciation goes to Nadine Naber, Barbara Ransby, Akemi Nishida, Gayatri Reddy, Jennie Brier, Anna Guevarra, Rod Ferguson, Beth Richie, Elena Gutiérrez, Lynette Jackson, Laurie Schaffner, Kishonna Gray, Norma Moruzzi, Deana Lewis, Carmella Gómez, Judith Gardiner, John D'Emilio, J. Lorenzo Perillo, Michael Jin, Mark Chiang, and Karen Su. Special thanks to Nadine, Jennie, Anna, Rod, and Beth for crucial guidance at the finish line. Other comrades who make work at UIC both pleasurable and meaningful include Andy Clarno, Patrisia Macías-Rojas, Atef Said, Erica Chuh, Sarah Abboud, Therese Quinn, Lisa Yun Lee, Jen Delos Reyes, Anthony Stepter, David Stovall, Claire Decoteau, Nicole Nguyen, Jane Rhodes, Lynn Hudson, Cynthia Blair, Johari Jabir, Amanda Lewis, Tyrone Forman, Amalia Pallares, Lorena Garcia, Teresa Córdova, Zeina Zaatari, Laurie Jo Reynolds, Elise Archias, Sara Hall, Iván Arenas, Prudence Browne, Chris Boyer, Cedric Johnson, Adam Goodman, Junaid Quadri, Aaron Hughes, Nasser Mufti, Sunil Agnani, Rahim Kurwa, Liat Ben-Moshe, Ramona Gupta, Rachel Caïdor, Helen Jun, Rama Mantena, Mary Anne Mohanraj, and Elizabeth Todd-Breland. I am especially indebted to my junior faculty of color writing group (the Chiya Chai crew), the IRRPP Write-Out! faculty retreats,

and Facebook's Writing Every Day (WED) virtual group. These URL and IRL spaces were all instrumental in shepherding this book to its goal. Finally, my undergraduate and graduate students at UIC are consistently sharp, passionate, and fearless. I feel immensely fortunate to work with so many radical working-class, first-generation, immigrant, nontraditional, queer, and/or trans students of color committed to transforming their communities. I want this book to do justice to their high expectations for what academic scholarship can and should emit into the world.

Many generous sources of institutional funding have made this book possible, including the Mellon Art History Publishing Initiative at Duke University Press; the Great Cities Institute Faculty Scholarship, the Institute for Research on Race and Public Policy Faculty Fellowship, and the Liberal Arts and Sciences Dean's Award for Research in the Humanities at UIC; the Henry M. MacCracken Fellowship and the Provost's Global Research Initiatives Summer Dissertation Fellowship in Berlin, both at NYU; the Consortium for Faculty Diversity in Liberal Arts Colleges Dissertation Fellowship (my thanks to colleagues in Race, Ethnicity, and Migration Studies at Colorado College); and the University of California President's Postdoctoral Fellowship (my thanks to colleagues in the Department of Ethnic Studies at UC Riverside, especially Jodi Kim, who remains an ideal mentor).

This book also benefited from a wide and luminous constellation of close scholarly friends and editors who have offered vital sustenance, encouragement, and feedback at crucial moments. Their cheerleading and counsel allowed me to not only survive but thrive as I neared the finish line. My greatest appreciation to Justin Leroy, Anurima Banerji, Tejasvi Nagaraja, Nicole Fleetwood, Junaid Rana, Rod Ferguson, Caren Kaplan, Keith Feldman, Jenny Kelly, Alexis Lothian, Akemi Nishida, Chandni Desai, Erica Edwards, Grace Hong, Jodi Kim, Cathy Hannabach, Claudia Castañeda, Jill Petty, Amanda Malloni, Liz Mesok, Kristy Parrish, Saumitra Chandratreya, Cathy Schlund-Vials, Tina Chen, Nitasha Sharma, Nada Elia, Nadine Naber, and many others whose discerning eye made for a much sharper book. Of course, any remaining gaps, errors, and inadequacies are mine alone.

Since 2012 I have had the pleasure of workshopping versions of this book project with supportive colleagues and audiences at University of Colorado Boulder; University of California, Riverside; University of California, Los Angeles; Human Resources Los Angeles; University of California, San Diego; Rutgers University; San Francisco Art Institute; University of California, Berkeley; University of Chicago; School of the Art Institute of Chicago; Queens Museum of Art; University of Illinois at Urbana-Champaign; Illi-

nois State University; Newberry Library Seminar on Gender and Sexuality; Northwestern University; University of Arizona; and University of California, Irvine. For generously coordinating these lectures and visits, I thank Deepti Misri, Jens Giersdorf, Anurima Banerji, Jodi Kim, Mariam Lam, Jennifer Doyle, Fatima El-Tayeb, Nicole Fleetwood, Sampada Aranke, Keith Feldman, Sean Brotherton, Seth Kim-Cohen, Jaishri Abichandani, Mimi Nguyen, Maryam Kashani, Erin Durban-Albrecht, Liz Son, Francesca Morgan, Sabba Elahi, Adela Licona, Denis Provencher, and Sohail Daulatzai.

While academic life can often feel solitary and stultifying, I remain buoyed by an incredible assembly of academic pals across North America who inspire me and make our work feel worthwhile. Here is my academic appreciation roll call and intentionally unwieldy affirmation into the void: Rabab Abdulhadi, Su'ad Abdul Khabeer, Alejandro Acierto, Vanessa Agard-Jones, Ujju Aggarwal, Aren Aizura, Amna Akbar, Grace Ali, Jafari Allen, Sama Alshaibi, Leticia Alvarado, Paul Amar, Kadji Amin, Sampada Aranke, Bill Ayers, Paola Bacchetta, Moya Bailey, Aimee Bahng, Falu Bakrania, Vivek Bald, Zeina Barakeh, Samiya Bashir, AJ Bauer, Moustafa Bayoumi, Toby Beauchamp, Tallie Ben Daniel, Liat Ben-Moshe, Dan Berger, Nilanjana Bhattacharjya, Lisa Bhungalia, Natasha Bissonauth, Felice Blake, Abbie Boggs, Sony Coráñez Bolton, Michelle Boyd, Ricardo Bracho, Jayna Brown, Simone Browne, La Marr Bruce, Tisa Bryant, Rachel Buff, Jodi Byrd, Umayyah Cable, Louise Cainkar, Jordan Camp, James Cantres, Micha Cárdenas, André Carrington, Josh Chambers-Letson, Sylvia Chan-Malik, Piya Chatterjee, Jian Chen, Tina Chen, Wendy Cheng, Aymar Jean Christian, Kandice Chuh, Andreana Clay, Cathy Cohen, Ebony Coletu, Raúl Coronado, Jaime Cortez, Ashon Crawley, Roderic Crooks, Debanuj DasGupta, Sohail Daulatzai, Dana-Ain Davis, Lawrence-Minh Bùi Davis, Ashley Dawson, Iyko Day, Jennifer DeClue, Meiver de la Cruz, Chandni Desai, Jigna Desai, Karishma Desai, Manan Desai, Pawan Dhingra, Keila Diehl, Robert Diaz, Micaela Díaz-Sánchez, Kirstie Dorr, Erica Doyle, Jennifer Doyle, Patti Duncan, Erica Edwards, Hasan Elahi, Nada Elia, Jordache Ellapen, Kale Fajardo, Laila Farah, Ramzi Fawaz, Keith Feldman, Brad Flis, Lezlie Frye, Laura Fugikawa, Catherine Fung, Francesca Gaiba, Lyndon Gill, Craig Gilmore, Ruthie Gilmore, Alyosha Goldstein, Macarena Gómez-Barris, Sara Gonzalez, Paul Goodwin, Dayo Gore, Tourmaline Gossett, Kai Green, Inderpal Grewal, Zareena Grewal, Perla Guerrero, Rudy Guevarra, Alexis Pauline Gumbs, Joshua Javier Guzmán, Eva Hageman, Lisa Hajjar, Jack Halberstam, Sarah Haley, Sherine Hamdy, Christina Hanhardt, Jennifer Hayashida, Christina Heatherton, Feng-Mei Heberer, Linda Hess, Emily Hobson, LaMonda Horton-Stallings, Stepha-

nie Hsu, Renee Hudson, Emily Hue, Ren-yo Hwang, Allan Isaac, Zakiyyah Iman Jackson, Karen Jaime, Rana Jaleel, Joseph Jeon, Anne Joh, E. Patrick Johnson, Miranda Joseph, Priya Kandaswamy, Caren Kaplan, Manu Karuka, Maryam Kashani, Kerwin Kaye, Robin Kelley, Arnold Kemp, Ted Kerr, Roshanak Kheshti, Kareem Khubchandani, Mimi Khúc, Alice Kim, Jina Kim, Ju Yon Kim, Sue Kim, Laura Kina, Homay King, Jason King, Katie King, Ashvin Kini, Zenia Kish, Katerina Kolarova, Emma Kreyche, Rushaan Kumar, Scott Kurashige, Larry La Fountain-Stokes, Mariam Lam, Laurie Lambert, Marisol LeBrón, Jim Lee, Josephine Lee, Myles Lennon, Darry Li, Lázaro Lima, David Lloyd, Lori Lopez, Alexis Lothian, Lisa Lowe, Alex Lubin, Sunaina Maira, Sara Mameni, Simeon Man, Martin Manalansan, Amita Manghnani, Bakirathi Mani, Anita Mannur, Curtis Marez, William Mazzarella, Katherine McKittrick, Art McGee, Leerom Medovoi, Parvinder Mehta, John Melillo, Victor Mendoza, Liz Mesok, Nick Mitchell, Francesca Morgan, Ghassan Moussawi, Linde Murugan, Kaitlin Murphy, Kevin Murphy, Amber Musser, Kip Myers, Asha Nadkarni, Julie Nagam, Lisa Nakamura, Jennifer Nash, Manijeh Nasrabadi, Mimi Nguyen, Viet Nguyen, Marcia Ochoa, Ariana Ochoa Camacho, Gary Okihiro, Jan Padios, Naomi Paik, Lena Palacios, Terry Park, Shailja Patel, Hiram Pérez, Roy Pérez, Dawn Peterson, Minh-Ha Pham, Eric Pido, Leah Lakshmi Piepzna-Samarasinha, Elliott Powell, Vijay Prashad, Jasbir Puar, Junaid Rana, Sherene Razack, Chandan Reddy, Sujani Reddy, Vanita Reddy, Shana Redmond, Gabriela Rico-Spears, Imani Roach, Daniel Rodríguez, Dylan Rodríguez, Juana María Rodríguez, Ricky Rodríguez, Jason Ruiz, Sandra Ruiz, Steven Salaita, Tom Sarmiento, Cathy Schlund-Vials, Rebecca Schreiber, Zach Schwartz-Weinstein, Stuart Schrader, Sarah Schulman, Sarita See, Meera Sethi, Nayan Shah, Svati Shah, Alex Shams, Shalini Shankar, Lila Sharif, Christina Sharpe, Setsu Shigematsu, Mej Shomali, Audra Simpson, Shanté Smalls, Andrea Smith, Robert Smith III, Riley Snorton, Valerie Soe, Seema Sohi, Liz Son, Sandy Soto, Dean Spade, Rajini Srikanth, Max Strassfeld, Anantha Sudhakar, Eric Stanley, Karl Swinehart, Julie Sze, Lena Sze, Thea Quiray Tagle, Eric Tang, Mitali Thakor, Stanley Thangaraj, Christy Thorton, Steven Thrasher, Emily Thuma, Tony Tiongson, Kyla Wazana Tompkins, Karen Tongson, Somi Umolu, Nishant Upadhyay, Alok Vaid-Menon, Ma Vang, Deb Vargas, Ricky Varghese, Barb Voss, Rinaldo Walcott, Lee Ann Wang, Alex Weheliye, Manya Whitaker, Craig Willse, Ivy Wilson, Naomi Wood, Cindy Wu, Judy Wu, Connie Wun, Wayne Yang, Damon Young, Genevieve Yue, and Ji-Yeon Yuh. I appreciate you; your work enriches the world, and your energetic presence in my world is affirming, necessary, and welcomed.

I would be nowhere without my civilian BFFS (chosen family and close comrades, mostly outside academia, who have sustained and grounded me with abundance for years). My love and thanks to Roopa Mahadevan, Justin Leroy, Vidya Chander, Ritu Sarin, Erick Flores, Iquo B. Essien, Cindy Muya, Karishma Desai, Tejasvi Nagaraja, Caroline Kuntz Graham, Umi Jensen, Julian Liu, Marnee Meyer, Swati Rao, Ankur Dalal, Naomi Jackson, Jasmine Teer, Angel Lopez, Jamille Teer, Indhika Jayaratnam, Leslie Park, Ashleigh Collins, Young Sun Han, Rosemary Simon, Eyal Wallenberg, Jessyca Kim, John Funteas, Kate Lorber-Crittenden, Ragini Shah, Swati Khurana, Jaishri Abichandani, Vivek Bharathan, Sabelo Narasimhan, Ashwini Rao, Rupal Oza, Felicia Pless, David Kalal, Zulfikar Bhutto, Parijat Desai, Minal Hajrat-wala, Marie Varghese, Vanessa Agard-Jones, Prerana Reddy, Rekha Mal-hotra, Atif Toor, Alicia Virani, Promiti Islam, Neo Nkhereanye, Anna Otieno, Thaala Loper, Jesse Loper, Monique Anderson, Taurean Brown, J'Leise Springer, Alice Brathwaite, Surabhi Kukke, Paige Trabulsi, Soniya Munshi, Amita Swadhin, Yalini Dream, Linda Chavez, Alex Loera, Thomas Lax, Ta-dashi Dozono, Arvind Grover, Miabi Chatterji, Sonny Singh, D'Lo, Adelina Anthony, Ravi Saksena, Prachi Patankar, Anjali Kamat, Silky Shah, William Johnson, Tanuja Jagernauth, Sufina Ali, Chaumtoli Huq, Ali Mir, and Saadia Toor. Fostering these friendships across great distance and time has filled me with an eternal supply of joy, laughter, and gratitude. If I have missed anyone here, please charge it to my head and not my heart! I love you all and am excited for our collective futures yet to come.

Finally, I reserve special thanks for my family of origin, especially my parents, Kumud and Ramila Kapadia, and my sister, Reshma, and brother-in-law, Tim, who have witnessed firsthand this project bloom slowly and over time: thank you for your love and protection. I am lucky to have you close in my life and wish for our collective health, happiness, and wellness. I also promise bountiful hugs and cuddles for my niblings, who comprise Kapadia Generation 3.0: Asha, Riya, Naiya, and Rikhil. I look forward to nurturing your most insurgent aspirations and affiliations, and I hope this book will become part of your own vibrant intellectual and political legacies as you grow older, illuminating more expansive designs of utopian futures from which we might all revel and rejoice.

PARTS OF THIS book have appeared as essays. An earlier piece of chapter 1 was published as "Death by Double-Tap: (Undoing) Racial Logics in the Age of Drone Warfare," in *With Stones in Our Hands: Writings on Muslims,*

Racism, and Empire (Minneapolis: University of Minnesota Press, 2018). A very early version of chapter 2 appeared as "Up in the Air and on the Skin: Wafaa Bilal, Drone Warfare, and the Human Terrain," in *Shifting Borders: America and the Middle East/North Africa* (Beirut: American University of Beirut Press, 2014), and reprinted as "Up in the Air and On the Skin: Drone Warfare and the Queer Calculus of Pain," in *Critical Ethnic Studies: A Reader* (Durham, NC: Duke University Press, 2016). An earlier piece of chapter 3 was published as "Kissing the Dead Body: Conjuring 'Warm Data' in Archives of US Global Military Detention," *Verge: Studies in Global Asias* 5, no. 1 (spring 2019). All previously published sections have been reworked and reimagined in the pages ahead.

Waging war in some ways begins with the assault on the senses: the senses are the first target of war. —Judith Butler, *Frames of War*

Blank spots on maps outline the things they seek to conceal. —Trevor Paglen, *Blank Spots on the Map*

To say there is a Muslim—a thing, an object rendered as manipulable—is to create a figure, a ghost, a lie. . . . The zealous indignation and fear of the Muslim betrays a deeper hypocrisy. "Terror" talk is the new race talk—the "terrorist" (or the "militant" or the "radical") is the twenty-first-century way of saying "savage." —Sohail Daulatzai and Junaid Rana, "Left"

Let us begin with a vision of an armed drone in the night sky. For more than a decade, the US government has told us that these stealth unmanned aerial vehicles (UAVs) represent the revolutionary edge of twenty-first-century lethal military technologies, remotely targeting and precisely eliminating so-called known and suspected terrorists in the distant battlefields of the global "war on terror."[1] US drone strikes and aerial surveillance operations have been reported or suspected across the proliferating theaters of Washington, DC's seemingly interminable planetary war. While many Americans recognize the state-sponsored military conflicts in Afghanistan and Iraq since 2001 as traditional, full-scale "hot wars"—as measured by air and ground invasion and occupation of national territories—the ongoing US war on terror

against a shape-shifting constellation of enemies like Al-Qaeda and ISIS is a far more diffuse project. It heralds instead a nearly two-decade-long globalized biopolitical struggle of regulating, managing, and warehousing populations scattered across the heterogeneous landscapes of Afghanistan, Pakistan, Iraq, Iran, Algeria, Syria, Palestine, Yemen, Somalia, Libya, Niger, and beyond—to say nothing of the undeclared wars closer to home. Although the US monopoly on drone technologies has ended, the global military arms race in unmanned aerial systems has just begun. Soon our "voluminous spaces of human existence" will be filled indefinitely with a wider "matrix of military violence," not just overseas in the frontiers of US empire but also on domestic shores, with remotely controlled objects of death and destruction owned and patrolled by foreign military powers, private security forces, and start-up rebel groups alike.[2] The armed drones of the near future are expected to resemble dragonflies and honey bees—an everlasting multispecies swarm of intel, misery, and sovereign power from above.[3]

What do the people on the ground who are targeted by the so-called signature strikes of the drone age see, think, feel, and sense when they encounter this swarm in the dystopian here and now? How have early twenty-first-century technologies of aerial warfare and remote surveillance disordered and rearranged people's collective sense of place, space, and community across the expanding scenes of American warfare in South and West Asia, North and West Africa, and the Greater Middle East?[4] Legal reports on drone strikes have documented how community gatherings such as weddings, funerals, communal prayer, tribal council meetings, and other forms of social congregation have been undermined by the unpredictable but steady stream of war machines enveloping the rugged borderlands region that sutures Afghanistan to Pakistan, known as "Af-Pak."[5] Af-Pak today symbolizes the so-called lawless frontier of lethal experimentation and algorithmic warfare. It is an extreme topography of counterterrorism where "uneven geo-legalities of war, state, and exception make drone warfare a reality in certain places and not others."[6] The differential powers of the US military over precarious life and death, freedom and suffering, recognition and obliteration have been radically expanded and revitalized through these new technologies of surveillance that seek to enclose suspect humanity within its aerial view, transmitting and translating what it "sees" of that humanity into abstract data for the US security state. How are patterns of life and collective embodied lifeworlds of people who dwell under the drones disorganized and destroyed by US aerial attacks on their towns and villages?

Consider the life and death of Mammana Bibi. Bibi was a sixty-seven-

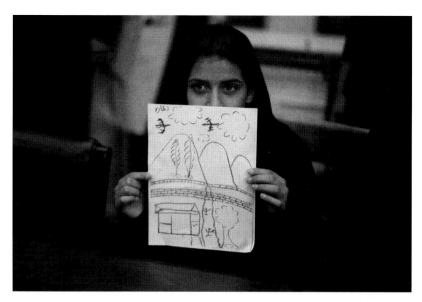

FIG I.1 Nabila Rehman, nine, holds up a picture she drew depicting the US drone strike on her Pakistan village, which killed her grandmother, Mammana Bibi, at a news conference on Capitol Hill in Washington, DC, October 29, 2013. Nabila and her father and brother attended the news conference to highlight the personal costs in collateral damage for civilians killed and injured in the US drone strike program. Photograph: Reuters/Jason Reed.

year-old grandmother and the only midwife in her remote mountainous village in North Waziristan, Pakistan. She was killed by a CIA drone strike while tending okra as her grandchildren played nearby on October 24, 2012.[7] A year later, Bibi's son Rafiq ur Rehman, a primary school teacher, traveled to Washington, DC, with two of his children—Zubair, age thirteen, and Nabila, nine—to testify at the first-ever congressional hearing on the civilian impact of US drone strikes.[8] At this sparsely attended inquest, Rehman described his mother as *aik lari main pro kay rakhna* (literally translated from Urdu as "the string that held our family together").[9] His children went on to depict in harrowing detail both the sensory destruction caused by the drone's imprecise targeting and the collateral aftermath in their lives (figure I.1). Rehman's son Zubair, who was injured in the attack when shrapnel ripped through his leg, reflected on the traumatic and disordering impact of the strikes: "I no longer love blue skies. In fact, I now prefer grey skies. The drones do not fly when the skies are grey. . . . When the sky brightens and becomes blue, the drones return and so does the fear."[10] The poisoned air, the buzzing sounds,

the deadly hellfire pouring down from above, the earth rattling beneath their feet, and the interminable waiting—the absolute indeterminacy and lack of syncopation that breaks the rhythms and beats of everyday life—all collide and collude in crafting a new US global imperial sensorium. This conjures a felt world of necropolitical ruin on the frontiers of US empire in the Greater Middle East that also enfolds and enables contemporary US civic life. What can be seen, counted, and known from these tales of today's wars and their toxic afterlives?

For an alternative sensorial relation to the drone and its manifold violences, we can turn to the contemporary work of Pakistani American visual artist Mahwish Chishty.[11] Upon traveling home from the US to her native Lahore in 2011, Chishty found her family and friends furiously debating the merits of the new American-led drone war raging along the border with Afghanistan. Trained as a miniature painter at the National College of Arts, Lahore, Chishty was so roused by this news (and of her family's proximity to war) that she quickly transformed her art practice to grapple with this freshly intimate aspect of twenty-first-century warfare. She began creating colorful paintings and sculptural installations featuring armed drones adorned in the ornate tradition of Pakistani truck art.[12] The regional folk tradition of truck art is an information-intensive medium that pairs well with the big data aspirations of drone warfare.[13] In Pakistan, long-haul freight trucks made by American companies such as Ford and General Motors are often retrofitted and bejeweled with regional styles. Street artists then meticulously paint them with poetic and religious texts, images of martyrs and film heroes, and brightly colored mosaics.[14]

Chishty's *Drone Art Paintings* series (2011–16) appropriates the signature motifs from this labor-intensive craft folk tradition for her fine-art practice (figures 1.2–1.6). She first stains her paper with tea, following the miniature painting practice of creating a neutral canvas. For Chishty, the stained paper is meant to conjure the distressed landscape of the Af-Pak border as seen from above. After tracing a blank architectural silhouette of an unmanned aerial vehicle, the artist then fashions what she calls a "second skin" for the drone. She refracts the drone's signature shadows and lines through elegant embellishments that mimic the vibrant floral patterns and calligraphic folk art used to adorn the long-haul trucks in Pakistan.[15] The visual effect is luminous and haunting. A dense bricolage of finely patterned flowers, fish bones, human skulls, crescent moons, and feminized eyes and lips meticulously fill in the paintings, which are then embellished with gold leaf borders, in keeping with the Mughal miniature tradition. In "Reaper" (2015), Chishty

scatters flecks of gold leaf on the horizon to resemble blasted shell fragments (plate 1). In a neat reversal, the artist seizes on this flamboyant regional folk tradition, which revels in its visibility and dramatic splendor, to shed light on the otherwise stealth war machines wreaking havoc and instability across her homeland. In the process, she has made the foreign and distant appear familiar and intimate. Her aesthetic practice defines new ways to disclose the unseen and unsaid of contemporary US global state violence.

The complex interplay between visibility and invisibility and between beauty and terror featured in *Drone Art Paintings* is central to this book's examination of aesthetics in the context of the violence of the forever war. Of particular note is Chishty's use of gouache, a painting technique that uses opaque pigments ground in water and thickened with a glue-like substance. There is a permanence to the opaque watercolor paint that not only renders a brilliant exuberance to her visual artworks but also belies the persistent temporality of the forever war (plates 2-6). I deploy the forever war critically to describe the seemingly permanent US-led war on terror and its multiple disastrous permutations in the nearly two decades since the events of September 11, 2001.[16] The durative nature of the forever war challenges the willful presentism and nationalist amnesia of the US military's invocation of only the most recent invasion of Iraq as a "long war." The phrase originates in a speech delivered by former Secretary of Defense Donald H. Rumsfeld on the eve of the Pentagon's release of its Quadrennial Defense Review (QDR) in October 2006. In it, Rumsfeld opened with the declaration, "The United States is a nation engaged in what will be a long war," announcing an incipient generational conflict akin to the twentieth century's Cold War and characterized by a struggle to "root out terrorism" and "battle extremism" that could stretch across several decades.[17] In this way, Rumsfeld viewed the unilateral Iraqi conflict as the first foray into an eternal embrace of a twenty-first-century counterinsurgent campaign in Iraq, Afghanistan, Pakistan, the Horn of Africa, the Philippines, and beyond. In this book, I disidentify with the elite military source of this term and reorient it to consider instead how the US has engaged aggressively in a "long war" since its inception and throughout the twentieth and early twenty-first centuries—in effect examining not the US "at war" but the US "as war."[18]

As the lone global superpower in the early decades of the twenty-first century, the United States is the primary purveyor of racial-colonial terror and neoliberal violence across the contemporary world. Its national security and counterinsurgent policing apparatus unfolds across ever-expanding terrain, a transnational battlespace that includes distant, often secret wars and nu-

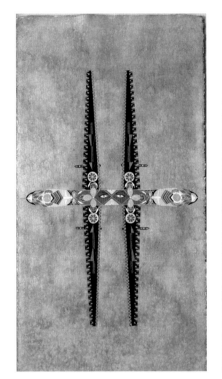 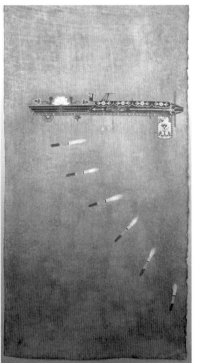

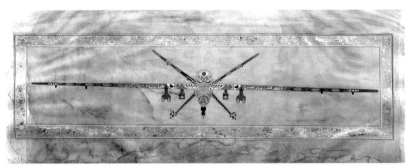

FIG I.2 (*top left*) Mahwish Chishty, MQ-9/*Guardian*, 2011. Gouache and tea stain on paper, 24 in. × 12 in. © Mahwish Chishty.

FIG I.3 (*bottom*) Mahwish Chishty, MQ-9/*Predator*, 2011. Gouache and tea stain on paper, 24 in. × 12 in. © Mahwish Chishty.

FIG I.4 (*top right*) Mahwish Chishty, MQ-9/*1*, 2011. Gouache, tea stain, and gold leaf on paper, 8 in. × 28.5 in. © Mahwish Chishty.

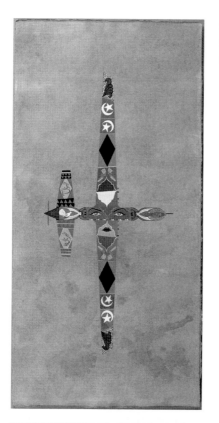

FIG I.5 Mahwish Chishty, *MQ-9/5*, 2013. Gouache and tea stain on paper, 24 in. × 12 in. © Mahwish Chishty.

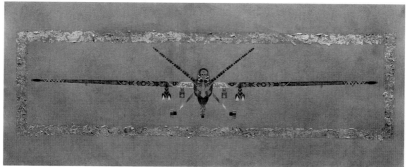

FIG I.6 Mahwish Chishty, *MQ-9/2*, 2011. Gouache, tea stain, and gold leaf on paper, 8 in. × 28 in. © Mahwish Chishty.

merous intertwined policing and security arrangements closer to home. The US has acted over decades in complex and shifting relation to a range of other imperial projects and regional regimes in the Greater Middle East, including other Middle Eastern states and outside powers. It is for this reason difficult, if not impossible, to offer a sweeping appraisal of the astounding vision and strategic expanse of Washington's worldwide counterterror and counterinsurgent wars. But we can locate a particular genealogy of the forever war in the longue durée of US colonial expansion and war-making in the Greater Middle East across the long twentieth century.[19] This book argues that the forever war is not only a historical period describing a series of geopolitical and military conflicts, but also an ongoing archival project, structure of feeling, and production of knowledge for interpreting and acting on the geopolitical alignments of the US in the broader "post"–Cold War era. The "forever" of "forever war" calls up a fantasy sense of temporal perpetuity in wartime's violence in the dystopian here and now that likewise mimics the uninterrupted and limitless spree of US global war-making across the long twentieth century.[20] This is a particularly apt description given the twenty-first-century US military empire's quest for "full-spectrum dominance," or the geo-strategic campaign for total planetary control across all combat domains: land, sea, air, space, outer space, and cyberspace.[21]

Today the US military depicts its forever wars of public safety and security as newly deterritorialized, that is, an "everywhere war" that can, in principle, occur anywhere and is thus no longer sequestered spatially, either horizontally or vertically, to battlespaces putatively outside US borders.[22] Instead, through new strategies for the reproduction and suspension of state sovereignty—such as drones and satellites operated from within US territories, on the one hand, and an invisible empire of foreign military bases and paramilitary proxies across the globe, on the other—the US security state purports to have conquered the challenges of space-time in armed conflicts and is therefore unbridled from the territorial strictures that have historically defined it.[23] The abstract sense of temporal limitlessness of a planetary forever war is further evidence that the US military has been most preoccupied by a struggle to overcome the geographic limitations of warfare and sovereignty in its pursuit of global supremacy over the past several decades. Along with the lack of sustained public consciousness of US involvement in all-out global warfare, this borderless vision of twenty-first-century military empire links temporally and spatially dispersed bodies and geographies through differential forms of management and extermination, revealing the nation as a "forever war" machine: seemingly enduring, mutable, and eternal.

But nothing truly lasts forever. Despite its projected sense of dominance, breadth, and precision, the contemporary US military-surveillance state is not static nor omnipotent. If we follow the lead of Mahwish Chishty and the other visionary artists and cultural practitioners considered in this book, we might discover that the US state's capricious imperial powers are in fact fleeting, fragile, and always failing. Felicitous cracks have appeared in the surface of the forever war's architecture that can be exploited by forms of fugitivity, refusal, and rebellion "that were impossible yesterday and might be impossible tomorrow."[24] New assemblages of state security and flexible warmaking, including drone warfare, have engendered racialized worlds of untold anguish for those rendered suspect within its imperial world order. But this historical fact also augurs new openings for the forever war's insurgent undoing. So much of the popular and scholarly discourse on contemporary US militarism attunes so closely to the dominant strategies and technologies of late modern warfare that such work has the unintended effect of making the state's frameworks and institutions seem monolithic and omniscient even as that work seeks to critique war and empire. This book plots another, more arresting approach.

Insurgent Aesthetics:
Cultures of Counterinsurgency, Security, and Struggle

Insurgent Aesthetics is about the creativity and fugitive beauty that emanate from the shadows of terrible violence incited by forever war. Of freedom dreams flecked by inscriptions of wartime's death and dispossession.[25] The forever war is an assault on the human sensorium for citizens, subjects, survivors, and refugees of US empire alike.[26] A time of ever more state security and imperial violence, the historical present necessitates more sensuous ways of knowing and feeling that challenge the militarized imperatives of the state and exceed the visual register alone. The global circulation of images of violence and social suffering has also intensified in our public culture over the past three decades. As a privileged regime of power, the field of vision is central to the manufacture and global supremacy of US war-making regimes and to the violent regulation of racialized, gendered, and sexualized bodies under the conditions of state security and surveillance.[27] Given the US state's will toward quantified abstraction in counting, without ever being accountable to, those killed, diseased, displaced, traumatized, and/or maimed in its armed conflicts, how might we divine other, more sensuous and affective ways of knowing this forever war and its inhuman violences? This book asserts that

we must demand a stranger calculus—what I term a *queer calculus*—that unsettles prevailing interpretations of the forever war, makes sensuous what has been ghosted by US technologies of abstraction, and endows the designs for seemingly impossible futures amid infinite aggression. A queer calculus of the forever war advances an account of both dominant knowledge apparatuses and data logics of the US security state as well as alternative logics, affects, emotions, and affiliations of diasporic subjects living and laboring in the heart of empire. One such embodied queer calculus can be found in the corpus of aesthetic forms created by contemporary diasporic artists from South Asia and the Greater Middle East. These imaginative works of art reassemble vision with the disqualified knowledges, histories, geographies, and memories preserved by the "lower" senses of empire's gendered, racialized Others to fashion an insurgency against empire's built sensorium. In so doing, these insurgent aesthetics craft a queer calculus of US empire that makes intimate what is rendered distant, renders tactile what is made invisible, and unifies what is divided, thereby conjuring forms of embodied critique that can envision a collective world within and beyond the spaces of US empire's perverse logics of global carcerality, security, and war.

This book engages a wide range of critical interdisciplinary paradigms to reveal the radical experiments, aesthetic strategies, and freedom dreams of contemporary Arab, Muslim, and South Asian diasporic artists. I argue that these works comprise a transnational constellation of visual art and aesthetics that together have animated new ways to think, feel, sense, and map the world amid US global state violence and its forever wars across the so-called Muslim world.[28] Specifically, the book surveys the broader post–Cold War expansion of US militarism in the Greater Middle East (Iraq, Afghanistan, Pakistan, Palestine) and the domestic regimes of surveillance and repression in the US and other militarized sites mapped onto a transnational jihadist network. It contends that new and flexible forms of remote killing, torture, confinement, surveillance, and lawfare have built a distinctive post–9/11 infrastructure of gendered, racialized state violence both within and beyond US borders, which in turn marks the ongoing present as a distinct age within the longue durée of US settler colonial society. I explore this complex terrain through a contrapuntal queer feminist analysis of contemporary Arab, Muslim, and South Asian diasporic visual cultures and their critical intersections with the contemporary logics and tactics of global warfare.[29] Although many scholars have studied the impact of liberal empires and late modern warfare in the Greater Middle East, including the militarized and racialized vision of US imperialism at its core, insufficient attention has been paid to how the

state's dominant necropolitical calculus of neoliberal security and warfare has been thwarted and reimagined.[30] By contrast, this book foregrounds the conceptual works of contemporary artists from South Asian and Middle Eastern diasporas, whose insurgent aesthetic acts refashion ascendant ways of knowing and feeling the forever war.

My chief premise in this book is that if we want to apprehend (so as to ultimately arrest) contemporary transnational security politics and carceral practices, especially the prevailing biopolitical regimes of surveillance, imprisonment, and killing perfected at the domestic and international fronts of the forever war, then we need an alternate approach to the maps of strategic thinkers and security analysts who have been telling us how we should look, think, and feel about the world and its violences. By privileging a wide range of diasporic cultural forms—namely, visual and sound installation, performance, painting, photography, new media, and video—as a generative site for critiquing American war and empire, this book illuminates what I term *insurgent aesthetics*, an alternative articulation of minoritarian knowledge produced by those populations and their diasporic kin most devastated by the effects of the homeland security state and its forever wars.[31] This book illustrates how Arab, Muslim, and South Asian diasporic artists in the US and Europe, including Mahwish Chishty, Wafaa Bilal, Naeem Mohaiemen/ Visible Collective, Rajkamal Kahlon, Index of the Disappeared, Mariam Ghani, and Larissa Sansour, have grappled in their work with the neoliberal state of exception and the national security state's use of gendered racial violence. *Insurgent Aesthetics* documents the impact of present-day militarized security practices and historical legacies of imperial violence on diasporic, (im)migrant, and refugee communities in the US who have been besieged both by domestic wars on terror, crime, drugs, and immigration as well as military and foreign policies directed at their homelands. These artists, in turn, have produced sensuous affiliations and political imaginaries that critique the simultaneous proliferation of gendered racism, neoliberal capitalism, heteropatriarchy, and Islamophobia in the post–9/11 period. These concepts represent intersectional systems of power and violence that fuel the ideological engines that legitimate the homeland security state's use of global prisons, confinement technologies, overt killing, and permanent warfare as inevitable features of a political economy that seeks to "solve" our multifarious contemporary crises. In this context, what role can expressive culture and aesthetics play in struggles over hegemony of the contemporary neoliberal carceral, security, and warfare state? This book answers this question by centering the expansive world-making knowledge practices of diasporic vi-

sual and multimedia artists who hail from societies besieged by war but live and labor in the heart of empire. In short, the book investigates how South Asian and Middle Eastern diasporic artists challenge violent histories of US militarism, sustain critical opposition to the global war machine through the realms of art and culture, and create alternative systems of knowing, feeling, and living with and beyond forever warfare.

The theoretical strategy and interpretive framework that I name "insurgent aesthetics" brings together diverse histories, geographies, and archives organized around several unifying themes. First, the book argues that insurgent aesthetics is a collective and relational praxis. *Insurgent Aesthetics* represents the first sustained effort to analyze contemporary works of conceptual art across the South Asian and Middle Eastern diasporas as a coherent social, cultural, and political formation challenging the explanatory power of dominant "expert" knowledge about US empire and its forever war. Second, these artists share a collective concern with revealing the gendered racial violence at the heart of the US security state. My close readings of their artworks make visceral and palpable what artist and cultural geographer Trevor Paglen calls "the black world," the contradictions and disavowals of official archives of US global warfare.[32] In this study, I grapple with the contradiction between the US state's claim to rational security and the material orders of brutality, misery, ruin, detention, confinement, and extermination upon which that claim continuously is made. For instance, the US state has, on the one hand, come to "know" the so-called human terrain[33] of global conflict in the war on terror by using abstract vision and limitless data to map racialized "Muslim" populations and innovate surveillance and intelligence-gathering procedures. On the other hand, the US state persistently disavows imperial violence in efforts to disappear the corporeality of its wars through "black sites," redactions of classified documents, so-called touchless torture of detainees, denials of civilian death counts in drone attacks, and bans on images of the coffins of US soldiers killed in combat. This imperial paradox of transparency and opacity in discourses of state security reveals what political theorist Laleh Khalili calls "the contrasts and connections between that far twilight realm in which sovereign violence occurs without concealment and the domestic liberal order in which the same violence is concealed in broad daylight."[34] This incongruity is manifest in both the gendered racialization of contemporary Arab, Muslim, and South Asian communities in the US and in the aesthetic works highlighted throughout this book, which cast light on the manifold unseen and disembodying technologies of secrecy and terror that define the forever war.

Third, as theorists and practitioners, these artists exemplify the significance of insurgent aesthetics by utilizing official archives and technologies of war, such as declassified government documents and surveillance cameras, as resource and inspiration for their experimental and conceptual art practices. Many newly released government documents detail widespread US military practices of torture, interrogation, kidnapping, and rendition. The artists' direct engagement with the "black world" of US statecraft is central to the book's contention that insurgent aesthetics not only expose the contradictions of the warfare state but also make available more capacious ways of knowing, feeling, and sensing states of security. However, I reject a strict sociological reading of these artists' contributions in line with approaches that would view them as native informants for the international art world. The US-based minoritarian art practitioner is routinely seen as merely transmitting information rather than pushing aesthetic boundaries. By contrast, a focus on aesthetic aims, innovations, and formal manipulations of these cultural forms is, as queer critics Kadji Amin, Amber Musser, and Roy Pérez contend, "the very *substance* of many of these artists' engagement with legacies of social violence. Aesthetic form offers resources of resistance to the violences of interpretation that prematurely fix the meaning of minority artistic production within prefabricated narratives."[35] As such, I opt to center a formal analysis of artistic techniques and forms in keeping with newer queer feminist approaches to visual aesthetics.[36]

Fourth, these artists embody insurgent aesthetics' public dimension through site-specific visual, installation, and performance art practices that often extend beyond gallery walls. They use common aesthetic strategies to co-implicate audiences, thus closing the distance between state violence and its afterlives. I am drawn to these artists in particular because they comprise an important part of my own scholar-activist relational orbit. Much of their work has been informed by deep contact with a legacy of urban grassroots activism, legal advocacy, and civil and human rights work. They encompass a group of artists (as activists, scholars, lawyers, curators, journalists, architects, and multimedia cultural producers in their own right) who, in the main, came of age in the cultural and political organizing milieu of New York City and other cities across the US in the 1990s. This pre-9/11 period spawned an efflorescence of urban multiethnic activist and creative cultural production against a range of violences such as urban police brutality; immigrant detention; and feminist, LGBTQ, and labor struggles. This invigorating milieu had profoundly politicizing effects on successive generations of Arab, Muslim, and South Asian diasporic artists and activists in the US and North

America.[37] In this sense, the contemporary art of social practice featured in this book draws on activist traditions and social movements, including prison abolition, immigrant justice, antiwar activism, US Third World feminism, and Black liberation, which often predate the global war on terror and stem from earlier encounters with US military, security, and penal regimes.

Fifth and finally, in my analysis of contemporary US war and empire, I focus on intimacy, affect, and sensation in ways that exemplify hallmarks of postcolonial, Black, Indigenous, and women of color feminist inquiry in American studies. It is worth recalling that feminist and queer studies have the longest critical engagement with the figure of the body as a gendered, sexualized, and racialized entity.[38] *Insurgent Aesthetics* examines how the body is implicated in the workings of US global warfare and in the diasporic visual art and aesthetics that challenges counterinsurgent knowledge. This focus critiques how security states turn counterinsurgency into an abstraction that has no visceral, physical, or psychic impact on the victims of security. In contrast to the security state's will to abstract knowledge, these artists illustrate how war is felt on the flesh and how the corporeal is a key site for acquiring political knowledge. The body and the senses thus become vehicles to affectively "know" the circumstances of security, carcerality, and counterinsurgency. It is important to note that I treat the body not as an abstract entity but as a social formation differentiated by race, gender, sexuality, ability, citizenship, and religion. By making the body and its sensory states the primary focus of the formation of security states and the challenges to that formation, my book extends this critical intersectional queer feminist legacy. It does so further by arguing that an analysis of what I term "the sensorial life of empire" is an urgent question of a just and equitable future. I ultimately argue that the insurgent aesthetics of Arab, Muslim, and South Asian diasporic cultural producers are crucial not only for their diagnosis of the dominant maps of exclusion and political violence characterizing the US forever war, but also for the open-ended and sensuous models of subjectivity, collectivity, and power that they imagine and inhabit.

At once a critical formalist examination of how diasporic cultural producers have innovated new directions in contemporary American art and visual media, *Insurgent Aesthetics* prioritizes a transnational queer feminist account of the effects of the US forever war on the racialized, gendered, and sexualized bodies that are its targets. Drawing on and advancing frameworks in critical ethnic and postcolonial studies, queer and feminist studies, and visual culture and performance studies, *Insurgent Aesthetics* outlines alternative maps for exposing violent global histories of US militarism in the

Greater Middle East and designing collective futures. It further argues that critical analysis of insurgent art and culture can excavate subjugated forms of knowledge about the US and its forever wars, a vital resource for policy, activism, and social transformation.

Theorizing Culture in the Age
of Neoliberal Security and Warfare

My approach to the study of insurgent aesthetics as a mediation of material conditions builds on works across disciplines that understand visual art and expressive cultures as offering a critical and sensuous intervention in the context of debates on neoliberal security and late modern warfare. To date, global security has been a rich topic of critical analysis in the social sciences, but not yet fully for the humanities. Rather than cede an engagement with these issues to the social sciences, I explore in this book how contemporary social, political, and economic processes of security governance can be understood through the lens of South Asian and Middle Eastern diasporic visual and performance art practices. I contend that the global politics of imperialism, war, terrorism, and militarism cannot be extracted from practices and processes of cultural mediation. In this way, insurgent aesthetics do not literally represent social crises and contradictions, but rather do the work of defamiliarizing or queering the social order. Put differently, they implicate their audiences in the violence of the forever warfare and in turn engage our collective critical analysis of its existing hegemonic formation. As such, insurgent aesthetics poses a critique of the knowing subject at the center of dominant Western aesthetics and the social exclusions at the heart of that project.[39] By radically challenging who the subject is that gets to "know" the endless emergency of the forever war and its gendered racialized regimes of institutionalized terror and violence, this book illuminates a method for knowing and sensing otherwise. The dissident works of art under investigation here are not about inclusion or assimilation, or even civil or human rights, but rather about advancing a rebellious aesthetic depiction of the "impossibility of such resolutions"—to paraphrase literary critic Christina Sharpe—by representing the paradoxes of brownness within the legacies of the forever war.[40]

Although the first chapter of this book develops a historical genealogy of contemporary twenty-first-century US counterinsurgency and global war-making regimes, my primary goal is to shift attention *away* from the dominant imbricated structures of US gendered racial and imperial formation

to focus *instead* on the capaciousness and creativity of insurgent aesthetics. That is, I wish to spotlight the affective structures and aesthetic forms of resistance found in Arab, Muslim, and South Asian diasporic cultures. This analytic shift is about foregrounding the alternative so as to identify, interrogate, and animate race radical and decolonial queer feminist experiments with speculation, fabulation, and otherworld imaginings in the midst of *and in spite of* the forever war. However, the diasporic cultural field of art and performance that I seek to enliven through this book does not have an obvious or indexical relation to the logics and tactics of US global warfare. Furthermore, insurgent aesthetics are not uniformly oppositional or resistant to the violent practices of the counterinsurgent state. Yet, when read through the lens of critical theory, these works of art produce a radical cultural archive that, while illegible within prevailing discourses of foreign relations, make visible the contours of race, gender, sexuality, religion, and citizenship in US forever wars. They further allow us to articulate social visions and political imaginaries that are incompatible with dominant counterinsurgent and counterterrorist solutions to crisis. I thus see these cultural forms as offering epistemological and affective interpretations that expose, without ever succumbing to, the contradictory logics of the US security state.

The notion of insurgent aesthetics of the forever war challenges a state-based security framework. In this fundamental paradigm, security is defined as "the quality of being free from threats" (whether those threats come from external invasion or internal rebellion), a status ensured through the state's historic monopoly over violence. In my queer feminist analysis of the cultural politics of national security and the securitization of everyday life, I draw upon critical security studies and international relations scholarship that embraces poststructuralist insights to interrogate the rhetoric, grammar, and motives of key terms and concepts such as "security," "terror," "danger," "targets," "bodies," and "expertise" in the forever war.[41] In so doing, I expose how prevailing conceptual framings contribute to US imperial and identity formation across the contemporary period. My analysis of insurgent art and performance practices further challenges the so-called proper objects and conventional reading practices of the social sciences. Rather than taking the notion of "security" as a given, I ask instead, who does this normative framework make "secure"? Who does it target for killing, abandonment, or humiliation? US global counterinsurgencies (GCOIN) and militarized regimes often work to obscure evidence of the proliferating and intersectional forms of racialized, gendered, sexualized, xenophobic, Orientalized, and Islamophobic violence they inaugurate. By contrast, the artists I study find complex

and creative ways to account for the subjects who are murdered, detained, disappeared, tortured, abstracted, ignored, or otherwise dispossessed by the forever wars waged in the name of security and freedom. Closely reading their art is my way of locating ethical practices and perceptual regimes that access those subjugated knowledges, histories, geographies, and memories absented by the abstractions of war. Analyses of insurgent aesthetics thus provides a "trace," material and affective evidence of the redacted archives of security wars and their affective afterlives.

Insurgent Aesthetics is also informed by scholars of race, war, and empire who have traced how the neoliberal state of exception enables the post–9/11 war on terror and its national security regime.[42] These critics argue that the emergence of the US national security state in the mid-1940s[43] is closely tethered to the subsequent neoliberal political and economic restructuring starting in the early 1970s that has led to mass criminalization, securitization, and inequality in the US and globally.[44] More specifically, this set of interconnected historical, political, and economic shifts over the latter half of the twentieth century has intensified racialized, gendered, and regionalized class disparities and led to the militarized retrenchment of multiple freedoms through the dismantling of the welfare state, the social wage, and the broader "liberal-pluralist distributive order" characterizing the mid-twentieth century.[45] In this context, transnational feminists such as Inderpal Grewal have argued that US neoliberal and imperial policies can be understood through the "'state effect' of appearing like a security state," which paradoxically signals "the rationale for militarized cultures of surveillance and protection that lead to insecurities, threats, and fears, which work at material, affective and embodied levels. Security is also a cause and effect not just of the relations of the United States with the world, but also of neoliberal policies that have contributed to the inequalities that create insecurity throughout the world, including in the United States itself."[46] Detailing multiple approaches to "security" as the shape-shifting keyword of contemporary governance across the period that she terms "advanced neoliberalism," Grewal outlines how the concept has been appropriated in vast domains of welfare, militarism, criminalization, humanitarianism, and beyond in the production of "exceptional citizens" who claim responsibility for national security in the absence of the state's dismantled social safety net and at the expense of its gendered racialized Others.

This book's approach is informed, moreover, by scholars who take the longer view to articulate the nexus of security, race, and capitalism in the US since its founding. Historian Nikhil Pal Singh pursues an approach to

"America's long war" that highlights the durable entanglements of race and war that gave rise to the US as a capitalist power well before the advanced neoliberal age of globalization. He writes, "The frontier wars, the wars of the early US empire, and the twentieth century's world wars all illuminated affinities between war-making and race making, activating or reanimating distinctions between friend and enemy along an internal racial border."[47] The gendered racialization of enemies of the state was crucial to the so-called law and order policies of ensuing decades that led to the criminalization of both domestic and foreign populations and the formation of the neoliberal turn as early as the 1940s.[48] As Singh adds, "new conceptions of inequality were realized and practiced in trials by violence: the wars on crime, drugs, and now terror. Through the 1990s, the success of neoliberal policies that rolled back welfare-state protections and market regulations in the name of austerity, efficiency, and individual responsibility carried a similarly sharp racial edge as they sought to separate the deserving from the threatening poor."[49]

Singh's critical reformulation of America's long war echoes other scholarly arguments on how these fundamental social transformations were the state's response to what sociologist Jordan T. Camp calls "the organic crisis of Jim Crow Capitalism."[50] Camp observes how "moral panics around race, crime, disorder, security, and law and order became the primary legitimating discourse for the expanded use of policing, prisons, and urban securitization in the state's management of social and economic crises."[51] What he terms "neoliberal racial and security regimes" are the "outgrowth of a long counterinsurgency against the Black freedom, labor, and socialist alliance that took shape in the struggle to abolish Jim Crow racial regimes."[52] The resultant period of neoliberal political and economic restructuring (which has its roots in early Cold War bipartisan consensus) has given rise to uneven capitalist development, mass criminalization, and violent securitization in cities across the US and globally. I would add that worldwide counterinsurgency operations of the European great powers (developed in the wake of revolutionary decolonization movements across the Global South) also emerged at the precise moment in which antiracist and socialist critiques of domestic counterinsurgency (police surveillance and incarceration) "gripped the imaginations of radical social movements in the US."[53] In particular, the late 1970s and early 1980s mark the beginning of the explosive boom in the racialized US prison population and a turn toward mass incarceration, domestic counterinsurgency, and neoliberal restructuring that is part and parcel of the "war on drugs" and the "war on crime."[54] Putting my account of the forever war in conversation with this scholarly literature on racial capitalism and the

Black Radical tradition provides more historical context for the domestic and international ends of US counterinsurgency warfare and its gendered racial targets into the twenty-first century.

The work of Camp and Singh builds on the groundbreaking contributions of Stuart Hall and his students in edited volumes such as *Policing the Crisis* and *The Empire Strikes Back*.[55] These scholar-activist projects provide endlessly compelling blueprints for analyzing our ongoing crises of authority caused by police violence; mass and racialized incarceration; seemingly permanent foreign and domestic wars; and struggles for global economic, environmental, social, sexual, and religious justice. To better understand issues of crime, of terrorism, of immigration, of gender violence, of poverty, of forever wars, and so on, we need to adopt intersectional, interdisciplinary approaches to understand how presumably distinct spheres collude in producing dissident outsiders. By now, scholars take for granted this notion of "articulated categories," or a framework of intersectionality (in works of Stuart Hall, Kimberlé Crenshaw, and countless others) that formulates an understanding of race, class, gender, sexuality, religion, and other categories of social difference as co-constituted, that is, coming into existence "in and through relation to each other," to adopt Anne McClintock's terms.[56] But this understanding of articulated categories advanced by Hall and other Black British thinkers of the time went one step further to demonstrate the intersectional nature not only of social difference but of culture, politics, and the economy too. These realms are rendered too often as discrete spheres of inquiry rather than co-constituted social forces. In their classic volume *Policing the Crisis: Mugging, the State, and Law and Order*, Hall and his colleagues argued that the problems confronting advanced capitalist nations such as Great Britain and the US in the 1970s were not purely economic, but that the crisis of overaccumulation was a political and social crisis too. That is, they claimed that race and other salient categories of difference were at the heart of capitalist violence. Governments repeatedly scapegoat "outsiders"— whether undocumented Central American migrants, trans and gender-nonconforming people, sex workers, the homeless, the seroconverted, Muslim refugees, and so on. The point here is that there is often an unseen cultural and ideological dimension to what is conventionally understood as "merely" political or economic.[57] So too with the moral panics of security.

It follows, then, that state surveillance and racism are deeply imbricated in the history of US capitalism. The saga of national security surveillance in the US, in turn, is inseparable from the history of US colonialism, gendered racism, and empire. As many scholars have argued, racialized surveillance

has enabled the consolidation of capital and empire throughout US history, from the settler colonial period through to our advanced neoliberal era of forever war.[58] According to Arun Kundnani and Deepa Kumar,

> What brings together these different systems of racial oppression—mass incarceration, mass surveillance, and mass deportation—is a security logic that holds the imperial state as necessary to keeping 'American families' (coded white) safe from threats abroad and at home. The ideological work of the last few decades has cultivated not only racial security fears but also an assumption that the security state is necessary to keep "us" safe. In this sense, security has become the new psychological wage to aid the reallocation of the welfare state's social wage toward homeland security and to win support for empire in the age of neoliberalism.[59]

To their account of the neoliberal and racial regimes of security at the heart of empire, we can add the insights of US women of color and Third World feminists who have long argued that racial and imperial capital, in Grace Kyungwon Hong's terms, "was always organized around gender, reproduction, and sexuality."[60] Indeed, debates on national security surveillance and warfare remain impoverished without an intersectional analysis of gendered racism, capitalism, and empire.[61]

To review, this book's critical cultural studies approach to insurgent aesthetics and neoliberal security and warfare is indebted to at least three major intellectual formations. The first inspiration, as described above, is my reading of the work of the late Stuart Hall and his comrades in the 1970s and 1980s at the Birmingham Centre for Contemporary Cultural Studies.[62] The second body of scholarship is the US Black Radical tradition, most often associated with the writing of Cedric Robinson.[63] The third strand of critical cultural materialist influence on this book is the work of Lisa Lowe and other "post-Marxist" materialist feminists of color and queer of color critics who likewise reject the crude dichotomous thinking on cultural politics that emphasizes stale binaries between social control and resistance or incorporation and subversion of earlier cultural Marxist traditions. These writers also note how "culture" names "the field on which economic and political contradictions are articulated."[64] Under this formulation, diasporic visual art and related cultural forms are the sites where knowledge and meaning about the forever war are at once constituted and unraveled. These works can provide essential reserves for articulating ideological systems of difference across multiple national sites. "Because culture is the contemporary reposi-

tory of memory, of history," writes Lisa Lowe, "it is through culture, rather than government, that alternative forms of subjectivity, collectivity, and public life are imagined. This is not to argue that cultural struggle can ever be the exclusive site for practice; [but] it is only through culture that we conceive and enact new subjects and practices in antagonism to the regulatory locus of the citizen-subject."[65] Moreover, for Hong, as for other materialist feminists of color in this rich intellectual tradition, culture is a "material force rather than a transcendental, autonomous, aestheticized separate sphere," or "the site to express that which is unspeakable."[66] *Insurgent Aesthetics* thus presents a vital counterhegemonic site for constructing new political subjects and analytics that are materially and aesthetically at odds with the institutions of citizenship and national identity—the grounds from which insurgent alternatives and political coalitions against the forever war might emerge. As such, this book connects the intersectional theorizations of diaspora, migration, and insurgency in critical race, postcolonial, Black, Indigenous, queer, and feminist studies to the long-standing scholarly tradition on the cultures of US imperialism.[67]

On the Queer Calculus of US Empire

In this introduction's opening account of the "collateral afterworlds"[68] of US drone strikes in Af-Pak, I asserted that we require a stranger calculus to grasp the violence of the forever war and challenge the state's dominant militarized logics—what I term a *queer calculus*—that unsettles normative analyses of the forever war and outlines blueprints for utopian future imaginings amid limitless violence. In this section I elaborate on queer calculus as an epistemological and affective intervention, and in so doing dwell on the essential, if unexpected, reservoir of political inspiration and theoretical power that the field of queer studies affords this book's account of the forever war. Queer calculus is a critical hermeneutic strategy through which racialized and dispossessed peoples, including Arabs, Muslims, and South Asians in the diaspora, have created alternative world-making knowledge projects to render visible or sensuous all that has been absented by the abstractions of the forever war.[69] The constellation of contemporary art and performance works analyzed here produces an insurgent aesthetics by how it interacts and plays with viewers' multisensory experiences of and responses to its aesthetic objects. This book questions the abstractions and rationalities of US imperial discourse and the statistical modes through which the forever war's "collateral damage" is calculated, aggregated, and divided. In the process, I ex-

pose another calculus, a *queer* calculus, of bodies in pain and of bodies that imagine alternatives to that pain. Queer calculus is thus about inhabiting another arithmetic altogether, one that constructs a slantwise relation to how imperial warfare has been measured conventionally, including body counts, combat time, military budgets, and the price of oil. This critical hermeneutics is at odds with the US state's necropolitical calculations, an investment in numeracy and counting that dates back to the early American slave period and further evokes what geographer Katherine McKittrick suggestively names "the mathematics of unliving."[70] If, as I contend in this book, global counterinsurgencies disorganize and destroy communal modes of belonging for racialized and diasporic populations targeted by US forever wars, then an antiracist, feminist, and decolonial queer calculus not only identifies an alternative frame from which to interpret these violent imperial practices but also signals an entirely new mode of inhabiting and feeling the world collectively and relationally in times of neoliberal security and war.

Insurgent Aesthetics is indebted to the major paradigm shift in queer studies over the past two decades that situates the study of sexuality at the intersections of race, nationalism, (settler and franchise) colonialism, capitalism, liberalism, migration, militarism, and empire.[71] The mode of critical inquiry (that is, antiracist, feminist, decolonial, and queer critique) prioritized in this project is in explicit conversation with the emergent formation known as critical ethnic studies.[72] As Chandan Reddy, Grace Hong, and Roderick Ferguson have all argued, Third World and women of color feminisms and queer of color critique emerge from this intersectional, race radical tradition of scholarship rather than primarily from Eurocentric strands of queer theory.[73] I use these broader theorizations of the social world from queer of color, queer diasporic, and queer Indigenous/Native studies to suggest that we can further de-link queer reading practices and analytics from putatively queer bodies. Moreover, the mode of queer studies I draw on in this project understands queerness not simply as an identitarian category (to describe LGBTQIA populations), but as a critical set of interpretative practices or a decolonial praxis that makes possible the production of new knowledges, affects, and affiliations.[74] Here, a willingness to accept that queer theory can be marshalled beyond studies of non-normative sexualities and genders becomes paramount.[75] This is not at all to suggest that the decolonizing erotic project at the heart of queer theory should be abandoned. I likewise remain attentive to scholarly criticism that has called into question the wholesale valorization of sexual deviance and disorder that is endemic to contemporary queer studies and politics, and the genealogies of what theorist Kadji

Amin calls "disturbing attachments" that sometimes ensue from the field's idealization of the queer erotic.[76] But I equally want to join other queer critics who hold on to the power of queerness as a complex sign for decolonization and radical pleasure, intimacy, fugitivity, coalition, and utopian futures despite (and perhaps also because of) these conditions of violent subjection.[77]

By asserting the sign and method of queerness centrally within this study, I bring the intellectual and political tools from queer of color and queer diasporic critique—intersectionality and assemblage theory and an attention to embodiment, sensation, and aesthetics—to address violent transformations in the sensorial life of US empire in the late twentieth and early twenty-first centuries. While the primary goal of this book is *not* to privilege an examination of non-normative gender and sexual subjects in a criticism of the forever war, this is not at all to imply that heteropatriarchal structures or non-normative sexual or gender subjectivities, expressions, and embodiments do not centrally undergird US neoliberal security state practices of racialization, war, and empire. In fact, US global security and surveillance regimes have long been concerns of at least radical feminist, if not queer and/or trans*, studies.[78] As literary critic Kyla Wazana Tompkins observes, one of the clearest insights of queer of color criticism is that as the "foundational racial violences" undergirding modern nation-states "were being laid down and concretized, categories of normative and non-normative sexuality were constructed alongside and over them Queer of color critique articulates queer theory from the heart of these and other histories."[79] Moreover, US, Israeli, and other settler colonial and biopolitical regimes have long rendered the sexualities of nonwestern and racialized Others (including Arabs, Muslims, South Asians, and Palestinians) as non-normative—that is, savage, repressed, and deviant—in order to legitimize settler colonial dispossession over people and lands. While attentive to the intersectional systems of social power and violence that structure the imperial and racial formation of the forever war, my primary goal in this book is to apply the conceptual traditions and tools of queer criticism to enhance a scholarly investigation of race, security, and empire.

At the same time, this book explores how queer politics and queer studies themselves might be enriched and reimagined in light of violent practices such as aerial bombings and remote warfare, military detention and extrajudicial torture, and the atmospheric and subterranean politics of US/Israeli settler colonialism. Because these sites comprise the major flashpoints of neoliberal security and warfare examined in this book, I ask further, what are the effects of these violent practices on the gendered, racialized, and

sexualized bodies that are their targets? What alternative forms of being and belonging do such vulnerable queered and racialized bodies in turn enact and imagine through culture and performance? And finally, how do the insurgent aesthetics of South Asian and Arab diasporic artists "queer" the governing calculus of US empire to propose alternative modes of sensuous affiliation and fugitive coalition in the forever war? As my brief tripartite discussion reveals below, I aim my use of queer criticism in concrete ways throughout this book. "Queer calculus" thus names an alternative lens to analyze (1) logics and evidence, (2) affects and the senses, and (3) sensuous affiliations and coalition in the forever war.

ON LOGICS, ARCHIVES, AND EVIDENCE

The first meaning of "calculus," from its origins in mathematics, refers to a particular method or system of reasoning used by the state in its often senseless enumeration of wartime violence. Central to this book are questions of expertise, mastery, and evidence—concepts finely calibrated to serve the super-panoptic ambitions of the US forever war. How does the US global security archipelago "see"? How does it devise a visual order to know what it knows about its citizens, subjects, economies, enemies, and geographies? In chapter 1 I analyze key aspects of contemporary security expertise and the dominant knowledge practices through which security threats are visualized, rationalized, and managed. In this way, I highlight the centrality of the aerial perspective, both literally and figuratively, to imperial epistemes of global warfare. This analysis of the normative logics of US empire demands that we pay close attention to what is "up in the air." The post–Cold War national security state, in its efforts to contrive what Randy Martin called a "techno-scientific intelligence war," has attempted to acquire infinite knowledge about the so-called terrorist enemy while actively destroying the evidence of its collateral violences in the process.[80] Yet, as seen in nearly two decades of disastrous war and occupation in Iraq and Afghanistan, the US security apparatus remains befuddled by precisely *how* to rule as a neocolonial power. This recursive failure of mastery in imperial theaters of war ensues despite the US's "sturdy confidence in the power of calculable information."[81]

While this first meaning of "calculus" captures these contradictory logics and evidentiary tactics of US imperial governance, which I trace extensively in chapter 1, I also use "calculus" here to analyze the *alternative logic or system of reasoning* produced by diasporic cultural workers as they attempt to make better or different sense of the incoherences of the forever war. "Calculus," in this manner, refers to the queer epistemologies of the

diasporic cultural forms I amplify in chapters 2 through 4. This book's expressive cultural archive of insurgent aesthetics thus offers another system of value for visualizing, knowing, and sensing the forever war. Queer and feminist criticisms provide important stimuli for my approach through their persuasive attacks on normative claims to evidence, archives, and systems of representation.[82] For example, drawing on the work of subaltern and postcolonial studies, the late queer performance theorist José Esteban Muñoz, in his assessment of the politics of knowledge, proposes an alternative mode of valuation, or "proofing," that is crucial to this book's account of the queer calculus of the forever war.[83] For Muñoz, the search for publics, or "outposts of actually existing queer worlds," led him to place critical utopian emphasis on ephemera, which is a "kind of evidence of what has transpired but certainly not the thing itself . . . a mode of proofing and producing arguments often worked by minoritarian cultural and criticism makers."[84] According to Muñoz, analyses of ephemera do not displace materiality but instead refashion it for the service of contemporary queer politics. Identifying ephemera, like queerness, involves attending to traces and performances of lived experiences—"the remains, the things that are left, hanging in the air like a rumor."[85] Because the historical archives of queerness were often unintelligible to heteronormative eyes ("makeshift and randomly organized"), it has been easy for those who subscribe to traditionalist methodologies to critique the evidentiary authority of queer scholarship and its still incipient (non-) claims to "rigor."[86] He continues: "This has everything to do with the fact that leaving too much of a trace has often meant that the queer subject has left herself open for attack. Instead of being clearly available as visible evidence, queerness has instead existed as innuendo, gossip, fleeting moments, and performances that are meant to be interacted with by those within its epistemological sphere—while evaporating at the touch of those who would eliminate queer possibility."[87] Muñoz's powerful methodological vision thus challenges both heteronormative and disciplinary constraints on "the archive" and offers some of the most lucid insights into the subaltern queer scholar's especially vexed relation to historical evidence.

This book's approach to archival production is likewise indebted to Indigenous, queer, postcolonial, transnational, and race radical feminisms, which have questioned the evidentiary force of normative epistemological claims that are often saturated with racism, sexism, classism, regionalism, ableism, casteism, and homophobia. For instance, Grace Hong argues that women of color feminist praxis names the return of the repressed by US neoliberal abstraction in both its early twentieth-century and its late twenti-

eth- and early twenty-first-century forms. For Hong, race is a kind of "ghost: almost inarticulable, always slipping away. It is almost always misrecognized as something more solid, something more knowable."[88] Historically, there are "ways of seeing, evaluating, classifying, and representing" that effectively silence other systems of representation, but notably, those "silences produce their own echoes."[89] Hong and other critics demonstrate how women of color and transnational feminist cultural forms offer an analytic—that is, a "way of making sense of"—that reveals the contradictions and incoherences of the racialized and gendered state. This conceptual approach to ghosting resonates closely with the groundbreaking work of sociologist Avery Gordon, who argued evocatively that "haunting is one way in which abusive systems of power make themselves known and their impacts felt in everyday life, especially when they are supposedly over and done with (such as with transatlantic slavery, for instance) or when their oppressive nature is continuously denied (such as with free labor or national security)."[90] For Gordon, "haunting" is therefore "an animated state in which a repressed or unresolved social violence is making itself known in the archive."[91] Taken together, these critical insights on ephemera, silences, and ghosting all point to how critical queer, feminist, and postcolonial approaches to dominant archives offer creative strategies to unmoor the stranglehold of common explanatory frames of imperial power over the meanings of late modern warfare, especially when the oppressive nature of empire is continuously denied or disavowed. I find this collective archival impulse to be highly generative for my queer feminist decolonial exploration of the forever war, which itself is an archive that continues to unfold violently, even as it refuses to see itself *as* an archive. *Insurgent Aesthetics* thus ruminates on the imaginative function of diasporic expressive cultures to offer an alternate, demilitarized system of "proofing," one that summons the ephemeral echoes, traces, and ghosts silenced by the sovereign frames of American war and empire.

ON AFFECTS, SENSATIONS, AND EMBODIMENT

If this first meaning of calculus underscores the role of logics, archives, and systems of reasoning in developing a critique of the forever war, the second, less circulated sense I use in this book has a more physiological origin. This notion of calculus underscores the role of affects, sensations, and embodiments. In medicine, "calculus" (or "calcification") describes a concretion of minerals within the body, in places such as the kidney or gallbladder. This process is often painful, as these stones are difficult to displace or dissolve. Their destructive power accrues as they grow in number, wreaking havoc on

different organs, first one by one and then on the entire system as a whole. This organic sense of calculus also conjures the idea of residue, a palimpsestic view of time that carries with it the somatic sedimentation of older histories, encounters, and legacies of violence. The second interpretation thus opens up a particularly generative way of describing the forever war as a violent, corporeal, and temporal process working on minoritarian bodies. It allows me to accentuate not only what we might call "the sensorial and somatic life of empire," but also the sedimentation of different forms of embodied violence over time.

As students of race, gender, and empire well know, the material regulation of bodies and sensory processes is crucial to the biopolitical and necropolitical security practices perfected in the global forever war. Yet this phenomenon also has a pervasive discursive dimension. Scholars of war, crime, and governance have brought renewed attention to the interarticulation of physiological metaphors of contagion and illness with crime and terrorism.[92] "Quarantining," "infection," and "host" are all pathological discourses long used to express anxieties over the circulation of terrorism. For instance, in his study on the changing configurations of US governance after World War II that led to the "war on crime," legal scholar Jonathan Simon underlines the connection between the health of the individual body and the collective health of the body politic under the sign of US imperial governance, noting how "cancer and crime share a rich metaphoric tradition of trading images."[93] As literary scholar Patrick Deer adds, "like a virus, it seems, war tropes have *spread* throughout the body politic and global economy."[94] Indeed, these pathological security discourses obtain not only in the domestic arena, but in the context of foreign and military policy as well. Visual studies scholar Nicholas Mirzoeff illustrates this fact by citing the US military's own counterinsurgency field manual, which refers to three stages of counterinsurgency as "'first aid,' 'in-patient care-recovery,' and the final achievement of 'outpatient care—movement to self-sufficiency.'"[95] Mirzoeff elaborates on how these biopolitical and biomedical metaphors persist in the ongoing occupation as crucial, if imperfect, representations of US military doctrine.[96] The examples I draw together here from Simon, Deer, and Mirzoeff all reveal how biopolitical and necropolitical tropes of health, illness, and contagion saturate contemporary discourses of counterterrorism and counterinsurgency warfare. These symbols further permeate my archive of insurgent aesthetic responses, as the discussion in chapter 3 of visual artist Rajkamal Kahlon's haunting paintings and collages of anatomical figures culled from US archives of medical autopsies and death notifications will make clear.

While this dominant calculus of the forever war makes use of the gen-
dered racialized body and the senses to imagine threats and their violent
containment, one wonders whether a method exists to account for the for-
ever war that theorizes bios otherwise. To that end, Judith Butler argues that
to better understand the operation of warfare, "we have to consider how
it works on the field of the senses. What is forced and framed through the
technological grasp and circulation of the visual and discursive dimensions
of war?"[97] If the senses are the first targets of war, as Butler maintains, then
seizing an alternative relation to the sensorial realm is crucial to the devel-
opment of a sustained antiwar politics. *Insurgent Aesthetics* seeks out queer
approaches to embodiment and the senses in order to critique the state's bio-
political regulation of vulnerable populations and its simultaneous reliance
on corporeal metaphors. I call this alternate relation to the bios and senses
a "queer" calculus because queer critique offers the most vibrant account-
ing of the sensuous and embodied realms of inquiry that other frameworks
have sidelined.[98]

Insurgent Aesthetics documents how Arab, Muslim, and South Asian dia-
sporic cultural producers have seized the senses to develop different accounts
of the forever war. This book displaces the overemphasis of visual culture
in analyses of transnational warfare by focusing on lesser-studied senses,
including touch and sound. I demonstrate how these extravisual sensory re-
lations have become newly vital to US security governance, both as actual
military weapons (e.g., the use of music during torture[99]) and as resources for
diasporic public cultures. An attention to embodied performance art prac-
tices in chapter 2, specifically through a formal reading of Iraqi-born artist
Wafaa Bilal's tactile performances of pain, reveals how insurgent aesthetics
approach the body and its sensorial regimes otherwise in the context of aerial
and drone warfare. In chapter 3 I explore these questions through aesthetic
responses to US military detention and confinement globally, analyzing how
collaborative art practices by the Visible Collective and the Index of the Dis-
appeared manipulate vision and visuality to conjure an aesthetics of "warm
data," a sensuous record of the absences and redactions in archives of the
US security state. In chapter 4 I explore queer sensorial approaches to flight,
escape, weightlessness, and fantasy in the context of the ongoing Israeli occu-
pation of Palestine. I show throughout how these diverse diasporic cultural
forms develop queer feminist approaches to embodied sensory relations, see-
ing bodies not only as texts but as flesh and bones, "material and not just
materialized" through social relations.[100] An account of the queer calculus
of the forever war thus takes up the conjoined material and discursive con-

notations of the phrase to capture how affects, fantasies, sentiments, and the senses have figured in and mattered to the shaping of US empire and its insurgent undoing in multiple sites across the forever war.

ON SENSUOUS AFFILIATIONS,
RELATIONALITY, AND BELONGING

The third and final interpretation of calculus in this project follows closely from the first two on reason and affect, respectively, to examine how transnational and diasporic affiliations have been undermined and transformed by the forever war. If "affect" refers to the "glue" that coheres social relations,[101] I argue that the forever war makes various forms of affective belonging difficult or impossible to sustain through its violences, abstractions, and restrictions on the movement of gendered racialized bodies. At the same time, the US global security state conflates multiple groups of people into "terrorist lookalike" populations (through the gendered racial figure of the "Muslim") and evinces Manichean Cold War–style binaries that divide the world into those who are "with us" and those who are "against us" in the war on terror. This dominant map of US empire, characterized by its fixity, abstractions, and incoherences, has produced what Patrick Deer calls "a strategy that partitions, separates, and compartmentalizes knowledge, offering a highly seductive, militarized grid through which to interpret the world."[102] This existing "grid" of intelligibility not only creates schisms and separations when imagining targeted groups and militarized geographies; it also attempts to produce a coherent idea of the "Muslim enemy Other" from disparate populations of Arabs, Middle Easterners, and South Asians with divergent histories of race and class oppression in the US. This process of gendered racialization is meant to construct, in anthropologist Junaid Rana's terms, "a visible target of state regulation and policing for consuming publics."[103] The great irony of this blatant form of enemy production is that rather than celebrate the "richness of population historically forced together by conquest," as Randy Martin notes, US empire treats this diversity instead as "a menacing entanglement from which imperial might must flee."[104] In this light, the US forever war project is about not only resource extraction or control over strategic territories, but also systems "to effect a separation from unwanted attachments and attentions—precisely what is meant by terror."[105]

Nevertheless, these forever war conflations, abstractions, and estrangements generate unintended and potentially valuable consequences for theorizing queer alternatives now. As I document throughout this book, the tactics of the US global security state inadvertently produce new sensuous

alliances and coalitions between groups of people who might not have pre-viously seen themselves as allied with each other or who might not have understood how they were involved in overlapping struggles against impe-rial policing, racialized punishment, and gendered militarism at home and abroad.[106] Put differently, *Insurgent Aesthetics* argues that an alternative map of radical diasporic affiliation and transnational belonging has been pro-duced among groups of Arabs, Muslims, and South Asians in the US as well as activists in civil and immigrant rights and antiwar movements as a result of, and in spite of, the dividing orders of the forever war. This book points to insurgent aesthetics to reinstate the memory of these collective attachments and sensuous affiliations. Thinking "Arab–Muslim–South Asian" concur-rently thus indexes a powerful, if evanescent, alternative politics of belonging and coalition that is not circumscribed by the hostile categories conjured by US state security as it targets populations for discipline or dispersal.[107] Here I am accentuating the time-based and durational dimensions of the forever war (as ostensibly eternal) juxtaposed by the fleeting, fugitive, and ephemeral nature of insurgent collective aesthetics forged over the past two decades. What might it mean to consider the queer legacy of "Arab–Muslim–South Asian" as an anti-identitarian formation of racialized struggle that emerged in a particular time and place and that is just as temporally and spatially unbound as the US forever war?

By historicizing "West Asian" and "South Asian" racial formations in the forever war, *Insurgent Aesthetics* further expands the field of Asian American studies, in which "Muslims" and "Arabs" have been invisible or ambiguously addressed at best.[108] Sunaina Marr Maira has aptly described a new form of comparative "US Area Studies" emergent after 9/11, arguing that the "hyper-visibility of Muslim Americans after 9/11 is tied to the state's desire to map Muslims, and especially Middle Eastern and Pakistani communities, within the US to monitor them and convince the American public that it is guarding against the threat of terrorism."[109] Postcolonial feminists such as Rey Chow, Chandra Mohanty, and Ella Shohat have likewise argued that academic prac-tices in the US, which produce knowledge formations and mappings through a variety of ideological state apparatuses, cannot be understood outside of their relationship to imperialism; the visual force of these intellectual and political projects produces realities on material landscapes, bodies, and affili-ations.[110] *Insurgent Aesthetics* contributes to the field of contemporary scholar-ship that emanates from this rich postcolonial feminist tradition by drawing together these conceptual insights with comparative area studies literature on the Greater Middle East and South Asia as well as transnational, dia-

sporic, and global assessments of South Asian, Muslim, and Arab diasporas as newly hypervisible political categories for US scholarship.[111]

Thinking relationally about insurgent aesthetics as a new queer poetics of solidarity produced in and through the forever war additionally refuses to simply reproduce the violences of US gendered racialization, whereby a full set of social differences is reduced to a chain of equivalences under the sign of "Islam." Instead, this relational approach resonates with the queer studies emphasis on locating models of non-blood-based affiliation routed in and through difference and with critical attention to the challenges and traps of identification.[112] The forever war thus evokes queer forms of belonging, desire, and intimacy that often evade recognition or translation—what Elizabeth Povinelli, writing elsewhere on liberal settler colonial states, calls a "politics of espionage."[113] If global forever war manipulates, conflates, and destroys communal bonds, stripping away our sense of responsibility and our way of knowing each other and ourselves in times of war, then it also engenders the conditions of possibility for imagining alliances and fugitive coalitions anew. This book explores this contradictory queer terrain created by shape-shifting states of security, breaking open imperial frames of violence to reveal a queer account of the insurgent aesthetics of the forever war and to conjure the moment when, as Judith Butler performatively avows, "war stands the chance of missing its mark."[114]

Locating Arabs, Muslims, and South Asians in the Heart of US Empire

Many racialized and Indigenous peoples have been targeted by contemporary US global war-making and thereby experience different degrees of precarity, vulnerability, dispossession, immiseration, and risk in relation to the US national security state. While this book focuses on the violences of contemporary US global war-making in the Greater Middle East, it understands settler colonial histories of settlement, land theft, Native genocide, African chattel slavery, and Asian exploitation as wholly vital to the genealogy of the US forever war and its racist architecture of social control. I also observe the complex traffic of Euro-American colonizing discourses and practices in the Greater Middle East and throughout the Global South that inevitably borrowed from and refashioned each other, as well as the longer history, throughout the twentieth century, of revanchist security thinking and imperial governance, whose gestations have all materialized into the horrors of the twenty-first-century world.[115] Thus, I see the broader US national se-

curity project to be integral to settler colonial processes in North America and constitutive to the genesis of the modern state and its capitalist mode of production.[116] *Insurgent Aesthetics* approaches these conjunctural concerns by analyzing the racialized architecture of security and surveillance in the historical epoch that Inderpal Grewal describes as "advanced neoliberalism."[117] This period extends before 9/11 but ramps up dramatically under the Bush, Obama, and now Trump administrations with foreign wars (including the deployment of US forces, the training of foreign counterterrorism forces, relentless US bombings, targeted assassinations, and black sites throughout parts of the Greater Middle East, South Asia, and Africa). This corresponds to a panoply of carceral regimes on the domestic front including aggressive militarized policing, mass deportations, migrant detentions, forced removals, and prison expansion, including the criminalization of whistleblowers and social justice activists.

Given this sprawling global imperial formation, I have chosen to focus on the aesthetics and politics of contemporary Arabs, Muslims, and South Asians in the US and Europe and the transnational networks of subjugated knowledge, affect, and affiliation they have forged during the forever war. I do so for three principal reasons. First, the vast majority of the subjects under investigation in this book are women artists who trace their origins back to numerous countries across the Greater Middle East and South Asia, including Iraq, Afghanistan, Lebanon, India, Bangladesh, Pakistan, and Palestine. They comprise multiple geographic, religious, and supranational ethnic identities, and this relational lens powerfully captures how the events of September 11 have collided with older histories of imperialism, gendered racism, heteropatriarchy, neoliberal capitalism, Islamophobia, and US Orientalism while also amplifying newer modes of anti-Muslim, anti-Arab, anti-Palestinian, and anti–South Asian racisms.[118] Second, a focus on the visionary, world-making potential of contemporary art and aesthetics in the context of US war and empire has been sorely underinvestigated in the scholarly literature on Arab, Muslim, and South Asian diasporas.[119] This book intervenes by centering the social potential of aesthetics as a queer feminist fugitive strategy for critiquing politics and reimagining collective social life under conditions of surveillance and securitization.[120] Third, while many of the artists under review here have risen to prominence in the fine art world over the past decade, they remain largely understudied in visual culture, art history, and performance studies. This book contributes to these scholarly fields by explicitly highlighting the work of contemporary Arab, Muslim, and South Asian diasporic queer feminist cultural producers as indispens-

able to both US/North American and international art worlds and markets alike.[121]

The critical praxis of insurgent aesthetics that I trace throughout this book is centered on the long-standing dialectic between insurgency and counterinsurgency in the forever war. This book argues that the contemporary global forever war machine is the culminating product of consecutive, long twentieth-century campaigns of US GCOIN in the Philippine-American War, the American War in Vietnam, and the wars in Afghanistan and Iraq since 2001. GCOIN refers to a military strategy that involves containing or extinguishing the threat of so-called insurgencies that thwart the political authority of an occupying power. And yet, as the late Pakistani political theorist Eqbal Ahmad aptly observed, counterinsurgency is better recognized as a "multifaceted assault against organized revolutions. This euphemism for counterrevolution is a product neither of accident nor of ignorance. It serves to conceal the reality of a foreign policy dedicated to combating revolutions abroad and helps to relegate revolutionaries to the status of outlaws."[122] US and European counterinsurgencies, when historically directed at rebellions from one constellation of racialized or colonized peoples, also have exacerbated erstwhile forms of terror and violence directed at other Indigenous and racialized communities of color.[123] As Ahmad crisply adds, "the reduction of a revolution to a mere insurgency also constitutes a priori denial of its legitimacy."[124]

I embrace the radical language of insurgency in this book's queer calculus of the forever war to theorize how the figure of the "Muslim terrorist" has shaped post–9/11 security discourse. The obsession on the "Muslim terrorist" as a political enemy, of course, did not begin after 9/11. It has evolved steadily since at least the Iranian Revolution of 1979 and the Reagan-era focus on the threat of so-called Islamist politics.[125] Critical scholars of the Muslim International have argued emphatically that, by normalizing the language of terrorism and antiterrorism, the figure of the "Muslim" has become a twenty-first-century way of marking the "savage"—casting out particular individuals, groups, and ideas as threats to the "Human."[126] In the great tradition of Frantz Fanon and Sylvia Wynter, for instance, cultural theorists Sohail Daulatzai and Junaid Rana provocatively ask, "Can the Muslim be human?"[127] The normalization of "terrorism" as a category, and the gendered racialized Muslim figure as its constitutive object, has sanctioned the US security state to inflict barbarous violence on the militarized and racial-colonial targets of its forever wars and to delegitimize any critical form of anti-imperial dissent or rebellion. Indeed, it is precisely this racial-religious

figure of the Muslim that has enabled the expansion of the national security apparatus, the militarization of US urban police forces, mass incarceration, so-called deradicalization programs targeting Muslims on college campuses and places of worship, and countless other imperial and racial projects across the advanced neoliberal period, all of which together spawned the institutional conditions of possibility for something as blatant as a "Muslim ban" in the age of Trumpism.[128]

Despite master narratives of American exceptionalism, which view the US as both distinct from the world and simultaneously its microcosm and thus its metonym (through the language of multiculturalism and diversity), the US state actively weaponizes forms of racial and religious difference in the service of empire.[129] It does so further by demonizing as "anti-American militants" all those who would resist US policies of global hegemony, especially its contemporary security wars in the Greater Middle East and their domestic reverberations. My insurgent account of the global forever war challenges the white supremacist, Islamophobic, and heteropatriarchal logics of domination through which popular consent is routinely marshalled for "the state-organized killings of 'Islamic militants,' 'radical extremists,' 'terrorists,' 'jihadis,' and any other number of conjurings of the Muslim in the racialized imagination."[130] By embracing the language of a radical insurgency in my discussion of contemporary diasporic artists, I thus seek to denaturalize the prevailing language of the state that views the figure of the Muslim as the preeminent militarized and racial-colonial target of US counterinsurgent warfare. My goal here is instead to prioritize a thorough engagement with what literary scholar Julietta Singh calls "forms of worldly living that do not entail mastery at the center of human subjectivity."[131] Doing so will help animate what cultural theorist Alexander G. Weheliye cogently terms alternative "genres of the human"—that is, aesthetic works that cannot be reduced to the lexicon of resistance and agency but instead make possible a deeper interrogation of the forms of critical humanity imagined by those cast outside the domain of "Man."[132]

By insurgency, I also summon the longer history of subterranean and fugitive consciousness of insurgent struggle, or what geographer Ruth Wilson Gilmore refers to as "infrastructures of feeling" against the forces of empire, gendered racism, and capital.[133] This fugitive consciousness of insurgent struggle is a key element in making visible, so as to undermine, the forever war. The insurgent is a figure of hope, possibility, futurity, and trespass. As part of my analysis of twenty-first-century insurgent aesthetics, I evoke the wide-ranging historical legacies of Black-, Latinx-, Asian-, Arab-, and

Native-led revolts against state terror, racial capitalism, and settler colonialism in the US/North America. In addition, I call upon the legacy of various so-called nonstate actors of revolutionary liberation movements sweeping across the decolonizing world (Africa, Latin America, Asia) during the long twentieth century; which responded to the emergence of global counterinsurgency campaigns by former imperial powers.[134] These race radical freedom struggles have long been incompatible with global counterinsurgencies and have provided salient critiques of the common sense of US global militarism and securitization. By embracing the language of insurgency and its dialectical relation to counterinsurgency in my queer feminist treatment of art and aesthetics, I thus describe an approach to creative political struggle that works through decentralized networks and across multiple contexts to abolish a society structured in dominance. I aim to situate the work of the contemporary Arab, Muslim, and South Asian diasporic cultural producers under review here within this longer legacy of race radical and Native rebellion to US imperial warfare and state terror.[135]

Although this book focuses on the historical present, the forms of material violence enacted by the contemporary US security state under the guise of a forever war have a long history. When we understand the US forever war not as exceptional but as part of a global, neoliberal racial regime firmly rooted in the history of settler colonialism and racial capitalism, we begin to see some instructive parallels and relationships. The ideological threat and material practice of (national) security and terror upon multiple, overlapping populations stretches from territorial expansions, internal frontier wars, chattel slavery, settlement, and genocides in the eighteenth and nineteenth centuries to annexation wars in the Pacific and the Caribbean in the late nineteenth century; and transitions from European colonial domination to the ascendance of the US onto the world stage in the twentieth century, along with unending wars in Asia and the Pacific in the period after World War II; counterinsurgent interventions against left-leaning movements in Africa, Central America, and Indochina throughout the Cold War; and the cultivation of pro-American autocrats and CIA-sponsored proxy wars and political terror in Latin America, Africa, and the Middle East; through to post–Cold War militarized humanitarian interventionism and twenty-first-century renovations of overt militarized invasion, occupation, and counterterrorism in the Greater Middle East.[136] These multiple, consecutive, and overlapping permutations of exploitation and dehumanization encompass the long racist settler colonial history of the United States and are crucial to understanding the rise of twentieth- and twenty-first-century US global

power through military governance of the decolonizing world. This complex relational history conjoins both the violent subordination *and* the freedom struggles of Native and Indigenous peoples and Asian, Arab, Latinx, and African-descended peoples in the US and globally. As such, the histories of racial slavery, settler colonialism, imperial expansion, and fascism inform not only what Lisa Lowe strikingly names the "intimacies of four continents," but also the genealogy of the contemporary forever war.[137] As *Insurgent Aesthetics* will reveal, these braided histories of violence and their material afterlives are imprinted onto the DNA of the forever war and in the very practices of state violence that the artists in this book interrogate so evocatively in their creative works.[138]

As countless scholars have argued, the repression of Muslims and related racial-religious groups after 9/11 is not exceptional; instead, as Sunaina Maira states, it "must be situated in the longer, global history of US imperial policies in West and South Asia and in relation to other, domestic processes of criminalization, regulation, and elimination of racialized peoples by the US state."[139] As such, I approach the "post–9/11" moment not as a radical historical or political rupture, but rather as a continuation of a longer history of US imperialism that has been erased or evaded. Empire, in this sense, is my lens for tracing the gendered racial formation of US imperial power that took shape long before 9/11 and includes the state's policies of surveilling and repressing radicals or leftist insurgents during the Cold War, as well as a history of undermining Arab American activism before the current war on terror.[140] The "post–9/11" designation should more properly be understood, in anthropologist Nadine Naber's words, "as an extension if not an intensification of a post–Cold War US expansion in the Middle East," which prompted, in Maira's terms, a moment of "renewed contestation over the state's imperial power and ongoing issues of war and repression, citizenship and nationalism, civil rights and immigrant rights."[141] While the geopolitical realignments of the first two decades in the new millennium clearly impact my analysis of insurgent aesthetics, I follow historians Mahmood Mamdani's and Rashid Khalidi's arguments that the roots of contemporary political violence in the Greater Middle East (and their domestic effects) must be traced back to the conflicts and transitions of the "late Cold War" period of the 1970s and early 1980s, a topic I explore further in chapter 1, where I discuss how the US transitioned from its Cold War machinations to overt and unilateral military occupations in Afghanistan and Iraq after the Cold War.[142] As I will show, these historical developments have, in turn, produced

new forms of sensuous affiliation, fugitive coalition, and decolonial knowledge about the US and its twenty-first-century military empire.

Finally, framing my critical investigation of the forever war in this fashion helps to amplify an important strand of Asian Americanist criticism over the past two decades.[143] This scholarship compellingly argues that Asian migration to the US is largely a by-product of uninterrupted US war-making, gendered racialization, and empire in the global Asias across the long twentieth century.[144] This powerful reframing of Asian diasporic subjectivity in the US/North America appreciates how populations from Palestine to Pakistan, Afghanistan to the Philippines are not only (economic) migrants to the Global North but also often refugees, postcolonial, and neo-imperial subjects of the United States.[145] In contrast to studies that rely on the language and frameworks of post–civil rights liberal multiculturalism (e.g., recognition, inclusion, belonging, rights, assimilation), this alternative perspective highlights the entanglement of (South and Southwest) Asian Americans with the US as one marked by indirect but interminable forms of imperialism and (neo)colonial power.[146] Unlike some artists under investigation here, who forged works in the diaspora after years of living in conflict zones marked by direct embodied experience with the US war machine and its client states, the majority of the artists under review in this book are instead diasporic subjects of surveillance societies in the West, differentially impacted by hierarchies of US gendered racialization but not directly targeted by militarized projects of US imperial warfare.

As critics of the US forever war in the Greater Middle East, however, these artists have pursued often more privileged transnational art activist careers that are paradoxically upheld by US empire in global cities such as New York, Dhaka, Amsterdam, and Berlin. This complicated social location situates them differently from many of the racialized and dispossessed subjects of their artworks, including criminalized immigrant detainees and suspected enemy combatants who are forced to suffer the dividing brutalities of US empire as military targets either in the US, at US military prison sites, or in the Global South. For many of these artists, it is precisely their privileged lack of proximity to nonwestern populations and social geographies most ravaged by US global warfare in the Greater Middle East that haunts their insurgent aesthetic practices. Much of their artistic work reflects precisely on the hardened if tenuous line that divides them from violent conflict and its collateral afterworlds. This is so despite the histories of Western colonialism, anticolonial nationalism, postcolonial citizenship, and US racialization that

they often share with many of those they seek to recuperate from archives of the US security state. One way to depict these artists' insurgency against their structural complicity with state violence, then, is in how they wrestle with their own structural participation in the post–9/11 forever war in their formal works as diasporic subjects estranged from the war's cruelest victimizations, even while simultaneously being racialized with these populations through the complex visual order of the forever war machine.[147] By examining insurgent practices and comparative analytics forged by South Asian and Middle Eastern diasporic cultural producers who trace their origins to nonwestern societies that are engulfed by war but who live and labor in the heart of empire, *Insurgent Aesthetics* not only questions what counts as "security" in voided archives of US imperial war-making but also demonstrates how these aesthetic projects reveal a more capacious critique of the transnational politics of surveillance, torture, and killing in theaters of state-sanctioned forever warfare.

Insurgent Aesthetics: Mapping the Book

Insurgent Aesthetics is the product of transnational queer feminist cultural studies. Its critical investigations and arguments are grounded in an interdisciplinary method of close readings of art and diasporic cultural production. I promiscuously and willfully read and sourced secondary materials across the humanities, including critical and cultural theory; critical ethnic studies; American studies; Asian American studies; Indigenous/Native studies; Black studies; postcolonial and diaspora studies; affect studies; queer studies; feminist, gender, and women's studies; area studies of South Asia and the Middle East; art and art history; visual studies; performance studies; and traditional fields of interpretive social science such as geography, anthropology, sociology, criminology, political science, and international studies (lawfare/military/carceral studies). The aesthetic genres assembled in order to advance this book's arguments are equally wide-ranging, and I have selected a self-consciously radical activist cohort of contemporary visual, installation, and performance artists to study concurrently. Many of these conceptual artists know each other and have collaborated over a number of years; they represent a dynamic segment of a broader efflorescence of radical justice–oriented artists, activists, archivists, lawyers, journalists, and intellectuals committed to revealing and combating the multiple social crises of our time.

In this introduction I have established the primary concepts and ap-

proaches of this book through extended reflection on the collateral after-maths and sensorial devastation of US drone warfare as a way to locate my own investment in the study of war and empire through contemporary art and performance. As a queer feminist scholar in the field of American stud-ies, with long-standing research interests in postcolonial and transnational studies of late modern warfare and empire, I have sought to highlight how attention to art and aesthetics as forms of sensuous knowledge and critique can make available alternate ways of knowing and feeling the social world. This introduction interweaves discussion of the primary concepts of and ap-proaches to insurgent aesthetics and queer calculus as critical hermeneutics through which to reappraise the US forever war. By opening with visual art-ist Mahwish Chishty's work on *Drone Art Paintings*, I firmly anchored the book's investigations to the concerns of the contemporary moment, even as the longer history of US empire is crucial to grasping the legacy and impact of the forever war.

Chapter 1, "Up in the Air: US Aerial Power and the Visual Life of Empire in the Drone Age," begins to trace that longer history by developing a criti-cal genealogy of the foremost logics of gendered racial and imperial forma-tion that define the present sites of US militarism and imperial warfare in the Greater Middle East. Using a genealogical historical method, I outline some major flashpoints and material transformations of counterinsurgent policing and killing, liberal confinement, and global war-making across the twentieth and twenty-first centuries that are necessary in order to better ap-praise both dominant US militarized imaginaries in the Greater Middle East and South Asia as well as critical interventions by Arab, Muslim, and South Asian diasporic artists, whose insurgent aesthetics are central to this book's study of the forever war. For instance, I examine the US military's use of drones for targeted assassinations across Iraq and the borderlands region of Afghanistan and Pakistan (Af-Pak). I underscore how the human sensorium (specifically vision) is central to what is "up in the air," that is, the principal epistemologies of waging war across the late twentieth and early twenty-first centuries. I investigate the fundamental role of sensory knowledge in con-temporary discourses of the US global security state in the Greater Middle East. As such, chapter 1 considers three major discursive sites and corre-sponding areas of scholarship. First, I detail security policing and counter-insurgency in the US, South Asia, and the Middle East from the end of the Cold War to the present. This period is referred to as the Revolution in Mili-tary Affairs (RMA) and was precipitated by the fall of the Soviet Union and the subsequent rise of "non-state actors." Second, I highlight the military's

experimental and controversial Human Terrain System, a US Army support program (2005–15) in which social scientists and academics provided military commanders with an understanding of local populations under siege. Finally, I investigate the expanded use of drone technologies across the imperial geographies of the forever war. Drawing on postcolonial feminist criticism and critical geography, lawfare, and military studies, I show how the aerial perspective is central to contemporary US global security regimes, thereby demonstrating the pivotal role of visual frames to manufacturing and obliterating vulnerable populations.

Chapter 2, "On the Skin: Drone Warfare, Collateral Damage, and the Human Terrain," shifts this book's focus away from the dominant militarized calculus of the US forever war and toward insurgent aesthetics of Arab, Muslim, and South Asian diasporic expressive cultures. In particular, this chapter examines visual, performance, and literary works by New York City–based Iraqi artist Wafaa Bilal as a meditation on the bodies of those rendered precarious and dispossessed by US global state violence. Through close readings of his work, I trace an alternative relation to the social worlds disappeared by US aerial warfare in Iraq (and by extension in Af-Pak) to illuminate the insurgent aesthetics detailed in the introduction. The crucial force of Bilal's artwork hinges primarily on the pain he inflicts on his own body—especially his skin. He is best known for a performance in which he lived in a gallery for a month and was shot with paintballs by remote internet users watching through a webcam. Bilal's other works include a twenty-four-hour endurance performance in which artists tattooed a borderless map of Iraq onto his back and another in which he surgically implanted a surveillance camera onto his skull for a year. My reading of Bilal's creative work highlights the critical role of touch, embodiment, and the senses in forging a queer calculus. This framework carefully reconceptualizes the violence wrought by US aerial wars in Iraq and by extension in Af-Pak, Yemen, Somalia, Niger, and beyond.

Chapter 3, "Empire's Innards: Conjuring 'Warm Data' in Archives of US Global Military Detention," returns to the securitized space of the "homeland" to consider the domestic ends of forever warfare in the United States. I examine contemporary aesthetic responses to the archive of detentions, deportations, and deaths at US global military prison sites. This chapter examines how collaborative visual art projects outline the redactions, mistranslations, and disappearances wrought by the US military empire. In particular, this chapter considers the formal and sensory aspects of collaborative works by the Visible Collective (Naeem Mohaiemen and Ibrahim Quraishi) and

the Index of the Disappeared (Chitra Ganesh and Mariam Ghani), two New York City–based multiethnic art collaborations, as well as solo visual installations and drawings by Berlin-based artist Rajkamal Kahlon. These artists conjure an aesthetics of "warm data" in documents related to US global military detention by affixing warmth, touch, and sound to otherwise "cold" data, thereby transforming the administrative violence of the regulatory security state into an imaginative queer haptic archive of the disappeared. As part of my analysis of their works, I discuss the complicities of contemporary US-based Arab, Muslim, and South Asian refugee and migrant communities with war and empire. Through the specific language of trespass and betrayal, I investigate the complex participation and uneven incorporation of diasporic subjects into the projects of the US military empire and its forever wars.

In chapter 4, "Palestine(s) in the Sky: Visionary Aesthetics and Queer Cosmic Utopias from the Frontiers of US Empire," I trace the transnational dimensions of insurgent aesthetic responses to US security regimes, and their entanglement with Israeli settler colonial violence, through a queer feminist analysis of the science fiction and fantasy film work of London-based Palestinian visual artist Larissa Sansour. Chapter 4 tracks joint settler security state logics between the US and Israel, with Palestine as the "archetypal laboratory" for experimenting with new technologies of global counterinsurgencies and asymmetric war-making. Concluding the book in this way allows me to highlight the staggering reach of the US forever war and the numerous entanglements between what Laleh Khalili calls "the two major liberal counterinsurgencies of our day."[148] In particular, I analyze a set of speculative film and visual art practices that call attention to the links between US and Israeli security state practices and advance queer, feminist, decolonial, Indigenous, and diasporic modes of thinking about utopian futures beyond the US/Israeli forever war. Sansour's science fiction films provide an alternate sensorial regime through which to understand the "facts-on-the-ground" of contemporary US/Israeli security policing and securitization. By closely reading her science fiction film trilogy series as a form of sensuous knowledge and critique, I also question what architecture, outer space, and Arabfuturism together might yield for thinking Palestinian sovereignty otherwise. In the speculative visualities Sansour constructs, the dystopian here and now of settler colonial rule in Palestine/Israel has not simply faded away, rendering the Israeli occupation and broader colonization of Palestine vanquished. Sansour's fantasy work does, however, offer an outside and an otherwise that reaches toward an elsewhere of Palestinian freedom un-

bridled by the strictures of settler security states. In this way, her work is an exemplar of what I term "queer feminist visionary aesthetics." It conjures both a sensuous record of present-day Israeli settler security state violence and a necessary queer feminist diasporic recalibration of enduring questions about home, land, collectivity, sensation, embodiment, and sovereign futures beyond settler time. By outlining the links between US and Israeli neoliberal security regimes, this final chapter also probes fugitive alliances and radical forms of insurgent political consciousness between Palestine and Indigenous/Native futurisms and Afrofuturisms in the US/North America. In so doing, this chapter not only contributes to the transnationalization of American studies but also probes the field's outer-planetary and cosmic dimensions too.

In the book's epilogue, "Scaling Empire: Insurgent Aesthetics in the Wilds of Imperial Decline," I review the primary concepts and approaches animating this study of the forever war and offer a brief reflection on how we might rethink insurgent aesthetics and sensuous affiliations in the context of accelerated American imperial decline and the rise of Trumpism. The botched efforts at "nation-building" in Iraq and Afghanistan over the past two decades combined with skyrocketing inequality, planetary destruction, and accelerated human suffering across and within national boundaries all together attest to the spectacularly failed nature of the twenty-first-century empire-state and presage the ends of the American Century. Through brief close readings of the Index of the Disappeared's latest work, *The Afterlives of Black Sites*, and popular media accounts of two instances of contemporary aerial insurgent acts, I reflect on the multiple scales of US empire and the visionary aesthetic and political possibilities for trespass, fugitivity, and ungovernability into the wild. What remains to be seen is how the contradictions of the present historical conjuncture of imperial decline and imperial expansion will assemble new techniques of security expertise and practices of gendered and racialized governance that alter the central calculus of life and death on this planet. I suggest in the epilogue that the insurgent diasporic cultural forms that emanate from this moment of global economic crisis and political instability offer powerful clues that signal a necessary moment of collective reckoning and an opportunity to imagine outside and beyond the stranglehold of US empire, when global warfare finally misses its mark.

In the midst of enduring bloodshed in Afghanistan and Iraq; population displacements and drone attacks in Pakistan, Somalia, Libya, Niger, Syria, and Yemen; the drumbeat of war against Iran and North Korea; the deepening occupation of Palestine; the normalization of intensified disciplinary

tactics against racialized immigrant and nonimmigrant peoples of color in the US; and the complex unfolding of imaginative geographies of liberation and freedom in the US, the Greater Middle East, and around the world today, a queer feminist fugitive relation to these violent archives advances urgently needed genealogies of the forever war and its affective afterlives. The prevailing logics of state security in discourses of terrorism, militarism, and war have impoverished our political imaginations. *Insurgent Aesthetics* reveals how diasporic art and expressive culture can make available new ways of knowing, sensing, and feeling that were once thought to be unintelligible or unimaginable. An analysis of insurgent aesthetics offers a moment of refreshment—an opportunity to think antiracist, anti-imperialist queer feminist politics anew. It lets us move beyond the state's supreme calculus of security and carcerality to propose urgently needed alternatives to US empire. A queer calculus of the forever war designs sensuous affiliations and freedom dreams as expansive as the Pentagon's fever dreams of everlasting warfare but without the violence of their vision.

ONE. **UP IN THE AIR**
US Aerial Power and the Visual Life
of Empire in the Drone Age

Violence is the standard operating procedure of visuality.
—Nicholas Mirzoeff, *The Right to Look*

The managerial approach [in liberal wars] also means that all things—even those that should not be calculable—are made subject to measurement and quantitative finessing. All things can be counted: acceptable levels of collateral damage, the degree of pain meted out in interrogations, the number of people detained, the extent of their access to food or water or medical care. . . . This need for quantitative data, for statistics, for an understanding of how to measure death, incarceration, "useful" intelligence, and the like, means that even as the counterinsurgents decry the crude use of metrics . . . they try to construct vast databases that capture not only intelligence but also the everyday and the intimate. . . . These knowledge repositories are crucial to managerialism but also, in their quantification of suffering, to the task of defending such confinement in courts of law and public opinion. —Laleh Khalili, *Time in the Shadows*

It is not just a more exhaustive reckoning with the past and present of imperialist violence that is needed but, more specifically, a non-juridical reckoning. For this, our starting point should be neither the law nor any desire for a "progressive" appropriation of the law, but the mounting dead for whom the law was either a useless means of defense or an accomplice to their murder. —Randall Williams, *The Divided World*

On May 2, 2011, Osama bin Laden was discovered by a US Special Forces military unit to be hiding in a compound on the outskirts of Bilal Town, an affluent suburb of Abbottabad, Pakistan. A team of twenty-three US

FIG 1.1 "Situation Room." President Obama and his national security team in the White House, receiving live updates from Operation Neptune Spear, which led to the killing of Osama bin Laden, the leader of Al-Qaeda, May 1, 2011. Photo: Pete Souza.

Navy SEALS from the US Naval Special Warfare Development Group (also known as "Seal Team Six") carried out "Operation Neptune Spear" under the command of President Barack Obama, the CIA, and the Joint Special Operations Command, killing bin Laden (codename "Geronimo") (figure 1.1).[1] Reflecting on the US military operation's haunting codename, cultural historian Keith P. Feldman observed how "the residues of a late-nineteenth century settler colonial violence [have been] resuscitated in [this] contemporary project of extraterritorial jurisdiction."[2] As news accounts of the raid and murder spread, speculation quickly ensued over whether images of bin Laden's bullet-stricken body (or even his hastily arranged Muslim burial at sea) would be circulated within the global press. There was some precedent for this moment: images and cellular phone videos of the capture and hanging of Iraqi leader Saddam Hussein in December 2006 were widely disseminated, as were later images of the ghastly public beating and killing of Libya's Muammar Gaddafi in October 2011. Visual studies scholar Nicholas Mirzoeff imparts how, particularly with Hussein's killing, "it no doubt seemed important that, in the swirling, rumor-driven climate of the occupation, some form of proof be made available."[3] In times of contemporary forever war, this "proof" almost always takes the form of visual evidence,

a dominant ocular logic that represents the prevailing sensorial relation to war and empire.

Notably, the few photographs that did emerge as visual testimony immediately after bin Laden's assassination in 2011 were aerial views and Google Earth images of the destroyed compound and surrounding areas in Pakistan (figure 1.2). These photographs are remarkably vital to both dominant world-making and war-making regimes of late modern US frontier violence in the Greater Middle East. The aerial image, as Caren Kaplan instructs, "does a certain kind of work. Like all photographs, the construction of the image—its intensely mediated process—is almost never what we notice. Instead, we think we see the world below us in precise, if flattened, form. A kind of truth-value in uncertain times, located and therefore seemingly known."[4] News that the prolonged and fitful "hunt for bin Laden" had climaxed in his spectacular death at the hands of US military forces set off an outpouring of affective glee among wide swaths of Americans, a terrifying moment of jingoistic celebration and collective catharsis that could have, but of course did not, signal the cessation of the decade-long global war on terror in the Greater Middle East. This violent geopolitical and cartographic project was inaugurated long ago through bin Laden's spectral presence in grainy video and audio recordings released by Al-Qaeda at the turn of the century. In this belated moment, many in the West were eager to channel their sadness and rage about the events of September 11 and its violent aftermath into perhaps one definitive visual encounter with this foremost "enemy" (through pixelated evidence of bin Laden's disfigured body). They were presented instead with two-dimensional and disembodied representations of geographic space at a distance, what Kaplan calls "truth-values in uncertain times." These digitized "views from above" illustrate the political salience of the aerial view to war-making and the global circulation of that view through uploading, copying, and linking of the images.

Participating in the circulation and consumption of this abstracted aerial view provided epistemological certainty in "knowing" the forever war and its militarized terrains. As Mirzoeff notes, "much of the military video and photography from the Iraq war has [also] reflected this uncertain status. Raw TIFF files circulate with no means of contextualizing them, while unedited video footage of routine military events is interrupted on shocking occasion by the eruption of violence. Explanations, context, and consequences are rarely available, whether in US or purported insurgent video."[5] Judith Butler further contends that the differential process of grieving produced in the context of US-led global state violence is rendered through visual represen-

FIG 1.2 Google Earth image of Osama bin Laden's compound in Abbottabad, Pakistan, summer 2011.

tations and media forms that are themselves a central part of waging war.[6] In reference to the spectacular bombing raids over Baghdad conducted by US and allied forces in March 2003, Butler argues that the "panoramic aesthetic," which is built into the discursive conventions of war-making strategies, compels Americans to ethically distance themselves from the consequences of US aerial bombardments abroad.[7] This process, in turn, facilitates Americans' tacit approval of these violent projects, at least from afar. How then do these twenty-first-century technologies of distanced warfare and remote surveillance from above rearrange people's collective sense of place, space, and community on the frontiers of the forever war? And what are the insurgent implications for those of us living in the heart of empire during the drone age?

Taking the visual aftermath of the targeted killing of Osama bin Laden as a point of departure, this opening chapter offers a critical genealogy of the dominant logics of race-making and war-making that undergird the present sites of the US forever war and its complex visual orders.[8] With an expansive approach to the study of US global state violence, I trace across the late twentieth and twenty-first centuries major historical and material transfor-

mations of counterinsurgent policing and killing, liberal confinement, and global war-making. The remnants of these imperial visualities and settler colonial trajectories allow for better appraisal of both the dominant visual life of contemporary US empire in the Greater Middle East and critical interventions by Arab, Muslim, and South Asian diasporic artists whose rebellious and unruly aesthetic practices are central to this book's account of the forever war. This genealogical method helps to locate twenty-first-century US global war-making in the recursive logic of the longue durée, or what critic Jodi Kim rightly calls "America's imperial pasts and presents."[9] The wide array of contemporary military strategies and tactics of neoliberal security and liberal warfare examined in this book are unique and differentiable. These technologies include counterinsurgency, counterterrorism, incarceration, torture, biometrics, and surveillance. They fundamentally destroy and rework human existence and the human sensorium, but they do so by operating differentially and in ways that sometimes compound one another and at other times are at odds.

In later chapters, I explore insurgent aesthetic rejoinders to a distinct but interconnected range of national security and military practices across three major domains. In chapter 2, I read performance works that respond critically to US global military practices of outright killing via distance warfare and targeted assassinations through the use of drones, or unmanned aerial vehicles, in Af-Pak and Iraq. Chapter 3 examines the sensorial life of unlawful confinement in visual and installation art responses to US global military prisons and the related affective, ethical, and legal concerns over extrajudicial practices of torture, interrogation, and rendition at military bases and detention sites. In the fourth and final chapter, I turn to an important outpost of US neoliberal security and warfare, examining overt forms of settler colonial occupation through Palestinian diasporic visual art films produced in opposition to the US's client-state relation with the state of Israel and the enduring Israeli Zionist settler colonial occupation and ethnic cleansing of Palestine. Together, these multiple sites of investigation do not offer an exhaustive survey of contemporary South Asian and Middle Eastern diasporic visual cultures in the forever war. Instead, this book spotlights diverse but interrelated flashpoints of security and securitization to argue that an insurgent aesthetics can conjure sensuous modes of knowing and feeling the manifold fronts of the forever war.

This opening chapter portrays the dominant visual life of empire in which artists make their work, and it unfolds in three parts. I begin by examining the contemporary expansion of counterinsurgency and counterterrorism

through twenty-first-century drone strikes and extrajudicial targeted killings in Af-Pak and beyond. I detail the nature and development of security policing and counterinsurgency in the US and across the Greater Middle East from the end of the Cold War to the present. This period is referred to as the global Revolution in Military Affairs (RMA), a Cold War military theory about the advanced technological future of warfare that was reactivated by the fall of the Soviet Union, the dawning of a new era of globalization, the rise of US technological dominance, and the emergence of so-called global nonstate actors. The RMA is most often associated with the inclusion and expansion of new military tactics, including drones, satellite imaging, and remotely operated vehicles, and scholars have argued that the RMA "has [also] extended and transformed visuality, using digital technology to pursue nineteenth-century tactical goals."[10] I further assess why the US military abandoned Cold War–style low-intensity proxy wars in favor of a bellicose reprisal of its global counterinsurgency doctrine in the military occupations of Iraq and Afghanistan in the period since 9/11.

Second, this chapter explores legacies of imperial incarceration and counterinsurgent confinement to understand the inside/outside binary of US empire, thereby linking the study of US imperial wars abroad to domestic sites of racially targeted state-sanctioned violence at home. As such, I review critical scholarship on US empire, elucidating the tangled ideological and material links between the domestic and international contexts of contemporary global state violence and warfare. In the process, this discussion reconsiders prevailing ideas on the "American Century."[11] I specifically track transformations in immigration law and the collusion of domestic counterinsurgent wars on crime/drugs/terror in the development of the homeland security state. Finally, I highlight the early twenty-first-century "cultural turn" in the US military related to the RMA, analyzing how the experimental and controversial Human Terrain System (HTS) program in particular ignited active debates among critical scholars and defense experts alike on the role of social scientists and academics in twenty-first-century US warfare.

Third and perhaps most centrally, this chapter reflects on the expanded use of drone weaponry in the imperial geographies of the forever war. Drawing on postcolonial feminist criticism and critical geography, lawfare, and military studies, I show how the aerial perspective is central to US global counterterrorism, thereby demonstrating the pivotal role of visual frames in manufacturing and obliterating vulnerable populations. I ask how the global forever war's panoramic "views from above" shape the way the US and its allies think about Orientalist imperial geographies in the Greater Middle East,

and how those aerial views are conceived, framed, disavowed, and impli-
cated in the fundamental destruction and reconstitution of populations, in-
frastructures, and social geographies targeted by US militarism throughout
the region left in their wake. While global air power is neither omnipotent
nor brand new, its expanded use in the twenty-first-century forever war has
implications for the interplay between vision and power/knowledge projects
and for the ethical engagements of those of us situated in US civic life whose
liberal freedoms are predicated on the unfathomable violence of drone at-
tacks in the frontier spaces of the US forever war. Attention to what is up in
the air allows me to examine the pivotal role of sensory and affective knowl-
edge in the racial and imperial formation of the US homeland security state
and its forever wars in the Greater Middle East. In closing, I speculate on the
possibility of transnational activist coalitional politics in the drone age and
the desire to displace and reorder anew the visual life of empire, which is a
principal goal of the chapters that follow.

US Global Counterinsurgencies: Empire Inside Out

While this book adopts a comparative and relational approach to interrogate
the current carceral and militarized practices deployed by the neoliberal se-
curity regimes of the US and Israel across the Greater Middle East, it under-
stands race wars and counterinsurgencies to be as old as empire.[12] Contem-
porary US defense experts argue that, in contrast to conventional combat,
global counterinsurgency (GCOIN) is a military strategy that involves con-
taining or extinguishing the threat of insurgencies that thwart the political
authority of an occupying power. Celebrated by advocates for its so-called
technological precision, cultural and spatial knowledge, and intimate forms
of intelligence gathering, early twenty-first-century US GCOIN doctrine sig-
naled a transformation in military thinking about the nature of global power
in the post–Cold War era. In her introduction to the re-released *US Army
and Marine Corps Counterinsurgency Field Manual*, national security expert
Sarah Sewall writes that counterinsurgency "emphasizes constant adaptation
and learning, the importance of decentralized decision-making, the need to
understand local populations and customs, and the key role in intelligence
in winning the support of the population."[13] A "kinder and gentler" form
of counterinsurgency involves isolating and crushing resistance movements
in occupied territories by "winning the hearts and minds" of local popula-
tions under siege. As Patrick Deer outlines, the goal of counterinsurgency
operations in the US occupation of Iraq since 2003 had been "the deploy-

ment of culturally sensitive, technologically nimble Special Forces to 'clear, hold, and build' the territory as they persuade civilian populations that the insurgents have no legitimacy."[14] In Mirzoeff's terms, this "clear, hold, and build" mantra of counterinsurgency entailed "remov[ing] insurgents from a locality using lethal force, sustain[ing] that expulsion by physical means such as separation walls, and then build[ing] neoliberal governance in the resulting space of circulation."[15] As an existential neoliberal policing and surveillance strategy spanning multiple military and civilian agencies, counterinsurgency is not exceptional to the US, and its contradictory application in a wide set of cases across disparate geographies makes it difficult to assess as a coherent material, ideological, and cultural project. And yet many historians have shown how the US perfected tactics of counterinsurgency well before Vietnam and Iraq through both its fin de siècle wars in the Western Pacific and covert domestic Cold War programs.[16] This involved the systematic repression of Black nationalists and other domestic radicals in the US, and the uneven exportation of those tactics to the post–1945 hot wars in the Global South, a project whose afterlives continue to haunt the global terrain of war-making in the twenty-first century, as I will soon show.[17]

These complex genealogies of counterinsurgency have taken shape in recent Cold War historiography, in which authors importantly reframe the period in a global context. A renewed scholarly focus on the decolonizing world rejects the standard Cold War narrative privileging the post–World War II contest between US democratic liberal capitalism and Soviet-inspired communism. This critical scholarship instead spotlights local developments in Asia, Africa, Latin America, and the Middle East, specifying the regional military interventions imposed by superpowers and how postcolonial elites produced their own agendas for independence and development during the period.[18] For example, historian Odd Arne Westad shows how Cold War globalization sowed the seeds for contemporary international conflicts, including the global war on terror.[19] Westad's *Global Cold War* bridges important debates within international history. While some scholars have focused on the continuities in US imperial governance before and after 1945, suggesting that US foreign policy mirrors the frameworks of older European imperial regimes, historians of decolonization question the very salience of the "Cold War" as an analytical rubric.[20] They argue that many transformations and alliances in the Global South had little to do with superpower elites. Defining the period in limited Western terms thus elides anti-imperial resistance and insurgency that were predicated on regional nationalisms and local priorities, not the imperatives of Washington or Moscow alone. Wes-

tad's work, however, transcends these debates by arguing that the two global transformations that defined the twentieth century—decolonization and superpower confrontation—were inextricably linked. He details the origins and trajectories of Third World revolutions and explains the ideologies behind the superpower military interventions that incited resistance and resentments still smoldering around the world.[21]

While the geopolitical realignments of the new millennium's first two decades clearly impact the analysis of the forever war in this book, I follow the critical argument of historians such as Odd Westad, Mahmood Mamdani, and Rashid Khalidi that the roots of contemporary political violence in the Greater Middle East (and their domestic reverberations) must be traced back at least to the conflicts and transitions of the "late Cold War" period, stretching from the end of the American war in Vietnam to the fall of the Soviet Union in 1991.[22] This transformative period, marked by declining superpower détente and the proliferation of proxy wars in Africa, Central America, and the Middle East, is one of the most consequential nodes in the longue durée of US imperialism in the Greater Middle East across the long twentieth century.[23] The US military continuously engaged in overt and covert interventions between 1946 and 1989. This period also witnessed the expansion and consolidation of worldwide counterinsurgency programs in the wake of revolutionary decolonization movements.[24] In this way, the Cold War's true legacy is not the "long peace" imagined by liberal internationalist apologists such as John Gaddis, but rather a long war of perpetual and violent interventionism all over the globe.[25]

We can learn much about the post–9/11 expansion of overt US counterinsurgency warfare in Iraq and Afghanistan, as well as the greater architecture of post–Cold War global militarized interventionism, by studying the superpower proxy wars of the late Cold War period. In *Good Muslim, Bad Muslim*, Mamdani persuasively argues that the emergence of political Islam was the result of a modern entanglement with Western colonial powers and that the early twenty-first-century terrorist movement at the heart of Islamist politics is an even more recent phenomenon, an outgrowth of the US military's counterinsurgent defeat in Vietnam and its subsequent late Cold War embrace of proxy policing wars in the Third World.[26] Turning attention to the late 1970s and early 1980s, Mamdani shows how President Ronald Reagan's military doctrine of "rollback" against the forces of communism (and his use of the highly ideological politics of "good" against "evil") led to an embrace of counterrevolutionary forces and a policy of "low-intensity conflict" (LIC) across the Third World.[27] Viewing the Third World as the new central

battlefield in the global struggle against communism, this late Cold War shift from the ambitious American counterinsurgency wars of the Vietnam era to an offensive strategy—arming local guerilla groups and undermining revolutionary nationalist governments through the military's use of Special Operations Forces—signaled a "strategic reorientation in US war strategy."[28]

The Reagan doctrine of "rollback" (rather than coexistence or containment) involved advocating for "a determined, sustained, and aggressive bid to reverse defeats in the Third World," including the revolutionary uprisings against US-backed dictatorships in Nicaragua and Iran in 1979.[29] Portraying these militant nationalist governments as nothing more than "Soviet proxies" (rather than organic expressions of anticolonial rebellion), the Reagan administration financed the brutal terror tactics of counterrevolutionary anticommunist forces, including the contras in Nicaragua, UNITA in Angola, and the mujahideen in Afghanistan.[30] Reagan ultimately hailed these counterrevolutionary groups as "freedom fighters" and the "moral equivalents of America's Founding Fathers."[31] What is often missing in post-9/11 US discourses on terrorism and political Islam is how, from the late 1970s onward, "America's benign attitude toward political terror turned into a brazen embrace: both the contras in Nicaragua and later al-Qaeda (and the Taliban) in Afghanistan were American allies during the Cold War. Supporting them showed a determination to win the Cold War by 'all means necessary,' a phrase that could refer only to unjust means."[32] Following Rashid Khalidi, this Cold War legacy of "sowing crisis" (by both US and Soviet powers) exacerbated already fraught tensions between Arab states and Israel and intensified regional conflicts from Turkey and Iran to Lebanon and Iraq.[33]

The "brazen embrace" of political terror in US proxy wars in the Greater Middle East continued throughout what literary critic Phillip E. Wegner calls "the long nineties"—from the fall of the Berlin Wall and the precipitous end of the Cold War until 9/11.[34] Put differently, Reagan-style proxy warfare continued even after the fall of the Soviet empire, through the Bush I and Clinton years.[35] This era of LIC came crashing to a halt, however, after the violent attacks of September 11, which Mamdani calls "the result of an alliance gone sour" that needs "to be understood first and foremost as the unfinished business of the Cold War."[36] With the 2003 invasion of Iraq and the return of counterinsurgency doctrine and high-intensity combat, the Bush II administration, replete with neoconservatives and Sovietologists trained well before Bush Sr.'s declaration of a "New World Order," was free to "shed the inhibitions of the Cold War and declare open season on militant nationalism."[37] The Bush II administration's emboldened and interventionist

posture in the Greater Middle East was no mere post–9/11 anomaly. It represented instead an especially virulent expression of a long-standing imperial legacy, even as the phantom enemy-other shifted from communism to terrorism in the global order after the Cold War. As Khalidi concludes of the expansionist Bush II era, "It is the terrible misfortune of the Middle East to be at the epicenter of this new galaxy of disorder, and of intertwined wars, crises, flashpoints, and failed, failing, or precarious states, ranging from Afghanistan and Iraq to the east, to Palestine and Lebanon in the center, to Sudan and Somalia in the south and west."[38] Accounting for these late Cold War machinations allows us to illuminate the manifold ways in which race-making is crucial to the "new" war-waging strategies that the US military claimed to be innovating, and to the permeable borders between so-called domestic and foreign state counterinsurgency practices.

Blurring the Borders of the Inner and Outer Forever Wars

One of the central goals of this book is to link domestic racial politics of Arabs, Muslims, and South Asians in the US to overseas wars and occupations in the Greater Middle East. Building on a major shift in comparative American and ethnic studies toward the postcolonial study of the US, this book investigates the intimacies between internal structures and processes of US empire at "home" and external histories of imperial rule "abroad."[39] Thinking historically about race and warfare in a transnational frame reveals the crucial dialectic between imperial wars abroad and domestic forms of (racial) violence at home. As Leerom Medovoi remarks, "in both the colonial and Cold War eras, an inside/outside binary [was] obtained: the policing of 'life' applied on the inside of the state's territory; on the outside one waged a war against biologically foreign 'races' (colonialism) or against ideologically foreign 'ways of life' such as fascism or communism (the Cold War)."[40] While some scholars of twentieth- and twenty-first-century US empire dissect the intimacies of racialization and imperial wars abroad, others have exposed the centrality of race to the "calculus" of the domestic US nation-state.[41] These scholars reveal the importance of race—its historical formation, social construction, and material consequences—for understanding US empire. As Timothy Mitchell notes, "imperialism employed a widely accepted principle of political, moral, and intellectual organization to create its social order—racism."[42] Inequitable systems of racial differentiation legitimated varying degrees of formal dispossession in the modern world, and as a consequence, race has long been featured analytically in the historiography of

US imperialism. As I show in subsequent chapters, Arab, Muslim, and South Asian diasporic artists engage this theme by calling attention to the role of race and racialization in their aesthetic responses to US forever warfare. The artists whose work I examine throughout demonstrate how links between the inner and outer wars are often obscured in public discourse, which eschews direct accounts of the connections between domestic and foreign policies across the long twentieth century and into the contemporary period.[43]

This inextricable history of race and empire helps explain the changing calculus of domestic and foreign governance that link the so-called war on crime and war on terror—neoliberal political and economic projects of security that are equally central to what I term the "forever war." Indeed, the 1990s domestic war on crime, and its attendant war on drugs, provided what legal scholar Jonathan Simon calls "a panoply of political technologies and mentalities" for the emergence of the post–2001 war on terror.[44] As Simon notes, the Bush administration's approach to the domestic war on terror primarily advanced the tactics of the war on crime, "as seen in the arrest of suspected militants, both citizens and aliens; the use of harsh methods to extract confessions; and mass incarceration of a class defined by race and religion as 'dangerous' in a global archipelago of prisons. Many of the deformations in American institutions produced by the war on crime, developments that have made our society less democratic, are being publicly justified as responses to the threat of terror."[45] As I demonstrate in my analysis of the work of the Visible Collective in chapter 3, US forever wars at home and abroad share many of the same affective, political, economic, and cultural logics.

The domestic ends of US wars on crime, drugs, and terrorism all are structured by hierarchical binaries that center race, gender, sexuality, class, and religion, placing white cisgender heterosexual male citizen-subjects above gendered racialized Others and those otherwise considered "at risk" of social failure. Randy Martin imparts how the US neoliberal racial state urges "an embrace of risk and self-management to others as it would to its own domestic subjects," which allows it to justify "ignoring, incarcerating, or dispossessing those who cannot make the grade."[46] Jonathan Simon notes further that whereas "race and perceived cultural pathologies of young minority males in the inner cities made them the prime focus of new, harsh laws and surplus police attention" in the "war on crime," the "war on terror" profiles the "nationality and perceived religious pathologies of young Muslim men, mostly of Middle Eastern or Arab descent, [to drive] a harsh and explicit strategy by the DOJ [Department of Justice] to use criminal and immigration laws to isolate and confine terror suspects."[47] Put differently, the war on

terror relies on constructing a visible, *external* "Muslim" enemy by conflating transnational differences of region, nationality, ethnicity, class, gender, and religious affiliation, whereas the "war on crime" constructs an identifiable, *internal* enemy—one often perceived to be young, urban, working-class men of color.

This gendered racialization process not only produces a dialectic between a normal "self" and a monstrous, criminal "other"; it also disaggregates those internal racialized others even further. As Randy Martin notes, "the shared approach to managing threats to homeland security isolates and excludes one segment of the population against another."[48] This, in turn, reshapes the internal/external boundaries, "internally dividing national space so as to efface ideas and locations of the foreign and domestic. With no clear delineations between a shared inside and a discernible outside, the very idea of uniform national interest is brought to a crisis."[49] By outlining the crisis of imperial race-making in this way, we begin to see what cultural theorist Chandan Reddy calls the "deeply buried borders" between domestic legislation and foreign policy and between federal policing and global military power.[50] The imperial paranoia of the global security state therefore blurs the boundaries of the homeland to render the security emergency, or the state of exception, into "the new normal."[51]

Empire Outside In

US wars on crime, drugs, and migrants have militarized law enforcement, expanded the prison industrial complex, and implemented a domestic war on terror and a deportation regime in new ways across the forever war period. The ascent of President Donald J. Trump signals the continuation and rampant escalation of the global forever war as a range of existing legal and administrative bodies, from immigration to municipal policing, are enfolded into the security state's counterinsurgency practices. As Nikhil Pal Singh presages, "with Trump, the violent contradictions of the inner and outer wars are laid bare Trump poses an old question: who is entitled to freedom and security—or more precisely, to the freedom of an unlimited security and the security of an unlimited freedom?"[52] Since 2017 the Trump administration has amplified nearly every possible front of US empire in the name of "America First." The Trump administration quickly intensified the war on Muslims in new and provocative ways. Trump ran for president and was elected on a platform demonizing Muslims, and one of his first acts was to block Muslim immigrants from entering the US; many of those immigrants

were seeking to reunite with their families. This prefigures the family separation that is also playing out today at the heavily securitized US-Mexico border. The US Supreme Court sustained its shameful Islamophobic lineage by refusing to strike down the Muslim ban, thereby upholding Trump's anti-Muslim agenda and policies.[53] Overseas, Trump has intensified the use of special forces and drone attacks built on the racial and imperial predicates of the other two forever war architects: George W. Bush and Barack H. Obama. Trump's Justice Department and FBI are poised to expand the Bush/Obama-era surveillance state and wage counterinsurgent wars on activists and social movements.

In the immediate aftermath of 9/11, the Bush administration framed Muslims and immigrants as threats to the "homeland," leading to a massive reorganization of the US government through the creation of the Department of Homeland Security (including the creation of US Immigration and Customs Enforcement [ICE]), the creation of policies requiring Muslim men and boys in the US to "register" with the government, and the launch of the forever war on terror and untold violence against Iraqis and Afghans by the US military that continue to this day. But this history stretches to even before 9/11. For instance, historian Robin Kelley effectively skewers the legacy of the Clinton era of the 1990s. He notes how the Clinton administration "oversaw the virtual destruction of the social safety net by turning welfare into workfare, cutting food stamps, preventing undocumented workers from receiving benefits, and denying former drug felons and users access to public housing; a dramatic expansion of the border patrol, immigrant detention centers, and the fence on Mexico's border; a crime bill that escalated the war on drugs and accelerated mass incarceration; as well as the North American Free Trade Agreement (NAFTA) and legislation deregulating financial institutions."[54]

Among the many profound transformations in federal and military policing during this pre–9/11 period, so-called pretextual, or preemptive, law enforcement for preventing terrorism has led to a resurgence of mass disappearances, detentions without trial, and summary deportations in the forever war. In a telling coincidence, Congress passed the National Defense Authorization Act (NDAA) on December 15, 2011, the same date as the official start of the US forces' pullout from Iraq, signaling the "official" end of violent military combat in the country. The NDAA, renewed annually by Congress and signed by the president, forms the annual operating budget for the Department of Defense, which directs various aspects of the US military.[55] As legal scholar Ramzi Kassem notes, "one front in the US's post–9/11 conflicts closed overseas, as another front seemingly opened at home."[56] Even more,

the law not only kept open the Guantánamo military prison facility; it also codified *within* the US "a set of practices and legal approaches that stem from the Guantánamo experiment."[57] Kassem is careful to note that the "Guantánamisation of the American justice-and-carceral-system" has been well underway over the past two decades, with cumbersome pretrial detention conditions as the new norm in federal terrorism cases, draconian sentence enhancements, and imprisonment under severe "special administrative measures" and in majority-Muslim communications management units.[58]

While these issues have primarily involved sites of incarceration outside of the US, including the now-infamous prisons at Guantánamo Bay in Cuba, Bagram Air Force Base in Afghanistan, and Abu Ghraib in Iraq, the 2011 NDAA extended the military law of Guantánamo to the US domestic national space. Thus, while noncitizens suspected of terrorism were previously placed in indefinite civilian custody in the US, NDAA required an "automatic default" of military imprisonment, and civilian authorities must intervene with a waiver to halt the process. This key shift demonstrates the further blurring of the line between civilian and military policing and incarceration under the guise of combating terrorism in the US and globally. As Kassem continues, the indefinite detention of noncitizens in the US "on mere suspicion of ties to terrorism is not unprecedented. Section 412 of the USA PATRIOT Act, hurriedly passed by Congress in the immediate wake of the attacks in 2001, unambiguously vests the Attorney General with that authority (which has not yet been employed). But under that scheme, a civilian official has to affirmatively exercise civilian discretion to place a non-citizen suspected of terrorism ties in indefinite—but still civilian—custody. Under the NDAA, the automatic default would be military imprisonment, and the civilian authorities would have to intervene with a waiver to interrupt that mechanism."[59] Kassem's observations forecast a dystopian legal future in which the racially ordered militarism that has come to characterize the global ends of the forever war comes more fully "home to roost" in US national space.[60]

As scholars of prisons, empire, and the carceral state have well documented, there is a long history of these forms of US government warfare on domestic populations of color.[61] Although racial disciplining is not an exception to US governance, the past two decades have witnessed the rise of everyday forms of new racism (including "hate crimes"), where previously invisible populations in the public sphere were made "racially legible," as Junaid Rana puts it, to highlight "the Muslim body as a visible object of racial containment."[62] In keeping with the criminalization of racialized "others," this period also stimulated renewed questions about the US immigration

system and the violence of the state's security and policing apparatuses. Rana notes, "In the wake of 9/11, what appeared in the guise of a new state security system—the revitalization of immigration controls through legal, social, and state sanctioned forms of policing—was in fact a magnified and expanded version of practices of legal sovereignty that were already in place."[63]

Immigration enforcement and the criminal justice system have become increasingly intertwined in the US over the past two decades as well.[64] The creation of ICE in 2003 enmeshed criminal sentencing policies with immigration law. Some of these post–9/11 shifts do not mark the large-scale *creation* of new immigration laws per se, but rather mark a series of modifications in the *enforcement* of existing laws. As Silky Shah of the Detention Watch Network notes, "Bush and the Republicans saw an opportunity to shift the enforcement of immigration laws to local jurisdictions whereas before it [had] been under the purview of the federal government."[65] This "post–9/11 legislation" had multiple precursors in earlier policies, especially the 1996 laws instituted under President Clinton, including the 287(g) program and the Criminal Alien Program (CAP), which are expansive immigration enforcement programs through which immigrants have been apprehended and "removal proceedings" initiated.[66] This shift in enforcement also applies to the Illegal Immigration Reform and Immigrant Responsibility Act of 1996 and its sister legislation, the Antiterrorism and Effective Death Penalty Act of 1996. Both laws were passed amid terrorism concerns after the 1995 Oklahoma City bombings. The Secure Communities program debuted in 2008 in Houston, Texas, which incidentally is also the site of the first private prison in the United States, a Corrections Corporation of America immigration detention center built in 1984. As Shah notes, immigration enforcement has resulted in big business for private corporations: "Private prison lobbying expenditures came out to over $20 million from 1999 through 2009 and today private companies operate around half of the 33,400 immigration detention beds nationally. Along for the ride is rural America, where small counties see immigration detention expansion as a source of jobs and revenue for the county's [sic] law enforcement agencies."[67]

These transformations in immigration law and enforcement across the forever war period are crucial to understanding one of the key post–9/11 carceral shifts shaping our reception of the insurgent aesthetic works that I engage in this book: the bureaucratic reorganization of the national immigration infrastructure and the creation in 2001 of the US Department of Homeland Security (DHS) and its legacies across the Bush, Obama, and Trump administrations. Indeed, the administrative function of the state is

being ramped up dramatically under the Trump administration. In particular, DHS has drawn spectacular outcry most recently through news accounts of the so-called Central American refugee crisis at the US-Mexico border, that is the forced displacement, exodus, and slow death of Central Americans fleeing the vestiges of US-sponsored political and economic catastrophes, and the Trump administration's widely disparaged "zero tolerance" family separation policies of sovereign torture and militarized terror.[68] Despite important recent symbolic calls by activists to "Abolish ICE," such a move to eliminate or reallocate the agency's functions would largely be insufficient because ICE operates along a network and continuum in collusion with other federal agencies such as US Customs and Border Protection and local law enforcement. Moreover, in reality, none of Trump's recent actions regarding immigration, including the 2018-19 partial government shutdown, are about securing the physical US-Mexico border; they are about securing the racial border, and the border as a fetish of sovereignty and security.

As scholars of global migration have shown, US immigration policies never actually address or even acknowledge the "root causes" for current waves of migration to the US. Such sources might include the passage of NAFTA in 1994, US proxy intervention in Central American wars of the late Cold War period, shifts in global climate change, structural adjustment and privatization policies that facilitated the accelerated upward redistribution of wealth in countries of the Global South, and countless revolutionary political upheavals that have ensued across the region.[69] And yet, as Chandan Reddy rightly points out, the racialized migrations of "so-called immigrants and refugees to the metropole [are in fact] the *consequence* of US wars in Asia, Latin America, Africa, Eastern Europe, and the Middle East, [while] their violent deterritorializations are figured prominently in US public culture as racialized humanitarian crises to which the US nation-state must respond."[70] The shifting natures of these legal genealogies of punishment and control demonstrate the interconnections between racialized systems of incarceration, immigration, and terrorism, which together comprise the carceral infrastructure of the US global forever war.[71]

The "Cultural Turn" and the Human Terrain

In addition to transformations in the domestic racialized legal architecture of the forever war, US military and counterinsurgency strategies in the Greater Middle East have also undergone a "revolution" in the late and post–Cold War periods during the global RMA.[72] One such innovative flash-

point that forms part of the shifts outlined above is the newly enhanced role of "culture" and intimate knowledge in the counterinsurgent dimensions of the global forever war. We see this in the development of an experimental program known as the Human Terrain System (HTS), run by the US Army Training and Doctrine Command from 2005 to 2014. HTS was billed as an effort to counteract the security and intelligence communities' perceived inadequate cultural and historical training and cultural-interpretive capacities in US military operations in Iraq and Afghanistan. The program involved "embedding" anthropologists, sociologists, linguists, and other social scientists with combat brigades to better "interpret" and "understand" local cultures.[73] Historian Osamah Khalil notes that "although a majority of team members had degrees in political science and international relations, they were dubbed 'anthropologists' by the media and military leaders. Yet they described themselves as 'cultural advisors' to the US military and 'cultural brokers' to Iraqis and Afghans."[74] Assembled by the US Army between July 2005 and August 2006, HTS thinking remains a permanent facet of the military's broader global counterinsurgent defense strategy in the forever war. The HTS program grew from a small pilot program with five deployed teams and a $20 million two-year budget at inception to one with thirty-one deployed teams and a $150 million annual budget, thus becoming the most expensive social science–based project in US military history.[75]

The HTS program ignited multiple controversies. In a 2007 statement, the executive board of the American Anthropological Association broadly condemned the military program, viewing it "as a problematic application of anthropological expertise, most specifically on ethical grounds."[76] We can glean as much from the US military's definition of "the human terrain." Military historian Jacob Kipp describes it as "the social, ethnographic, cultural, economic, and political elements of the people among whom a force is operating . . . the human population and society in the operational environment . . . as defined and characterized by sociocultural, anthropologic, and ethnographic data."[77] The *US Army and Marine Corps Counterinsurgency Field Manual* further attests to the increasingly strategic importance of "cultural knowledge" to a successful counterinsurgency, seeing culture as an "operational code" or a set of rules that can be memorized and rehearsed in theaters of war.[78] This dominant imperial calculus also involves promoting and funding a number of "cultural knowledge projects" within the US Army and the intelligence community, including the Minerva Initiative and the CIA's Pat Roberts Intelligence Scholars Program.[79]

These strategies are represented as "kinder and gentler" approaches to

"winning the hearts and minds" of occupied peoples and as an antidote to the use of direct military force. But as anthropologist Roberto J. González rightly notes, the program ultimately has nothing to do with culture itself but instead "was designed to provide brigade commanders with intelligence for achieving short-term combat goals in a theater of war—not for improving the well-being of people living under military occupation."[80] He goes on to suggest that "the emphasis is primarily on recognizing and exploiting 'tribal,' political, religious and psychological dynamics."[81] In the HTS, "human intelligence" is refigured as a battle space and as a weapon, as knowledge of occupied peoples and violent geographies enables "territory to be captured, as flesh-and-blood, *terra nullius* or vacant lands."[82] Mirzoeff notes further how the static, totalizing notion of "culture" that undergirds the HTS oscillates "between Victorian anthropology and the first-person-shooter videogame."[83] Taken together, these projects distinguish the US forever war strategy, which involves "weaponizing anthropology," a discipline long enmeshed in colonial operations but that has worked tirelessly for decades to shrug off its mark as a "handmaiden to colonialism."[84] In this way, the HTS views the volatile and highly contested role of localized academic expertise and information collection as central to the global forever war.

Death by "Double-Tap":
The Time and Space of Drone Warfare

The nonscientific, uncertain "cultural expertise" that the social scientist embodies in the HTS represents the US military's desire for intimate knowledge "on the ground." But US defense strategists have also experimented with what they see as more "precise" if contradictory counterterrorist expert knowledge "up in the air." We see this development in the rapidly expanding use of twenty-first-century drone weapon technologies, which represent US military and security planners' preferred counterterrorist tool over the sovereign spaces of Afghanistan, Pakistan, Somalia, Yemen, Libya, and Syria.[85] In this chapter's final section, I examine the contemporary expansion of drone strikes and extrajudicial "targeted killings" under the Obama administration in North Africa, West Asia, and the rugged borderlands region of "Af-Pak."[86] My principal goal is to illuminate the differential "disposition matrix" of misery produced by the US state and to interrogate urgent questions conjured by this violence for coalitional politics and transnational solidarities in the drone age. This final section unfolds in three parts. The first part offers a primer on the geopolitical and racial logics of drone wars as

the latest installment in a long history of US military presence in the Greater Middle East. The second seeks to intervene into emergent drone criticism by highlighting the drone's destabilizing and disordering effects on social relations of civilians living under the constant threat of aerial bombardment. Finally, the chapter concludes that the durability of the drone forces us to wrestle with and contest the ethical common sense of Washington on the conduct of war and the grammar used to make sense of the US forever war. I assert that drones are not exceptional but endemic to racial domination and capitalist exploitation at the heart of US empire. Their expanded deployment both at home and abroad should be of central concern to activists and scholars of race, war, and empire.

Perhaps no issue today so disturbingly depicts the contemporary US homeland security state's expansive frontier violence than the rise of its drone strikes and so-called extrajudicial targeted killings. The accelerated deployment of armed unmanned aerial vehicles (UAVs), or drones, in US military conflicts of the forever war over the past decade offers a vital opportunity to reflect on shifting strategies, practices, and technologies of the US homeland security state and its imperial power, as well as their effects on contemporary political and legal life. What exactly are drones, and why does their expanded use trouble scholars and activists of race, war, law, and sovereignty? How do the so-called unmanned futures of remote warfare give rise to new ways of thinking about race and racialization—in both the distant, unseen battlefields of US empire abroad and the hidden-in-plain-sight theaters of undeclared war closer to home? In the remainder of this chapter, I identify how contemporary drone attacks in the Af-Pak borderlands region have worked to destroy communal bonds among Afghan and Pakistani civilians and to what effect. As I will show, a more direct engagement with the racialized figure of the Muslim, one of the primary sites for the development of late modern tactics of killing and surveillance, advances a more complex portrait of the US global security state and its targets. I explore how the global circulation of these weapons and the broader aerial power that they symbolize not only sow the seeds for resentment across the so-called Muslim world but also create fugitive conditions for new communities of insurgency, solidarity, and transnational affiliation in their wake.[87]

The increasing popularity of armed drones in US counterinsurgency and counterterrorism efforts forces us to reckon with the uneven global distribution of life chances, risks, and rewards in the age of security and forever war. A wide array of critics of late modern warfare have focused on the technoscientific dimensions of drone strikes. For instance, theorists have drawn

attention to the implications of how these surveillance technologies produce "God-like vision" through video feeds from aerial platforms and how killing from a distance transforms the relation between a bomber and his targets.[88] Others have noted the historical legacies of modern airpower and visual aerial surveillance across the twentieth century[89] or homed in on the ethical questions raised by the contemporary civilian and commercial adoption of drones.[90] What is most clear from a review of this swelling body of scholarship is that the drone commentary has evolved as quickly as the technology itself. In lieu of an exhaustive summary of these findings, I choose to distill some recent insights in the following section to make visible (so as to better challenge) contemporary global circuits of US imperial violence. But my chief concern here is less that the empire has new toys and more how unique aspects of these militarized technologies have transformed racialized social relations on the targeted terrain for those rendered most precarious by the buzzing beat of drones in the so-called lawless frontiers of US forever warfare.

To illustrate this point, I focus on the controversial "double-tap" phenomenon, when drone operators repeatedly strike a targeted terrain in quick succession, leading to a variety of disordering and dehumanizing effects on the ground.[91] The double-tap phenomenon forces an ethical predicament when one must decide between one's own life and the lives of others when deciding to aid the wounded and to honor the dead, producing a kind of institutionalization of callousness as constitutive to drone strikes in the region. In what follows, I illuminate how contemporary aerial warfare innovates new barbarous modes of racialization that attempt to manipulate, conflate, and destroy communal bonds among its targets, thereby further stripping away our sense of responsibility to the nonwestern racialized subjects of wartime violence and our way of knowing each other and ourselves in times of war. And yet, even as the double-tap of drone warfare disorganizes and makes impossible previously existing forms of affective belonging, I contend that it also produces conditions for the possibility of new affective intimacies across space and time. I close with a consideration of the prospects of transnational and multi-issue coalition building in the drone age and the mandate to challenge the official narratives and ethical common sense of Washington about the conduct of global surveillance and warfare. In sum, this chapter asks how activists and scholars can expose the greater "dronification of state violence" to further make visible the systemic continuities of imperial violence between the global wars on terror and the domestic carceral state.[92]

Drones are suddenly everywhere. Like many imperial technologies perfected in the colonial laboratories of empire, these unmanned flying objects have come home to roost.[93] Drones have been popularized in a range of quotidian sites beyond the US military, from commercial aerial surveillance, filmmaking, sports, and photography to domestic policing; oil, gas, and mineral exploration; disaster relief; and scientific research.[94] Its zeitgeist is confirmed further by news that US corporate titans such as Amazon, Apple, and Microsoft all plan to release drones in future offerings of goods and services.[95] Yet I am concerned here less with the banal violence of consumer capital or the techno-fetish of the drone itself and more with the spectacular modes of aggression that armed drones make possible as they become the lynchpin in a comprehensive US military strategy in the Middle East, South Asia, and North Africa.[96]

Drone weapon technologies epitomize the growing trend and preferred counterterrorist tool for contemporary US military and security planners in Iraq, Afghanistan, Somalia, Yemen, Libya, and Pakistan.[97] Whereas some drones are controlled remotely from locales thousands of miles from their bombing sites (including air-conditioned command and control centers for global surveillance in rural areas of Colorado and Nevada), other UAVs fly reconnaissance missions without any human direction; instead they are preprogrammed with flight plans and complex automation systems. Yet all drones are supplied with the "power to make the faraway intimate."[98] Since at least 2004, the CIA and the US Air Force have discharged an illegal "targeted killing" program in Pakistan and Afghanistan, where individuals on the borderlands of violence who are deemed to be "enemies of the state" are assassinated without charge or trial. The executive branch has claimed the unchecked authority to classify citizens and others on what it obliquely terms a "disposition matrix," a secret capture/kill database of alleged terrorists and enemy combatants designed by the Obama administration and "based on secret determinations, based on secret evidence, that individuals meet a secret definition of the enemy."[99] The most widely publicized example of this form of covert military invention is the General Atomics MQ-1 Predator drone. First formulated in the early 1990s and in flight since 1995, the Predator has been deployed by the US Air Force and the CIA in combat missions over Afghanistan, Pakistan, Bosnia, Serbia, Iraq, Yemen, and Libya. The Predator drone was first deployed in late 2001 from bases in Pakistan

and Uzbekistan as part of the newly branded global war on terror; it was designed to strike so-called high-profile targets, including "terrorist leaders" in Afghanistan. Randy Martin, in his account of the parallels between war-making and financial markets, notes how these counterterrorist drones, in their "technologically sophisticated, precise applications of force, perform a kind of arbitrage, an exploitation of small variations in the environment to achieve large-scale gain."[100] He continues: "The hit-and-run occupation belies a strategy of disoccupation that aims to actively dispossess populations from sources of social wealth," because the ultimate goal of these "shock and awe" terror wars is to "make more of what they fight."[101] Martin's argument flies in the face of prevailing military rhetoric about the secret program, which suggests that drones are a way of making sure the conflict zones of war stay "over there" so as to keep us safe "over here," at home. But the drone campaign, in its "hit-and-run strategy of disoccupation," has sown crisis and discontent in the region that will last for decades to come. As a vital symbol for the US RMA, the Predator is the preeminent representation of the military's technocratic aspiration for an automated future of algorithmic warfare in the twenty-first century.[102]

The CIA's and the military's use of these highly publicized, if officially covert, drone attacks and aerial surveillance campaigns has sparked immense debate among defense experts and critics alike.[103] Their emergence provokes questions about the ethics of civilian casualties, sovereignty and border disputes, and conventional and unconventional approaches to waging war.[104] Mainstream critics question the accuracy of drone targeting, the legality of these extrajudicial assassinations (including Obama's and now Trump's targeted killings of US citizens abroad), and the greater "collateral damage" of these bombings more generally, which are widely denounced as grave breaches of international laws of war such as the Geneva Conventions.[105] Publicized news accounts have exposed US-led covert drone attacks in remote areas of northwest Pakistan since as early as 2004. The Pakistani drone strikes in the Federally Administered Tribal Areas and Waziristan are particularly troubling given how the Pakistani government acts, at least ostensibly, as a willing partner and ally of the United States in its counterterrorism agenda, a fragile alliance that seems to be dissolving under the weight of the now nearly decade of drone attacks in the region.[106] This fractured neoliberal security alliance is not unlike the fate of Pakistan's own territorial integrity as the United States continues to bomb various targets along Pakistan's sovereign border with Afghanistan without officially declaring war.[107]

"Af-Pak," as the rugged borderlands region between Afghanistan and

Pakistan has come to be known within US foreign policy circles, refers to a racialized state of exception. First coined by the late Richard Holbrooke, Obama's special advisor on the region, the neologism symbolizes "not just an effort to save eight syllables. It is an attempt to indicate and imprint in our DNA the fact that there is one theater of war, straddling an ill-defined border, the Durand Line."[108] Holbrooke's vision of a single battlefield of military operations to disrupt the transnational presence of Al-Qaeda speaks volumes about the imagined geographies of US empire. This ever-expanding territorial map violates national sovereignty and international humanitarian law on a variety of fronts while simultaneously building on and advancing older legacies of European colonialism and racism that predate the US encounter with the region altogether.[109] "Af-Pak" today symbolizes the "lawless frontier" of lethal experimentation, a topography where, as Ian Shaw and Majed Akhter rightly observe, "uneven geo-legalities of war, state, and exception make drone warfare a reality in certain places and not others."[110]

The fact that certain geopolitical terrain is considered *more* hospitable to drone targeting than other sites prompts an important question: Why have drones become so popular now in the first place? While the technology has been in the works for decades, common explanations suggest that drone strikes were seen as a necropolitical and counterterrorist *antidote* to the messiness of Bush-era counterinsurgent detention, rendition, and interrogation practices, scandalous spectacles widely conjured by the names of disparate carceral sites such as Guantánamo, Abu Ghraib, Bagram, and other still secret centers of confinement and misery around the globe. As Nicholas Mirzoeff explains, "although the U.S. military continue to use a moralized rhetoric of nation-building, their practical administration of counterinsurgency has significantly shifted to the management of disaster by means of targeted killing of insurgents using Unmanned Aerial Vehicles (UAV), Special Forces, and private contractors."[111] Military planners in the Obama administration believed it to be easier to *target and kill* outright suspected terrorist leaders (including Osama bin Laden) rather than to *detain and interrogate* them. And yet, while some defense experts favor the use of drones for "surgical strikes" in this manner, others would still opt for the more expensive and labor- and time-intensive counterinsurgency operations used in the Iraq and Afghanistan ground wars of the 2000s—where US and allied combat forces "embedded" within civilian populations in an effort to target their enemies. As detailed earlier, this so-called kinder and gentler mode of affective governance involves accessing sociocultural knowledge of the local occupied populace in an effort to shape "hearts and minds."[112] To

date, the first two decades of the global war on terror have reflected an ad hoc and often clashing assemblage of flexible biopolitical military strategies under the Bush, Obama, and Trump administrations, ranging primarily from rendition, indefinite detention, torture, and domestic surveillance in the Bush years to Obama's steadfast "imperial commitment to cyberwar, digital surveillance, and a global 'targeted killing' (that is, assassination) program using both Special Forces and drones."[113] The racial and colonial predicates of these biopolitical and necropolitical tactics, which we witness every day, have only accelerated under the Trump administration's foreign policy, with its overtly barbarous and protofascist recombination of "fire and fury."[114] To be sure, bipartisan support for runaway military spending, domestic surveillance, air strikes, ground troops, and special forces has prevailed across all three administrations.

Finally, we can observe that the aerial view of the drone is particularly significant to the unified position of scopic mastery desired by the United States as part of its RMA. As discussed earlier, the RMA refers to key transformations in the fantasies and trajectories of post–Cold War military sciences, which were increasingly aimed at advancing a high-tech, low-personnel vision of warfare after the fall of the Soviet Union.[115] Drones became indispensable to this recalibrated vision because military and security planners imagined that they could provide a way of fighting perceived insurgencies without public scrutiny. The goals and outcomes of this "unseen war," however, were dubious at best. According to Mirzoeff, the objective is to "maintain a permanent state of crisis, rather than achieving a phantasmatic victory. In the game context in which war is now visualized, the point is less to win than to keep playing, permanently moving to the next level in the ultimate massively multiplayer environment."[116] Drone wars perfectly encapsulate this video game context of endless warfare with its "massively multiplayer" visualizations. The drone is further imagined as, in the terms of Derek Gregory, "an assemblage of force" because it combines "knowing (intelligence, surveillance, reconnaissance), sighting (targeting in movement and in the moment), and eliminating ('putting warheads on foreheads')."[117]

This process of racialization specifically operates through the visual targeting of suspected Al-Qaeda affiliates.[118] Scholars of visual culture and warfare have explored the gulf between what a drone operator sees and how they make sense of what or who is actually on the ground. The subjective dissonance of drone targeting underscores a larger conceptual debate about the links between modern visuality, knowledge, and warfare.[119] Many theorists have argued that visual and conceptual frames have contributed to manu-

facturing and obliterating populations as objects of knowledge and targets of war. From these critical studies, we learn that perspectival vision is in fact constitutive of the logic of surveillance and the materiality of war. As the eye became the privileged organ of knowledge and authority, the power to *see* became equated with the power to *know* and to *dominate*. We see this enduring alliance between vision and war across the twentieth century. As military fields increasingly became reconfigured as fields of visual perception, preparations for war were increasingly indistinguishable from preparations for making a film. As Rey Chow succinctly summarizes, "war would mean the production of maximal visibility and illumination for the purpose of maximal destruction."[120] We might conceive of the global forever war, then following Anne McClintock, not only as a struggle over "oil, water, and the resources of globalization but [also quite centrally over] control of the global image and data worlds."[121] Thus, rather than the invisible, stealth, precision targeting that US security planners presume, these military operations have produced instead devastating destabilizations in the region and insecurities for diverse populations that were brought together conceptually and violently in the "crosshairs" of drone strikes. In the discussion that follows, I turn to a mostly underreported aspect of drone weaponry to clarify why drones are crucial for theorizing the forever war anew.

Double-Tap and the Disorganization
of Collective Social Life

Whereas countless critics have focused on how the covert drone war heralds the vanguard of technological revolution in the US military, my primary concern in the balance of this chapter is to explore how the racial logics of drones work by disaggregating embattled Muslim populations beset by bombs. I see this practice itself as a different mode of racialization.[122] Lawyers and human rights activists recently illuminated a particular practice of US drone attacks that clarifies how war disorganizes and destroys communal bonds—namely, the "double-tap" phenomenon. A double-tap strike denotes when a Predator or Reaper drone targets a terrain with "hellfire" missiles multiple times in quick succession. Cases were reported in northern Waziristan in late 2012, for instance, where missiles of an unmanned drone slammed into a house, reducing it to shards. Minutes later, villagers who had rushed to the scene to aid the injured were struck by another round of fire, with an even greater number of civilian casualties as a result.[123] Human rights lawyers have conjectured that the double-tap phenomenon is less a

military strategy and more an outcome of the "less-than-pinpoint-accurate technological capacity of the missiles."[124]

The "double-tap" phenomenon is disquieting for a number of reasons. First, it exposes the notion of a "surgical strike" as anything but precise. Drone proponents ardently maintain that the "bureaucratic, rational, even scientific nature of targeted killings replaces individual thought with machinic certainty."[125] There is an almost messianic belief that deadly force "can be applied with thoughtful, prophylactic discretion."[126] The impression of a cleaner, gentler, more effective and bureaucratic form of war—which was crucial to the public debate on drones in the Obama era, just as it has been to the broader postwar liberal-democratic belief that US forms of killing are not murder—has been widely repudiated by numerous human rights testimonies and investigative accounts. An important 2012 report by legal experts at Stanford University and New York University (NYU), for instance, found that only *one in fifty* victims of "surgical strikes" in Pakistan were known militants.[127] The US military makes bold and often unverifiable assertions about the so-called endurance, proximity, and precision of drone operations, but we must recognize now that in twenty-first-century asymmetric warfare, the line between civilians and militants, or what the US government calls "affiliates," has been blurred to the point of oblivion, thereby rendering counterfeit the state's necropolitical calculus.[128] US enemy targets are instead racialized in relation to algorithmic calculations of imminent threat to the homeland, a bureaucratic process that targets "patterns of life" and signals the emergence of a new mode of race war.[129] In Sepoy Mutiny's estimation, "there is no clarity in determining who anyone may be and what their purported sin may be."[130] What is clear, though, is that drone killings produce untold consequences for and devastation in local communities in the borderlands of Af-Pak and other militarized cartographies across North Africa, the Middle East, and South Asia.

Second, these reports reveal that double-tap strikes have induced a chilling effect on survivors of drone-targeted terrain because they dissuade civilians from rescuing the injured or caring for the dead. They have also stopped emergency humanitarian workers from providing crucial and urgent relief. One organization in northern Waziristan, for example, instituted a mandatory six-hour delay.[131] Human rights reports detail countless examples of civilians who were killed or injured when trying to rush to the aid of the maimed. A queer calculus indeed. We should reflect here on how the double-tap phenomenon effectively freezes the basic function and organization of collective social life in drone-targeted regions, a mode of collective paralysis

that has devastating and long-lasting effects. Legal experts have noted the impact on education, health care, community gatherings, and cultural and religious practices related to burials and funerals in northern Waziristan. "Because drone strikes have targeted funerals and spaces where families have gathered to offer condolences to the deceased, they have inhibited the ability of families to hold dignified burials."[132] Furthermore, key aspects of the burial process are impossible because bodies are so badly burned or torn apart as to be unrecognizable. We might contemplate the barbarous logic at work here among US military planners—the civilizational ideology that those targeted by drones need not mourn their dead. This is an apt reminder that a crucial part of the logic of US warfare has always been the racial dehumanization of its victims.

An even more troubling occurrence related to the ongoing and ever-present fear of congregating has been the regional breakdown of the *jirga* system, "a community-based conflict resolution process that is fundamental to Pashtun society."[133] The Stanford and NYU report notes that the jirga is a crucial element of Pashtun legal and political life, as it provides "opportunities for community input, conflict resolution, and egalitarian decision-making. Hampering its functions could have serious implications for the communal order, especially in an area already devastated by death and destruction."[134] The targeting of centuries–old civic practices like the jirga, communal prayer in mosques, mourning–at funerals, and wedding celebrations spells isolation for those whose lives are already rendered precarious by the drone. The interruption of collective ceremonies, rituals, and kinship ties is but one of many unseen, stultifying, and routinized effects of drone war. This is part of this book's larger argument that the disorganizing and disaggregating effects of US global counterinsurgencies have produced new opportunities for communities of insurgent affiliation responding to these practices of racial dehumanization and disorder.

Third, double-tap drone strikes have caused, perhaps predictably, a range of traumatic mental health outcomes for survivors and civilian populations. Reports testify to experiences of posttraumatic stress disorder, stigmatization, anticipatory anxiety, and "diffuse and chronic" fear common among those living in conflict zones, where "the buzz of a distant propeller is a constant reminder of imminent death."[135] In the words of one interviewee, "God knows whether they'll strike us again or not. But they're always surveying us, they're always over us, and you never know when they're going to strike and attack."[136] In her short documentary feature *Wounds of Waziristan*, journalist and scholar Madiha Tahir further details this sense of powerlessness

produced by the indeterminacy of the drone: "Because drones are at a certain remove, there is a sense of uncertainty, a sense that you can't control this. Whether it's true or not, people feel that with militants there is some degree of control. You can negotiate. There is some cause and effect. But there is no cause and effect with drones. It's an acute kind of trauma that is not limited to the actual attack."[137] The lack of cause and effect produces its own perverse calculus to encode the debilitating racial logics of drone warfare and its right to kill and to maim civilian subjects.[138]

Fourth and finally, the "dissuasive effect" that the double-tap pattern of strikes has on first responders raises crucial moral and legal concerns. As legal experts from Stanford and NYU report, "not only does the practice put into question the extent to which secondary strikes comply with international humanitarian law's basic rules of distinction, proportionality, and precautions, but it also potentially violates specific legal protections for medical and humanitarian personnel, and for the wounded. As international law experts have noted, intentional strikes on first responders may constitute war crimes."[139] From multiple legal and ethical perspectives, then, the double-tap of the drone exponentially intensifies experiences of misery, isolation, debility, and pain in Af-Pak and related sites along the imperial circuits and geographies of the forever war.

Challenging the Future of US Drone Warfare

No rational response to drone proliferation to date has been successful. What's more, no meaningful debate in Washington has emerged over the past two decades about the dramatic reorganization in fiscal, political, ethical, and affective priorities brought on by the buildup of the homeland security state and its forever wars. Despite the grotesque failures of US-led military operations in Iraq, Afghanistan, Pakistan, Yemen, Somalia, and beyond, we must conclude that drones are here to stay and that their presence is symptomatic of the gendered racial violence and capitalist exploitation at the heart of US empire. But perhaps the extreme focus on the drone confounds the larger underlying problems of the homeland security era. This weapon is the latest in a long line of technoscientific spectacles that inure us from the unseen and unsaid of contemporary US imperial violence. Af-Pak presently serves as a frontier space of lethal experimentation on Muslim bodies. But we know that the technologies perfected in distant theaters of war will soon give rise to new modes of aerial surveillance, targeting, and elimination closer to home, not only in highly militarized borderlands spaces such

as the US-Mexico border, but also in the low-intensity, asymmetric urban wars in US inner cities that also often operate along an internal racial line. News accounts already have begun to reveal "drone creep," and the lines between US military and domestic police forces are blurrier than ever. As Priya Kandaswamy succinctly states, "the police and military are two faces of the same system of global repression and racism."[140] Blurred lines between militarism and policing in liberal warfare are nothing new, of course, as I have suggested in this chapter's approach to the forever war. Students of and activists within the Black Freedom movement know this entwined history all too well.[141] During the Cold War, for instance, global counterinsurgency tactics were perfected not only in Latin America, Africa, and the Middle East but on Black, Indigenous, Arab, Muslim, and other racialized immigrant populations in the United States as well.[142] As such, when analyzing the vastly proliferating deployment of drone weaponry, we must also look to identify unlikely alliances and new communities of struggle that have emerged in response and in contestation. Despite the seeming omnipresence and permanence of the drone, I want to hold on to the idea that the spectacularly failed counterterrorism and counterinsurgency operations in the age of drone warfare create conditions of possibility for insurgent forms of solidarity, new movements, and new communities of resistance.

Given the wide-ranging sites of neoliberal security brought together in this chapter, it would seem especially urgent to revitalize our political imaginations in the here and now and become more experimental in our tactics and strategies of insurgency to both the global ends of the forever war and its domestic reverberations, which are felt through mass incarceration, mass deportation, and police violence in the United States. Analysis of the late imperial project of drone warfare and the global surveillance regime provides ample illustration of how to build forms of solidarity that connect the domestic and foreign contexts of US war-making. This is especially crucial for scholar-activists who are concerned with tracing the links between the US domestic policing and prison expansion, which disproportionately targets poor people of color, and the newly emergent global prison archipelago that primarily enfolds empire's gendered racialized Others in the Global South and is part and parcel of the US global war on terror.[143] As Sunaina Maira notes, this mode of "solidarity may necessitate a *rupture* of the bonds assumed to be natural in certain preexisting 'communities' . . . and compels other affiliations that are forged against the groups' interests or rethought in new ways through joint struggles. . . . Solidarity can disrupt the ties that we think bind us."[144] Our transnational social and political movements ben-

efit from drawing synergetic relations and connections between distinct but overlapping struggles against the state's always unfolding regimes of policing and surveillance.

Finally, we need to challenge the ethical common sense in Washington that drones will solve our national security problems, and in so doing we might better expose the brutalities of late modern warfare. In the words of Randall Williams, we require a "non-juridical reckoning" with these global circuits of US state violence.[145] In the chapters that follow, I explore this "non-juridical reckoning" through insurgent aesthetics of Arab, Muslim, and South Asian diasporic cultural producers in the US and Europe who respond in complex and creative ways through their creative works to the emergence of US drone warfare and to the broader structures of the imperial state and neoliberal capitalism. If our freedom dreams have been depleted by the stubborn imperial calculus and crushing material practices of US forever wars, then our charge must be to challenge the ethical common sense of US global state violence (founded, as it is, on perverse fantasies and ideological trajectories of settler colonialism, imperialism, cis heteropatriarchy, white supremacy, and anti-Black racism). As scholar-activists committed to dismantling gendered racial domination and capitalist exploitation at the heart of US empire, the artists whose works I spotlight in the remainder of this book have taken dramatic license to be as experimental as the state in their fugitive aesthetics and insurgent strategies, thereby investing in new expressions of as yet unimaginable radical sociality and solidarity.

In closing, this chapter has asked after the many consequences of the drone age in the frontiers of the forever war as well as its boomerang effect on those of us living in the heart of empire. If the drone manipulates, conflates, and destroys communal bonds, stripping away our sense of responsibility to the racialized targets of US war-making in the frontiers of the forever war and our way of knowing each other and ourselves in times of war, then it also produces conditions of possibility for imagining transnational solidarities anew. We benefit from exploring this contradictory terrain created by US global security wars, breaking open the imperial frames of violence to develop a more expansive account of the drone, its gendered racial logics, and its targets. This chapter's focus on the aerial perspective as central to US global security regimes builds on a range of critical humanities, poststructuralist, postcolonial, and feminist accounts in a collective effort to challenge the systematic embrace of the ocular in cultural and intellectual responses to US global warfare and surveillance. As I have argued, visual and conceptual frames have contributed centrally to the manufacture and obliteration

of populations as objects of knowledge and targets of war. Given the dense interconnectivity between vision, knowledge, and warfare, what medium might adequately address both the violence the imperial state tries to render invisible and the "invisible obscene," as Anne McClintock has put it, of civilian populations exposed endlessly to this violence?[146] The answer, as I illuminate in the following chapters, can be found in the collective aesthetic practices of Arab, Muslim, and South Asian diasporic artists. A formal and sensory analysis of their artistic projects generates an alternative articulation of minoritarian knowledge animated by those populations (and their diasporic kin) most devastated by the effects of US global warfare.

Attention to insurgent aesthetics also points to other ways of collectively sensing and knowing the forever war outside the constraints of dominant imperial visuality. My analysis provides a different epistemological entrance point to expose, so as to better dismantle, the circuits of imperial violence that connect the US global security state to the distinct but overlapping political imaginaries of South Asia and the Greater Middle East. I contend that the field of contemporary security studies likewise profits from rethinking itself through cultural analysis and methods, areas of knowledge currently outside its fulcrum. In the process, we benefit from orienting our attention away from the visual and discursive frames of war and toward analyses that feature less-studied senses, including touch and sound. These extravisual sensory relations have become newly vital to US security governance, both as actual military weapons and as resources for diasporic public cultures. Rather than dispense with the visual altogether, however, I suggest that we attend more closely to the ambiguities and particularities of the visual experience produced by minoritarian subjects responding to these conditions, as they reveal alternate clues for knowing and mapping the world. The remainder of this book thus seeks to uncover the spectral and speculative registers of the forever war, attending to the intimate and affective politics of US imperial violence, whose animated traces and disqualified secrets are discarded by official accounts of the war, and the queer calculus of knowledge, affect, and affiliation these violent politics have engendered.

two. **ON THE SKIN**
Drone Warfare, Collateral Damage,
and the Human Terrain

"Skin, our largest organ, vulnerable to all ambient toxins, at the end, is all we have to hold us together, no matter how much it seems to keep us apart." —Ruth Wilson Gilmore, "Abolition Geography and the Problem of Innocence"

Is there some way to register war in a way that transforms the senses? And what role do transformed senses have in the demands for the cessation of war? . . . What restructuring of the senses does that require and enable? —Judith Butler, *Frames of War*

We need to strengthen those practices and our capacities to create, not destroy. To do that, rather than the kind of memorials and eulogies that seal, in the intent to heal, the gaping wounds before us, we need living memories, living histories, as openings into other futures. —Neferti Tadiar, "The War to Be Human"

When, in August 1990, President Saddam Hussein of Iraq invaded neighboring Kuwait just two years after the end of the Iran-Iraq War, Wafaa Bilal was forced to flee.[1] The Iraqi-born painter and visual artist was part of the secular student movement that refused to enlist in Saddam's army, which was newly tasked with suppressing Shia-led popular uprisings. Bilal fled first to Kuwait before escaping to an American-sponsored refugee camp in Saudi Arabia, where he lived for nearly two years.[2] He eventually was granted political asylum in the United States around September 11, 1992. In the context of US forever wars in Iraq, Afghanistan, Pakistan, Yemen, and beyond, Bilal's complex story of exile and displacement serves as a potent reminder that

the US military presence in Iraq long predates our more current preoccupations with the post–9/11 period. Including its involvement in the Iran-Iraq War, its intermittent peacetime bombing, and thirteen years of genocidal economic sanctions that starved millions of Iraqis between the two ground occupations, the United States has had a fatal hand in the country for nearly four decades. When asked in a May 1996 interview if the deaths of nearly half a million Iraqi children caused by economic sanctions and United Nations–mandated trade embargoes were justified, former US Secretary of State Madeleine Albright famously replied, "We think the price is worth it."[3]

This chapter reconsiders Albright's calculus of what counts as a "livable and grievable life" by critically examining contemporary US militarism and aerial bombardment in Iraq in works by Iraqi diasporic performance artist and memoirist Wafaa Bilal.[4] As outlined in chapter 1, the Obama administration's expansion of drone warfare across Iraq and the Afghanistan-Pakistan borderlands has been celebrated by US military planners as a precise and cost-effective alternative to traditional military combat.[5] Yet little attention has been paid to the impact of these drone strikes in the lives of Afghan, Iraqi, Pakistani, and Yemeni civilians, who comprise the "collateral damage" of US military operations.[6] This chapter critiques the abstractions and rationalities of contemporary US imperial violence that drone warfare represents, and the statistical modes through which its collateral damage is calculated. If chapter 1 discussed the differential strategies of neoliberal security that define the forever war, a suite that includes mass incarceration and detention, border walls and mass deportations, electronic surveillance and drone wars, and the rapid growth of police, prison, border patrol, military, and intelligence forces, this chapter pivots to the creative visual and performance works of diasporic artists. My analysis of insurgent aesthetic strategies and affective structures here provides alternative ways of encountering the histories, geographies, and sentiments of racialized and colonized populations rendered visible targets of US global military power. "On the Skin" thus serves as a hinge between the book's introduction and first chapter, which describe the dominant militarized logics of US neoliberal security and empire, and the latter chapters' focus on the queer calculus and insurgent aesthetics of Arab, Muslim, and South Asian diasporic expressive cultures. Drawing on critical ethnic studies, queer studies, and performance studies, I analyze here diasporic visual and performance works to provide more critical ways of understanding drone weaponry and the effects of these securitization practices on the gendered, racialized, and sexualized bodies that are their targets. In

so doing, I generate an alternative map for analyzing US militarism in the Greater Middle East and imagining other futures.

The present-tense violence of US militarism and aerial bombardment in Iraq and across the Greater Middle East can help explain Albright's calculus of what counts as a "livable and grievable life."[7] As detailed in chapter 1, the so-called unmanned future of drone warfare has inaugurated new ways of thinking about race and racialization—in both the remote battlefields of US empire overseas and the hidden-in-plain-sight fronts of undeclared conflict closer to home. By analyzing key human rights legal reports and documents on the collateral damage of contemporary drone attacks in the "Af-Pak" (Afghanistan-Pakistan) borderlands region in particular, I showed how these militarized practices have destroyed communal bonds among Afghan and Pakistani civilians. The controversial use of the "double-tap" tactic, in which drone operators repeatedly strike a targeted terrain in quick succession, led to a variety of disordering and dehumanizing effects on the ground. The double-tap phenomenon forced an ethical quandary for survivors and targets of drone warfare in which one is compelled to choose between one's own life and the lives of others when opting to comfort the wounded and to honor the dead, instituting a form of debased cruelty as constitutive to drone strikes in the region. Even as the double-tap of drone warfare disorganizes and makes impossible previously existing forms of affective belonging among survivors of the drone, I argued that it also produces conditions for the possibility of new affective and political intimacies across time and space—an argument that I seek to build on in this chapter's discussion of insurgent aesthetic responses to US drone warfare.

In this chapter, I critically analyze the experimental performance and literary works of Iraqi American artist Wafaa Bilal. Bilal's creative projects offer exemplars of the insurgent aesthetics that I trace in the remainder of this book. In his contemporary Arab diasporic aesthetic and political practice, the artist generates alternative sensory knowledges of the US security state in response to the violent effects of the forever war. The crucial force of Bilal's artwork hinges primarily on the pain he inflicts on his own body—especially his skin, that organ of touch and feeling that links the body to the social world and provides a key platform for his artistic interventions.[8] In these reparative works of insurgent aesthetics, we can analyze gendered-racialized embodiment and the artist's manipulation of the senses to account for and allegorize the subjective experiences and lived vulnerabilities of populations that are both produced and obscured by US neoliberal racial regimes of security.[9]

As I have argued earlier, if we want to understand modern security politics and practices, particularly the modes of intelligence gathering and killing technologies perfected in the domestic and international contexts of the US forever war, we need an alternate approach to the maps of strategic thinkers and security analysts. When read alongside the escalating use of drone technologies in US military operations across the Greater Middle East, Bilal's performance projects allow for a more sophisticated understanding of the ethical and affective relations that can emerge between Americans and Iraqis under the conditions of US state security and warfare. This insight is framed by the interplay between what's "up in the air"—namely, the discourses shaping the use of aerial surveillance and twenty-first-century military technologies—and what's "on the skin" as a way of capturing the painful intimacies of seemingly incommensurate peoples, histories, and geographies brought together in the crosshairs of forever warfare. These modes reveal two distinct but intersecting cartographic representations of landscape and the human terrain, with very different implications and blueprints for the future. Bilal is one artist who uses his own body to map the uneven contours of human vulnerability in times of war, uncovering the intimate and affective politics of US imperial violence, those animated traces and "disqualified secrets" discarded by official accounts of the war, as well as the alternative models of knowledge, affect, and affiliation these politics engender.[10]

Bilal's Backward Glance

Recognized internationally for his controversial online interactive and performative installations, Bilal, an arts professor of photography and imaging at New York University's (NYU) Tisch School of the Arts, made national headlines in November 2010 by announcing that he would have a small fist-sized camera surgically installed in the back of his head and would leave it in place for a year. The embedded camera captured a photograph every minute of the artist's daily life and then spontaneously transmitted that visual record to a website (www.3rdi.me). The inaugural images were displayed at Mathaf: Arab Museum of Modern Art (MOMA) in Doha, Qatar, as part of its new permanent collection, which includes more than six thousand works created since the 1920s by Arab artists from North Africa to the Gulf.[11] *3rdi* (2010–11) sutures the technological apparatus of photography onto the artist's own body (figure 2.1). The hundreds of arbitrary images captured by this cyborg creation composed a visual record that awaited further interpretation and reception.[12]

FIG 2.1 Wafaa Bilal, *3rdi*, year-long performance, 2010–11. © Wafaa Bilal.

The images depicted were often quite mundane, sometimes cryptic, but always antimonumental. In a mirrored room at the Arab MOMA, forty-two monitors displayed photographs from Bilal's online archive. The images were uploaded every minute, complete with their global positioning system (GPS) location. The speed of the changing pictures was altered according to museum visitors' movements, and when a viewer stopped in front of a monitor, the other screens went blank. Bilal created this series of interactive platforms—viewers in the museum, viewers online, and those un/willingly captured on camera—to provide a multilayered social commentary on privacy debates amid the proliferation of personal data on the internet. This context overdetermined much of the US media anxiety around Bilal's *3rdi* project. Reporters noted, for instance, how NYU administrators compelled Bilal to turn his camera off during instructional hours in the classroom after protests from concerned parents and trustees.[13]

Bilal's insurgent aesthetics is especially timely in the context of increasingly pervasive social media piracy and data drops, as WikiLeaks released thousands of classified national security documents and as Facebook and Twitter have played increasingly visible roles in antistate protests in countries such as Tunisia, Egypt, Yemen, and Iran and in Black- and Indigenous-led

revolts across the US. *3rdi* explores the ethical contours of how new technology has transformed the balance of power between governments and their citizens. With its simultaneous backward glance and bodily subjection, Bilal's piece asks us to confront visuality's tyranny and renewed salience in elevated surveillance and global security policing programs, as well as the legacies of pain, humiliation, and subordination in performance art and tactical media by racialized and minoritarian subjects.[14]

Bilal's masochism in *3rdi* is particularly relevant to this book's principal claim that the US global security state actively works to disappear the corporeality of its wars. Bilal's self-inflicted physical degradation in his performances symbolically represents the ongoing forms of imperial violence, disappearance, and erasure performed by the US security state. In a 2011 interview in *ArtAsiaPacific*, Bilal reveals the physical manifestations of his insurgent aesthetic acts:

> The surgery was no minor affair: at a body-modification clinic in Los Angeles, three titanium plates were inserted under his scalp and three transdermal pins screwed into it to support the custom-built camera mount. When I met him in late December, six weeks after the surgery, the physical toll of the project was already evident. Noticeably thinner, he explained that the trauma of the operation was worse than he had anticipated. In the following days, his body went into shock and he started having severe panic attacks; these have since subsided, but he now carries prescription drugs should another occur. Maintenance of the apparatus is also a demanding commitment. As the skin around the pins cannot fully heal, it is uncomfortable; Bilal has to wash the area three times a day and apply a steroid cream when the skin becomes irritated. Needless to say, he currently sleeps on his front.[15]

Soon after that February 2011 interview, Bilal's body rejected the prosthetic implant altogether. Fears of impending infection forced him to consign the now-detached ocular device to a brace around his neck until August 2011. At that time, a New York City product design firm took up the task of developing an updated, more lightweight version of the apparatus to develop a permanently resutured "machinic assemblage."[16] I discuss Bilal's technical difficulties of queerly melding the inorganic with the organic in this piece at some length here to outline his queer calculus in formation, as the artist weighs biological and discursive "risk" in pursuit of aesthetic interventions. These "bio art" experiments with visual surveillance produce uniquely intimate consequences on and for Bilal's body.[17]

Bodily pain and self-mutilation provide a consistent conceptual thread throughout Wafaa Bilal's performance oeuvre. The artist first gained international recognition for his 2007 piece titled *Domestic Tension*, where he confined himself to a Chicago gallery space for an entire month, inviting the public to visit a website where they could "shoot" him by remotely firing a paintball gun at his body (figure 2.2). In this interactive performance piece, originally known by the more straightforward and provocative title *Shoot an Iraqi*, more than sixty-five thousand online users fired at the artist by month's end, transforming this virtual experience about collective unfeeling toward US militarized warfare into a very tactile experience, most of all for its subject. Bilal's self-imposed spatial confinement in the Chicago gallery space conjures the dilemma that contemporary Iraqis, including his immediate family, face every day, living in domestic confinement as a result of foreign occupation and sectarian conflict.[18] The revised title *Domestic Tension* itself captures both the securitized "homeland" as it has been refigured under US-led occupation and gendered experiences of colonialism, militarism, and war.[19]

As with his other works, Bilal's *Domestic Tension* demonstrates an ongoing commitment to technological innovation, suggesting that the art project should determine the medium rather than the other way around. Thus, for this performance, Bilal worked with other interdisciplinary artists and technologically inclined collaborators to develop expertise in robotics, computer programming, viral marketing, and web technologies. During the thirty-one-day performance in Chicago, online viewers could access the project website to operate a robotic paintball gun in the gallery, which fired yellow pellets at the artist at all times of day, with only brief intervals between shots. In subsequent interviews and media accounts of the performance, Bilal describes the physical pain of being hit by a paintball at such close range as "excruciating." One journalist recounts that "to sleep, he had to tie himself down in his bed in case the sound of the gun made him sit up and into the line of fire. While he spent most of his days dodging the onslaught, he took some moments of respite at a desk—protected by a plastic screen—where he communicated with the shooters via a live webcam and a chat room."[20] Public engagement was central to the project, as Bilal could communicate directly with, and serve as target for, an audience that he often referred to as "the armchair warriors of the West."[21]

FIG 2.2 Wafaa Bilal, detail from *Domestic Tension*, performance, 2007.
© Wafaa Bilal.

Audience participation is one of the primary ways Bilal staged the interactive sense of complicity with bodily violence in the minds of his spectators, those simulated soldiers and "warriors of the West." Bilal described meeting online diverse people from "all walks of life—video gamers, paintball players, hunters"—during the performance month. "I'd ask the hunters why they are doing this, and they'd say, 'Well, you're in season.'"[22] Bilal went on to describe communities of hackers that formed spontaneously to alter and disrupt the game. Within days, for instance, one group had hacked the paintball gun software to make it fire like an automatic rifle, but another group of sympathetic programmers soon intervened to protect Bilal by keeping the gun aimed to the side.

Bilal documented these virtual encounters that took place in (what today might seem as "quaint") online chat rooms during the performance and uploaded his daily video journal to YouTube to highlight the multiple platforms of engagement with the artwork outside of the gallery walls. Recounting the increasingly aggressive and violent chat room comments, Bilal stated,

"I allowed people to act out their impulses and sometimes it brought out the worst in them because they felt no accountability. It *matters* that there are soldiers sitting in the US directing weapons elsewhere in the world," he said, critically reflecting on the remote nature of drone warfare. "They feel no consequences, no physical connection to the target."[23] By attenuating the distance between Bilal as the vulnerable target and the online viewer as the shooter/witness, *Domestic Tension* produces virtual intimacies that, while performative, generate significant material consequences for audience and artist alike. These intimacies reveal how racialized, gendered, and sexualized differences are at work in these violent encounters. Below are various direct quotes from the chat room log, which Bilal says became increasingly "aggressive, obnoxious and sexual." These comments demonstrate the centrality of gender and sexuality to the racist and Orientalist ideologies that the performance seeks to conjure and critique.[24]

- How do you feel about Jews?
- Are there any girls here?
- Golden shower for Wafaa? . . .
- Did you enjoy it when the bombs fell on Baghdad?
- I had an erection and was eating a cheeseburger.
- Shoot that fucker.
- We need a bin Laden cutout to aim at.
- I cap this muthafucka.
- Make that chair spin!
- FIRE!!!!
- Fuckin' Iraqis
- Come out and get shot little man.
- Those are cum shots on the glass . . . fuck and kill.
- Baba ghannoush
- Waterboard him . . . make him talk.
- I'm gonna waffle his balls.
- THERE HE IS!!!! SHOOT HIM!!!!
- Allahu Akbar

- Shoot him again for jesus.
- Send him to Guantanamo.
- Stone this infidel.
- Ohshit its [sic] that guy that's on the run with bin laden.
- Lyndie England where are you?
- I'm touching myself.

- It's a trap! Mossad put bullets in your gun.
- I'm going jihad on your ass.
- I want to shoot falafel balls at him
- Where is that fag Iraqi?
- Where's the towelhead?[25]

These toxic, if exceptionally banal, online comments produced during the performance underscore the artist's embodied vulnerability. They further signify what José Esteban Muñoz might call the "bad feelings" that virtual spectators emit.[26] They offer a trace of the violent and toxic affective reservoir of racism, sexism, xenophobia, Orientalism, Islamophobia, and homophobia that the performance elicits from its viewers.

In a journal entry toward the end of the month-long performance, Bilal reflects on the piece's unanticipated but ultimately crucial sexualized dimension of power.

> Day 25 . . . The project has taken on an aspect of sexual metaphor to me—I can relate to how women sometimes feel used and abused by sex. This testosterone-driven male impulse to fire, to ejaculate, to aggressively leave their slimy and pungent mark on a space or being before disappearing without a word. The gun is a metallic penis, the shots a series of quick angry orgasms. I see the gun as a symbolic and physical extension of the male aggressive drive to dominate, a reflection that disturbs me to my inner soul. I could never have guessed how strongly I would loathe the paintball residue—the slimy liquid around me and the sexual connotations it has evoked. Throughout my life I have confronted men who wanted to be in control. But this time I can't fight them, I have to submit to their aggression, hoping the interaction will awaken their consciousness on some level.[27]

Bilal juxtaposes his ruminations on the overtly (if conflated) gendered and sexualized nature of violent warfare, and the "ugly feelings" produced for the performance's subject, with vexed recollections from his childhood in Iraq.[28] Bilal tells stories of gendered power and sexual vulnerability, brothers being raped, highly sexualized forms of interpersonal conflict, and brutal retribution between the men in his life. Indeed, his entire memoir is marked by these failures and incoherences of heteropatriarchal masculinity. By contrast, Bilal disappointingly paints the Iraqi women featured as flat, unidimensional characters: mothers, daughters, and wives who only shore up the narrative of Bilal's exile from Iraq and his ultimate redemption as a refugee in the US.[29]

The "ugly feelings" and negative affects produced by the piece are likewise tied to the sensuous encounter with the performance for both audience members and artist alike. Art historian and critic Carol Becker, for instance, recounts the experience of visiting the artist at the Flatfile Galleries in Chicago:

> What had once been a spotless, white-cube gallery had become, over a short time, startlingly chaotic. Wafaa's installation room was covered in a sticky, slippery, soupy yellow paint, whose fish-oil smell permeated everything. It seemed impossible to breathe, let alone sleep, eat, write, or think in such a space. . . . The sound [of the gun] was as loud as a .45 caliber semiautomatic. I had not anticipated this sonic disturbance and how unnerving it would be. I have no idea what we talked about on that visit and in that interview; I was too focused on the gun, expecting it to go off at any time. It was like torture schemes where the randomness of the action, *the not knowing when the pain would be inflicted*, creates intolerable anxiety.[30]

Significant to Becker's thick description of Bilal's performance, and her affective response, is how her memory evokes multiple sensorial states. There is touch and tactility in the form of "sticky, slippery, soupy" paint, there is the permeable chemical "smell" of fish-oil, and there is the "sonic disturbance" of gunfire. There is also the impending sense of terror, chaos, and indeterminacy produced by the uncoordinated temporality of paintball gunfire, a rhythm that conjures the beat of global torture tactics and other extraordinary violence that have become increasingly spectacular, if all too ordinary, in this age of Guantánamo. These sensory registers are important aspects of Bilal's performative interventions into the unfeeling and cold rationalities of US war-making in the Greater Middle East and evoke greater awareness of the sensorial life of empire.

Becker further marvels at Bilal's "deliberate inactivity of sitting still—while the world took shots at him," a mode of radical passivity that, when combined with the "gunfire, the lack of sleep, the randomness of the shots, the sound, the inability to escape," contributed to the artist's "post-traumatic stress, *as if* he had been in an actual war zone." She continues: "It was surely astounding also that such conditions of war could be replicated in a gallery room while the outer spaces of the gallery housed regular art shows and on weekends were often rented out for weddings. For those guests who came to these events he probably appeared like the Hunger Artist in [Franz] Kafka's

parable, a curiosity engaged in an unnerving performative action of his own instigation."[31]

Like Kafka's "A Hunger Artist," Bilal distinguished his performance from the violence of an actual war zone through his consent and his willingness to voluntarily place his "body on the line."[32] Bilal's ethical concerns include "war, reparation, life, death, the passing of time, the development of human consciousness and responsibility," as Becker details, and these concepts are most forcefully engaged in the piece as they manifest over time on the artist's own body, which underscores this chapter's central argument that the minoritarian and racialized body serves as a potent site of sensory knowledge about the logics and tactics of US forever wars.[33]

In a journal entry composed on one of the final performance days, Bilal reveals the steady deterioration of his physical, mental, and spiritual state:

> DAY 29. . . IT'S 3:30 IN THE MORNING. I wander out to the bathroom, feeling like I'm walking in a moon suit or entrapped in someone else's body. I've gained so much weight—20 pounds in 30 days—from lack of exercise, depression and stress-induced overeating. I strip to stare at myself in the bathroom mirror, obsessively filming up and down my body; a side view, a frontal view, a view from the back—*mug shots of the distortion and abuse wrought on my once proud physique* . . . My face is pale and bloated, speckled with the strange dark freckles that have suddenly appeared over the last few days. Drooping bags hang under my listless, bloodshot eyes . . . I put the camera under my swollen belly and point the lens straight up, seeking the most unflattering angle possible, cruelly pushing the flesh up in a mound, a rippling landscape below a jungle of wiry black hair.[34]

Exposing that "rippling landscape" to the camera's gaze not only laid bare the artist's embodied vulnerability but also offered a trace of both the temporal stakes and physical toll the performance exerted over its protagonist. These insights underscore the centrality of bodily manipulation to Bilal's performance practice. Queer feminist performance studies scholars have addressed the critical role of bodily pain, masochism, and negative affect in diverse performance art traditions in ways that dovetail closely with Bilal's work.[35] In addition to Leticia Alvarado's and José Muñoz's sharp insights into Chicanx performance artist Nao Bustamante's use of virtuoso physicality and Jennifer Doyle's beautiful treatment of extreme body art performances by Ron Athey, Jack Halberstam outlines the function of pain, reparation,

and what he terms a tradition of "radical passivity and unbeing" in feminist performance art of the 1960s and '70s.[36]

Particularly salient to Bilal's *Domestic Tension* is Halberstam's discussion of conceptual artist Yoko Ono's *Cut Piece* (1964). In video archives of Ono's nine-minute-long "happening," first staged in Tokyo, Japan, we see the artist walk onstage and kneel in a draped garment. Audience members were asked to come on stage and begin cutting pieces of her garment until she was seminude, covering her breasts. In subsequent site-specific reiterations of this performance, we see the subtle distinctions between audiences, increasingly male-identified, who recklessly and spontaneously cut her garment in ways that dangerously literalize her bodily submission to the other, as well as the "sadistic impulses that bourgeois audiences harbor toward the notion of woman."[37] In the piece, the act of cutting is assigned to the audience rather than the artist, which Halberstam reads as "an authorial gesture . . . dispersed across the nameless, sadistic gestures that disrobe her and leave her open to and unprotected from the touch of the other."[38] Halberstam views Ono's feminist performance as exemplifying the "extreme forms of self-punishment, discipline and evacuation" that capture a "shadow archive of resistance" in postcolonial, Black feminist, and queer art.[39]

Bilal's aesthetic practice likewise engages the philosophical demands and consequences of leaving oneself open to the touch of the other. In this case, Bilal's undoing is facilitated by the paintball gunfire against his flesh, which indexes the bodily and sensory distortions of warfare.[40] Yet Halberstam critiques male masochistic performances, suggesting that the male artist provides only a "heroic antiheroism by refusing social privilege and offering himself up Christ-like as a martyr for the cause."[41] The female masochist's performance, on the other hand, is "far more complex and offers a critique of the very ground of the human," and the work is feminist because of its attention to "fragmentariness, subversion and sacrifice [as] the masochist tethers her notion of self to a spiral of pain and hurt."[42] I part ways with Halberstam's overly generalized reading of male masochistic performance here by pointing out that in Bilal's *Domestic Tension*, audiences' negative affects are key to his performance project. Bilal is indeed just sitting there and "taking it," but this mode of sacrifice does not make him a martyr. In fact, he implores:

> They want me to be a martyr and sacrifice myself to make a point. That makes me furious . . . I didn't do this to be turned into a joke or a game. And I'm not a martyr—I'm not trying to kill myself, I'm just an artist trying to make a point. I hate the idea of martyrdom in general.

I believe in surviving . . . in Iraq, in a war zone, you don't jump in front of a gun asking to be shot. You go into survival mode, and that survival mode is what changes your entire life and saps your energy and attention. On a daily basis, Iraqis are shaping their whole lives and routines just to avoid getting hit—taking different routes to work, only going out at certain times of day, always staying alert.[43]

While Bilal's denials of martyrdom might raise suspicion, his description of quotidian survival strategies in Iraqi warzones chillingly conjures the immobilizing quality of warfare and security governance. Bilal hearkens heightened security regimes around the globe and ongoing military operations in Af-Pak, Iraq, and elsewhere, which discipline racialized and minoritarian bodies through detention procedures, border restrictions, and checkpoints. Bilal's knowledge project thus allows us to discern militarization, segregation, and occupation as lived realities for the precarious many in order to ensure the vitality and life chances of the prosperous few. Yet despite Bilal's statement about sexualized violence against women discussed earlier, he also seemingly displays little insight into the gendered dimensions of these phenomena, given how Iraqi women and girls are disproportionately affected by the immobilizing wages of warfare. Despite these contradictions, Bilal's adamant opposition to martyrdom stems further from his memories of living under the Saddam regime during the Iran-Iraq War, when the language of martyrdom was applied to deaths of Iraqi male soldiers. Bilal notes that Iran used the same tactic, but "it was especially cynical for a secular leader like Saddam to invoke the religious connotations of martyrdom to try to keep his people from questioning that pointless war."[44]

Thus, while on the surface it would seem that Bilal's solo performance interventions take the form of male masochism to be derided, a form of spiritually inflected martyrdom, closer inspection reveals that his work resonates instead with the radical passivity that Halberstam sees in female masochistic performances. I would argue that Halberstam's notion of female masochism thus applies to a range of racialized and postcolonial subjects (including cisgender men such as Bilal) who participate in the "willing giving over of the self to the other, to power."[45] This "willingness of the subject to actually come undone" is present in Bilal's performative transformation and unraveling over the thirty-one days of *Domestic Tension*. His virtuoso performance thus illuminates the racial and imperial logics of subordination, what I term the queer calculus of the forever war, in a moment when racialized male masculinity is fervently on display in the age of torture.[46]

Bilal's masochistic performance draws affective ties between people and places that the US security state deems "collateral damage." In his memoir, Bilal ruminates on the counter-publics his work constructs: "In my paintball prison, I seem to be filling quite a range of roles for different people. Symbol of the anti-war movements, lightning rod for hatred and racism; subject of intellectual discussion, diversion for the bored; company for the lonely. And catalyst for flirting, heartfelt confessions, and existential philosophical discussions . . . I can only conclude that social isolation has reached such proportions in this culture that when given a platform for dialogue—however unusual—people will grasp at the opportunity to connect with each other."[47] Bilal's rendering of the piece as an antidote to "social isolation" and division arrives unexpectedly at a conclusion opposite that proposed by Halberstam on feminist unbecoming. Given my reading of Bilal's work, therefore, racialized male masochistic performance can be understood as a mode of becoming, not unbecoming, connection, not failure of contact. This form of affiliation is precisely what Bilal's queer calculus proposes: human connectivity and intimacy, even the virtual kind, across the digital divide, thereby generating a mode of insurgent aesthetics that powerfully resists the stultifying and isolating effects of US forever wars.

Bilal's ensemble of visual and performance works and literary memoir collectively exemplifies the complex ways diasporic expressive culture can diagnose and provide alternatives to the US security state's geopolitical and epistemological maps. In the remaining discussion in this chapter, I explore how Bilal's performance works further ask us to consider how the visual field is constitutive of both the logic and the materiality of war. This is true not only in the case of pilotless drones over the "conflict zones" of Iraq and Af-Pak, where cameras are quite literally appended onto missiles and bombs, but also in what he names "the comfort zone," those more mundane settings, far from killing fields, in which war enlists and acts upon our senses. Thus, an encounter with Bilal's artwork elicits a transformation in our affective relationship to dominant visual and discursive frames of war. My queer reading of Bilal's tattoo performance . . . And Counting (2010) in the following section reveals how insurgent aesthetics provides a privileged terrain from which to interrogate the dominant calculus of the US global security state (its logics, frames, tactics, and desires) while simultaneously offering an affective and tactical map from which we might develop alternatives to imagine and inhabit.

Collateral Damages

Bilal's performance piece . . . *And Counting* (2010) highlights the queer calculus of the forever war that I have outlined in this chapter by examining the ongoing US-led massacre of Iraqi civilians, including the artist's own brother Haji, who was killed by a drone missile strike in their hometown of Kufa, Iraq, in 2004.[48] In this March 2010 piece staged in New York City, the artist transformed his body into a canvas by tattooing the names of Iraqi cities on his back and then, during a twenty-four-hour-long live performance, tattooing 105,000 dots onto this borderless map, solemnly reciting the names of Iraqis and Americans killed during the US occupation since 2003 (figure 2.3). Audience members stood as witnesses. Five thousand dots were marked first in red ink to represent dead American soldiers. The remaining 100,000 dots, memorializing the "official" Iraqi death toll from the war, were in green ultraviolet ink, invisible unless viewed under a black light. As this cursory description suggests, Bilal's piece asks its audience whose death "counts" in times of war, erecting what postcolonial feminist scholar Neferti Tadiar calls "living memories, living histories, as openings into other futures."[49] The performance also elicits timely questions about the proliferating use of US drone strikes in targeted assassinations across the Greater Middle East, North and West Africa, and the borderlands region of Af-Pak. A spotlight on Bilal's own sensate body in pain, with ink pressed into bare skin, depicts my focus on how we might glean evidence of the histories, geographies, and sentiments of those disappeared by US global warfare in tactile and corporeal forms.[50]

Bilal's insurgent aesthetics make possible an alternative sensorial relation to the violence of US militarism, what I am calling the queer calculus of forever war. . . . *And Counting* enumerates personal and collective traumas. Bilal is a blacklisted political refugee from Saddam-era Iraq mourning the loss of his brother, who was killed by a drone strike for simply being in the way—the "collateral damage" that belies the war machine's imprecision.[51] Bilal's use of tattooing and body art here is particularly instructive in light of the earlier debate on masochism. First, we must contend with the map of Iraq tattooed onto Bilal's body. Although maps regularly function as instruments of centralized surveillance, information retrieval, and warmaking,[52] the borderless cartography that Bilal imprints onto his back (see plate 7) resonates instead with what literary historian Jonathan Flatley calls an "affective map"—a map that "not only gives us a view of a terrain shared with others in the present but also traces the paths, resting places, dead ends

FIG 2.3 Wafaa Bilal, detail from . . . *And Counting*, performance, 2010.
Photo: Brad Farwell.

and detours we might share with those who came before us."[53] Turning to the modernist writings of Henry James, W. E. B. Du Bois, and Andrei Platonov, Flatley stitches individual suffering onto modernity's historical development. Connecting one's emotional life to broader historical processes allows us to process "'how long our misery has been in preparation,' as Walter Benjamin put it, and thus to see our lives as the site and potential culmination of a long historical struggle."[54] According to Flatley, these disparate writers generated affective maps for their readers, transforming depressive melancholia into a way "to be interested in the world." Following Freud and Benjamin, Flatley's surprising contention is that melancholia need not be depressing alone but can be instead "one of many attempts to understand and explain the new affective terrain of modernity."[55] His "affective mapping" thus evokes this new historical relation, a "collective affective attachment" where one might ask, "Who shares my losses and who is subject to the same social forces?"[56]

Flatley's work allows Bilal's individual art practices to be reconsidered as part of an epistemological project engaged in a politics of knowledge, one that has collective and social effects.[57] As viewers and witnesses to . . . *And Counting*, we are asked to think concurrently about individual and collective pain, sorrow, mourning, loss, and hope. To think of Bilal's immediate pain during the tattoo performance, to give it shape and meaning, is then

necessary to attempt an account of ongoing collective pain and loss for Iraqis around the globe—a diaspora whose connective tissue is forged in bloodshed, violence, occupation, and permanent war. Hence Bilal's performances of pain and mourning are not solely metaphors but also "evidence of the historicity of [his and our] subjectivity."[58]

In . . . *And Counting*, the source of this affective attachment is Bilal's own skin—that organ of touch and feeling that sutures the body to the social world. Thus, while this performance is surely a visual and sonic experience for his audience, it is only through the tactile—where we are asked to confront Bilal's body in pain—that this affective relation to past histories is drawn. Through touch, not vision, Bilal provides affective relationality and newly conceptualizes the self in relation to others. Bilal's haptic impulse to "touch the past" by charting the "dead ends and detours" shared with those who came before him thus becomes crucial in specifying his sensorial interventions, as it suggests another way of archiving and knowing the forever war.[59]

Bilal's queer calculus of pain demands a complex analytic relation to the senses for minoritarian subjects. He conceptualizes the forever war's killing and violence by isolating touch and other modes of affective transmission that circumvent the visual field and that might even contradict the scopic altogether. As I argue throughout this book, tactical and haptic knowledge can elicit an alternative, sometimes contradictory, conceptualization of social relations to that offered by visually based epistemologies.[60] Sensations can reveal feelings that are otherwise inaccessible to the regime of the visible and make possible other ways of organizing collective social life beyond the dominant logics of the US security state.

To further delineate Bilal's queer calculus in . . . *And Counting*, we must question what the borderless map seeks to represent. How does death sort livable from grievable lives? What is the "unspoken calculus of the value of a life and a death on this planet" that . . . *And Counting* critiques?[61] With Bilal's work we are forced to contend with the failure of numbers and body counts to adequately represent the disappeared.[62] We can really never know how many people have died in the name of "security" and "freedom" in the terror wars we currently wage. The material archive of the forever war provides no evidence of that. Indeed, the value of numerical calculations in collective efforts both to wage and to memorialize war is dubious at best. Judith Butler effectively outlines this: "Numbers, especially the number of war dead, circulate not only as representations of war, but as part of the apparatus of war-waging. Numbers are a way to frame the losses of war, but this

does not mean that we know whether, when or how numbers count. . . . Although numbers cannot tell us precisely whose lives count, and whose deaths count, we can note how numbers are framed and unframed to find out how norms that differentiate livable and grievable lives are at work in the context of war."[63]

Butler underscores enumeration's failure to comprehend state violence and US warfare. She further questions how quantitative reasoning continues to frame "whether, when, or how" we come to "know" the populations that are most vulnerable to war's destruction. This is paradoxical, Butler observes, because we often are told that quantitative methods are superior in the social sciences and that qualitative reasoning "does not 'count' for very much at all": "And yet, in other domains of life, numbers are remarkably powerless. This suggests that certain implicit schemes of conceptualization operate quite powerfully to orchestrate what we can admit as reality . . . so even the positivist weight of numbers does not stand a chance against them."[64] In . . . And Counting, Bilal critiques these "implicit schemes" and employs his body as a queer calculus to conceptualize the "death toll" beyond standard quantitative logics.

Building on sociologist Avery Gordon's challenge to find new terminology for new forms of power and knowledge, Herman Gray and Macarena Gómez-Barris propose a sociology of the trace "to attenuate the distance between empirically social worlds and those things that are not easily found through methodologies that attempt to empirically account for social reality."[65] In contrast to the sociological imperative toward "generalizability, systematicity, and a normative notion of rigor," Gray and Gómez-Barris suggest an alternative methodological approach that "points toward inscriptions, traces, the audible, the inaudible, cacophonies, incoherences, assemblages, translations, appearances, and hauntings as methodological necessities rather than those things that do not quite fit into overtly social categories."[66] Their emphasis on "archives of traces and inscriptions" speaks both to my analysis of Bilal's insurgent aesthetics and to the broader political dimensions of this book's decolonial queer feminist methodology, reviewed in the introduction. By connecting Bilal's performance works to histories and theories of aerial bombardment and collateral damage, this chapter decenters the primacy of the visual, given its centrality to US global security logics. It attends instead to extravisual sensory and haptic relations as a way of "attenuating the distance" between the counterterrorist views from "above" and those from "below."

My analysis of Bilal's work reveals that positivist framing of loss, in-

cluding death counts, cannot contain what it seeks to make visible or readable. While this dominant necropolitical frame of war "jettisons the delegitimated alternative versions of reality," it busily generates what Butler calls "a rubbish heap whose animated debris provides the potential resources for resisting."[67] Given that the US global security state continues to violently unfold an archive of war-making and destruction (even as it refuses to see itself *as* an archive), I follow the specters that haunt the "animated and deratified traces" of killing to produce a queer calculus of forever war.[68] This approach provides a trenchant methodological antidote to archival-based studies of US racial formation, state secrecy, and military empire. It also demonstrates how conventional representations of the death toll fail to capture the complex amalgamation of memory, imagination, and pain in queer diasporic visualities and aesthetic practices.[69]

If my queer diasporic account of Bilal's insurgent aesthetics rejects the dominant politics of wartime enumeration, in its place we are left to confront Bilal's back under black light (see plate 8). His back was transformed by the tattoo performance into a craggy terrain that looks like the remnants of a surface scarred by cluster bombs and missile strikes. No numbers are present in this arresting image. Instead, the tattoo assemblage conjures burns marks, a starry night, a galaxy from outer space, or satellite imagery—which is all too pervasive in this era of GPS. Yet we must recall that Bilal's own "view from above" is a cartographic representation that is permanently etched on his skin, a reminder that the abstract queer calculus of the forever war is sometimes materially inscribed, quite literally, on the minoritarian cultural worker's body in pain.

Beyond "Authority's Clenched Fist": A Violent Interlude

While critically assessing Bilal's craterous back under black light, I am transported to another haunting aesthetic archive that confronts the material effects of bombing campaigns and their aftermaths. elin o'Hara slavick's drawing and painting series *Protesting Cartography or Places the United States Has Bombed* (1998–2005) offers an important intertext to Bilal's embodied performances (figures 2.4 and 2.5, plates 9–12).[70] I turn to slavick in the final section of this chapter not because I see her as explicitly contributing to the diasporic expressive cultural field that I am tracing throughout this book, but because her work illuminates key aspects of my analysis of insurgent aesthetics that are worth considering directly before concluding this chapter's engagement with Bilal's work. Moving from a formalist analysis of diasporic

FIG 2.4 (*top*) elin o'Hara slavick, *Iran, 1953 and 1987–1988*. © elin o'Hara slavick.

FIG 2.5 (*left*) elin o'Hara slavick, *Vietnam, 1961–1971*. © elin o'Hara slavick.

FIG 2.6 elin o'Hara slavick, *Baghdad, Iraq, 1990–Ongoing.* © elin o'Hara slavick.

performance works and memoir in the work of Bilal to painting and drawing in slavick's necessitates a more expansive interdisciplinary lens and toolkit to assess the continuities and discontinuities across artistic forms and media that is consonant with my queer feminist scavenger methodology for insurgent aesthetics in this book.

Composed on paper from ink, watercolor, graphite, and other media, slavick's sixty drawings in *Protesting Cartography* likewise confront our collective so-called failure of imagination about what bombs do to populations, bodies, and topographies (figure 2.6). Working from an eclectic archive of military surveillance imagery, aerial photographs, battle plans, and maps, slavick reimagines these geographies and landscapes, disengaging them from what she terms "authority's clenched fist."[71] In the process, her drawings compose a sustained archive of largely uninterrupted US aerial bombing campaigns since the 1940s: from Hiroshima and Nagasaki to Vienna, France, Korea, Vietnam, Vieques, Laos, Lebanon, Afghanistan, Haiti, El Salvador, Grenada, Pakistan, and even sites closer to home, including Alamogordo, New Mexico, which is the site of the first atomic explosion in 1945. In this

FIG 2.7 elin o'Hara slavick, *Pakistan, Democracy Now, 1998.* © elin o'Hara slavick.

way, slavick's work powerfully echoes my argument about the US forever war across the Greater Middle East. Together these images attest to the unimaginable breadth and uninterrupted violent expanse of postwar US geopolitical power in the global Asias.

I am drawn to slavick's series not only for the dreamy aesthetic of her paintings, which are often swathed in sumptuous primary colors, but because the airborne view she constructs differs so dramatically from the austere, bone-chilling cold aerial photography we have come to expect in the digital age of Google Earth (figure 2.7). That dominant view, as I discussed in chapter 1, has re-educated our senses on how to look at and think about territories besieged by bombs. While both of these visual representations are technically "views from above," they call for radically distinct analyses and affective connections. slavick notes that even if she "*could* make photographs," she would not because there are "already too many photographs—too immediate, too true, too real, and too brief—countries and lives reduced to singular images."[72]

Working in the techniques of drawing and painting instead of photography, slavick astutely critiques the violent and singularizing effect of digital photographic representations. Her 1998–2005 series, however, is even more prescient given Wafaa Bilal's later performances challenging the US military myth of so-called precision and precise targeting in drone warfare. To capture this contradiction, slavick uses a crucial bleeding effect to her imagery and formalist aesthetic:

> [Ink] dropped onto wet paper like bloodstains on damp clothing. When it dries this becomes the foundation upon which to tell a violent story. I use this ground of abstract swirling or bleeding to depict the manner in which bombs *do not stay within their intended borders.* Depleted uranium and chemical agents contaminate the soil, traveling in water and currents of air for decades. . . . Bombs lay the groundwork for genocide, cancer, more war, terrorism, widows, orphans and a vengeful populace on all sides of conflict.[73]

slavick's analysis of her aesthetic practice captures how bombs rarely stay within their circumscribed borders. The "abstract swirling or bleeding" in her paintings belies the unintended but all-too-pervasive consequences of late modern wars. Indeed, this work reminds us that, as Mahmood Mamdani states, "it was not the Saddam Hussein regime but successive U.S. administrations that freely resorted to using weapons of mass destruction beginning with the 1991 Gulf War"; these weapons include incendiary bombs containing napalm and depleted uranium.[74] Attending to the toxic aftermaths of these histories of US aerial wars in formalist terms, both slavick's and Bilal's fine art and performance works thus construct an affective relation with peoples, landscapes, and ecologies deemed by the US security state as so-called collateral damage.

slavick's insights on the perennial bleeding, unintentional, and collateral nature of violence in the US forever war resonate further with a key aspect of my March 2011 interview with Wafaa Bilal, during which the artist recounted how he was initially upset that his original digital, pixelated renderings of the map (that was to be tattooed onto his back) did not ultimately match the final product on his body. During the performance, the tattoo artists realized there was not enough space on his back to appropriately arrange the dots across his skin according to his prefabricated illustration. Despite the gulf between the abstracted digital map he had envisioned and the tattooed landscape that ultimately manifested on his body, Bilal was pleased because

the disconnect spoke to the realities and randomness of waging war. This gulf between expectation and reality is an affective experience that US military planners also encountered (and instigated) when they hastily landed in Iraq in 2003, as did British forces in "Arabia" in the 1920s. In this light, the supposed "failed" tattoo performance, and the unintentional insurgent aesthetic of nonalignment that it produced, offers a potent reminder that we should resist the impulse to cede unwarranted ground to US air power as a totalizing nexus of domination. As journalist Peter Baker notes, "If we are to challenge successfully the official efforts to make high-tech war an acceptable foreign policy option . . . we need to get more intimate, get in close and witness how, from the micro- to the macro-level, fog, fiction, and general screw-ups regularly operate in war games as well as in war."[75] In short, there is nothing precise or expert about US forever wars, and this impression of wartime violence leads to a possible methodology of resistance for the dispossessed.

The disorientation produced by the "fog of war" speaks volumes to what elin o'Hara slavick suggests is the affective force behind her drawings, which start with ink or watercolor but bleed and drip in unanticipated and unlikely ways. I want to linger on one final aspect of slavick's commentary in light of this book's argument that a queer feminist critique of the bodily, sensorial, and affective registers of violent warfare is a crucial analytic contribution of the insurgent aesthetics I have assembled here:

> I do hope that the cellular references that appear in many of the drawings—replicated stains in the background, connected tissue in the foreground, concentric targets like microscopic views of damaged cells—conjure up the buried dead and deadly diseases as a result of warfare. . . . We know that more civilians die in war than combatants. We know that uranium tipped missiles cause radiation-related diseases like cancer and that landmines remove limbs from innocent children years after the conflict.[76]

Attending to the unintended bodily and sedimented forms of violence summoned by US counterinsurgency and counterterrorism practices, slavick's commentary begins to offer glimpses of the queer calculus of the forever war; her remarks on the toxic toll of US warfare serve as a powerful reminder of how the violence of war devastates humans, animals, *and* social ecologies, to say nothing of the exact "nuclear nightmare" (of radioactive contamination and hazardous waste) left behind by US weapons

and bombs in Iraq since the first Persian Gulf War.[77] This durative fact of environmental destruction attests to the urgent and radical potential of insurgent aesthetics to make visible and palpable the toxic contradictions of the forever war.

Conclusion: On Deadly Inscriptions

In light of slavick's interventions, I return finally to Bilal's tattoo performance—and specifically to his back—to underscore the salience of analytically isolating the extravisual and haptic sensory relations and formal processes in insurgent aesthetics. While there is no official tradition of body art in Iraq, Bilal's use of tattooing powerfully captures the missing history of the disappeared. In an interview with journalist Anjali Kamat, the artist recounts how, while living in a Saudi refugee camp after escaping Iraq in 1991, he was granted asylum in the United States on the condition that the American delegation be allowed to interrogate his brother, who was also in the camp.[78] One of the US translators who befriended Bilal informed him that Americans would not take three kinds of people: criminals, communists, and people with tattoos. Bilal's brother had a tattoo, and the reason that he got it was related to the war. During the Iran-Iraq War (1980–88), many young people lost family members on the front lines, and their bodies came back unidentifiable. Young Iraqis started getting tattoos of their names and cities, sometimes on one or two of their body parts, so that if they were killed and their bodies mutilated beyond recognition, their families would still be able to identify them. If the Americans saw the tattoo on his brother's arm—this inscription of a future death yet to come, they would not grant Bilal asylum. That night his brother decided to burn the tattoo off his arm using a hot spoon.[79]

Bilal's vividly painful recollections from the camp reveal a paradoxical queer calculus at work. To gain access to refuge in the United States, his brother needed to efface this other, unseen record of the US proxy war in the Greater Middle East, as evidenced by US participation in and financing of the Iran-Iraq War. Bilal's story captures the nexus of the body in pain and the violence of the regulatory security state as it reveals the somatic and sensorial life of empire. The burned-off tattoo provides "material evidence of power's whereabouts."[80] What lies outside the visual archive, then, are these sensorial traces, memories, and feelings that conjure individual, familial, and collective histories beyond official war records. Analyzing the formal and experi-

ential dimensions of Bilal's creative works through queer feminist and affect studies thus better captures the sensorial logics of imperial governance and its manifold resistance. Paying particular attention to the tactile nature of Bilal's performances elucidates an alternative sensorial logic through which we might begin to access these long-submerged and entangled histories of violent conflict. Such an approach reveals further how the discarded remnants and accumulated debris of dominant US security logics comprise the raw materials for sensing and feeling anew the queer calculus of the forever war.

Being haunted draws us affectively, sometimes against our will and always a bit magically, into the structure of feeling of a reality we come to experience, not as cold knowledge, but as transformative recognition. —Avery Gordon, *Ghostly Matters*

To bring out your dead is to remember what must be forgotten, to find the "evidence of things not seen": that the notion of American equality in the protection of life is a fallacy, that life is not protected if you are raced and gendered, and that you are raced and gendered if your life is not protected. To bring out your dead is to say that these deaths are not unimportant or forgotten, or worse, coincidental. It is to say that these deaths are systemic, structural. To bring out your dead is both a memorial and a challenge, an act of grief and of defiance, a register of mortality and decline, and of the possibility of struggle and survival. —Grace Kyungwon Hong, *Death beyond Disavowal*

In a military-spy state that crushes resistance movements through permanent surveillance, infiltration, and tactics that sow distrust and suspicion, perhaps it is a politics that is *against* the grain of translation, visibility, and recognition that is needed. "Quiet encroachments," rather than spectacular protests, and fugitive knowledges can thrive in the underground and escape detection by the surveillance state, erupting in public when the conditions of possibility are ripe and congealing into visible protest in ways that can catch repressive regimes off guard and create new tactics of protest. —Sunaina Marr Maira, *The 9/11 Generation*

Whereas chapter 2 examined the global dimensions of empire through contemporary US aerial warfare and counterterrorist policing in Iraq and the "Af-Pak" borderlands, this chapter returns to the securitized space of the

"homeland" to consider insurgent aesthetics emanating from the domestic ends of the contemporary US military-surveillance state. I extend the preceding discussion of archival traces and fugitive knowledges by examining aesthetic responses to the carceral regimes of surveillance, detention, and deportation of Arabs, Muslims, and South Asians after 9/11. These security state practices have entailed the use of secret evidence and predatory prosecution policies, as well as torture, extraordinary rendition (transnational abduction), and secret prisons at the legal grey zones of US military bases and detention "black sites" across the globe.[1] In my analysis of creative works that confront the imperial and necropolitical orders of US forever warfare, I examine twenty-first-century carceral practices as part of the longer and more continuous history of invasion and military occupation through which the United States has affirmed its sovereignty in North America, and in the world at large. In this vein, the detention facility has been a long-standing site of confinement for those awaiting asylum and facing deportation—both within and outside of the history of US global counterinsurgencies.[2] US military detention, as one major dimension of the forever war under investigation here, is built upon distressed embodiment and forced disembodiment of the racialized and dispossessed enemies of warfare in ways that make my broader focus on embodied vulnerability and the senses in this book particularly cogent to an analysis of what I term "the sensorial and somatic life of empire."[3] This chapter advances this book's shift away from dominant visual logics of empire toward alternative sensorial registers, affective structures of resistance, and subjugated knowledges in works of art that evoke the embodied queer calculus of the forever war. If the last chapter used Arab diasporic performance art and memoir to explore what is discarded and devalued by ruling regimes of security and warfare, this chapter, then, elucidates how collaborative visual art projects can further critique the redactions and disappearances wrought by the US security state in its imperial prisons and detention centers.

Through a wave of creative output, artists, activists, lawyers, journalists, documentarians, and scholars have responded critically to state practices of surveillance, privacy, secrecy, torture, confinement, and violence in US global military detention since 9/11. From the Center for Constitutional Rights in New York City and the Bureau of Investigative Journalism in London, to investigative reporters of the *Intercept* and WikiLeaks "whistleblowers" such as Edward Snowden and Chelsea Manning, to artists such as Jenny Holzer, Trevor Paglen, and Laura Poitras, a resurgence of creative multimedia activism and human rights has addressed the scale and scope of twenty-

first-century US global warfare.[4] Numerous cultural workers are producing what sociologist Asef Bayat calls "quiet encroachments," new tactics of protest that thrive in the underground and interstitial to escape detection by the surveillance state.[5] Artists in particular have disentangled narratives from the very same source materials as the US state to force a broader conversation about the absence of any unilateral meaning that can be derived from these state practices and their evidentiary traces. And yet what is often missing from prevailing accounts of art activism and criticism in the post–9/11 global war on terror (GWOT) era are the racialized bodies of minoritarian art practitioners themselves and their indispensable links to diasporic communities and social geographies most affected by US global state violence in the Greater Middle East.[6]

As I argue throughout this book, the aesthetic and political imaginaries that emanate from Arab, Muslim, and South Asian populations are vital to knowing the submerged histories of the forever war, not merely because these distinct minoritarian groups have survived but because their creative works clarify the critical terrain of an ideological contest that transcends the security state and the meanings of late modern warfare. This chapter therefore deepens my account of insurgent aesthetics by analyzing the formal and sensory dimensions of collaborative works by two New York City–based multiethnic collectives from the 2000s—Visible Collective (cofounded by filmmaker and scholar Naeem Mohaiemen, who is of Bangladeshi origin, and visual and performance artist Ibrahim Quraishi, who is of Pakistani origin) and the Index of the Disappeared (comprising Afghan/Lebanese American multimedia artist Mariam Ghani and Indian American visual artist and painter Chitra Ganesh)—as well as solo installations by Berlin-based Indian American visual artist Rajkamal Kahlon, created in collaboration with the American Civil Liberties Union (ACLU). I am drawn to these artists and their collaborative works in particular because they compose an important part of my own scholar-activist relational orbit. Like me, much of their work is informed by deep contact with a legacy of community activism, legal advocacy, and civil and human rights work in New York City. They encompass a group of artists (as activists, scholars, lawyers, curators, journalists, architects, and multimedia cultural producers in their own right) who, in the main, came of age in the cultural and political organizing milieu of New York City in the 1990s. This pre–9/11 period spawned an efflorescence of urban multiethnic activist and creative cultural production against a range of violences, such as urban police brutality; immigrant detention; and feminist, LGBTQ, and labor struggles, and it had profoundly politicizing effects on successive gen-

erations of Arab, Muslim, and South Asian diasporic artists and activists in the US/North America.[7]

Unlike artists who forged works in the diaspora after years of living in conflict zones marked by direct embodied experience with the US war machine and its client states, the artists under review in this chapter are instead diasporic subjects of surveillance societies in the West, differentially included within hierarchal orders of US gendered racialization and militarized security but not directly targeted by US imperial warfare. As outspoken foes of the US forever war in the Greater Middle East, these artists have created often more privileged transnational art activist careers that are paradoxically upheld by US empire in global cities such as New York, Dhaka, Amsterdam, and Berlin. This complex social location positions them at a distance from many of the racialized and dispossessed subjects of their artworks, including criminalized immigrant detainees and suspected enemy combatants who are made to suffer the eviscerating violences of US empire as military objects either in the US, at US military prison sites, or in the Global South. By examining insurgent practices and comparative analytics forged by diasporic cultural producers who have roots in nonwestern societies beset by war but who live and labor in the West, this chapter thus not only questions what counts as "security" in dominant archives of US imperial war-making but also shows how these aesthetic works offer an expansive and intimate social critique of the transnational politics of surveillance, torture, and killing in military detention.

In my analysis of these artists' drawings, paintings, videos, photographs, and installation art projects, I focus on their aesthetic incorporation of declassified government documents and autopsy reports detailing widespread abuses over the past two decades at military bases and secret prison sites across the globe. These institutional reports highlight brutal and often secretly enacted practices of state violence, including torture and extraordinary rendition, which compose a key aspect of the domestic and international contexts of the US forever war, as elaborated in chapter 1. This chapter builds on and advances a critical study of state violence, representation, and the archive by elaborating on the perverse entanglements between "official" records of military detention and war (as seen in declassified torture documents) and poetic and embodied renderings by multimedia visual artists whose works highlight sensation and collective affects to capture the unknowable and to develop an alternative sensuous and ethical relation to the dead. The dense intermingling of the empirical with the subjective, the clinical with the intimate, and the disembodied with the corporeal in these aes-

thetic practices call attention to what I term, following artist Mariam Ghani, "warm data."

"Warm data" is a conceptual art strategy and feminist methodology to conjure the violent absences and haunted abjections in carceral archives of US military detention. The forever war is an inhumane project that transforms public institutions, national economies, and intimate relationships alike. As detailed in the introduction, a queer feminist decolonial method would locate the forever war's violently unfolding archives as repositories not only of data and information but also of collective affects and structures of feeling that can elicit subjugated knowledge about the dispossessed and their critical relation to the social world.[8] Ghani develops an insurgent aesthetics of "warm data" in her ongoing collaborative art practice with Chitra Ganesh on immigrant detention and deportation to distinguish "hard factual information typical of legal and bureaucratic systems with the unquantifiable aspects of human life."[9] Warm data, juxtaposed with the weaponization of "cold hard facts used against you in a court of law," evokes heat, intensity, vibration, feeling, tactility, energy, and affect. Specifically, warm data moves beyond dominant sensorial experiences with militarized information and surveillance that manifest primarily through the ocular, including, among others, drone and infrared technologies, to open up other ways of knowing war, destruction, and survival.[10] I build on and extend Ghani's conceptual framework here to capture the aesthetic, political, and sensorial demands of South Asian and Arab diasporic artists who use the cold bureaucracies of empire as the raw material for their creative interventions. "Warm Data" is thus an insurgent aesthetic strategy and reparative queer feminist intervention that poetically limns the fissures, failures, and absences in records of US global military detention. It further generates alternate modes of knowing how racialized and diasporic subjects have contested the stultifying logics and tactics of US forever warfare in the realm of contemporary art and culture.

Given the forever war's quest for secrecy and opacity, I also want to explore a core epistemological question undergirding critical theories of violence in/ and the archive, asking *how we know what we know* about practices of detention and deportation, interrogation and torture, and the related range of state-sanctioned and socially sanctioned carceral violence that defines the "colonial present."[11] Scholars Sally Howell and Andrew Shyrock have described the post–9/11 period of racialized security as the overt "cracking down on diaspora," when domestic counterinsurgencies disproportionately targeted cosmopolitan urban centers where diasporic communities and eth-

nic, postcolonial migrants are concentrated.[12] As historian Rachel Ida Buff asserts, the architects of "the deportation terror" saw their efforts as central to a global counterinsurgency.[13] Many scholars have subsequently connected the unprecedented US domestic policing and prison expansion project that disproportionately targets working-class people of color with the emergent "global war on terror" prison archipelago.[14] The racial state's permanent war against and indefinite imprisonment of racialized immigrant and foreign populations under the guise of combating terrorism echoes what cultural theorist Sohail Daulatzai rightly calls the "carceral logic and captive power that has historically been forged around Blackness in the United States," a model that now serves as the primary template for the "export[ation] of this prison regime to the colony in the 'War on Terror.'"[15] How do artists and cultural producers make sense of these innovative carceral security practices of policing, confinement, and enclosure? How might we come to "know" the archive of the detained and disappeared beyond empirical registers? What do the prevailing archives of US global military detention obscure? How do the artists featured here diagnose these gaps, disavowals, and erasures in the archive while also conjuring the ghostly and spectral life of "warm data," or alternative articulations of affective collectivity and sensuous knowledge in the forever war?

My consideration of warm data as both antidote and analytic upon which to map enduring violence and violation relates to a broader intellectual and political concern characterizing present-day struggles against US militarism and empire. That is, I seek to explore the core contradiction between the US security state's desire to "know" the so-called human terrain of global conflict in the forever war.[16] On the one hand, the state attempts to map racialized "Muslim" populations and innovate surveillance and intelligence-gathering procedures. On the other, it is distinguished by a persistent disavowal of imperial violence and attempts to disappear the corporeality of its wars through "black sites," redactions, so-called touchless torture, denials of civilian deaths during drone attacks, and manifold unseen technologies of secrecy and terror that define the violence of the counterinsurgent state. In this chapter, I further ask how we might understand the constitutive contradiction of making certain bodies hypervisible to state surveillance while simultaneously disembodying the violent consequences of global warfare. These killing abstractions have featured prominently in US wars in the global Asias across the long twentieth century. As postcolonial critic Nerissa Balce imparts regarding visual abjection in the imperial archive, histories of US warfare in the Philippines and Vietnam offer important lessons on how to

analyze the twenty-first-century resurgence of counterinsurgency doctrine in the Greater Middle East, which "requires the narration of an efficient and effective way of conducting war against combatants who look like ordinary citizens."[17] US global counterinsurgencies work by "waging war without humanizing enemy casualties, abstracting or erasing blood and bones by turning actual bodies into body counts and statistics, and emphasizing military victory over ethical or moral concerns."[18]

I engage the insurgent aesthetic and political practices of South Asian and Arab diasporic visual artists here and throughout this book to identify ethical practices and perceptual regimes that access these intimate and affective histories ("blood and bones") of those generally absented by abstract accounts of wartime violence, including "abject bodies [that] occupy the ragged edges of modernity that American imperialism cannot do without."[19] In the process, I offer a more extensive accounting of the centrality of sensory knowledge to torture and confinement—what elsewhere in this book I have termed a "queer calculus of the forever war"—that amplifies our account of late modern forms of security and empire. A focus on "warm data" now reorients our vision away from the deadening logics of militarized detention toward sensuous imaginings of security and freedom that are less circumscribed by the dominant sensorium of the security state. In making this case for alternatives through the realm of the aesthetic, however, I am not suggesting that diasporic visual cultures are somehow inherently resistant or effortlessly oppositional in the face of forever war. Indeed, in this chapter's final section, I assess through the language of trespass and betrayal the complex participation, incorporation, and collusion of diasporic and refugee subjects with projects of security and militarism. In so doing, I reveal how a post–9/11 insurgent aesthetics of warm data can provide a contradictory site of contestation that, as Grace Hong suggests, "express[es] that which is unspeakable"—an alternative way of sensing how empire's gendered-racialized Others resist and reiterate the governing logics of US forever warfare.[20]

Visible Collective's *Disappeared in America* (2004–2010)

I now begin a closer examination of insurgent aesthetics and efforts by multiethnic art collectives to conjure "warm data" in the aftermath of the events of September 11 by engaging key works of the Visible Collective. Comprising a diverse set of artists, activists, and lawyers led by Naeem Mohaiemen and Ibrahim Quraishi, the now-retired Visible Collective exhibited its work at

urban sites as diverse as Amsterdam, Belgrade, Seoul, London, Los Angeles, San Francisco, Zagreb, Delhi, Dhaka, and even New York City, at the 2006 Whitney Biennial, inside a subshow, "Down by Law," curated by Wrong Gallery (Massimiliano Gioni, Maurizio Cattelan, Ali Subotnick).[21] Their project's first iteration was curated by Jaishri Abichandani and Prerana Reddy as part of the 2005 Queens Museum of Art (QMA) group show titled "Fatal Love: South Asian American Art Now."[22] These exhibits ensured their reception as transnational art activists in global art markets even as that very system of networked connectivity became increasingly undermined by twenty-first-century state surveillance.[23] The Collective emerged alongside a constellation of other informal, overlapping creative collaborations in New York City, including Blue Triangle Network, 3rd i South Asian Film Collective, Youth Solidarity Summer, and the Mutiny club night started by Vivek Bald and DJ Rekha. Their concern about the limits of political rallies and direct organizing during the Bush II era, as well as a mounting frustration with the "'strangely silent" (about America's two overseas wars of that time) 2003–4 Whitney Biennial in New York, frames their insurgent aesthetic interventions. The Visible Collective received positive reviews in the *New York Times*, the *Village Voice*, *TimeOut* magazine, and various European presses for its collaborative film projects, soundscapes, photographs, objects, and audience interactions that together comprise their first traveling installation project, *Disappeared in America* (2004–10) (figure 3.1).

As its name suggests, the Visible Collective interrogated questions of visibility and invisibility in the context of the newly emergent global war on terror. They erected large-scale installation projects that referenced the "twinned conditions of invisibility ('shadow citizens who drive taxis, deliver food, clean tables, and sell fruit, coffee, and newspapers') and sudden, hyper-visibility in moments of crisis" that produced the racialized, gendered, and classed figure of the "Muslim" as visible target and existential national security threat.[24] In *American Gothic—Casual, Fresh American Style*, the Collective produced a series of translucent photographs styled to mimic the original Gap clothing advertisements by the same name (starring none other than the iconic white princess of neoliberalism herself, Sarah Jessica Parker, of *Sex and the City* fame). In the third site-specific iteration of this project in 2006 at Project Row Houses, an arts organization located in one of Houston's oldest African American neighborhoods, the artists installed jumbo photographic portraits of former Muslim detainees and their loved ones in the windows of the art space (which is, in fact, a series of repurposed row houses that encompass five city blocks and thirty-nine housing structures that serve as home base for a

FIG 3.1 Visible Collective (Naeem Mohaiemen, Ibrahim Quraishi, Vivek Bald, Aimara Lin, Anandaroop Roy, Sehban Zaidi, Anjali Malhotra, Donna Golden, Kristofer Dan-Bergmann, Toure Folkes, Aziz Huq, Sarah Olson, Uzma Rizvi, and Jee-Yun Ha), *American Gothic (Casual, Fresh, American Style)* series, *Disappeared in America*, 2002–7. Print installation, Brecht Forum, New York City, 2006. Reprinted with permission from Naeem Mohaiemen.

variety of community-enriching initiatives, art programs, and neighborhood development activities) (figure 3.2).[25] The Visible Collective's installation title *American Gothic* ironically references the famous 1930 modernist oil painting on beaverboard by artist Grant Wood, which is held in the collection of the Art Institute of Chicago. Wood's Depression-era depiction of an authentically American scene, featuring a white bespectacled farmer holding a pitchfork and standing beside a woman dressed in a colonial print apron, interpreted as his daughter or wife, has been widely parodied in American popular culture. By mimicking this tradition of modernist portraiture with large photographs of Muslim detainees and family members in this piece, the Visible Collective placed their works literally within the "home," or the domestic sphere, forcing its viewers to wrestle with the persistent "foreign in a domestic sense" in which Muslim immigrants are viewed in the US.[26] Shot in single studio settings, the images appear without text until one goes

FIG 3.2 Visible Collective, *American Gothic (Casual, Fresh, American Style)* series, *Disappeared in America*, 2002–7. Print installation, Project Row Houses, Houston, 2006. Reprinted with permission from Naeem Mohaiemen.

to a distant wall (in the first iteration at QMA) or to a row house interior (in the third iteration).

At the QMA exhibit, one portrait depicted Tariq Abdel-Muhti, the son of Palestinian activist and WBAI reporter Farouk Abdel-Muhti, who was detained from 2002 to 2004, was released after a widespread international campaign of protest, and subsequently died in July 2004 from a heart attack caused by health complications he had contracted while incarcerated (figure 3.3). Muhti's legal case offers a particularly fascinating glimpse into the capricious regulatory facets of the racist US immigration system. As a Palestinian born in the West Bank in 1947, he could not be deported from the United States, but as a "stateless" legal subject he was unable to obtain travel documents, given the present-day Israeli occupation of Palestine and the refusal of Israel to recognize the right of return for Palestinian refugees displaced by war. Muhti was released multiple times because of his unique juridical status, but one wonders why the US state persistently sought to detain him in the first place. Many have speculated that it was the result of his decades-long involvement with the Palestinian freedom movement as an activist and radio host.[27]

Another portrait features James Yee (a.k.a. Yusuf Lee), the well-profiled Chinese American Muslim US Army chaplain who was wrongly accused of spying at Guantánamo Bay and detained in solitary confinement for seventy-six days before the government eventually dropped all charges.[28] In another panel, a young bearded man, Mohammed Mohiuddin, is dressed in a long white kurta (figure 3.4).[29] The Bangladeshi native was in the US for medical treatment of a rare blood disease when he went through the required Special Registration process, discussed at length below. When the Collective first met him in 2004, Mohiuddin was fighting mandatory deportation proceedings in court. The lone woman profiled in the series is Shabnum Shahnaz, the daughter of Pakistani native Rani Shahnaz, who was similarly ensnarled by the detention and deportation process (figure 3.5). Visible Collective members explained the absence of more female figures in the project as a result of the challenges of finding a female detainee, or a female relative of a detainee, who was willing to participate. And yet, Shahnaz's embodied presence in the series forces the viewer to question more closely the gendered and sexualized dimensions of the US immigrant detention and deportation process.

This bold, if somber, photographic image series relays an ironic response to the Gap's niche marketing of Americana. Moreover, the Visible Collective's disidentificatory relation to *American Gothic* channels instead a composite of larger-than-life personalities—colorful police mug shots, perhaps—of the largely working-class and lower-middle-class immigrant sons and daughters of "Muslim" patriarchs lost and "wronged" by a broken immigration system. The Visible Collective used this installation project to explore the intimate relation between photography and the surveillance practices of the security state.[30] As with the work of many art activists who are interested in detention and deportation, including Rajkamal Kahlon and the Index of the Disappeared (both discussed later in this chapter), we see here an emphasis on the affective resonance of asylee testimonials—the "human casualties of the war on immigrants" made visible, quite literally, alongside heteronormative chronicles of "families torn apart" by a racist and increasingly authoritarian regime. As Jasbir Puar notes, the work displays the "quintessential use of personal testimony to incite outrage and dissidence."[31] While neither *casual* nor *fresh*, the stories rendered legible by this project are still entirely *American*.

Next, in *Driving While Black Becomes Flying While Brown*, the Visible Collective explores the tenuous cross-racial alliances and conflicting interests between African Americans and South Asian and Arab American communities. This piece presents a paper scroll of several repeated columns of tiny black-and-white mug shots—a photocopied scan that blurs from black

FIGS 3.3–3.5 Visible Collective, *American Gothic* (*Casual, Fresh, American Style*) series, *Disappeared in America*, 2002–7. Print installation, "Knock @ the Door," South Street Seaport, New York, 2006. Reprinted with permission from Naeem Mohaiemen.

to brown to white faces—but they are actually the same five mug shots (from people in an Oregon "cell" who were arrested; they are also featured in Visible Collective's film *Invisible Man*), photocopied until they fade into obscurity (figures 3.6–3.8). *Driving* ostensibly responds to changing targets of racial profiling and surveillance amid shifts from the "war on crime" to the "war on terror," from "wilding" to "person of interest," from the "Central Park Five" to "those nineteen hijackers," citing the changing local and national security paradigms of the US forever war discussed in chapter 1. In a pyramidal chart of the kind often displayed in lectures, the Visible Collective illustrated how the largest American Muslim population was African American, whereas the smallest was most often stereotyped as "Muslim." Art critic Susette Min also notices how the Collective's use of photocopying, as a "low-tech art practice," at once points to "the dematerialization of art in its very reproducibility and lack of originality" and also serves as "a metaphor for the dematerialization of hundreds of citizens and immigrants whose detention and expulsion from the United States since 9/11 has gone unnoticed."[32]

Throughout the Collective's work, there is an effort to draw out the centrality of African American Muslims and to critique their status as imagined prototypical "homegrown terrorist" threats in the forever war. For instance, we see a predominance of mostly male African American Muslim figures, especially in the Collective's photographic series of antidetention and Special Registration protests in New York City from the early 2000s, titled simply *Against Empire*. These photos visually complicate the seemingly discrete affective, racial, and religious boundaries that mark Black-brown relations and political affiliations. They gesture at the history of post–9/11 cross-racial alliances contesting US global state violence at home and abroad. These images further remind viewers of the robust historical presence of African-descended Muslim populations in the Americas since the antebellum era, when Black African Muslim captives were brought as slaves to what became the United States, thereby tethering their spiritual practice to a racial order from which Islam has yet to be disentangled.[33] As such, the Collective's representational practices respond to recent state conceptualizations of the figure of the "African American Muslim" as "homegrown terrorist threat," a gendered racial phantom that, as Sohail Daulatzai puts it, provides the "site of the literal and ideological unraveling of national unity . . . the figure that threatens the national coherence upon which the empire so tenuously rests."[34]

FIGS 3.6 – 3.8 Visible Collective, *Driving While Black Becomes Flying While Brown*, installation at "Peer Pleasure 2," Yerba Buena Center of Arts, San Francisco, 2006. Photocopy collage, ink on paper, 8 ft × 2 ft. Reprinted with permission from Naeem Mohaiemen.

Revised version of artist caption on *Driving While Black Becomes Flying While Brown*: "Wilding" in the lexicon as we hear of "savage wolf packs," "beasts in the park," "super predators" and the "full moon" enveloping the Central Park jogger. Pete Hamill whispered, "they were coming downtown from a land with no fathers." That hyper-racialized orphan beast is strangely absent from terrorphobia. Melanin supplemented by names, accents, and assimilation to understand if the wogs are here to roll an honest burrito or blow up the trade center. Our orphans don't fit because the deportation solution collapses. The sleeping ghosts no one wants to disturb are those of Robert Williams and Negros With Guns. "America is a house on fire. Freedom Now! Or let it burn, let it burn. Praise the Lord and pass the ammunition!" — a Christian god in those days, but still the volatile mix of righteous fury and black rage. Eldridge Cleaver's letter prefigures today's No Fly lists: "1) I was not to go outside a seven mile area; specifically, I was not to cross the Bay Bridge. 2) I was to keep my name out of the news for the next six months; specifically, my face was not to appear on any TV screen. 3) I was not to make any more speeches. 4) And I was not to write anything critical of the California Department of Corrections or any California politician. In short, I was to play dead, or I would be sent back to prison." Goldberg's confident thesis about the DC sniper's Al-Qaeda link suddenly under crisis—sniper turns out to be Muslim (good!) but also Black (not so good!) and Gulf War vet (terrible!). The largest group of Muslims are Black Americans (40%) followed by Deshis (24%) and Arabs (76% of Arab Americans are Christian or other religions). An inverted pyramid of the sum of our national fears.

ni' (Peter Brimelow, who also went for immigrants in 'Alien Nation'), 'super predators' and the 'full moon' effect Pete Hamill informed New York, ' They were coming downtown from a world of crack, welfare, guns, knives
, and a zsmile form as an indicator of whether the 'wogs' are here to kill an honest burro or blow up the world trade center Africa-n-Americans complicate the picture because the deporta tion solution validates Parallels i
a a nnunition' Eldrige Cleaver's 'severe new restrictions' evoke DHS 'no fly' lists '?) I was not to go outside a seven mile a rea: specifically, I was not to cross the Bay Bridge. 2) I was to keep my name out of the new
s play dead, or I would be sent back to prison' During the Washington DC sniper case, NRO Online editor Goldberg made confident predictions of Al-Qaeda cells ' This is part of the fall of ferisive, a long, with the attack
American Gulf War set African-Americans are 90% of the US Muslim population, and the fastest growing group among minor populations. Arabs by contrast are only 17% and South Asians 24% It is an inverted pyrami

One might wonder, however, whether *Driving*, while productively compli-
cating figurations of American Islam, also constructs a troublesome teleol-
ogy of the forms of disciplinary policing that define the current moment of
state racism and empire. In other words, *Driving While Black Becomes Flying
While Brown* subtly and somewhat problematically implies that the racial
state's post–9/11 targeting of "brown folks"—South Asian and Arab Mus-
lims, in particular—at cosmopolitan spaces of transit, such as airports and
checkpoints, has replaced or somehow supplanted its centuries-long and on-
going terrorization of African Americans.[35] Puar sharply assesses this prob-
lematic analysis of the racial state and of Black-brown political relationalities
after 9/11:

> The most recent manifestation of this fissuring occurred after Septem-
> ber 11th, 2001, when policing resources (in New York City to an ex-
> treme but also nationally) purportedly shifted from black neighbor-
> hoods, establishments, families, churches, and bodies to South Asian,
> Arab American, and Muslim temples, mosques and *gurudwaras*, stores,
> and religious and community associations. Such securitization mea-
> sures have taxed the long-standing animosity between the two "groups"
> fueled by differential treatment and access to jobs and state resources
> based on citizenship privileges as well as racist hostility perpetuated by
> South Asians, for whom racism towards Blacks and Latinos has long
> been a rite of passage into model minoritization citizenship. This rite of
> passage is complemented by disinterest in the economic disenfranchise-
> ment and the struggles against police brutality of African American
> communities.[36]

Puar rightly underscores the social antagonisms and perceived transfor-
mations in racial security and carceral paradigms that unevenly affect ra-
cialized communities of color and have, in fact, disproportionately intensi-
fied against African American and Latinx communities in the US/North
America.[37] The state is undoubtedly actively involved in manufacturing
and fomenting these "long-standing" animosities between seemingly dis-
tinct communities of color, which prevent multiethnic and racial/religious
coalitions from critiquing (so as to transform) the differential distribu-
tion of wealth, resources, and life chances of Black and brown majorities in
the US.

We can complicate Puar's assessment, however, by drawing attention
to emergent multiracial and cross-class political actions in urban centers
across the US over the past two decades. These actions contest cases of lo-

cal police violence, surveillance, and spying practices, as well as a range of other domestic state protocols. As I argue throughout this book, these instances scramble older racial identifications and inherited antagonisms to create terrain for thinking the queer calculus of the forever war and its anti-identitarian assemblages and for theorizing anew seemingly unlikely cross-racial alliances. For instance, a more generous reading of the Collective's intention might foreground their interest in relationally juxtaposing "ghost prisoners" to signify the haunted and unresolved excesses of empire. In this light, the artists make visible the links between current racialized security panics and related historical conjunctures. They do so specifically by invoking, without flattening out, the historical and geographical specificities of events such as the 1919 detention of 10,000 immigrants after anarchists bombed the attorney general's home; the 1941 internment of 110,000 Japanese Americans; the trial and execution of the Rosenbergs; and the blacklist hearings under Senator Joseph McCarthy.[38] This cross-racial genealogy of security panics across the long twentieth century grafts the post–9/11 detention and deportation of "Muslim terrorists" onto past securitized "witch hunts" for political outsiders and gendered racialized Others that comprise the long history of invasion, settlement, and military occupation that culminated in the creation of the United States.[39]

The Visible Collective further explores these present-day pogroms in *NaHnu Wahaad, but Really Are We One?* (We Are One, but Really Are We One?) (figures 3.9–3.12). Here, the Collective offers a beautiful, disidentificatory response to the performative afterlife of the Immigration and Naturalization Service (INS) Special Registration "list" mentioned earlier. As has been well documented by civil liberties activists and scholars, thousands of Muslims in the US were detained, deported, and monitored in the immediate aftermath of 9/11.[40] South Asian and Arab Muslims continue to withstand the worst of ongoing practices such as unwarranted arrests, special registration, police raids, FBI interrogations, profiling at airports, and unlawful detention and deportation, as racialized and colonized notions of "terrorism" have become affixed to Islam and Muslims. It is important to reiterate the conflation of ethnic, racial, national, and religious forms of difference under the sign of "Muslim" both before and after 9/11. These profiling regimes were not used solely against "Muslims"—whatever that term means in the forever war. All sorts of unlikely "terrorist look-alike" populations have been detained and deported under the guise of national security and have faced substantial amounts of interpersonal "hate crime" violence as well. The artworks and insurgent aesthetics under consideration here illuminate how

FIGS 3.9–3.10 Visible Collective, *NaHnu Wahaad, but Really Are We One? Disappeared in America*, 2002–7, mixed media installation, University of California, Irvine Art Gallery, 2006. Reprinted with permission from Naeem Mohaiemen.

FIG 3.11 Visible Collective, *Patriot Story*, digital video, Whitney Biennial, New York, 2006. Reprinted with permission from Naeem Mohaiemen.

FIG 3.12 Visible Collective, *It's Safe To Open Your Eyes Now, Part 3*, mixed media, shredded Abu Ghraib photographs, Project Row Houses, Houston, 2006. Reprinted with permission from Naeem Mohaiemen.

commonsense categories of group identification (e.g., "Black," "South Asian," "Arab," and "Muslim") begin to loosen under the racializing and counterinsurgent practices of the surveillance state. I seek throughout to mine these incoherences and complexities, as well as the creative and contradictory ways artists and activists capture complex modes of relationality and alliance that can challenge state violence.[41]

The short-lived INS Special Registration program, formulated in the seemingly endless post–9/11 "state of exception" that I call the forever war, offers a compelling glimpse into the racialized disciplinary crackdown perpetuated by US homeland security policies. The policy refers to the now infamous "call-in" portion of the National Security Entry-Exit Registration System (NSEERS), a program of the Bureau of Citizenship and Immigration Services (formerly one component of INS) for tracking border entries and exits. Although NSEERS was intended as a program for tracking newcomers to the country, it was applied widely to people and communities that were already present within the United States. Under the policy, between November 2002 and April 2003, the Bush administration required men and boys over age sixteen from twenty-five countries to report to immigration offices for fingerprinting, photographing, and interrogation under oath. Those who failed to report faced arrest, detention, or deportation. The targeted men and boys all came from predominantly Muslim countries in Asia and Africa, except, tellingly, North Korea, which famously composed part of President Bush's "axis of evil" (along with Iraq and Iran)—regimes accused of sponsoring terrorism and seeking weapons of mass destruction. The Bush administration did not inform potential registrants that registration would often lead to arrest, detention, or deportation, mainly for minor immigration violations that might have been ignored in other circumstances. The Bush administration reported that by as early as May 11, 2003, it had collected information on 82,581 people, with at least 3,153 of them in deportation hearings— and many of whom were denied contact with their loved ones or legal representation and thus, quite literally, were "disappeared" by the state.[42] The effects of this dehumanizing policy were felt far beyond the walls of INS detention centers. What Puar calls the "sliding between *indefinite* and *infinite* detention" had chilling effects in immigrant and Muslim-majority neighborhoods across the country, with hundreds of immigrants and citizens fleeing to Canada, Europe, and Asia as part of a newly produced "US diaspora" that has only intensified in the nearly two decades since 9/11.[43]

Scholars of race and immigration have pointed out that forms of racist legal control used in the Bush era have a robust legacy in US immigration

law; indeed, they are constitutive of the national security state in the long twentieth century. Historian Mae Ngai, for instance, examines how legal governance produced the "impossible subject" of the illegal alien during the period of immigration restriction (1924–65).[44] She traces a genealogy of the "illegal alien" in US law and society, explaining why illegal migration became the central problem for US immigration policy, dramatically shaping twentieth-century racialized citizenship and state governance. Immigration (and immigrant policing) was clearly central to the US's emergence in the international world order well before the events of 9/11. Ngai names the law as a "race-making" regime that has continually shifted the bounds of citizenship over time. Immigration law became a central governance tactic, a racial engineering instrument that constructed legal and political subjects deemed fit for national belonging and inclusion. By analyzing the incipient "hardening of borders," including proliferating networks of immigration laws, surveillance, and transnational policing, Ngai sees the nation-state itself emerge as the central administrative legal category in the twentieth century.[45]

Twentieth-century selective immigration profiling reveals the centrality of race to the US nation-state, and this fact continues to hold true well into the twenty-first century. Such practices of coding and aggregating populations further expose what Inderpal Grewal calls the myth of the "privilege of transnational identification," that is, the ability of immigrant and diasporic subjects to sustain political and economic ties to multiple sites of belonging and social reproduction that are not American and are not fully subject to US sovereignty.[46] The Special Registration program was implicated in the forcible detention and deportation of hundreds of immigrant Muslim men—disappearing large masses from majority Muslim neighborhoods like Midwood, Brooklyn, and Jackson Heights, Queens.[47] Puar traces how the government program functioned as a conduit between the disciplinary containment that Michel Foucault theorized and the regimes of control Gilles Deleuze conceptualized. She argues that "the list" proved to be more efficacious than direct policing: "The vacating of entire predominantly Muslim neighborhoods in Brooklyn and other cities suggests that the means of control bleed far beyond the disciplinary apparatus of the prison. That is, the affects of detention are mimicked in public spheres."[48] I would extend Puar's compelling observation to argue that the "list" functioned both as a disciplinary tool of the state (racially targeting whole neighborhoods, detaining and deporting "Muslim" bodies) and as a policing strategy that dictated the docility of the greater populace because now any *body* can be read as a suspected "terrorist" body. This gestures at the list's performative afterlife—an

idea that is illuminated by insurgent aesthetic responses to racist immigration protocols of the forever war.

Finally, in considering the affective aftermath of the Visible Collective's interventions from the early years after 9/11, I want to linger on one additional element in their *Against Empire* photographic series (photographs of rallies taken by Fred Askew, Mohaiemen, and others): an image of a woman in chador[49] holding up a placard on which is written in bold black ink: "I WILL NOT REGISTER." This image conjures contemporary Muslim American protests against racism and signals the widespread harassment and abuse faced by Muslim American women in particular, especially those who wear the hijab.[50] The Visible Collective's photographs highlight the centrality of immigrant Muslim women as organizers in antidetention activist campaigns in New York City and across the country, often speaking on behalf of their "disappeared husbands, sons, fathers, and brothers."[51] The image of the female protestor further points to the ruptures in transnational heterosexual kinship formations because of the post–9/11 detention praxis: "Muslim men—brothers, husbands, fathers, uncles, grandfathers—are disappeared, vanishing from work, while going to pick up groceries, from their homes in the middle of the night."[52] Several scholars have observed that one of the consequences of detention and deportation is changing nuclear heterosexual and extended kinship patterns for immigrant families, which immigration law produce as always already heteronormative. As Puar contends, "heteronormativity is out of reach, literally disallowed by the state, utterly untenable for these families . . . these practices [make] heterosexuality a mandate while making heteronormativity impossible."[53] Finally, the image calls attention to how the intense focus on these kinds of state violences, disproportionately imposed on cisgender male bodies, similarly elides the forms of violence that (cis and trans, nonbinary, and gender nonconforming) immigrant mothers, wives, daughters, sisters, and lovers often experience—specifically the unseen, nonbodily effects.[54] These are evidence of "other wounds" that dominant visualities likewise fail to capture.

The work of the Visible Collective exposes the political and cultural casualties of the domestic forever war—gendered and racialized citizenship and constitutional rights being some of the most visible sites under siege. Yet, beyond what its name suggests, the Collective's work extended deeper into the psychology of US racism and xenophobia, thereby rendering legible that which cannot be seen, that which is made invisible by the state or perhaps even unintelligible to the super-panoptic frame of US homeland security surveillance. Its artworks collectively provide empirical grounds

for an alternative analysis of the gendered and sexualized underpinnings of detention and deportation practices, the shifting dynamics of racial profiling that differentially implicate various communities of color, and a genealogical account of the vagaries of asylum and immigration law. *Disappeared in America* generates a queer calculus that uncovers the multiple affective resonances and long-submerged histories that mark contemporary surveillance and legal regimes. The insurgent aesthetics of the Visible Collective thus proposes an alternative system of proofing or knowing the disappeared, one that allows us to move beyond surface modes of visual recognition that are overdetermined in controlling discourses of surveillance and security, a concept I elaborate further in the following sections.

Sensing Security: Index of the Disappeared's *Warm Database* (2004–Present)

We can continue to explore these questions of representation, knowledge, and violence in the forever war through the ongoing collaboration between Brooklyn-based artists Mariam Ghani and Chitra Ganesh and their web project *How Do You See the Disappeared? A Warm Database.*[55] Ghani is of mixed Afghan and Lebanese parentage, and Ganesh is the child of Indian immigrants.[56] Both have produced successful solo artistic careers and works that circulate across North America, Europe, Asia, and the Middle East. Since 2004, this duo has worked on the Index of the Disappeared, which they describe as both a material archive of post–9/11 disappearance and a platform for public dialogue and digital exploration. As scholar-activists, they have garnered praise for how they convene a diverse cross section of activists, artists, critics, and lawyers to explore a range of issues related to and consequences of US military and intelligence interventions in the forever war. Ganesh and Ghani have used these dialogues to translate the materials into visual elements installed in various physical and virtual spaces, including galleries, museums, universities, community centers, libraries, conferences, magazines, books, windows, streets, malls, and the internet.[57] More recent commissions include mixed-media visual art works on surveillance, the US prison camp at Guantánamo Bay, codes of conduct from the Army Field Manual and Geneva Conventions, "detention bed mandates" under the Obama administration, and the afterlives of "black sites."[58] These projects have been installed at diverse venues such as NYU, the Park Avenue Armory for Creative Time's "Democracy Now" exhibition, Franklin Street Works, and the Schell Center for International Human Rights at Yale Law School.

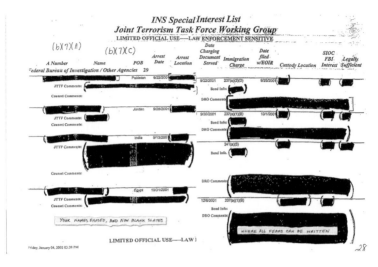

FIG 3.13 *Index of the Disappeared*, Special Registration Form, 2004. Courtesy of the artists (Mariam Ghani and Chitra Ganesh).

As critics of the US military's Human Terrain System (HTS), Ghani and Ganesh understand well the intimate role of information, secrecy, and intelligence gathering to imperial and military bureaucracies. As discussed in chapter 1, the HTS program was run by the US Army Training and Doctrine Command, in an effort to counteract the intelligence communities' perceived inadequate cultural and historical knowledge and cultural-interpretive capabilities in counterinsurgency operations in the Global South.[59] In contrast, and as part of the Index's first set of works, the artists constructed a "Warm Database," a digital archive thoroughly saturated in the economy of senses that attempts to challenge the demand for the quantifiable that is the hallmark of traditional military and legal knowledge (figure 3.13). Art is a medium with so much power that even in domains of the law (which are devoted to reasoning and analytics, judgment and justice), the language of art can provide a noninstrumental relation to subjects dispossessed by the law. Ghani recounts the impetus for their creative work in the immediate aftermath of 9/11:

> I watched as immigrant men from "terror watch list" countries came forward to wait in long, cold lines for days, only to be asked long lists of dehumanizing questions, then often remanded to custody overnight and asked them again, and again, before being detained or deported away from their families. I read the 1996 immigration laws, the Patriot

[*sic*] Act, reports and legal briefs, and discovered the traps built by the language of the law: reactions that become terms that become classifications that enclose and exclude. I found the post–9/11 documents full of absences—redactions, erasures, censorships—that were paralleled by the absences visible in every immigrant community in the city, as midnight raids spread from neighborhood to neighborhood. . . . In my studio, I had pinned up on the wall a copy of the list of special interest detainees. . . . I was worrying over the question of how to fill in those blank spaces where first their names, and then their real lives and family ties, had been erased. How could I "give a face" to this issue, as immigrant rights advocates were telling me was necessary, when I wasn't allowed to see or speak to the people I wanted to portray? The impossible trick would have to be creating a portrait of someone that would restore their humanity while maintaining their all-important anonymity—whether legally mandated, as in the case of the special interest detainees, or dictated by fear of losing status or social stigma with former detainees and deportees.[60]

Central to Ghani's reflections is the art activist impulse to render visible and coherent that which the state systematically disappeared and destroyed—the "impossible trick to restore their humanity."[61] Her affective relation to immigrant men being interrogated, detained, and deported compelled her research on legal policies and practices that systematically disappear community members. She created the warm data questionnaire after reading actual government registration questions and in consultation with immigration lawyers, activists, and former detainees. The Index of the Disappeared attempted to disidentify with the very frameworks of state recognition and the systematic apparatus of coercion and captivity that, according to Laleh Khalili, "rests to a great degree on the extent to which it can be represented as benign, legal, and legitimate."[62]

Questions on the Index database include things such as, "Who was the first person you ever fell in love with?"; "What is your earliest childhood memory?"; and "Name a piece of music that is always running through your head." The form was left open-ended and free to subjective interpretation. Unlike federal governmental tabulations, the Index's questionnaire delinked the descriptive categories usually aligned with visual evidence (e.g., face, age, sex, status, and other bioinformatics) and proposed instead an alternative system of knowing the disappeared to resist those identificatory surveillance procedures (figure 3.14). This aesthetic strategy is significant to my broader

FIG 3.14 *Index of the Disappeared: Codes of Conduct*, site-specific installation (slideshow, sound loop, documents, shredded documents, office supplies; dimensions variable) at the Park Avenue Armory for Creative Time's "Democracy in America," 2008. Photo: Meghan McInnis. Courtesy of the artists.

analysis of warm data and insurgent aesthetics, given how the state relies on bioinformatics to survey populations within the US and globally. By contrast, Ghani and Ganesh's feminist system of knowing the disappeared conjures warmth by foregrounding the intimate, the minor, and the everyday, and it is not predicated on turning those memories into "actionable" intelligence. In fact, this project calls attention to the very impossibility of recovery and representation—when the very assembly and organization of dominant archives work to occlude or exclude certain historical subjects. Nevertheless, in light of the HTS program, and at this point in the life of Big Data and the enduring domestic racialized surveillance of Muslims, with its increased focus on predictive policing and algorithmic criminology, it is conceivable that answers to the seemingly benign questions in the Index's "Warm Database" may well also be actionable, whether linked to concrete detainees or not.[63] In this way, we can see how, even in the politicized artists' effort to create an alternative epistemological and affective relation to those targeted by the US forever war, the Index both capitulates to and reorganizes the surveillance state's rapidly evolving technological quest for data and information.

FIG 3.15 *Index of the Disappeared: Parasitic Archive* (vinyl cling, 66 in. × 35 in.), installed at NYU's Kevorkian Center, 2014. Courtesy of the artists (Mariam Ghani and Chitra Ganesh).

Ghani and Ganesh's use of redacted government documents (figure 3.13) serves as an emblem of the contemporary period's absence of a viable official record (figure 3.15). The Index's counterarchival "warm database" is in conversation with other activists and cultural producers who are interested in US global military logics of carcerality and disappearance. For example, the conceptual artist and geographer Trevor Paglen notes how the contemporary United States has witnessed an "almost uninterrupted growth of a secret 'state within the state.'"[64] He contends that this "secret state" is far more insidious than just a collection of bureaucratic politics and procedures: "Its constitutive economic, legal, social and spatial dynamics constitute a 'geography' of secrecy . . . rife with ever increasing numbers of internal contradictions whose continual management requires the secret state to continually expand."[65] Paglen's conceptual work brings attention to the transformations of and attacks on open democracy by creating a "geography of the classified universe, a circumnavigation of the blackworld."[66] The Index likewise elucidates the role of this redacted "blackworld" in repressing the violences and incoherences of the security state, and it summons the strained echoes, audible traces, and intimate histories of people and places abstracted by these neoliberal racial regimes of security. As historian Anjali Arondekar notes in

her treatment of the British colonial archive's construction of Indian sexuality, "far from being exterior to the archive, the fact of re-presenting absence becomes the very condition of possibility for our archival returns."[67] The Index's "Warm Database" is thus saturated in the economy of the senses, demonstrating how sensory processes are crucial to diasporic interventions and their mode of "re-presenting absence."

The Index's haptic and sensorial elements are perhaps most apparent in their use of the adjective "warm":

> Warm data is easiest to define in opposition to what it is not: warm data is the opposite of cold, hard facts. Warm data is subjective; it cannot be proved or disproved, and it can never be held against you in a court of law. Warm data is specific and personal, never abstract. Warm databases are public, not secret. However, warm data can only be collected voluntarily, not by force; the respondent always has a choice—whether to answer or not, which questions to answer, on what terms she will answer, and if her answers will be anonymous. A warm database is distinguished from a corporate or government database not primarily by its interface or its underlying structure, but by the way its data is collected.[68]

The "Warm Database" offers an alternative form of knowledge about intensified states of security and surveillance (figures 3.16–3.20). Its emphasis on haptic dimensions of heat, energy, and warmth in proliferating records of detention, interrogation, and confinement tries to circumvent the prevailing "cold" regimes of surveillance. Ghani and Ganesh see their work as intervening in the "repeating codes and languages" found in mainstream documentaries about detention and deportation, including the use of testimony, statistics, and expert witnesses. These practices mirror criminal legal courtroom dynamics and "pundit-driven rhythms of network news."[69] To legitimize their mode of address to governments, media, and international agencies, human rights organizations often rely on liberal humanist strategies that emphasize visibility as a form of empowerment and inclusion, and in the process, they downplay what Avery Gordon calls "the ambiguity, complicity, imagination, and surreality that necessarily characterize the theater of terror."[70] Departing from these overriding aesthetic choices, the Index instead proposes a novel system of knowing and sensing the disappeared (see plate 13).

In addition to rejecting these human rights documentary conventions, Ghani and Ganesh also often refuse figurative and mimetic representations in their projects (figures 3.21–3.24). As art historian Abigail Solomon-Godeau

FIG 3.16 *Index of the Disappeared: Missing* (watercolors; dimensions variable), installed at White Box, New York, 2004. Courtesy of the artists (Mariam Ghani and Chitra Ganesh).

FIG 3.17 *Index of the Disappeared: Missing,* watercolor image of Mr. Akbar, installed at White Box, New York, 2004. Courtesy of Chitra Ganesh.

FIG 3.18 *Index of the Disappeared: Missing*, watercolor image of Berna Cruz, installed at White Box, New York, 2004. Courtesy of Chitra Ganesh.

FIG 3.19 *Index of the Disappeared: Missing*, watercolor image of Maya Nand, installed at White Box, New York, 2004. Courtesy of Chitra Ganesh.

FIG 3.20 *Index of the Disappeared: Missing*, watercolor image of Suleiman Abdullah, installed at White Box, New York, 2004. Courtesy of Chitra Ganesh.

puts it, "this refusal of the image avoids the risk of reiterating either the sensationalism or the spectacle-like aspects of the Abu Ghraib visual archive, and it includes the sorts of information, history, and context that images alone cannot provide."[71] Rather than reproducing endless "pornotropic" depictions of detainees being interrogated, tortured, and disappeared, as in the Abu Ghraib abuse photographs, the Index's text-heavy images are distinguished by a poetic visual language "to escape from the expected," where memory, myth, privacy, and security combine to critique and befuddle the various technological surveillance regimes defining our collective present.[72] Their project functions as an index not only for its archival relation to primary source documents, but also, as Ganesh and Ghani note, "because it extracts, transposes, and re-visualizes the fragments from those documents which can serve as indices of another kind . . . as traces of the individual voices and stories, which otherwise disappear into the sea of data."[73] This avant-garde shift toward reassemblage allows the artists to disidentify with the callous and numbing quality of quantitative modes of knowing confinement. Thus they reanimate the redactions and erasures of official archives to

FIG 3.21 *Index of the Disappeared: Watch This Space*, window installation (vinyl cling, vinyl lettering, banner prints, barbed wire, video loop, drawings, posters) at NYU Kimmel Center, 2014. Detail: window based on a Muslim Student Association poster. Courtesy of the artists (Mariam Ghani and Chitra Ganesh).

FIG 3.22 Detail of *Index of the Disappeared: Watch This Space*, window installation (vinyl cling, vinyl lettering, banner prints, barbed wire, video loop, drawings, posters) at NYU Kimmel Center, 2014. Courtesy of the artists (Mariam Ghani and Chitra Ganesh).

FIG 3.23 *Index of the Disappeared: Parasitic Archive* (vinyl cling, vinyl lettering, library books, document binders, videos) at the downtown Buffalo Public Library for CEPA Gallery's *Art of War*, 2010. Photo: Lauren Tent. Courtesy of the artists (Mariam Ghani and Chitra Ganesh).

FIG 3.24 *Index of the Disappeared: We Will Not Be Silent/Your Silence Will Not Protect You*, window installation (LED lights, corrugated plastic; 24 in. × 288 in.) at the Abrons Art Center, New York, New York, for *Archival Alchemy*, 2017. Courtesy of the artists (Mariam Ghani and Chitra Ganesh).

produce an alternative repository of poetic knowledge about the "blood and bones" of the forever war.

Exposing Empire's Innards: Rajkamal Kahlon's
Did You Kiss the Dead Body? (2009–2012)

The complex affective relation between aesthetic and legal reasoning present in the Index's "Warm Database" resonates with the creative work of Berlin-based Indian American visual artist and painter Rajkamal Kahlon. In 2012, Kahlon served as the first ever artist-in-residence at the ACLU's National Security Project (NSP) in New York City.[74] The NSP has legally challenged policies of the Bush, Obama, and Trump administrations, including torture, unlawful detention, targeted drone killings, kidnapping and rendition by the CIA, and arbitrary no-fly lists. The NSP filed a Freedom of Information Act (FOIA) request and subsequent litigation that led to the release of over 100,000 pages of redacted documents that came to be known as the Torture FOIA. The Torture FOIA, like the declassified US Senate CIA Torture Report itself, details how CIA "enhanced interrogation" practices of torture on detainees included waterboarding, mock execution, sexual abuse, confinement of prisoners in coffin-like boxes for days on end, beatings, psychological torture, and rectal force-feeding.[75] Within this massive archive of documents is a collection of US military death certificates and autopsy reports for Iraqi and Afghan men killed while in US detention facilities. Kahlon uses these declassified military documents, and the representations of torture, memory, and pain that they evoke, in her installation *Did You Kiss the Dead Body?* (2009–12).[76]

Did You Kiss the Dead Body? comprises a series of black ink anatomical drawings on red marbled autopsy texts, sculptures that draw on the tradition of medical wax castings of the body, and site-specific installations incorporating sound, sculpture, and found objects (figures 3.25–3.27).[77] The drawings, which Kahlon transposed, are culled from European anatomical textbooks and are often surgical in nature. These images reference Medieval-era torture and punishment, visual histories of phrenology and physiognomy, and other pseudoscientific racial projects that, as communications scholar Rachel Hall suggests, are "motivated by a popular desire to classify bodies according to visual appearance."[78] Kahlon's images conjure "warm data" in archives of US military autopsy and detention records by depicting graphic views of the inner and outer body, often distended, manipulated, radiographed, or oth-

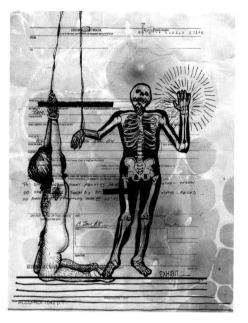

FIGS 3.25 – 3.27 Detail from Rajkamal Kahlon, *Did You Kiss the Dead Body?*, ink on marbled autopsy report, 8½ in. × 11 in., 2009–12. Courtesy of Rajkamal Kahlon.

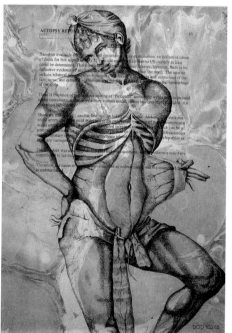

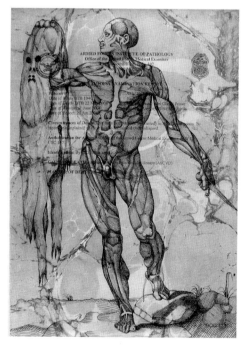

erwise grotesquely displayed. In light of more contemporary visual archives, the drawings call up the medical examinations of deposed Iraqi leader Saddam Hussein when videos and images of his capture and interrogation were widely circulated by the international news media in December 2003. The popular images of Hussein's body being pulled out of a "black hole in the ground" and later scrutinized by US military operatives under the global media gaze captures both the "hypervisibility of surveillance technologies" and the "mundane visibility of mainstream war coverage."[79]

Kahlon's grotesque and pathological images provide a useful counterpoint for understanding the proliferation throughout the forever war of biometric surveillance practices as what Hall calls an "aesthetic of transparency." Recent surveillance studies scholarship has spotlighted the role of biometric identification in US militarized information systems that seek to make enemy bodies both visible and knowable.[80] These scholars build on work that highlights the elements of statecraft and governance involved in measuring, classifying, and controlling the movements of colonized and racialized populations.[81] As historical anthropologist Ann Stoler explains, this emphasis on precision and rationality tracks the "forms of knowledge collection that epitomized state commitments to large-scale rationalized reform based on predictive and comprehensive scientific knowledge."[82] Following Hall, an "aesthetic of transparency" involves efforts by the state to "force a correspondence between interiority and exteriority on the objects of the panoptic gaze or better yet, turn the object of surveillance inside out, thereby doing away with the problem of correspondence altogether."[83] In this way, we see how interrogation (focused on the agentive, consenting voice) and biometrics (focused on the unagentive, nonconsenting body) work in tandem to advance the current carceral modes of surveillance that define the forever war.

Like the Index's "Warm Database," *Did You Kiss* affectively conjures and reorients legacies of surveillance, torture, and confinement (see plates 14–18). The piece poetically witnesses overlapping histories of racialized and Indigenous bodies being turned into information and code for imperial and colonial knowledge-making regimes. Kahlon's drawings literally depict the body turned inside out—organs distended, mouths opened, forks slicing bare the innards of throats, stomachs, and intestinal walls. When viewing these works, we might ask, what "intel" is being gathered here? What "truths" can be acquired from such miserable operations? An account of forever war surveillance and counterintelligence tactics would suggest that "truth comes to reside not in the behavior or speech of [suspected 'terrorist'] bodies . . . [but

rather] truth is to be found in the information encoded in iris scans and digital fingerprints, thereby doing away with the problem of the global citizen's agency altogether."[84] If, as Hall notes further, the US military's conceptualization of "truth" rests in the relation "between the scanned individual and the information held in US databases," then Kahlon's drawings highlight the disembodying effects of forever war interrogations and detentions in which "enemy" bodies are disassembled into "actionable" parts.[85]

Kahlon's work importantly articulates the connections between normalized detentions, deportations, and disappearances on the US domestic front and within the global military prison archipelago. Anne McClintock has characterized this violent international formation as a "shadowy, global gulag of secret interrogation prisons, 'black sites,' torture ships, and off-shore internment camps now known to straddle the world."[86] Sohail Daulatzai further observes how "the racialized figure of the Muslim and its multiple iterations haunts the geographic and imaginative spaces of American empire" on both domestic and global fronts.[87] *Did You Kiss* effectively captures these unlikely intimacies. By repurposing European anatomical illustrations, Kahlon conjures warmth in the Torture FOIA archive, historicizing the official record by drawing out the continuities between the official record of the forever war and European colonial scientific legacies throughout the Global South. Her collages make explicit the proximities between redacted documents of contemporary US military detention and brutal histories of European imperial rule. Indeed, imperial states' social control of suspect bodies through coercive visual techniques such as biometrics is not a new phenomenon. Colonial regimes have an extensive biopolitical history of making vulnerable bodies intelligible, both individually and in aggregate, in the form of birth certificates, passports, and medical records.[88] We can think alongside Kahlon's work, however, to advance our understanding of how the body's biopolitical information and sensory states have become newly crucial to US warfare. Moreover, in its varied colonial laboratories of occupied Iraq, Af-Pak, Palestine, and elsewhere, the US has innovated new technological information and security regimes that have important consequences for the future of US global power and the evolving biopolitical relation between citizens and the security state.

At US global military detention centers, officials attempt to make "enemy" bodies transparent, as the Torture FOIA archive reveals through autopsy reports and death certificates from US military bases and prisons in Iraq and Afghanistan. As a radical interdisciplinary archivist, Kahlon transforms this redacted information into "warm data" to intervene in the dominant cal-

culus of the forever war. Her aesthetic incorporation of redaction itself is telling. The redacted document stands in for an official record. To protect so-called sensitive or classified information, government officials often edit or modify large sections of leaked documents. What are left are large blocks of black ink over text. In the context of recent data drops, WikiLeaks, torture memos, and documents authorizing waterboarding and other brutalities of terrorism investigations and interrogations of war, the redacted document itself indexes the state's compulsive investment in the accumulation of information and data in war-making, and its failed desire to erase the evidence of these traces. In theorizing the social life of the forever war's documentary archive, we note how these memos often *predate* the actual staging and event of torture and violence itself. Of special concern here is the proleptic nature of the violence that the record not only represents but also makes possible and secures. We must recall that these documents, though disembodied, are produced by human actors who craft, type, initial, and photocopy them. The marks we often see on these photocopied and crudely redacted documents are "indices of the various hands and bureaucratic processes the documents go through before they are released."[89] As Solomon-Godeau notes, "the history of a document's redactions is visible on its surface."[90] In short, these secret documents, complete with their archival traces and "epistemic anxieties," are thus conditions of possibility for the forever war's violence.[91]

Kahlon's diasporic social location adds another important twist to her insurgent aesthetic practice. As an American artist living in Berlin, Kahlon became interested in Landstuhl, Germany, which is home to the largest US medical center outside the United States. Founded in the 1950s, Landstuhl Regional Medical Center (LRMC) serves as the first treatment center out of Iraq and Afghanistan for wounded and dead US soldiers. LRMC is where, according to Kahlon, "dead American bodies are put back together and beautified before being sent home to their families," and where autopsy notations for Iraqi and Afghan detainees who have died in US custody are compiled into standardized US military autopsy reports.[92] Kahlon notes how these reports marshal a "rational scientific language to catalogue the internal and external details of the men's bodies while attempting to determine a cause of death, ranging from 'natural' to 'undetermined' to 'suicide.'"[93] Her research at the NSP reveals that twenty-one of forty-four documented Iraqi and Afghan deaths were homicides, eight of which "appear to have resulted from abusive techniques used on detainees, in some instances, by the CIA, Navy SEALS, and Military Intelligence personnel. The autopsy reports list deaths by 'strangulation,' 'asphyxiation' and 'blunt force injuries.'"[94] An overwhelm-

ing majority of the so-called natural deaths are attributed to arteriosclerotic cardiovascular disease, which means these detainees likely suffered fatal heart attacks during their detentions. These documents, which induce for Kahlon "a cocktail effect of nausea, sadness, and rage," provide undeniable evidence that US interrogations at various military bases and global "black sites" have resulted in injuries and deaths.[95]

Furthermore, the anonymity of detainees killed in captivity, and the efforts by the ACLU and the wider human rights community to piece together fragments of their lives from these redacted documents, speaks to the structuring logics of political disappearance itself. As Avery Gordon elaborates in her account of the roughly thirty thousand people who were disappeared by Argentina's military government of 1976–83, "a key aspect of state-sponsored disappearance is precisely the elaborate suppression and elimination of what conventionally constitutes the proof of someone's whereabouts. The disappeared have lost all social and political identity: no bureaucratic records, no funerals, no memorials, no bodies, nobody."[96] The aesthetic and political rejoinders to twentieth-century Latin American regimes and their "dirty wars" of state-sponsored disappearance are a formative historical source and inspiration for the works under review here.[97] However, in the case of anonymous Afghan and Iraqi men killed in US military captivity after 9/11, certain bureaucratic records often *do* exist in the form of autopsy reports and related documentation. Kahlon's *Did You Kiss the Dead Body?* thus constitutes a reparative form of "warm data" by aesthetically reassessing this horrifying, if utterly austere, archive of US military human rights abuses. I call this archive "austere" because the Torture FOIA is, in the main, profoundly tedious and mundane. Pages upon pages document administrative procedures in formulaic cadences, and even the most horrific events are abridged in penetratingly cold detail. The detached form of the archive performs the perpetuity of wartime violence. There is a numbing effect at work that resonates with other technologies of the racial state and other perpetual wars, including the war on crime, where fingerprinting and police reports comprise most of the mundane archive,[98] as well as North American Indian wars where, as Sherene H. Razack argues, state-sponsored attacks on Indigenous peoples reveal "the annihilative impulse that is the beating heart of modern life."[99] The sheer volume of these imperial documents works like an opiate, a tidal wave of cold data, anesthetizing us to the eviscerating violence glossed within its pages.

By contrast, Kahlon infuses warmth into her drawings by queerly "kissing" the dead bodies in these autopsy reports. She invites us to come up

close, brush warm lips across cold flesh, and exchange intimate heat, sweat, and breath to revive the (data) body and make it warm again. Kahlon's abject images and aesthetic practice together reject what Nerissa Balce calls the "deadly yet sanitized manner" in which US counterinsurgencies attempt to operate, revealing instead "the dark legacies, the detritus, the filth, and fantasies of the U.S. empire."[100] In Kahlon's own estimation, her goal is "to raise the dead."[101] In this way, *Did You Kiss* forces its audience to accept the dirty truth that these detainee deaths were not accidental nor anomalous but instead systemic and structural to the necropolitical power of the security state. The piece thus performatively enacts what Black studies critic Christina Sharpe calls "wake work," an interpretive strategy distinct from "state-imposed regimes of surveillance" that seeks instead "to find a way to hold onto something like care as a way to feel and to feel for and with, a way to tend to the living and the dying."[102] Through these spectral and reparative aspects of her art practice, Kahlon intervenes into the central archival logics of state security by reanimating these documents with intimate attachments and embodied vulnerabilities. In short, in the words of Ann Stoler, Kahlon's work forces us to contend not only "with the soft undertissue of empire, but its marrow."[103]

Moreover, Kahlon's inventive aesthetic strategy has the effect of making state practices of counterterror *visible* while equally washing them out. Her drawings, with red and pink patterns swirling on paper, appear to lack an immediate indexical relation to the Torture FOIA documents described here. Many of the images instead appear warped because of the marbling technique that the artist uses throughout the series. The practice of marbling, an early form of watermarking imperial documents to discourage forgeries, has its roots in Iraq and Turkey, and Kahlon uses it here to refer to the body's "living interior."[104] While printed on paper, the drawings also have an aqueous or dreamy aesthetic and appear as though they have been submerged in water. Given the political content, the drawings appear to me to have been water-boarded. In fact, when I asked Kahlon to elaborate on her marbling process, she underscored water's centrality in conjuring an aesthetics of "warm data":

> [Marbling] carries with it the feeling of magic and divination. As a process, it involves floating inks on top of water thickened with Carrageenan, an Irish seaweed moss, then laying down a sheet of paper that has been pre-treated with aluminum sulfate for a few seconds on top of the water. Once the entire surface of the paper has come into

contact with the surface of the water, it is lifted out, rinsed and left to dry. The ink dropped onto the surface of the water can be left to organically bloom and drift into biomorphic shapes or manipulated with tools to create the decorative end papers found in finely bound books of the nineteenth century. Once I saw the biomorphic "stone" patterns, I knew the marbling was a key part of the intervention into the texts. They recalled cross sections of human cells under a microscope.[105]

In addition to the cellular and corporeal themes that emerge from the marbling process, Kahlon's images of dissection and bodily transparency further expose clues of empire's innards. These works provide urgently desired evidence of political disappearance in the US global security archipelago while simultaneously mocking state practices of evidence-making that make hypervisible so-called terrorist bodies.[106] Her collage mixes styles and materials (the black-and-white text of US war records, European anatomical figures, and the biomorphic imagery conjoining the two) to construct a "warm data" archive that evidences things not seen.

Finally, Kahlon's drawings raise several key concerns about the different legal, medical, and cultural frameworks needed to comprehend (and be ethically accountable to) the material histories and identities of inmates who have died in US custody since 9/11. Kahlon asks, "How do the lives of the men in these documents come to be remembered and brought into our shared history?"[107] For the artist, the autopsies represent "a second stage of violence to the bodies that have already experienced incarceration and death, further subjecting them to dismemberment and scrutiny. . . . But from a legal standpoint, the documents serve as proof of the excesses of power, providing the possibility to hold those in power accountable for their acts. Their existence is viewed as beneficial and there is a belief in the underlying functional rationality of the document and the archive."[108]

Kahlon's residency with the ACLU provided an opportunity to limn the gap between her own view as a cultural producer, one "engaged with ideas of empathy and remembrance," and the juridical perspective of these documents "as rational instruments serving justice."[109] Her self-assessment speaks to the limits of distinct knowledge regimes for understanding state violence and the circuits between aesthetic, ethical, and legal reasoning. *Did You Kiss* explores what is often missing or forgotten in human rights reports and official records of US forever warfare—namely, the suppressed life histories and intimate details of suffering and immiseration experienced by those anonymous detainees who are tortured, killed, or both during military detention.

In so doing, Kahlon activates the "ghostly elements" absented from official archives to "bring out the dead."[110] The aesthetic gesture of mourning and memorialization that emanates from this haunted position allows us, following sociologist Yen Lê Espiritu, to "look for the living effects of what seems to be over and done with. As such, the ghost is important not as a dead figure but as a sign of what is missing—or, more accurately, of what has been disappeared."[111] Kahlon's spectral work thus creates another mode of affective evidence that departs from officially sanctioned documentation, bringing into being the seething presence of that which the forever war disappears or redacts, including fleeting memories, intimate histories, and distressed embodiments that tell us more about empire's innards than official archives want us to know.

Interrogating Ghosts in the Room: Mariam Ghani's *The Trespassers* (2011)

Key sensorial and haptic elements accentuating the ghostly nature of these declassified military documents are also at work in Mariam Ghani's solo video installation *The Trespassers*, which is the final work of insurgent aesthetics I consider in this chapter. Originally commissioned for the spring 2011 Sharjah Biennial in the United Arab Emirates, the project involved interviews with Afghan Americans who were recruited as translators for the US military in Afghanistan.[112] Ghani subsequently hired these people to perform live translations of documents from the public domain related to US military prisons in Afghanistan, which she audio-recorded. The declassified documents were drawn from archives that Ghani and Ganesh collected for the Index, including the Torture FOIA. The culminating installation project at the Sharjah Biennial comprised two rooms—one containing a table, a few chairs, and twenty-nine binders featuring the Index of the Disappeared's massive archival collection; the other featuring a television set screening a 105-minute-long video produced by Ghani.[113] There was no beginning, middle, or end to the story told on the video; instead it was organized into six sections, varying from eight to thirty-five minutes long, each with its own story. On the soundtrack, listeners heard two distinct but simultaneous voiceover translations of the documents visible onscreen. The voiceovers followed an onscreen magnifying glass as it enlarged parts of the documents from left to right (figure 3.28). The translations were in Arabic and Dari, an Afghan dialect of Farsi, with a "sprinkling" of Pashtu. As noted by US military ana-

FIG 3.28 Mariam Ghani, *The Trespassers*, 2011 (run time 1:45:00). One-channel video with four-channel sound and annotated archive (approximately twenty thousand pages). Courtesy of Mariam Ghani.

lysts, expertise in these languages and dialects has become newly central to global counterinsurgency operations in the region, and a highly contentious debate has ensued over the state's technical capacity to "master" these languages during combat. US media accounts, for instance, have repeatedly criticized the military's poor record of retaining skilled translators over the past decade, and ethical questions have been raised about the role of military translators in torture practices at military prison sites including Abu Ghraib, Guantánamo, Bagram, and beyond.[114]

Ghani's video installation departs from the other works discussed earlier in that the "warm data" conjured by this piece manifests primarily in the realm of the sonic rather than the sensuous. Like many installation art projects, *Trespassers* explores concurrently the experiential dynamics of sound and image in ways that make this exchange crucial to its engagement with warm data. The embodied experience of watching and listening to Ghani's video is decidedly overwhelming. An immediate rush of sound occurs as the magnifying glass moves furiously across the screen, enlarging text as it moves—a pace that is tied to the speed of the real-time translations. Most of the onscreen documents move left to right (as if you were reading them in

English) but also top to bottom. We see pages upon pages of documents that are distinguished by their redactions—large sections of text are blackened. When watching the video, one is left to wonder how the translators, whose corporeal presence, or physical "warmth," is "missing" from the video, dealt with those gaps and erasures in the text. The sonic experience of simultaneous translations produces a sense of dissonance, perhaps allegorizing the "fog of war" translators experience in these settings. If, like me, the viewer is ill equipped to understand Dari, Pashtu, or Arabic beyond a few choice phrases, she might easily begin to "black out" the disembodied sounds, as if they were white noise. In the few moments at which the video slows enough to enable a reading of the onscreen text, I notice that the controversial government documents are clearly the product of FOIA releases. The visual experience of watching the video entices the viewer to enter the other room, sift through the binders, and review the results of Ghani and Ganesh's painstaking archival research, which resonates closely with Kahlon's approach to the appropriation of archival documents (figures 3.29–3.31). These binders include an intense collection of primary source documents such as government reports, memos, and emails that have been officially declassified, as well as secondary documents such as nongovernmental organization and media reports and legal briefs, which are also freely available online. These documents reveal questions about the role translators played in detention and interrogation operations in Afghanistan, Iraq, Guantánamo, and so-called black sites around the world. The sonic element of *Trespassers'* video provides another alternative sensorial format from which to access the volume of online information that often overwhelms or exhausts its readers. It further allows the audience to track the disembodied presence of the translators in both Ghani's video and the actual interrogations that the project seeks to represent.

Unlike works by Kahlon and the Index, the experiential accumulation of warm data in *Trespassers* stems primarily from the sonic elements of the simultaneous translations—data that serve as both archival recovery and art object in Ghani's meditation on the haunted absences of the forever war. In fact, what I find most salient about this aesthetic practice for my analysis of warm data is that in all the interrogation transcripts Ghani found in her research, the translators and their acts of translation were entirely invisible. She recounts that she knew they were present, "but their presence was unrecorded, and its implications avoided. They became the *ghosts* in the room."[115] She questions whether those invisible translators could ever serve as "witnesses" to what happens in those rooms, which are often as cold and sparsely

FIGS 3.29 – 3.31 Mariam Ghani, *The Trespassers*, 2010–11. Installation view (one-channel video, four-channel sound, mixed media installation; dimensions variable). Commissioned by Sharjah Art Foundation.

appointed as the gallery space where this artwork was installed, or whether the ephemeral act of translation "necessarily precludes the possibility of witnessing" the forever war's violence.[116]

Trespassers considers what it means to be a spectral accomplice to the violence of the forever war. Many scholars and activists have asked after the interrogation tactics of the US security state and its seemingly incoherent motives for torturing people whom the government and the interrogators both know to be innocent.[117] In Anne McClintock's estimation, to simply ponder the government's obsession with "actionable intelligence" and ask "Why torture innocent people?" is to enter "a dark labyrinth . . . haunted by the historical ghostings and half-concealed specters" that she calls "imperial déjà vu."[118] But what is usually absent from such critical discussions about the "spectral and nightmarish quality of the 'war on terror'" is how Afghan and Iraqi immigrant and refugee populations *themselves* are often centrally enmeshed in the operations and technologies of war that bolster the global security state.[119] In fact, the vast majority of translators used by the US military come from the populations under siege. Iraqi and Afghan refugees, some of whom fled their homelands during the conflicts of the late Cold War (1970s–80s) and some of whom were granted asylum in the US, are often the first ones to return to the conflict zones as military translators.[120] As I argue throughout this book, analyses of the forever war that elide or disregard these differing affective structures of and modes of belonging among racialized immigrant, diasporic, and refugee populations drawn from the very populations and the social geographies most devastated by its effects will be forever impoverished.

By contrast, Ghani deftly deploys her diasporic and refugee networks to find these alternative perspectives on the military conflict, thereby questioning the relation between the US military and the Afghan population, and on the Afghan American translators who are put in the "very uneasy position of being mediators, traitors, and trespassers all at once." She adds: "It's an interesting variation on the notion of the native informant and the translator as native informant because these translators are not natives, but were asked to stand in for the 'native' via the act of translation."[121] This relates to one of the more bizarre facts that Ghani discovered during her research for this art project: many of the translators who were recruited from Fremont, California (one of the largest Afghan American communities in the US) were initially conscripted to play a different role for the US military.[122] These Afghan Americans worked as "stand-ins" for native villagers in the mock Afghan village set up in the Nevada desert to train US battalions before

their deployment to Afghanistan. "Some of the ones who played 'Afghans' in this mock village bought into its fiction of polite military engagements, just as the soldiers did," Ghani notes, "and subsequently agreed to travel to Afghanistan and work as translators."[123] Their participation in these military trainings offers a stirring instance of the embodied counterinsurgencies of the experimental Human Terrain System (HTS).[124] As discussed earlier, the controversial HTS program involved "embedding" anthropologists, sociologists, linguists, and other social scientists into combat brigades in order to better "interpret" and "understand" local cultures. Assembled by the US Army between July 2005 and August 2006, HTS became a key facet of the military's global counterinsurgent defense strategy in the forever war until its closure in 2015.[125]

We can conclude that the US counterinsurgent state legitimates contemporary forms of imperial violence in part by actively soliciting racialized South, West, and Southwest Asian refugee populations into its war machine. The translators provide warm bodies to "flesh out" the perceived failure of "cold, hard data." In so doing, they become conscripted by the US war machine not only as subjects of surveillance, discipline, and dispersal but also as privileged mediators, translators, and "trespassers," if you will, as Ghani's video installation so vividly demonstrates.[126] Incorporating Iraqi and Afghan Americans (both immigrants and refugees) into counterinsurgency and military trainings is thus a way of better "knowing" the human terrain of global conflict across the Greater Middle East, a multicultural imperial project of waging war.[127] Ghani's experimental work is compelling because it helps to expose the "complex personhood" of contemporary South Asian and Arab diasporic life—that is, forms of information that exceed conventional modes of analysis and have been missed by even critical responses to the forever war, including "those fragments that are usually considered unquantifiable or were deemed irrelevant but are actually critical to narratives of post–9/11 militarization."[128]

In closing, this chapter has read contemporary South Asian and Arab diasporic visual cultures as sensuous knowledge projects that make visible the more unsettling knowledge project of the forever war. That principal claim over knowledge is ever more apparent in a time when national conversations on military torture have receded again in the aftermath of the confirmation of the first female CIA director, Gina Haspel, despite her pivotal role in destroying interrogation tapes and overseeing a black site in Thailand where detainees were brutally interrogated in the early days after 9/11.[129] It is imperative to spotlight insurgent aesthetic practices that retrain our gaze on the

recursively abject and ghastly practices occurring at US military prisons and the archival traces that remain. My investigations into the formal aspects of collaborative art practices that wrestle with the Torture FOIA and the afterlife of Special Registration provide an alternative sensorial relation to governing archives of national security and military detention, an antidote to repudiate what McClintock calls the state's "rational calculus of cause and effect."[130] Marked by legacies of imperial violence and ongoing forms of gendered racialization, these diasporic artists force a reckoning with the intimate, the unknowable, and the palpable. They make visible or visceral what has been absented by technologies of abstraction in state knowledge regimes. As I have shown, these artists create alternative languages to make sense of the sensorial and somatic life of empire in institutional records of US global military detention. They conjure elements of "warm data" in these redacted archives— sometimes visual, sometimes sonic, sometimes conceptual—evidence of things not seen in US imperial prisons and detention centers. In the end, their insurgent aesthetics challenge the experiential and intimate modes of knowing and visualizing US militarized practices of torture, confinement, and death while revealing how empire's gendered-racialized Others are summoned by the endless waging of war.

Art is both the means to project Indigenous life into the stars and the space canoe we use to paddle through these imagined galaxies. Art becomes a medicinal practice, healing our spirits, minds, and bodies as we move into possible futures. —Lindsay Nixon, "Visual Cultures of Indigenous Futurisms"

Biopower is thus a profoundly atmospheric power: it targets the voluminous spaces of human existence, from the soil beneath our feet to the skies above our heads. —Ian Shaw, "Scorched Atmospheres"

How do we begin to know or to feel where we are, or even where we are going, by lining ourselves up with the features of the grounds we inhabit, the sky that surrounds us, or the imaginary lines that cut through maps? How do we know which way to turn to reach our destination? It is by understanding how we become orientated in moments of disorientation that we might learn what it means to be orientated in the first place. —Sara Ahmed, *Queer Phenomenology*

How do contemporary artists conjure "up" impossible and unruly futures for Palestine? How have speculative works of Palestinian diasporic cultural production generated forms of insurgent aesthetics that expose the conjoined histories of US and Israeli settler security states? How do these conceptual works of art reveal both the shared colonial logics of elimination, confinement, punishment, and racial dispossession structuring these liberal democracies and their regimes of vision as well as the queer relational promise

of their insurgent undoing? Finally, if Palestine, and the Palestinian people subject to Israeli rule, have long served as one of the foremost paradigmatic "laboratories" for the development of late modern settler security states and their creation of new technologies of policing and killing, which are perfected on Palestinians under siege, how might we reimagine an archetypal "Palestine" instead as an experimental site of decolonial fantasy and freedom that likewise portends the queer feminist fugitive ends of US empire and its forever wars?[1]

This final chapter extends my analytic concern for US neoliberal and racial regimes of security to the US entanglement with Israeli state violence and the ongoing territorial colonization and ethnic cleansing of Palestine. I make this relational move here by attending to the critical and social potential of works by London-based Palestinian visual artist Larissa Sansour. Sansour's transnational multimedia art practice spans video, photography, experimental documentary, graphic novels, and new media. I want to think alongside her science fiction film trilogy in this chapter to explore the interplay between insurgent aesthetics and the imperial frontiers of the US forever war—frontiers imagined in Palestine, in the sky, and in outer space. A focus on what I term "visionary aesthetics" identifies radical experiments with insurgent consciousness, with speculative, fabulist, and otherworld imaginings that defy the borders and orders of settler colonial security states. In the process, I illuminate how these visionary aesthetic acts help redirect our attention to the affects, sensations, and imaginative practices of Indigenous and racially or politically dispossessed peoples, practices that both underscore and move us beyond the power of imperial and settler security state control.[2] While militarized settler colonial geographies often foreground the horizontal plane of human existence in their quest for full-spectrum dominance over native lands and territories, we can glean much from the unlikely utopian deployment of vertical and three-dimensional thinking in the world-making practices of queer feminist diasporic aesthetics, which reimagine a fantasy future for Palestine in the sky.[3] Bringing together insights on the affective, legal, and spatial dimensions of both contemporary Israeli security regimes and the Palestinian struggle for liberation with critical works in American studies, Black studies, Native studies, and queer studies, this chapter questions what visionary aesthetics might yield for knowing and feeling anew the experimental frontiers of US empire and its planetary forever wars of security and terror.

By exploring Sansour's speculative visualities in the *dystopian here and now*, I also seek to recalibrate transnational queer feminist politics and criti-

cism, which have much to gain from a closer engagement with Palestine and the insurgent aesthetics of Palestinian diasporas.[4] How might a queer calculus of the forever war better illuminate the fierce entanglements and specificities of US and Israeli settler colonialisms? In their introduction to a recent special issue of the *Journal of Palestine Studies* titled "Queering Palestine," scholars Leila Farsakh, Rhoda Khanaaneh, and Sherene Seikaly explore "what queer theory and activism can teach us about the Palestinian condition, and vice versa."[5] They ask what queerness-as-method can offer the struggle for Palestinian liberation today while also challenging the purported universality of US/Western queer theory and its "universalized notions of queer solidarity, which are confined to exclusionary gay, or single-issue, identity politics."[6] As Maya Mikdashi contends further in the special issue's roundtable, queer theory is abstracted and made allegedly universal "through a series of occluding moves: a disappearance of the research and context (mostly Euro-American, and mostly American), out of which queer theory emerges, precisely because some histories and contexts, some bodies, speak the universal; a disappearance of the structural, affective, and economic role that US empire plays in the circulation of research and universalizing theory; and, the homonationalist positioning of the United States as the ideological (if not geographic) end point of the transnational journey of queer and sexual rights."[7] Against this backdrop, these critics instead survey how the careful and ethical study of Palestine can be a fruitful incubatory site for a revitalized queer theory, one that develops new theorizations of "power, of race, and of indigeneity" emanating out of the settler colonial present.[8]

This invigorated mode of queer feminist criticism can help explain how, for instance, Israeli Zionist settler colonial logics of war and terror impose not only patriarchy but also heteronormativity "to discipline Native realities and sexualities."[9] A renewed focus on "Palestinian anti-colonial queer critique" would better explain how Palestinian queers resist Zionist colonial structures of domination or define Palestinian liberation themselves while also "questioning the discourse of modernity embedded in homonationalism and addressing the racialized and sexualized politics of Zionism, beyond its homonationalism, that are predicated on the erasure of the Palestinians."[10] This final chapter's discussion of Sansour's visionary aesthetics is indebted to these newer theorizations and adopts queerness as a decolonial and antiracist practice that "allows Palestinians and others to move beyond the reified notions of sovereignty, statehood, and identity that the Oslo process exemplified . . . [and] allows for all Palestinians, both inside and outside Palestine, in refugee camps or in the diaspora, to have a voice and to reclaim their Pal-

estine, and to imagine a future that affirms their presence and struggle for liberation and justice."[11]

My contrapuntal queer analysis of Palestinian visionary aesthetics in the context of contemporary US/Israeli security state violence is further enabled productively by what cultural historian Keith P. Feldman has called "Palestine's breach in US knowledge production."[12] This phenomenon refers to the growing, if belated, constellation of intellectual and political interventions made by scholars of transnational Arab American studies, Asian American studies, Middle Eastern studies, anthropology, queer studies, and Native American and Indigenous studies, who have sharpened new directions in the field by situating Palestine (and Palestine solidarity) at the heart of a critical American studies project.[13] I aim to contribute to that collective endeavor by contesting US exceptionalist visions and illustrating how queer feminist "Arabfuturist" speculative imaginaries of Palestine can inaugurate the vital forms of insurgent aesthetics I trace throughout this book. As a non-Arab queer feminist scholar of color situated in transnational American studies, writing about the interface between racialized diasporic artists and the US security state from the vantage point of the United States, I focus here more precisely on diasporic Arabfuturist aesthetics through critical ethnic studies (primarily, Arab American studies, Native studies, and Black studies), and I seek to offer an antiracist and decolonial intervention within US queer feminist criticism. Although my analysis of Sansour's work is not positioned directly in Palestine studies or Arab/Middle Eastern studies, this chapter is still centrally informed by the vibrant and heterogeneous discourse on Israeli colonial practices and Palestine postreturn futures led by diverse groups of Palestinians themselves, whether inside Palestine/Israel or in the diaspora.

My invocation of "Arabfuturisms" in this final chapter, like my approach to insurgent aesthetics more generally in this book, is also attentive to the duality of speculative futurities as a concept that fuels the engine of both empire/capital and resistance/insurgency. Following North American Native and Indigenous studies scholars, I question further how demands for inclusion within already existing state-centric settler polities are insufficient and can never be the end goal of Indigenous sovereignties. In this way, "Arabfuturism" (rather than or simply Palestinian futurism) is meant to evoke the complex transnational histories of Arab nationalism and pan-Arabism, as those histories are inevitably implicated in future plans for addressing the intractable problems of Palestinians postreturn.[14] It further gestures toward incommensurate utopian visions of diasporic solidarity politics in the West that, despite their imperfections, disavowals, and failures, are useful

for conjuring utopian futures beyond forever war. In so doing, this chapter reads Sansour's filmic work critically through the lens of Indigenous futurist and Afrofuturist aesthetics, mapping out new contrapuntal geographies and queer cosmic utopian imaginings of a world not structured in dominance by militarized security.[15]

Zionism as Settler Colonialism: Locating Palestine's Present

Because this book has centered aesthetic and cultural responses to the US forever war and the racialized regimes of institutionalized terror and violence it inflicts on its racial-colonial targets in the United States and around the world, it is worth highlighting at the outset of this chapter the pivotal role the United States has played in this story of state-sanctioned and socially sanctioned settler colonial violence in Palestine. This book's primary interest has been in theorizing, through transnational queer feminist criticism, questions of affect and the sensorium in relation to US war and empire, with expressed attention to how differentially racialized Arab, Muslim, and South Asian, diasporic sensate bodies can function as vital sites of political knowledge about the architectures of US forever warfare. Here, I reflect further on the felt, embodied, and phenomenological dimensions of the fatality, violence, and scale of Israel's permanent war apparatus over Palestine and Palestinian bodies. To do so, I invoke the analytics of settler colonialism and Indigenous futurisms, which have reemerged in recent decades in both Native/Indigenous studies and Palestine studies, to recalibrate prevailing interpretations of land, capital, race, demography, and the state, as well as questions of invasion, occupation, settlement, and decolonization.[16] These concepts are especially apt here given the US's "special relationship" and "shared values" with the state of Israel, an alliance that took different shape after September 11 but has been articulated consistently through unprecedented and unassailable "geostrategic, military, and economic support" for the state of Israel for more than six decades.[17]

By harnessing the critical frameworks of settler colonialism, racial capitalism, and Indigenous futurisms in my account of Palestine/Israel in the "post-Oslo" period,[18] I join scholars seeking to capture the expanse of Israel's ongoing theft of land and resources from Palestinians, its coordinated system of apartheid, its siege on Gaza, the fences and walls it continues to build in the West Bank in order to annex land and restrict movement, its ongoing support of illegal settlements, and related daily atrocities in Palestine.[19] In the context of Palestine/Israel, Zionism operates as a form of settler colonial

violence primarily through the logic of native Indigenous Palestinian Arab erasure.[20] Anthropologist Julie Peteet explains further that because Zionist settler colonialism is distinct from other colonial regimes and gendered racial projects, "locating Zionism in a family of colonial histories [importantly] works to counter claims of Israel's exceptionalism and forges beyond the impasse of nationalist frames of analysis. Most significantly, the settler-colonial paradigm calls forth such terms as *the indigenous, colonies, colonists, and decolonization*."[21] Peteet's greater ethnographic body of writing on Palestine has been central to my understanding of the modern Zionist project, which has included, in her words, "diluting and dispossessing the indigenous population; fragmenting and isolating their villages, towns, and cities; warehousing Palestinians in refugee camps and immobilizing them in enclaves (Peteet 2016); steady Jewish colonization; the expansion of Israel's sovereignty; and the control of borders and air space, along with a strategy of separation."[22] This critical move—analyzing contemporary Zionism as a settler colonial project undermining Palestinian "rights to property, inhabitance, and movement"—is, as political sociologist Andy Clarno observes, "part of a broader reorientation of scholarship and activism away from a narrow focus on the occupied territories toward a more comprehensive focus on Israeli practices toward Palestinians inside Israel, in the occupied territories, and in the diaspora."[23]

Israel is a leading domain, moreover, for the manufacture of militarized settler security technologies, including especially its vertical and atmospheric weapons of neoliberal warfare, and this process is facilitated and financed principally by the US through its geostrategic alliances and forever wars in the Greater Middle East.[24] I return later to the abundant scholarship detailing these joint strategic collaborations between military planners in the US and Israel, and to the lateral circuits of securitization and violence across incommensurable geographies that characterize the post–Cold War military consensus.[25] I do so to be mindful of the breaks and fissures in articulating relational and intersectional, but still deeply differentiated, colonial histories and ongoing collaborations between the US and Israel.[26] My primary goal in this chapter, however, as throughout this book, is to turn *away* from these dominant imbricated formations of state security and to focus *instead* on the affective structures and aesthetic forms of insurgency found in Arab, Muslim, and South Asian diasporic public cultures. An explicit turn toward an analysis of Larissa Sansour's visionary aesthetics in the face of US-funded Israeli settler colonialism better allows us to formulate speculative alternatives to "Zionist frontier relations" both in Palestine/Israel and across the

diaspora, with "Palestine" as the foremost conduit and inspiration for divining those once unimaginable utopian futures.[27]

To that end, I argue that Larissa Sansour's creative work invites her audience to dream outside the *dystopian here and now* of settler colonial rule in Palestine/Israel, to conjure a diasporic otherwise for a people imagined not to have a future, and to reach toward an elsewhere of Palestinian freedom unbridled by the strictures of settler security states. In the surrealist visual future imaginaries that Sansour assembles, the Palestinian predicament has not simply faded away, rendering the Israeli occupation and broader colonization of Palestine vanquished and dismantled.[28] But as I show, her creative work does offer an outside and otherwise that is exemplary of the insurgent aesthetics I analyze throughout this book and that is likewise resonant with the heterogeneous Palestinian diasporic political conversation about postreturn futures. That is, her work conjures both a sensuous historical record of the present-day Israeli settler security state—a violent territorial, ethical, and legal project that is always registered on and affectively felt by native Indigenous Palestinian Arab bodies, landscapes, and ecologies—and a necessary queer feminist diasporic recalibration of enduring questions about home, land, collectivity, sensation, embodiment, and sovereign futures outside settler common sense.[29]

Living the High Life in *Nation Estate*

Larissa Sansour's science fiction film trilogy provides a crucial point of departure for conjuring up seemingly impossible futures *alongside, after, and beyond* US and Israeli settler colonial violences and their forever wars. Born in East Jerusalem in 1973 and raised in Bethlehem by a Palestinian father and a Russian mother, Sansour and her family left the West Bank for London during the First Intifada in 1988.[30] Although she retains a Palestinian ID card and passport, thereby restricting her travel into and out of Palestine, Sansour maintains a diasporic itinerary not unlike that of the other major artists under investigation in this book. She studied Fine Art in Copenhagen, London, and New York and now lives and works in London with her Danish partner and frequent artistic collaborator Søren Lind. In the main, Sansour's transnational and multidisciplinary visual art practice traffics in what she calls the "fantastic conceptual and philosophical playground" of science fiction and fantasy to elucidate the material realities and everyday lifeworlds of contemporary Palestinians under occupation.[31] Her trilogy is comprised of works entitled *A Space Exodus* (2009), *Nation Estate* (2012), and *In the Future*

They Ate From the Finest Porcelain (2015). I first learned of Sansour's work through her coauthored science fiction graphic novel *The Novel of Nonel and Vovel* (2009). This collaboration with British Israeli artist Oreet Ashery offers a template for Sansour's later solo endeavors in science fiction and fantasy visual art by foregrounding the role of female comic book artists–superheroes from both Palestine and Israel collectively (and sardonically) fighting the Israeli occupation while also interrogating the role of the artist-as-critic and the artist-as-activist in a manner that resonates more generally with this book's account of insurgent aesthetics.

In her 2012 art film and digital photo series titled *Nation Estate*, we glean an unlikely aperture into the present-day Israeli occupation, settlements, and related miseries produced by the state of forever war (figure 4.1). This piece comprises a glossy nine-minute film created using high-definition computer-generated imagery (CGI) and a photo series of digital "outtakes." Using tropes from science fiction and popular culture, Sansour humorously dreams up a near-future world where the Palestinian people, left with no-where to build but up, have constructed their own state in a single skyscraper: "the Nation Estate." "One colossal high-rise houses the entire Palestinian population—now finally living the high life. Each city has its own floor: Jerusalem on the thirteenth floor, Ramallah on the fourteenth, Sansour's native Bethlehem on the twenty-first and so on. Intercity trips previously marred by checkpoints are now made [simply] by elevator."[32]

As the short film opens, we see our heroine, a new "arrivant" to the Nation Estate, clad in *Battlestar Galactica*–like couture, ascending a large escalator with carry-on luggage in tow.[33] Through a loudspeaker, an announcer with a serene voice instructs new visitors, first in Arabic and then in English, to "please prepare for security checkpoint." The camera then zooms in to close-ups of Sansour's fingerprint and iris being scanned for biometric identification. This shot, as well as the advertisements in the elevators reminding passengers to ensure that their passports are valid and up-to-date, provides stark reminders that "prophylactic and punitive" tactics of Israeli surveillance and security do not simply disappear even in this seemingly high-tech dystopic and decolonizing near-future Palestinian society.[34] We see shots of our pregnant female protagonist walking solemnly with purpose through the pristine, palatial, but mostly deserted lobby of the Nation Estate (figures 4.2 and 4.3). The skyscraper itself is a monumental if soulless marble structure surrounded by concrete walls on the outskirts of Jerusalem. As the film proceeds, we hear sounds of Sansour's heavy breathing and see another ex-

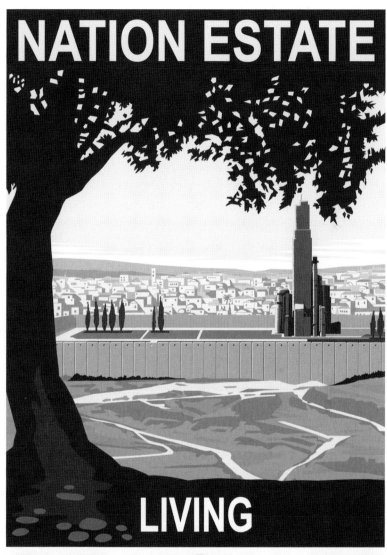

FIG 4.1 Larissa Sansour, *Nation Estate*, 2012. Poster, paper print, 100 cm. × 150 cm. © Larissa Sansour. Courtesy of Larissa Sansour and Lawrie Shabibi gallery.

FIG 4.2 Larissa Sansour, *Nation Estate*, "Main Lobby," 2012. C-print, 100 cm × 200 cm. © Larissa Sansour. Courtesy of Larissa Sansour and Lawrie Shabibi gallery.

FIG 4.3 Larissa Sansour, *Nation Estate*, "Manger Square," 2012. C-print, 100 cm × 200 cm. © Larissa Sansour. Courtesy of Larissa Sansour and Lawrie Shabibi gallery.

treme close-up depicting her blinking eye as her condensed breath fogs an invisible glass enclosure. (Is it cold or overly air-conditioned in the Nation Estate? Has she reconsidered her arrival? We know that breath is constitutive to flight and to the aesthetics of "otherwise possibility."[35]) Next, the camera pans up to a massive Palestinian flag adorning the wall. Under the sound of drumbeats, we see dramatic reference to the iconic 1930s Zionist political propaganda poster "Visit Palestine," with its lush depiction of pastoral pre-war Jerusalem.[36] Except these posters have been reimagined ironically as "Nation Estate: Living the High Life," with images of Israel's still-standing

apartheid wall in the distance (figure 4.1). Finally, the short clip ends as our heroine enters a lift to make her aspirational ascent up the Nation Estate.

The hypercapitalist high-rise building that Sansour imagines stands in steep contrast to the actual built environment of present-day Palestinian cities, which are generally low-rise and sprawling even as their Arab Indigenous inhabitants have become increasingly compelled to build vertically, especially in refugee camps, where horizontal expansion is undermined by the stranglehold of Israeli settlements. Here I suggest that the geographical specificity that demands verticality from Palestinians under occupation also functions as a mode of material resistance in ways that point to new aesthetic strategies that build on the tradition of speculative resistance on which "Arabfuturism" as a formation draws.[37] The aesthetics of Sansour's luxury skyscraper likewise diverge from the high-density, low-income public housing tower-blocks, or "council estates," across Western Europe that must also serve as a significant reference for our London-based artist. These high-rise flats were created in utopian aspiration by postwar, socialism-influenced governments in Europe but now function largely as warehouses for the poor and recent immigrants and refugees. The tower-block images of the "council estate" reappeared in the collective Western architectural imagination after the Grenfell Tower fire in June 2017, when a twenty-four-story block of public housing flats in northern London went up in flames, causing over eighty deaths and seventy injuries. The public outcry after that fire precipitated a formal governmental inquiry and brought renewed attention to the lack of safety precautions used by greedy residential housing developers, endemic patterns of housing segregation, and the enduring racial and economic precarities of those predominantly Arab, Muslim, and North African immigrants living in council estates in urban centers across Europe.[38]

The accompanying "outtake" series of seven photographs depicts key scenes on floors of Sansour's Nation Estate.[39] Each floor houses distinct Palestinian cities or "departments" (e.g., "Dead Sea," "Energy and Sanitation," "Vertical Urban Planning," and "Aid and Development"). While the skyscraper itself is surrounded by concrete walls, its inhabitants would be able to move effortlessly from one Palestinian city to another using elevators and to travel into and out of their country using a high-tech subway system—a stark contrast to the manifold constraints on space and mobility that everyday Palestinians presently endure. Sansour explains her approach as such:

> Trips between towns that at present are very hard to make due to Israeli checkpoints would become so easy, as they are made by way of

an elevator. The building also features a great development for Palestinians and that is the ease of movement between Jordan and Nation Estate. Palestinians are currently not allowed to use the Israeli airport, which would make trips from and to the outside world easier. Instead all Palestinians have to enter Palestine through Jordan which makes it a much longer journey. In *Nation Estate*, a new line between Amman and Palestine is constructed, the Amman express underground, which only takes fifteen minutes.[40]

Sansour's film represents these newly available sensations of speed and mobility for occupants of the Nation Estate. For example, in one of the photographs, we see our heroine exploring the "Jerusalem floor" (plate 19). She cruises past a replica of the renowned Dome of the Rock mosque and then encounters a pair of weary-eyed local residents. We see ads for "Gaza Shore: The Best Sushi on the Block" and other "iconic squares and landmarks of lost cities" relocated to the lobbies of each floor of the skyscraper, with residential living quarters presumably tucked away nearby.[41] The photographs are laden with heavy Palestinian/Arab symbolism (olive trees, kaffiyehs, flags) and over-the-top clichés that self-consciously depict a sterile, clinical, and cold sovereign future for Palestine. In another photograph, for instance, our lone heroine is seen nestled in her own room, performing gendered domestic chores that would seem to be crucial to future planetary survival, such as watering an olive tree—that iconic natural symbol for Palestinian resistance, resilience, and connection to the land (plate 20).[42] In this surreal setting, however, which foregrounds an ecological ethics as part of Sansour's queer feminist dystopian vision of Palestinian survival, the tree's roots are inexplicably growing out from the protagonist's apartment floor. In another image that explores the divide between the organic and inorganic, our protagonist is seated alone at a large rectangular dining table, contemplatively eating a salad while surrounded by stacks of dirty porcelain dishes and bowls (stamped with the black-and-white fishnet kaffiyeh pattern) littered throughout her otherwise spotless room (figure 4.4). This photograph draws attention to an imagined dystopic endgame of settler capitalism. It further advances tropes of waste, excess consumption, and unsustainable farming/food practices that disconnect the skyscraper's residents (and their self-contained artificial ecosystem) from the natural Indigenous landscape of Palestine.

An even more fantastical image shows Sansour casually strolling along the beachfront of the "Mediterranean Sea floor," waves crashing at her feet

FIG 4.4 Larissa Sansour, *Nation Estate*, "Food," 2012. C-print, 100 cm × 200 cm. © Larissa Sansour. Courtesy of Larissa Sansour and Lawrie Shabibi gallery.

(plate 21). A large boat is pulled up onto the shore, and what appears to be an Israeli helicopter hovers above the glass ceiling as it surveils the scene below. The glass operates as an interface, a surface, or a shield that mediates between distinct worlds. Finally, in perhaps the most haunting of all the photos in the series, a nighttime scene depicts a solitary Sansour peering out from her apartment's gunshot-stricken glass windows in the Nation Estate, as she protectively caresses her pregnant belly (plate 22). A reflection of the actual still-gleaming city of Jerusalem, just over the Israeli apartheid wall, surfaces on the window, while the foreground illumines the lamp of an Israeli watchtower casting a long shadow across the apartheid wall. It is as if our lonesome artist-protagonist is being held against her will, a reluctant if still reproductive witness to the vestiges of Israel's forever war violence persisting outside, all around her. Above all, this final scene crafts a haunting, ambivalent future for Palestinians "living the high life," including the character's unborn child.

Sansour's *Nation Estate* has enjoyed impressive tricontinental reception across Europe, the Middle East, and the United States. It debuted as part of her 2013 Middle Eastern solo exhibition "Science Faction" at Dubai's Lawrie Shabibi gallery.[43] The show featured *Nation Estate* alongside previous works by the artist, investigated later in this piece, including *A Space Exodus* (2009), which explores Palestinian space exploration as settler colonial land grab, and its accompanying art installation of little plastic Palestinian space figurines titled *Palestinauts* (2010) (figures 4.5 and 4.6). "Science Faction" also recycled and refashioned idioms of cinema and popular representation, and

FIGS 4.5–4.6 Larissa Sansour, *Palestinauts*, 2010. Sculpture, hard vinyl, 30 cm.
© Larissa Sansour. Courtesy of Larissa Sansour and Lawrie Shabibi gallery.

as the exhibit's title suggests, these works blur the arbitrary and historically ambiguous lines between "fact" and "fiction" in historical and contemporary nationalist accounts of Palestine/Israel. Both *Nation Estate* and *A Space Exodus* further exemplify the artist's "anti-documentary" aesthetic: deliberately mixing clean CGI with mostly solitary live female actors and "arabesque" electronica (featuring highly embellished sounds that mimic Western ideas about Arab music), in contrast to the tradition of gritty, objectifying realism associated with so much documentary film work on Palestine. The disorientation and rejection of the documentarian impulse in Sansour's work creates an aesthetic effect that, as one reviewer would have it, ultimately is "grim but not gritty."[44] Departing from the observational, handheld, cinema verité style of mainstream Palestinian documentary film, Sansour's science fiction film trilogy instead features sleek, surrealist forms that are full of camp, humor, and irony, thereby upending the modern realist film tradition that focuses on Palestinian self-definition in the context of national chaos.[45]

Visionary Fictions, Arabfuturisms, and the Queer Utopian Impulse

Sansour's startling if glossy images in *Nation Estate* are meant to shock the viewer into recalling that, even in this fantasy of a luxury, high-rise oasis-dwelling, where Palestinians finally have their own separate "Nation Estate," the brutal realities of Israeli settler colonial occupation and forever warfare are far from over. Instead, Sansour's speculative visual dystopia provides a mode of "visionary fiction" that forces her viewers to wrestle anew with perennial questions of Palestinian dispossession, state recognition, and un/freedom. By using the term "visionary fiction," I build on and advance the conceptual work of Walidah Imarisha and adrienne maree brown, editors of *Octavia's Brood: Science Fiction Stories from Social Justice Movements.*[46] These writers argue that "radical science fiction is actually better termed visionary fiction because it pulls from real life experience, inequalities and movement building to create innovative ways of understanding the world around us, paint visions of new worlds that could be, and teach us new ways of interacting with one another. Visionary fiction engages our imaginations and hearts, and guides our hands as organizers."[47] I extend this framework to capture various literary, visual, musical, cinematic, performative, theatrical, and other modes of expressive cultures aligned with social justice movements that at once critique differential distributions of power, resources, and life chances in the present and conjure what German Marxist philosopher Ernst Bloch

once called the "anticipatory illumination of art" that is necessary to envisage social life anew.[48] Visionary fiction thus offers a powerful framework through which to understand the aesthetic and political projects of Palestinian diasporic artists as part of broader transnational freedom struggles.

The idea of visionary fiction builds on the rich historical legacy of radical science fiction and speculative practice within African American, Latinx, Indigenous, postcolonial, feminist, and queer literary and expressive cultures.[49] This extensive body of scholarship is in keeping with my goal throughout this chapter to bring into contrasting relation Native/Indigenous studies and Black studies critiques of settler colonialism with Palestinian speculative futurisms. I wish to situate Sansour's creative work in dialogue with this rich, interdisciplinary tradition, and in so doing, I draw further inspiration from what Nēhiyaw-Saulteaux-Métis scholar and curator Lindsay Nixon calls "speculative visualities," that is, a way of projecting Indigenous life into the future imaginary, thereby subverting the "death imaginary" historically ascribed to Indigenous bodies within settler colonial discourse.[50] These cultural archives of visionary fiction and speculative visualities span radically disparate but imaginative genres of science fiction, fantasy, horror, and magical realism. They shine light on the conflict between the world as it is and the world as it could be. They generate new utopian maps of freedom and radical imagination that serve as the template and "testing ground" for what I am calling Arabfuturisms.[51] With their critique of pragmatism and embrace of the impossible, Imarisha and brown's concept of visionary fiction also extends the foundational feminist science fiction legacies of Ursula K. Le Guin and Octavia Butler, who elucidated how minoritarian aesthetic forms can hold the potential to oppose the violent present while simultaneously proposing more hopeful and just futures.[52] They write: "We started the anthology with the belief that all organizing is science fiction. When we talk about a world without prisons; a world without police violence; a world where everyone has food, clothing, shelter, quality education; a world free of white supremacy, patriarchy, capitalism, heterosexism; we are talking about a world that doesn't currently exist. But collectively dreaming up one that does means we can begin building it into existence."[53]

The prefigurative impulse behind visionary fiction (and its dreams for revitalizing radical social movements and social worlds) also resounds with the critical queer of color and queer diasporic project I amplify throughout this book and that now guides my treatment of Sansour's visual oeuvre. Indeed, a certain kernel of utopian political possibility animating queer studies has been a formative site for my critique and elaboration of visionary fiction and

speculative world-making in Arab, Muslim, and South Asian diasporic public cultures. In the words of the late, great theorist of futurity José Esteban Muñoz, queerness is "that thing that lets us feel that this world is not enough, that indeed something is missing . . . we can glimpse the worlds proposed and promised by queerness in the realm of the aesthetic."[54] Central to identifying future worlds is a focus on speculative archives, or what Ann Cvetkovich calls the "insurgent and experimental genres of queer cultures . . . that attempt to make things, to be creative, to do something."[55] As Muñoz elaborates: "Queerness is essentially about the rejection of a here and now and an insistence on potentiality or concrete possibility for another world."[56] Building on concepts by Ernst Bloch, Roland Barthes, and Fredric Jameson, Muñoz identified "the utopian" as "relational to historically situated struggles" and a quotidian impulse traceable in minoritarian life.[57] "This impulse is to be glimpsed as something that is extra to the everyday transaction of heteronormative capitalism. This quotidian example of the utopian can be glimpsed in utopian bonds, affiliations, designs, and gestures that exist within the present."[58]

I build on Muñoz's foundational insights on the world-making and socially transformative power of queer of color speculation here not only to refine my queer feminist decolonial reading of Sansour's work but also to argue that visionary aesthetics provides a compelling perceptual regime through which to search for those elusive "facts-on-the-ground" of US and Israeli securitization.[59] My point is that concrete utopias and dystopias are immanent to and emerge in relation to the historical condition of inequity that we seek to eradicate. I thus follow Avery Gordon's insight that "If we define the utopian not as it is commonly defined—as a homogeneous perfect future no-place—*but rather as a standpoint for living in the here and now*, then we might find meaningful instances of it in the history of social struggle."[60] I belabor the connections between queer feminist inquiry and the anticolonial, decolonial, and race radical facets of my analysis of future diasporic imaginings of Palestine in works by Sansour not only because queer feminist criticism best theorizes concrete forms of utopia and pleasure for differentially racialized and colonized subjects in the context of enduring settler colonial violence, but also because it is only through these interpretive frameworks, as I show, that we can draw out a more robust account of her critical interventions into an already vibrant array of cultural works envisioning postreturn futures for Palestine.

While much has been written about Palestinian expressive cultures as potent sites of resistance against Israeli occupation, little has been documented

to date on the role of contemporary Palestinian visual and installation art (both in Palestine and throughout the diaspora) in the post-Oslo period.[61] These creative projects advance visionary aesthetics as counter-visual tactics of insurgency against Israeli capture and confinement, detention and deportation, and they should be understood as equally formative sites within the transnational Palestinian liberation movement. Sansour's visual contributions in *Nation Estate* thus offer a critical mode of reflection, expressing an anticipatory consciousness that is not simply an uncritical escape into the realm of fantasy but instead a renewed point of departure for diagnosing the material circumstances ("facts-on-the-ground") of Palestine/Israel and for dreaming concrete utopias anew. As Peteet observes regarding the present-day settler colonial condition in the occupied territories, Palestinians often narrate their experiences of closure and related subjection "to living in an open-air prison."[62] In short, Israel relies on imprisonment as the centerpiece of its racialized social control over the West Bank and Gaza and to thwart and punish Palestinian nationalist rebellion.

Given the necropolitical impact of these toxic protocols of post-Oslo neoliberal carceral governance on the lives of Palestinians living under occupation, Sansour's *Nation Estate* seems to knowingly conjure a "closed-air" prison skyscraper in a dystopian near future as the visionary fictive opposite of the contemporary built environment and affective landscapes of Palestinians living under Israeli settler colonial rule. The dream for better living that she conjures is not, in the terms of Avery Gordon, "an off-world escape or a displaced fetish."[63] Instead, the vertical politics of enclosure and occupation are quite literally reimagined in her work. The building's cold, sterile (an) aesthetics further operates like a national museum full of relics and disembodied colonial histories and symbols in ways that mirror my assessment of the sensorial power of "warm data" in visual art installations by the Index of the Disappeared and Rajkamal Kahlon discussed at length in chapter 3. There, I analyzed how contemporary South Asian feminist diasporic visual cultures have conjured warmth in the corpus of otherwise "cold" archives of US global military detention and torture. Their insurgent works installed in public galleries and museum exhibitions call attention to the bureaucratic and machinic accumulation of information and surveillance "data" in the US forever war. My analysis raised questions about contemporary artistic efforts to revivify, and thereby bring sensorial relief to, otherwise austere records of the US forever war. We can accentuate the link to Sansour's insurgent aesthetics here as she draws out questions of affect and sensation, exploring what happens when, as the artist herself affirms, "elements retain

their identified meaning yet stop having any real function beyond that. *Nation Estate* sees the state of Palestine as either planted in the past, like a relic, or firmly looking towards the future, but never actually as a viable condition in the present."[64]

Sansour's aesthetic choices are particularly significant given the charged (Zionist settler) colonial history of cinema and photography in Palestine, technologies of the colonial state that have long transformed visual aesthetics of perception both for colonial documentarians and their colonized or postcolonial subjects.[65] While offering a haunting and intimate portrait of a dystopian future dwelling for Palestine, Sansour's *Nation Estate* notably insists on depicting Palestinians themselves as technological innovators and powerful agents of scientific modernity, not helpless objects in need of liberal (militarized) humanitarian intervention, as so much of the international human rights discourse and visual cultures about Palestine would suggest. Sansour herself observes the critical import of dispossessed peoples embracing the means of cinematic technologies: "When you are constantly in a documentary, and portrayed as victims and the object of analysis, you realize the position of the analyzer actually has a lot of power. I thought, I have the right to claim tools that are being used in filmmaking just as the rest of the world does. I want to raise awareness—it's one thing to sympathize with the Palestinian people, but it's more beneficial to create facts from the ground."[66] Her disidentificatory relation to dominant visual strategies is worth accentuating here, given that contemporary Palestinian artists, activists, and cultural workers have been exceedingly intentional about foregrounding their own leadership regarding "solidarity with Palestine" and the decisive ends of Israeli settler colonial occupation, and the full rights of Palestinian citizens of Israel and the return of Palestinian refugees, even as these emergent strategies are also often ambivalent about the shape and form of a future independent Palestinian nation-state.[67]

Sansour's playful, surrealist medium is even more notable because her own sister Leila is a fellow documentarian and activist, known for her most recent documentary *Open Bethlehem* (2014). This film explores walled enclosures and the cultural revitalization efforts by local activists in their celebrated hometown of Bethlehem in the occupied West Bank.[68] Sansour states: "It only feels appropriate to reflect that [absurd reality of occupation and dispossession] in a visual language that matches that other worldliness lived by Palestinians."[69] Indeed, this "other worldliness," or diasporic conjuring of "(outer-)planetarity," is precisely why her visionary fiction is so evocative for my analysis of insurgent aesthetics and other creative forms of resistance to

Israeli settler colonialism.[70] Sansour's hyperstylized visual forms mimic the material circumstances "on the ground" even as they insist on the potentiality of other worlds. It is here where her relation to both futurity and dystopia is most clear. "When you are confronted with the reality of the erosion of your own cultural landscape right in front of your eyes and with tremendous speed, then a camera seems to be the most readily available and comprehensive tool of recording."[71] She continues: "Even though Israel is never mentioned directly, it is completely present in its absence. These apocalyptic conditions that are imposed on the Palestinian people, whether in the form of outer space or architectural displacement, are all a direct result of the Israeli occupation. [The films] function as parallel universes, rather than solutions. They address our concerns as a humanity in general, a universal angst for the future."[72] Using elements of science fiction, spaghetti Western, and horror helped Sansour craft in *Nation Estate* a "parallel universe" that has a "retro" or vintage/nostalgic feel but retains the diagnostic power to indict the absurd, surrealist dimensions of actual present-day Palestinian life under Israeli security control and asymmetric warfare.

On the Vertical: Architecture
and Atmosphere as Weapons of War

My analysis of Sansour's *Nation Estate* further highlights the role of architecture, geography, and material infrastructures as potent sites of both violent settler colonial subjugation and anticolonial resistance in vertical terms. By attending to the different scalar dimensions of the *dystopian here and now* of US/Israeli state power in Palestine's present, I evoke what visual artist and geographer Trevor Paglen calls the "vertical dimensions of human worldmaking," which are equally central to Zionist settler colonial violence by building Israeli settlements oriented toward permanence and belonging.[73] For Paglen, human infrastructures include "deep sea mining and undersea cables to outer, and even arguably interstellar, space."[74] Likewise, we can appreciate how cities are better understood in vertical terms, what urban geographer Stephen Graham calls the spatial logics "from above and below"—from the satellites that encircle the planet to the tunnels deep underground.[75] In the context of Palestine/Israel, a theory of vertical geography "from above and below" helps to analyze concurrently the newly built Israeli environment and the endless bureaucratic web of checkpoints, bypass roads, permits, military bases, and security screenings in the occupied territories. In short, this form of settler colonial subjugation encompasses the aggressively

diminished lands, power, resources, and broader life chances of the Palestinian people amid encroaching illegal Israeli settlements and growing air power as well as the vexed potential for self-determination among Palestine's past, present, and future Arab Indigenous inhabitants.[76] In her analysis of post-Oslo Israeli policies of closure and separation, Peteet uses the concept of *dystopia* "less to refer to a degenerative process and more to an exclusivist utopian project that spelled disaster for the indigenous population and transformed their terrain into dysfunctional, unsustainable places."[77] The "scaffolding and logic" of post-Oslo policies of closure, buffer zones, and air power that Peteet analyzes are tactics of asymmetric Israeli war-making that create a dialectic formation for Israelis and Palestinians: "In Palestine, the mobility, order, and security of one population [the Israelis] is maintained through the imposition on another population of a punishing immobility and confinement, on one hand, and disorder and chaos, on the other."[78]

To rethink the dialectical geometry of occupation and settler security state violence in this way also conjures the influential work of Israeli architect and theorist Eyal Weizman, whose insights into "the politics of verticality" offer a critical language to explain the architectural dimensions of the ongoing Israeli occupation of shrinking Palestinian lands, water, sewage, and airspace.[79] In Weizman's estimation, the post-Oslo moment has featured new forms of bio- and necropolitical governmentality in the West Bank to assemble "a large three-dimensional volume, layered with strategic, religious, and political strata."[80] He describes the formation of three layers of control over the West Bank—the hills and valleys, ground water and sewage, and air space—to illustrate how the same topography is traversed in radically separate layers: a top one allocated for Israelis and a bottom one to Palestinians. Weizman and his co-conspirators at the Decolonizing Architecture Art Residency have argued that critics of Israeli settler colonialism must account for both vertical and subterranean topography, as Israel maintains full-spectrum control of both the skies and the underworld (without either appearing on political or military maps).[81] The critical constellation of ideas, policies, projects, and regulations proposed by Israeli state technocrats, generals, archaeologists, planners, and road engineers since the occupation of the West Bank composes "the politics of verticality," a dominant epistemology for territorial enclosure and disjuncture that remains a crucial settler colonial tactic in the here and now of occupation.[82]

Parsing the distinct layers of colonial occupation, atmospheric politics, and the tension between state sovereignty, property, and "free air" in Palestine's present has brought me further afield to emergent scholarly debates

in political geography, international relations, and critical security studies, which examine the links between violence and the scalar dimensions of state power. As geographer Ian Shaw imparts, empires are "impossible without infrastructures that anchor power relations to the landscape."[83] The scholarly inquiry into the spatialized nature of contemporary processes of power and violence in the forever war provide an alternative map of militarized colonial geographies for a space that US/Israeli viewers are used to visualizing cartographically as flat (e.g., on maps shown during news programs). This reflects the dominant dialectical form of settler security calculus traced throughout this book in relation to US military governance. Indeed, these dominant ways of thinking about territorial segmentation and disjuncture remain crucial settler colonial tactics in the here and now of the Israeli occupation. This queer calculus, which fragments and partitions space, is a critical Israeli settler colonial tool of conquest.[84] Close attention to this scholarly literature allows me to better accentuate the transformative power and anticipatory illumination of speculative practices of Palestinian diasporic culture. Sansour's visionary aesthetics provide an important lens through which to build on and disidentify with these academic insights on the centrality of architecture, archaeology, and atmosphere to the nature and reshaping of the US forever war and its frontiers, including the asymmetrical violence of the Israeli Zionist settler colonial project in Palestine "from above and below."

As I have suggested here, a turn toward visionary aesthetics from the US imperial frontiers of Occupied Palestine can help redirect our attention to the affects, senses, and imaginative practices of Indigenous and racially or politically dispossessed peoples—practices that both underscore and move us beyond the power of imperial and settler security state control. The dystopian aesthetic genres advanced in Sansour's work provide a fruitful lens through which to capture the material and affective contours of physically and socially shrinking space amid the interminable Zionist siege on land, demography, and critical resources. For example, in late summer 2017, Israel and the Palestinian Authority imposed new restrictions on electricity usage in Gaza to barely four hours a day, creating for its 2 million residents a humanitarian catastrophe that went largely unnoticed in the international press.[85] And yet, "while these actions have fostered a hypervigilant, angry, and anxious population, Palestinians continue to adapt, and to cobble together the means to live from day to day in a state of precariousness," thereby remaining, in Peteet's words, "active subjects creating social worlds."[86] *Nation Estate*'s diasporic reimagining of a very technologically advanced skyscraper dwelling and inhabitation (in the face of open-ended and seemingly

forever wars) thus offers a powerful, if fleeting, visual indictment and fugitive counterpoint to the suffocating stranglehold of Israeli settler violence.

Unlike critical diagnoses of the governing security orders in post-Oslo Palestine from above and below, Sansour proposes in her fine art practice a radically slantwise approach to these concerns—a mix of critical escapology and concrete utopian thinking that not only allows us to "imagine otherwise" but to "imagine up."[87] Sansour's aesthetic choice of the skyscraper as the prime mode for future Palestinian dwelling in *Nation Estate* is particularly telling given its pivotal role in structuring social and aesthetic perception across the long twentieth century. The term "skyscraper" was first used to refer to a "high-flying bird" and its virtual bird's-eye view. Whereas so much of contemporary settler colonial visualities conjure flat images of Palestinian refugee camps and Israeli settlements dotting the hills and valleys of Palestine, the gargantuan skyscraper, that glossy emblem of modernity and progress, is a powerful instrument of perception that transformed Western modernity's modes of seeing.[88] The first tall, fire-proof metal buildings were erected in the West in the late nineteenth century, at the apex of the imperial era, and they quickly became touted as a paramount index of "the alliance of thrusting capital and adventurous technology" that characterizes the "driving force of modernity."[89] These large buildings eradicated large portions of earlier built environments and communities and often required dramatic alterations to the terrain below. This social reorganization and exercise of power echoes what global media scholar Lisa Parks, writing on the contemporary use of drones, succinctly terms "vertical mediation": "the potential to materially alter or affect the phenomena of the air, spectrum, and/or ground" through the vertical field—an expanse that Parks sees as "extending from the earth's surface, including the geological layers below and built environments above, through the domains of the spectrum and the air to the outer limits of orbit."[90] Skyscrapers likewise vertically mediate airspace, built environment, ground, historical memories, and other ways of feeling, being, and knowing. As visual studies scholar Caren Kaplan astutely imparts, "we need to grasp the haunted nature of any tall building of significant height to assess what narratives and ways of being are buried beneath and around them, and engage with these histories with responsive care."[91] Given Kaplan's formulation, the skyscraper also always signifies a cemetery, built on the dead ends and detours of histories and futures past.

Such affective and aesthetic politics also envelop the skyscraper in *Nation Estate*. Sansour's use of the form to move Palestinians in and up provides another multisensory regime through which to reimagine the politics

of verticality and vertical mediation, even as we hold onto the vulnerability and fragility of vertical living that she so vividly depicts. Plus, her project endows a tongue-in-cheek response to the Gulfi obsession with erecting skyscrapers to project a sense of national greatness through the tall buildings that now dot the skyline of the Arab states of the Persian Gulf. In this way, my pluralist formulation of Arabfuturism is also in conversation with what Qatari American artist, writer, and filmmaker Sophia Al-Maria aptly dubs "Gulf Futurism," that is, "a byword for the way that a generation, forced indoors thanks to the intense heat, developed a view of the future informed almost exclusively by video games and Hollywood films."[92] For Al-Maria, the phrase originally was meant to depict not egalitarian nor emancipatory Arab futures but "how human life is being forced to accommodate the rampant growth of consumer and luxury culture in the region."[93] Despite these contradictions of late capitalist settler societies, Sansour's work conjures the haunting of Arab/Gulf futurisms through themes of territorial and ontological fragmentation, the endless checkpoints for and chokeholds on the movement of native Indigenous Arab bodies in Palestine, the stultifying and isolating vertical effects of Zionist settler colonial occupation and its post-Oslo policies of closure and airpower, but only now resurrected in one massive, vertical, architectural "solution" for Palestine in the nonwestern sky.[94] In short, *Nation Estate* reads architecture, geography, and technology as viable, if vexed, tools for decolonization and the fraught project of state sovereignty for the dispossessed.

While *Nation Estate* wrestles with Arabfuturist depictions of the built environment from *above*, Sansour's final piece in her science fiction trilogy series, *In the Future, They Ate from the Finest Porcelain* (2015), considers what is buried in the geological layers *below*, in order to recalibrate our understanding of settler colonial artifacts-in-the-ground. This thirty-minute art film and photo series provocatively imagines the archaeological remnants of "a hi-tech, highly sophisticated, yet entirely fictional" future Palestinian society that are buried in the ground (figure 4.7).[95] The film's narration follows the interrogation of a so-called narrative terrorist who, "at an unspecified point in the future, is guilty of a convoluted plot to place forged artifacts underground as evidence of a once-great Palestinian civilization to be uncovered by archaeologists further into the future, ultimately giving historical legitimacy to Palestine's claim to the land."[96] Sansour's *In the Future* allegorizes and critiques Israel's ongoing obsession with archaeological digs throughout Historic Palestine, practices that are animated by a desire to "prove" the existence of Jewish settlers in the region before both Chris-

FIG 4.7 Larissa Sansour and Søren Lind, *In the Future, They Ate From the Finest Porcelain*, 2016. Film, twenty-nine minutes. Courtesy of the artists and Lawrie Shabibi gallery.

tian and Muslim times.[97] For this art installation and film, Sansour literally buried several hundred pieces of ornate porcelain (props from *Nation Estate*, that mythic past high-rise civilization) throughout the desert landscapes of Palestine (plates 23 and 24). The film maintains that these artifacts would later be dug up by future (Arab) archaeologists as "fossilized 'proof' of a killed-off [counterfeit] culture."[98] The film provides, in Sansour's own terms, "a performative counter-measure to the unearthing of artifacts in order to justify further confiscation of Palestinian lands and erasure of Palestinian heritage. In the absence of any real peace process, archaeology has become the latest battleground for settling land disputes. Unearthed history is used as arguments for rightful ownership of the land today."[99] As an intellectual and political tool of liberal settler colonial states, archaeology plays a central role in solidifying historic myths of national identity, regional historiography, and cultural heritage for the state of Israel at the expressed exclusion of Palestinians.[100] By contrast, *In the Future* considers whether this work (and those settler colonial lifeworlds) can be thwarted and undone.

"Palestine 194" and the Visionary Fictions of BDS

While *In the Future* speculates on the pasts of Palestine's mythic future, *Nation Estate* was originally formulated as the artist's ambivalent response to Palestine's historic but ill-fated bid in 2011 for full recognition as a state by the United Nations (UN).[101] After a two-year impasse during negotiations with

Israel, the Palestinian Authority (PA), the primary interim self-governing/policing body for Palestinians in Gaza and parts of the West Bank during the post-Oslo period, began a diplomatic campaign to gain international recognition for the state of Palestine as a full UN member state, with East Jerusalem as its capital, and the borders that were acknowledged before the Six-Day War of June 1967.[102] The campaign was dubbed "Palestine 194" both because Palestine would have become the 194th member of the UN and to honor the landmark UN Resolution 194, which passed on December 11, 1948, and defines principles for a universal right of return for Palestinian refugees, just compensation for their land and property lost during the Israeli invasion, or both.[103]

The "Palestine 194" campaign led to momentary nationalist fervor among many Palestinians, as the plan was formally backed by the Arab League in May and confirmed officially by the Palestine Liberation Organization on June 26, 2011. Efforts from both Israel and the United States centered, perhaps predictably, on pressuring the Palestinian leadership to abandon its plans for international recognition and return to stalled bilateral or trilateral negotiations with Washington. At present, the major issues obstructing a peace agreement to resolve the so-called Palestine/Israel Conflict involve borders, security, water rights, the status of Jerusalem and freedom of access to religious sites, ongoing Israeli settlement expansion, and legalities concerning Palestinian refugees, including their internationally recognized right of return.[104] While the PA and the Arab League were unsuccessful in their bid for state recognition, the UN did ultimately confer "non-member observer state" status to Palestine in the fall of 2012, providing it with "de facto recognition" of sovereignty on the order of the Holy See.[105] While the vote has had little effect on the ground—Israel continues to occupy the West Bank and blockade the Gaza Strip—it did open up the possibility for Palestine to pursue, in the International Criminal Court, Israeli officials for war crimes committed during the course of the occupation.

Yet, importantly, the campaign for UN state recognition was also a pivotal moment for many Palestinian/Arab/Indigenous voices to express frustration and dissatisfaction with the concept of the nation-state as the best or primary means to achieve Palestinian freedom and a lasting peace, an idea that is also legible in Sansour's *Nation Estate*. Following scholars of indigeneity such as Audra Simpson, Alyosha Goldstein, and Elizabeth Povinelli, recognition within liberal settler states refers to a neoliberal form of governance that functions through symbolic denials of ongoing racial domination and Indigenous dispossession.[106] Many Palestinian activists and scholars have

objected to these UN initiatives, proposed by the (decidedly enfeebled) PA and various European parliaments, because of their uncritical embrace of the nation-state as the ultimate horizon of political sovereignty.[107] These critics express trenchant concerns over how recognition of a nonexistent Palestinian state within the 1967 borders might radically forestall the conditions of possibility both for current demands for Palestinian justice, which are generally framed in terms of international human rights, and for broader future freedoms.[108] In so doing, these measures effectively capitulate to liberal Zionist appeals for a bilateral "peace process" that has only accelerated Israeli settler colonial control over Historic Palestine (areas under the British Mandate) while preserving its institutionalized legal racism. Palestinian scholar Joseph Massad explains further: "As there is no Palestinian state to recognize within the 1967, or any other, borders, these political moves engineered to undo the death of the two-state solution, the illusion of which had guaranteed Israel's survival as a Jewish racist state for decades. These parliamentary resolutions in fact aim to impose a *de facto* arrangement that prevents Israel's collapse and replacement with a state that grants equal rights to all its citizens and is not based on colonial and racial privileges."[109] My argument resonates here with scholarly insights about Indigenous sovereignty and the insistence within Native studies criticism to call out the insufficiency of the nation-state model of sovereignty and governance. My goal is to connect an analysis of Sansour's work to the literature and organizing around postreturn, rather than statehood, and then to explore why speculative visualities and visionary aesthetics provide a necessary antidote at this critical historical conjuncture of Israeli settler colonialism.[110]

Amid these chronic diplomatic and geopolitical contestations on the international stage, contemporary Palestinian and Palestinian diasporic visual artists continue to respond to the colonial present by producing visionary aesthetics that defy the logics of state recognition and are accentuated instead by themes of diaspora, loss, migration, occupation, settlement, fugitivity, exile, escape, and post-Oslo belonging for Palestinians. In fact, when first conceptualizing the *Nation Estate* project, Sansour likewise found herself at the center of an international scandal unrelated to Palestine's UN bid for statehood. In brief, she was originally shortlisted as one of eight finalists, and notably the only Middle Eastern artist, for the 2011 Lacoste Elysée Prize. Less than a month later, she was "asked" to withdraw her application for the €25,000 ($33,000) award because the Musée de l'Elysée's corporate sponsor, the French fashion firm Lacoste, objected to her proposals as being, in their words, "too pro-Palestinian."[111] After international news reports exposed her

abrupt and unwarranted disqualification, large-scale protests were staged in front of Lacoste's Paris headquarters, many artists came to her defense, and the Musée de l'Elysée took the dramatic step of canceling the contest and severing its relationship with Lacoste over the firm's insistence that she be excluded from consideration for the juried prize.[112]

The censorship row fueled renewed debates about the role of private-sector companies in art sponsorships and remains but one of countless recent flashpoints where contemporary artists, activists, and scholars who evince avowedly "pro-Palestinian" work are effectively silenced.[113] The recent suppression and retributive violence experienced by Palestinian and Arab artists and cultural producers stems at least in part from coordinated political Zionist opposition to increasingly successful campaigns waged by the Palestinian Boycott, Divestment, and Sanctions (BDS) Movement and its cultural and academic wing. BDS is a nonviolent, antiracist global campaign introduced by Palestinian civil society in 2005 to increase economic, political, and moral pressure on Israel and Israeli and international companies involved in violating Palestinian human rights. Following in the footsteps of the historic and successful South African anti-apartheid struggle,[114] the Palestinian BDS campaign advances three principal demands: (1) an end to Israeli occupation of all Arab lands and the dismantling of Israel's wall; (2) recognition of the fundamental rights and full equality of Arab Palestinian citizens of Israel; and (3) respecting, protecting, and promoting the rights of Palestinian refugees to return to their home and properties as stipulated in UN Resolution 194.[115] BDS represents a visionary form of solidarity politics with Indigenous Arab Palestinian communities that, like Sansour's visionary aesthetics, prioritizes other modes of decolonial and Indigenous futurity that are not reducible to the liberal democratic state. Notably, opponents to BDS have orchestrated well-financed "lawfare" tactics across a range of targeted sites, and at the time of this writing, they have even advanced a draft of US legislation that would federally criminalize the act of boycotting Israeli institutions.[116] A key aspect of what makes BDS so politically dangerous for the state of Israel and its Zionist supporters is that boycott (or refusal more generally) is a speculative political act that is not predicated on recognition of the settler colony.[117] It is a form of visionary fiction that elicits different possibilities and once unimaginable futures.

Aside from the 2011 Lacoste Elysée Prize censorship scandal and a few related high-profile flashpoints in the realm of academia and activism, the silencing of, backlash against, and "witch hunts" among Palestinian activists, artists, and pro-BDS advocates often proceed in more subtle and subterra-

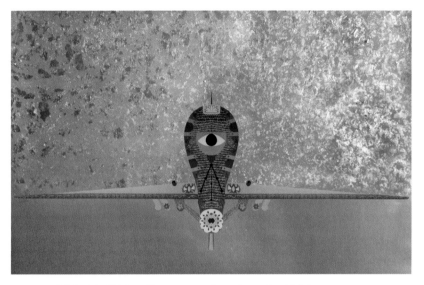

PLATE 1 Mahwish Chishty, *Reaper*, 2015. Gouache and gold flakes on paper, 30 in. × 20 in. © Mahwish Chishty.

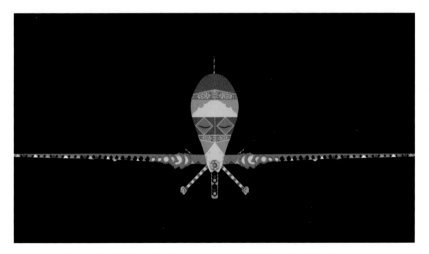

PLATE 2 Mahwish Chishty, *The Predator*, 2015. Still from digital video animation; dimensions vary. © Mahwish Chishty.

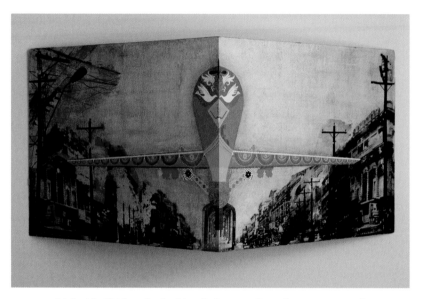

PLATE 3 Mahwish Chishty, *By the Moonlight*, 2013. Gouache, tea stain, and photo-transfers on birch plywood, 12.5 in. × 25 in. × 8 in. © Mahwish Chishty.

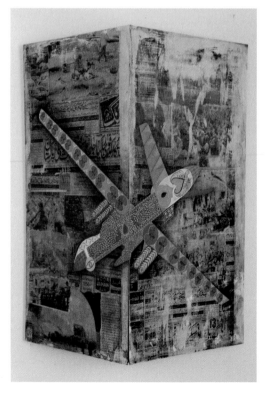

PLATE 4 Mahwish Chishty, *Untitled*, 2013. Gouache, tea stain, and photo-transfers on Masonite, 24 in. × 18.5 in. × 8 in. © Mahwish Chishty.

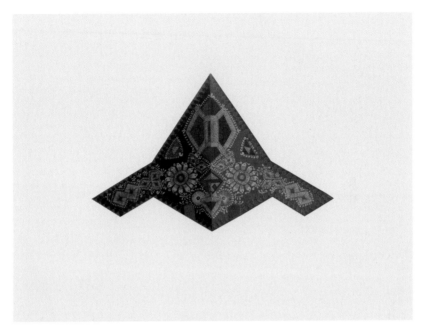

PLATE 5 Mahwish Chishty, *X-47B*, 2012. Gouache on paper, 16 in. × 16 in.
© Mahwish Chishty.

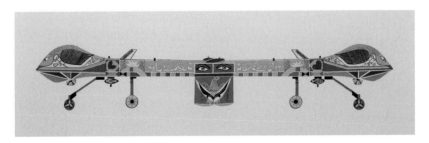

PLATE 6 Mahwish Chishty, *MQ-9 Reaper*, 2011. Gouache on handmade paper,
8 in. × 21 in. © Mahwish Chishty.

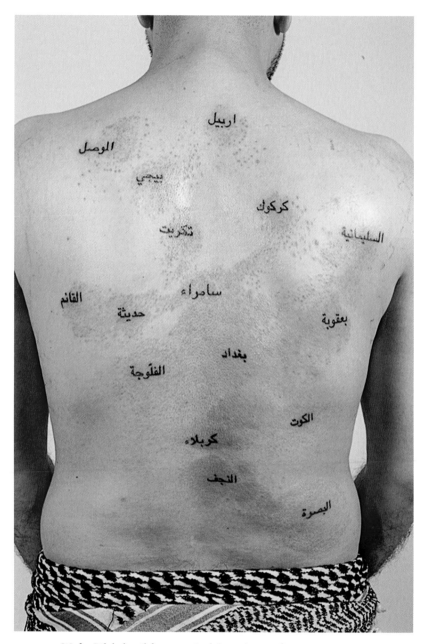

PLATE 7 Wafaa Bilal, detail from . . . *And Counting*, performance, 2010.
Photo: Brad Farwell, with original tattoo design illustration by Kyle McDonald.

PLATE 8 Wafaa Bilal, detail from . . . *And Counting*, performance, 2010.
Photo: Brad Farwell.

PLATE 9 elin o'Hara slavick, *World Map, Protesting Cartography: Places the United States Has Bombed, 1854–Ongoing.* © elin o'Hara slavick.

PLATE 10 elin o'Hara slavick, *Afghanistan I, 1979 and Infinite Reach, 1998.* © elin o'Hara slavick.

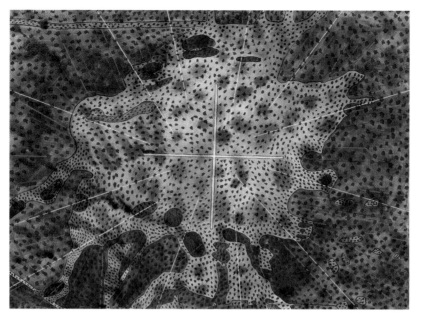

PLATE 11 elin o'Hara slavick, *Afghanistan II, Operation Enduring Freedom, 2001–Ongoing.* © elin o'Hara slavick.

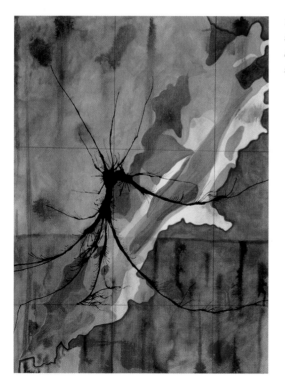

PLATE 12 elin o'Hara slavick, *Lebanon 1983–1984 and 2006.* © elin o'Hara slavick.

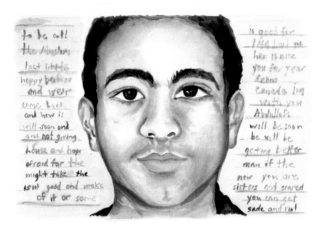

PLATE 13 *Index of the Disappeared: Missing*, watercolor image of Omar Khadr, installed at White Box, New York, 2004. Courtesy of Chitra Ganesh.

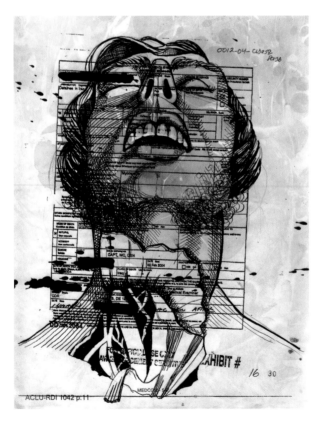

PLATE 14 Detail from Rajkamal Kahlon, *Did You Kiss the Dead Body?*, 2009–12. Ink on marbled autopsy report, 8 ½ × 11 in. Courtesy of Rajkamal Kahlon.

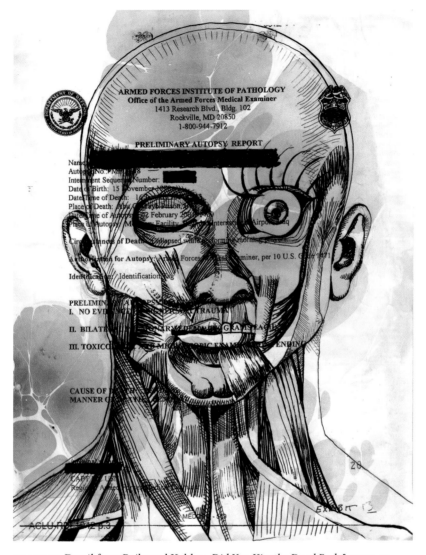

PLATE 15 Detail from Rajkamal Kahlon, *Did You Kiss the Dead Body?*, 2009–12.
Ink on marbled autopsy report, 8 ½ × 11 in. Courtesy of Rajkamal Kahlon.

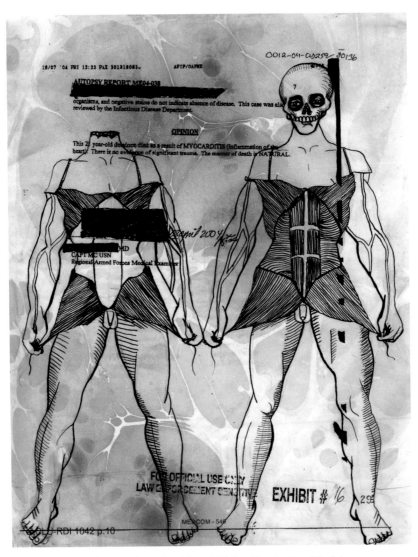

PLATE 16 Detail from Rajkamal Kahlon, *Did You Kiss the Dead Body?*, 2009–12. Ink on marbled autopsy report, 8 ½ × 11 in. Courtesy of Rajkamal Kahlon.

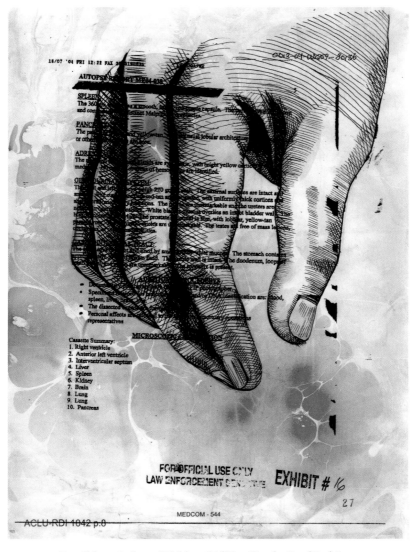

PLATE 17 Detail from Rajkamal Kahlon, *Did You Kiss the Dead Body?*, 2009–12. Ink on marbled autopsy report, 8 ½ × 11 in. Courtesy of Rajkamal Kahlon.

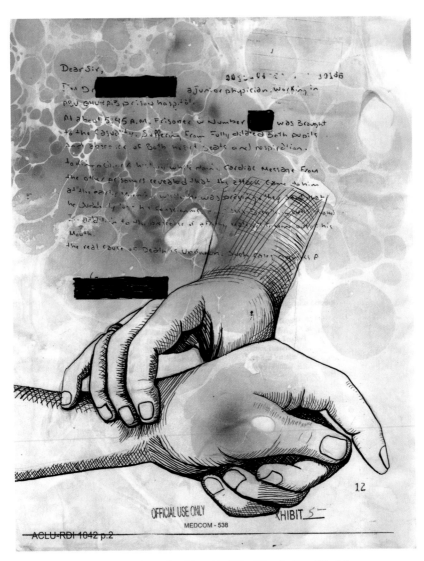

Dear Sir,

I'm Dr [redacted] a junior physician working in
ABU GHURAIB prison hospital.

At about 5:45 A.M. prisoner in Number [redacted] was brought
to the casualty, suffering from fully dilated both pupils
and absence of both heart beats and respiration.

Taking in consideration while doing cardiac massage from
the other prisoners revealed that the attack came to him
at the early morning while he was praying, they said that
he sudden[ly] lost his consciousness [illegible] [illegible]
and [illegible] to the presence of artificial plastic airway in his
mouth.

The real cause of death is unknown. [illegible]

OFFICIAL USE ONLY
MEDCOM - 538

[HIBIT 5]

12

ACLU-RDI 1042 p.2

PLATE 18 Detail from Rajkamal Kahlon, *Did You Kiss the Dead Body?*, 2009–12.
Ink on marbled autopsy report, 8 ½ × 11 in. Courtesy of Rajkamal Kahlon.

PLATE 19 Larissa Sansour, *Nation Estate*, "Jerusalem Floor," 2012. C-print, 100 × 20 cm.
© Larissa Sansour. Courtesy of Larissa Sansour and Lawrie Shabibi gallery.

PLATE 20 Larissa Sansour, *Nation Estate*, "Olive Tree," 2012. C-print, 100 × 200 cm.
© Larissa Sansour. Courtesy of Larissa Sansour and Lawrie Shabibi gallery.

PLATE 21 Larissa Sansour, *Nation Estate*, "Mediterranean Floor," 2012. C-print, 100 × 200 cm. © Larissa Sansour. Courtesy of Larissa Sansour and Lawrie Shabibi gallery.

PLATE 22 Larissa Sansour, *Nation Estate*, "Window," 2012. C-print, 100 × 200 cm. © Larissa Sansour. Courtesy of Larissa Sansour and Lawrie Shabibi gallery.

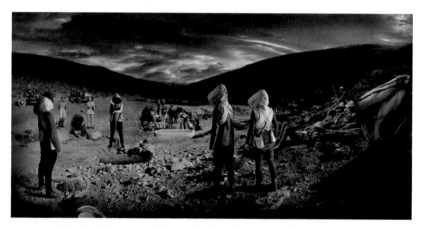

PLATE 23 Larissa Sansour and Søren Lind, *In the Future, They Ate From the Finest Porcelain*, 2016. Film, twenty-nine minutes. Courtesy the artists and Lawrie Shabibi gallery.

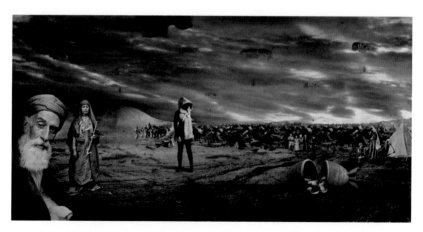

PLATE 24 Larissa Sansour and Søren Lind, *In the Future, They Ate From the Finest Porcelain*, 2016. Film, twenty-nine minutes. Courtesy of the artists and Lawrie Shabibi gallery.

PLATE 25 Index of the Disappeared, *Afterlives of Black Sites I: The Seen Unseen*, installation view of lightbox series and neon sign. Commissioned and produced by Creative Time Reports, the Juncture Initiative at Yale Law School, and Samdani Art Foundation for the 2016 Dhaka Art Summit. Courtesy of the artists (Mariam Ghani and Chitra Ganesh), Creative Time Reports, the Juncture Initiative at Yale Law School, Dhaka Art Summit, and Samdani Art Foundation. Photo credit: Jenni Carter.

PLATE 26 Index of the Disappeared, *Afterlives of Black Sites I: The Seen Unseen*, 2015–16. Overpainted neon. Commissioned and produced by Creative Time Reports, the Juncture Initiative at Yale Law School, and Samdani Art Foundation for the 2016 Dhaka Art Summit. Courtesy of the artists (Mariam Ghani and Chitra Ganesh), Creative Time Reports, the Juncture Initiative at Yale Law School, Dhaka Art Summit, and Samdani Art Foundation. Photo credit: Jenni Carter.

nean fashions. Some notable exceptions include the 2014 targeting and firing of Palestinian American scholar Steven Salaita by university administrators capitulating to pressure from pro-Israel agitators and donors who objected to his appointment as an associate professor of American Indian Studies at the University of Illinois at Urbana-Champaign, and the 2013–17 prosecution and ultimate deportation of Palestinian community organizer and former political prisoner Rasmea Odeh, a longtime resident of Chicago.[118] And yet, by contrast, Sansour herself seemed rather undeterred by the Lacoste affair, citing an awareness that Palestine is "still viewed as a toxic brand by many people, let alone by big corporations making a living out of selling polo shirts," and that she and her creative interlocutors often experienced more clandestine forms of censorship in the art world.[119] One might wonder how her status as a cosmopolitan, multiracial, and diasporic artist living and working in the UK might confer her selective, if still limited, protected status compared to that of Palestinians primarily living and working in the Arab region or in the US/North America, where Palestinians experience the dividing brutalities of accelerated anti-Palestinian racisms and Zionist frontier relations.[120] In the end, the Lacoste Elysée Prize episode had the opposite effect of its intended Zionist censorship, as it amplified exposure for the political content, if not the form, of Sansour's creative work (and its imbrication within the broader Palestinian liberation struggle), not only in the international art world but across multiple global social media platforms as well, further demonstrating how transnational artists can activate their multiple intersecting identities and insurgent affiliations to serve the ends of justice while also circumventing the stranglehold of US and Israeli settler colonial states.

Visionary Aesthetics of Exodus:
Astrofuturism and the Laboratories of Empire

Notwithstanding these debates over censorship and repressive lawfare tactics mobilized by Zionist opposition against the movement for Palestinian liberation, Sansour's larger body of work is pivotal to my formalist analysis of insurgent aesthetics because it provides an endlessly compelling epistemological entrance point for interpreting "the facts-on-the-ground" of Israeli occupation and Palestinian resistance. Her work contributes to the production of an alternative sensorial format through which to access perceptual regimes that are absented or constrained by the abstractions of Israeli settler security, war, and occupation. For instance, *Nation Estate* draws on an earlier

work by the artist titled *A Space Exodus* (2009), which is the third and final piece of the trilogy series that I analyze in order to advance this chapter's discussion of visionary aesthetics and queer cosmic utopias. Described on Sansour's website as "a never before seen case of thrillingly magical Palestinian displacement," the artist's short film adapts and sardonically reimagines Stanley Kubrick's iconic *2001: A Space Odyssey* (1968) for the Palestinian/Israeli political context. The musical scores of Kubrick's film are rearranged here with the cadences and chords of Arab music and surreal visions that posit Sansour herself as the first Palestinian into space. Parodying Neil Armstrong's iconic moon landing, Sansour plants the Palestinian flag, her impossibly buoyant dance stretching across the lunar surface: "That's one small step for a Palestinian, one giant leap for mankind" (figure 4.8). The parodic tone is further supported by the astronaut's moon boots, which depict an unequivocal shape to the Western imaginary: the sharpened and upturned toes that identify her steps as Arab ones. Her invocation of exodus evokes both the expulsion of 700,000 Palestinians from their land in 1948 as well as "the Israeli perspective of history and the creation of their own mythology that influenced Western understanding tragically of the Palestinian reality, and the biblical exodus and the use of that by the state of Israel to reiterate mythologies such as 'a land with no people for a people without a land.'"[121] We witness here an outer-planetary, if solitary, land grab that reimagines "one of America's finest moments—the moon landing—as a Palestinian triumph."[122] The film has a dreamy and surrealist quality that is in keeping with Sansour's highly stylized works that would follow. In the final scene of *A Space Exodus*, Sansour the lonesome astronaut (a la Sandra Bullock in *Gravity*) peers at Earth, that blue marble, glistening—or perhaps smoldering with its apocalyptical forever wars—in the distance (figure 4.9).

A Space Exodus likewise echoes the roots of "astrofuturism" in the United States. This concept refers to the aesthetic, scientific, and political movement that developed amid mid-twentieth-century Cold War commitments to the space race, when outer space represented, on one hand, speculation about colonial explorations and the presumed imperial ends of US technological and political power, and, on the other, liberal and utopian ideals for solutions to the conflicts and perils of modern American life. In De Witt Kilgore's estimation, astrofuturists "sought the amelioration of racial difference and social antagonisms through the conquest of space."[123] The narratives of planetary exile that Kilgore reads have also been critical to Black freedom movements in the creative forms of Afrofuturism and Afro-surrealism. These stories feature African Americans and their diasporic counterparts cast out into space

FIGS 4.8 – 4.9 Larissa Sansour, *A Space Exodus*, 2009. Video, 05:24. Courtesy of Larissa Sansour and Lawrie Shabibi gallery.

in what Ramzi Fawaz describes as "the search for another planet on which to produce a culture free of the racism, genocidal mania, and hierarchical economic systems advanced by Eurocentrism and Western imperialism."[124] As Robin D. G. Kelley elegantly imparts further on the meaning of exodus and its imposition of isolation for the freedom dreams of African Americans and other racialized/colonized peoples, "The desire to leave Babylon, if you will, and search for a new land tells us a great deal about what people dream about, what they want, how they might want to reconstruct their lives. . . . Exodus provided black people with a language to critique America's racist state and build a new nation, for its central theme wasn't simply escape but a new beginning. Exodus represented dreams of black self-determination, of being on our own, under our own rules and beliefs, developing our own cultures, without interference."[125] And yet, as Fawaz observes in his treatment of the racial and colonial context of Afrofuturist cinema, "narratives of planetary exile often result in an investigation of the very world or worlds that one intends to escape, sometimes even more so than the supposedly utopian place of exile itself.[126]

Indeed, these Afrofuturist representations of exodus and maroon societies imply that one needs to be isolated in order to come fully into being. Sansour stands in as the solitary Palestinian femme figure searching for self-determination but equally isolated and disconnected from her people. We might consider how Native or Indigenous futurisms operate differently than Afrofuturisms and how the question of indigeneity necessitates different fantasy visions. Moreover, are Afrofuturist fantasies of settling other shores or other worlds fundamentally insufficient to the problem of settler colonialisms, especially when the incipient violence is expropriation and land theft rather than chattel slavery? Sansour's utopian vision here might not be able to escape fully the logic of settlement, given her figuration of a Palestinian astronaut planting a flag on the moon.[127]

Nevertheless, *A Space Exodus* not only conjures the echoes of Afrofuturist and astrofuturist political and aesthetic traditions; it also makes available a material critique of the present-day US/Israeli securitization of aerospace.[128] The piece calls attention to the contemporary logics of planetary war and terror in which aerospace represents the "final frontier" for both US and Israeli global counterinsurgency operations in their quest for "full spectrum dominance."[129] Historian Alfred McCoy has described, for instance, how the Obama administration "presided over a technological revolution in defense planning, moving the nation far beyond bayonets and battleships to cyberwarfare and the full-scale weaponization of space."[130] McCoy now warns that

"the occupations of Iraq and Afghanistan have served as the catalyst for a new information regime, fusing aerospace, cyberspace, biometrics, and robotics into an apparatus of potentially unprecedented power."[131] US security planners hope the integration of global aerospace weaponry will evolve "into a robotic command structure that would be capable of coordinating operations across all combat domains: space, cyberspace, sky, sea, and land."[132]

The advancement of military technologies and the constitutive illusion of techno-mastery ostensibly central to future US global dominion prompts the ultimate question: What do US counterinsurgency and atmospheric military politics in outer space have to do with Palestine/Israel (and the global security state apparatuses that structure the colonial present)? When analyzing the (outer-) planetary ambitions of US forever warfare, it is crucial to underline the transnational connections between the US and Israel as joint settler colonial security states, "whose sovereign claims to territorial jurisdiction have [both] drawn on shared covenantal narratives that underwrite the permanent dispossession of native peoples."[133] These insights call attention to the strategic collaborations between military and defense planners in the US and Israel and trace what Laleh Khalili calls the "horizontal circuits of securitization" that broadly characterize the post–Cold War era.[134] Beginning in the late 1980s during the drug wars and then later, after 9/11, there was a massive restructuring of what Alex Lubin calls "domestic and foreign police forces under the rubric of 'homeland security'" [that] paved the way for a transnational network of policing and military strategies across uneven 'occupied' areas including urban black communities in the US and occupied Palestine."[135] In the process, Lubin contends, "Palestinians and African Africans were both, in different ways, rendered as surplus populations, and therefore were viewed as potential threats—insurgents—that had to be contained via counterinsurgency (COIN) measures characterized by heightened security and military techniques as well as mass incarceration."[136] If, as many scholars have argued, Palestine is the "archetypal laboratory" for the development of new technologies of security and late modern warfare, then perhaps outer space can serve as the template and testing ground not only for US/Israeli global counterinsurgencies but also for utopian imaginings beyond the here and now of settler security violence. My point is that these security "experts" are not the only ones who share intelligence and information. Instead we benefit from turning to the radical networks of knowledge, affect, and affiliation that diasporic cultural producers (Afrofuturists and Arabfuturists alike) generate precisely for the queer feminist logics of freedom, fantasy, and flight that they manifest in their works.

Conclusion: Queer Escapology as Insurgent Aesthetics

In that spirit, and by way of conclusion, I want to revisit the final scene and premise of Sansour's lunar setting in A Space Exodus (figure 4.10). What is particularly queerly beautiful about Sansour's futurist vision of Palestine is that it neither elides the realities of Israeli occupation nor capitulates to a sense of its inevitability. The political messiness and contaminated status of the artist's visionary aesthetics aligns neatly with the strand of decolonial queer studies I have evoked in this chapter. After triumphantly planting the Palestinian flag, Larissa the Astronaut appears to lose radio connection with Jerusalem, the homeland. She calls out, "Jerusalem . . .? Jerusalem . . .?" but there is only radio silence from the other side. Some critics read this final scene as an allegory of the Palestinian people's tragic nightmare, a depressive sign of "the hollowness of [their] de-territorialization and the loss of [their] continuous temporality."[137] In her review of the piece, Palestinian American critic Helga Tawil-Souri laments that "even if we follow our dreams to the edge of the universe, even if we plant our flag on new territory, we will still feel defeated, we will still be lost, if there is no communication, no response, no connection to Jerusalem."[138] I want to suggest another reading of what happens when we follow Sansour's move through the Earth's upper atmosphere to outer space and linger otherwise in the lunar zone.

What might it mean to be lost in space: untethered, exiled, unbounded, cast out beyond the horizon, far from home?[139] If this represents the unshakable *dystopian here and now* of the Palestinian diasporic people (under constraints of Zionist framings), how might we imagine a "then and there" of Arabfuturist and queer feminist utopian possibility in the terms of the late, great José Esteban Muñoz?[140] Muñoz's prophetic contributions to queer utopian hermeneutics animate (haunt) my interest in Sansour's dystopic fantasy vision of a Palestinian "future" and in the intimacies of racialized and Indigenous bodies and their inhabitations writ large. In an early essay on "Gesture, Ephemera, and Queer Feeling," Muñoz reminds us that "the dispossessed are appropriately adept at critiquing possession as a logic."[141] "We can understand queerness itself as being filled with *the intention to be lost.* Queerness is illegible and therefore lost in relation to the straight minds' mapping of space. Queerness is *lost in space* or lost in relation to the space of heteronormativity."[142] We can identify here not only a repudiation of the dominant system of power and violence named "heteronormativity" but also, as I have explored in this chapter, the normative violence of settler colonial security states. In the final scene of A Space Exodus, the antagonisms

FIG 4.10 Larissa Sansour, *A Space Exodus*, 2009. Video, 05:24. Courtesy of Larissa Sansour and Lawrie Shabibi gallery.

on Earth have led to a sense of permanent exile, a forever quest to search for new homes. Sansour leaves us with a complex structure of feeling that is about not only statelessness but weightlessness, too. To be without gravity, untethered by the weight of the body and its inscriptions, is a *queer feminist decolonial sensation*. I dwell on the world-making dimensions of insurgent aesthetics to theorize forms of critical self-enactment and to advance new approaches to and concepts of queer feminist decolonial flight—of escape, of being illegible, of missing in action, perhaps of being unreadable even by the super-panoptic gaze of global security states as they try to reach up "all the way to Heaven."[143]

In closing, I have established in this chapter a critical intimacy with the sensuous projects of Larissa Sansour to "ask after other worlds" and to launch an inquiry into "how other worlds matter for being in this world."[144] If cosmic queerness is to be lost, then perhaps we don't want to be found, at least not on the security planner's map of settler colonial violence. Being lost, untethered, cast out into outer space gives us new ways of imagining the politics of verticality and atmospheric warfare as well as a generative decolonial queer praxis of sensing and feeling vulnerable in relation to others in the world. Searching for Palestine(s) in the sky, where Zionist strangleholds on the present are no more, enacts what Muñoz called a form of "politicized cruising": identifying and animating "affective and cognitive maps of the world that a critically queer utopianism can create, maps that *do* include uto-

pia."[145] By enfolding and unfolding Sansour's speculative visualities through Black and Indigenous futurist critiques, I have sought to infuse into accounts of Palestine's *dystopic here and now* a "renewed and newly animated sense of the social" that can be glimpsed and felt in Arabfuturist diasporic cultural production.[146] My contrapuntal queer feminist reading of these deterritorialized fantasies offers a form of insurgent aesthetics that critiques Israeli settler security state violence while simultaneously centering diverse modes of Palestinian insurgency. An analysis of Larissa Sansour's visionary aesthetics thus allows us to move beyond the perverse calculus of settler colonial violence to propose urgently needed alternatives to US/Israeli forever wars while also asking after Palestine's queer lifeworlds—past, present, future, and in the sky.

This disturbance of conventions of distance and proximity, the presence of many pasts and places in what we try to think of as the here and now, constitute wartime, modernity's everyday aftermaths—the undeclared wars that grieve not only the present absences but the absent presents—not so much a matter of ghosts as multiple worlds that a singular worldview cannot accommodate. —Caren Kaplan, *Aerial Aftermaths*

Wildness has certainly functioned as a foil to civilization, as the dumping ground for all that white settler colonialism has wanted to declare expired, unmanageable, undomesticated, and politically unruly. For us, that makes wildness all the more appealing. Like another problematical term—queer—wildness names, while rendering partially opaque, what hegemonic systems would interdict or push to the margins. Unlike the way claims have been made on behalf of the queer, we are not brushing off a rejected term and refurbishing it here so much as we are attending to what an idea has always gathered in its wake and what it gestures toward in terms of the expunged features of our own critical systems of making sense and order. It is time to rewild theory. —Jack Halberstam and Tavia Nyong'o, "Theory in the Wild"

In the Index of the Disappeared's *Afterlives of Black Sites I: The Seen Unseen*, Mariam Ghani and Chitra Ganesh offer a powerful indictment of the visual and affective legacies of former CIA black site prisons. More than one hundred secret prisons across thirty countries were operated by the CIA as part of an extrajudicial kidnapping, interrogation, and torture program during the Bush II era of the forever war.[1] In this project the artists embrace an

even wider scope to suggest that, "any place that has been temporarily made invisible by (tacit or explicit) agreement to *not see* something that clearly exists can also be understood as a black site—including 'temporary holding' zones used for extrajudicial interrogation, from Homan Square in Chicago to the Forward Operating Bases deployed by the US military."[2] If the ability to torture and disappear terror suspects (and then ultimately disavow the event altogether) is emblematic of forever war tactics, these artists instead evoke the ongoing enduring relation between the global wars on terror and the brutal domestic policing, surveillance, and imprisonment project perfected on racialized and migrant communities in the US, in effect bringing to light the "blackness" and "blackworlds" of the domestic and global ends of contemporary US state violence.[3]

In a group show titled "Mining Warm Data" at the 2016 Dhaka Art Summit, the Index's *Black Sites I* chiefly grappled with the recent so-called dark pasts and presents of US empire (plates 25 and 26).[4] As their first significant artistic collaboration in South Asia, the exhibit at the Dhaka Art Summit provided an opportunity to reroute the Index's venerable diasporic insurgent aesthetic collaboration in the US through a more intimate engagement with social geographies and nonwestern lifeworlds targeted by the global ends of the US forever war. The artists conducted field research in Afghanistan on former secret prisons and collaborated with local LED and neon sign makers in Bangladesh in advance of the art summit. The culminating installation included eight photo lightboxes and a signature series of watercolor portraits by Ganesh based on select firsthand witnesses of the black sites; a short film by Ghani exploring how and why information that is widely known remains officially denied; and a large neon sign that pairs a poignant phrase from an official description of the first prisoner waterboarded by the CIA with the Bangla expression "covering a fish with greens," signifying an attempt to cover up something that everybody already knows.[5] As viewers enter the installation's dark room, they are confronted by the blinding illumination of the neon sign, with its bluish hue, and the lightbox images, and are thus enveloped by the Index's long-standing aesthetic and conceptual concern with the interchange between visibility and invisibility and transparency and opacity.

Given the many open secrets of the forever war, including the use of black site prisons, the artists explore the war's discarded landscapes and built environments that are still hidden in plain view. They speculate on whether it is ever possible to view the ruins of a former black site "without seeing it through the veil of its previous life in the unseen."[6] In their field research,

Ghani and Ganesh discovered that "the feeling of looking at a place that was once a black site but has now had any trace of that use removed or again hidden from view, is remarkably similar to the feeling of looking at a heavily redacted document. The surface opacity both frustrates the viewer who seeks concrete knowledge and underlines the importance of that which is concealed."[7] If a surface refers to the outermost boundary of an object, the artists seek to penetrate that outer layer and conjure the innards of US empire lurking beneath. In order to replicate this sensorial disturbance, the Index used redaction patterns extracted from declassified documents, which they obtained from their long-standing archive about the geopolitical sites captured in the photographs, to alter their images in the lightbox series. The sensuous aesthetic effect is a distorted and fractal view of the original landscapes photographed by the artists—a "collective hallucination" that perfectly encapsulates what remains of knowledge in the wake of the forever war.

I have argued throughout *Insurgent Aesthetics* that the state uses abstract vision and limitless data to map racialized "Muslim" populations and innovate surveillance and intelligence-gathering procedures while simultaneously disowning its imperial violence on a number of fronts. This imperial paradox of transparency and opacity in discourses of state security manifests both in the gendered racialization of contemporary Arab, Muslim, and South Asian immigrant and refugee communities in the US and in insurgent aesthetic works, which cast light on the manifold unseen and disembodying technologies of secrecy and terror that define the forever war. In outlining and affirming the space for alternative sensuous conceptualizations of the disavowals and disembodiments of state security, I have demonstrated in this book how these insurgent aesthetic practices inhabit dominant categories otherwise, thereby contesting the stultifying logics and militarized tactics of US forever warfare in the realm of contemporary art and culture.

The Index of the Disappeared's *Afterlives of Black Sites* captures the US security state's perennial preoccupation with officially denying that which everyone already knows to be true, not least of all the many sites of carceral violence in its imperial wars. As I have argued, "warm data" is an insurgent aesthetic strategy and reparative intervention that poetically limns the fissures, failures, and absences in visual archives of global military detention. What is hidden from view within the US state's production of imperial transparency is a new imperial sensorium, a sensuous world of necropolitics that enfolds and also engenders US civic life. The Index's warm data reveals how quantitative or empirical ways of knowing political violence and war do not exist independently or outside the aesthetic and sensory modes that

are equally central to the US forever war. This interplay between transparency and opacity—a contrasting relation that is part of the same visual and discursive field—comes alive on the surface of art objects in this latest work by the Index. Its multiplicity of perspectives on the disturbed visual terrain of former black site prisons evokes what Caren Kaplan describes as "not only the present absences but the absent presences . . . that a singular worldview cannot accommodate."[8]

I return to the ongoing aesthetic and political collaboration of the Index of the Disappeared at the end of this book in order to revisit conceptual trajectories traced throughout and to signal insurgent aesthetic possibilities that expand those included in this study. Throughout *Insurgent Aesthetics*, I have mined this rich field of expressive culture and artistic responses to twenty-first-century global warfare in a search for forms of aesthetic possibility that open up alternative modes of knowing, sensing, living, escaping, and feeling in the forever war. If the forever war is an assault on the human sensorium for citizens, subjects, survivors, and refugees of US empire, I have chosen to center a queer feminist analysis of the performative body of the racialized and dispossessed to reveal a complex insurgency against empire's built sensorium. The imaginative works of art that I call "insurgent aesthetics" reassemble vision with the disqualified knowledges, histories, geographies, and memories preserved by the "lower" senses of empire's gendered racialized Others. In so doing, I show how the minoritarian body serves as a critical site for the acquisition of unorthodox and often unexpected political knowledge about security, terrorism, and warfare. A major goal of this book is not only to offer a diagnosis of how neoliberal security and warfare have constrained dominant lifeworlds and accelerated human suffering via the atrocities of war, but also to elucidate how these artists provide the designs for sensing other, more disobedient and arresting ways of being in the world.

By foregrounding the phenomenological and sensuous dimensions of war-making in aesthetic practices of contemporary artists from the South Asian and Middle Eastern diasporas, I documented how ascendant archives of the US forever war have worked to bury, obscure, abstract, misrecognize, and misremember alternative accounts of the forever war and its gendered racial-colonial targets in the Greater Middle East. In my close readings of diasporic art and performance, I offered a queer calculus as a critical framework to account for the US state's differential valuation of human life. If "calculus" implies a cold accounting of wartime facts and figures, these cultural works upend such an accounting, queering the process of archival production so as to constitute a different and more sensuous mode of reckoning

with the ultimately unaccountable devastations of war. A queer calculus of the forever war advances an account of both dominant knowledge apparatuses and data logics of the US security state and alternative logics, affects, emotions, and affiliations of diasporic subjects living and creating in the heart of empire. In so doing, a queer calculus makes intimate what is rendered distant, renders tactile what is made invisible, and makes unified what is divided, thereby conjuring up forms of embodied critique that can envision a collective world within and beyond the spaces of US empire's perverse logics of global carcerality, security, and warfare.

To conjure the "afterlives" of black sites is to imply that even as this imperial violence is not over and done, its shape and form have been transfigured. The forever war's flexible assemblage of tactics and strategies most certainly mutates by the day in the dystopian here and now. As this book attests, new and malleable forms of remote killing, torture, confinement, surveillance, and lawfare have built an unparalleled post–9/11 infrastructure of gendered, racialized state violence both within and beyond US borders, which in turn marks the historical present as a distinct age within the longue durée of US settler colonial society. As I detailed in chapter 1, the Bush/Obama war on terror and deportation regime have been exacerbated under the Trump presidency. Despite decades of neoliberal security and warfare policies, the ascent of Trump, and the parallel rise of protofascist, authoritarian regimes and political movements across the globe, signals a reamplification of securitized violence in the forever war. In this book I have argued that the US nation-state was constituted by its forever wars. How will these wars unmake its citizenry and forms of governance in the balance of the twenty-first century? How might we rethink insurgent aesthetics and sensuous affiliations in the context of accelerated American imperial decline and the rise of Trumpism? The botched efforts at "nation-building" in Iraq and Afghanistan over the past two decades combined with skyrocketing inequality, planetary destruction, and accelerated suffering across and within national boundaries all attest to the spectacularly failed nature of the twenty-first-century empire-state and presage the ends of the American Century.

Critic Tom Engelhardt refers to Trump as both the harbinger and architect of this imperial decline.[9] Trump's rhetoric lifts the veil of what has been long-standing policy. His reign over a militarized regime of lies presents a perfect encapsulation of the dominant sensorial life of empire: a sword of chaos, spectacle, duplicity, trolling, corruption, and catastrophe with a deeply gendered, racialized edge. The vicious inner and outer wars waged by the US are coming clearly into view. Under Trump, the US has greenlighted

an immense number of airstrikes, bombings, massacres, special operation forces, arbitrary raids, and land grabs (both in the US interior and overseas) with unprecedented levels of civilian casualties; unchecked military arms deals with despotic regimes; and potential new alliances with authoritarian or antidemocratic leaders with names like Erdogan, Putin, Duterte, Conte, Netanyahu, Bolsonaro, and Modi. On the domestic front, we have already witnessed white supremacist and revanchist calls for Muslim bans, border walls, militarized urban policing, child detention, sexual abuse, and family separation at the US-Mexico border; the billion-dollar business of migrant shelters; rampant government corruption; a proliferation of toxic cis hetero-masculinities; attacks on the free press; an incitement to greater ecological chaos and devastation; and colossal cuts to social spending and government regulations, spurring ever more radical upward redistributions of wealth.

We know that this sort of gendered racial capitalist violence spikes when empires start to fall. The current administration has sustained and inten-sified political assaults on migrants, refugees, workers, women, queer and trans people, poor people, sick and disabled people, and empire's vulnerable Others differentiated by categories of race, gender, sexuality, class, religion, ability, and national origin. Our historical moment is marked by the exer-cise of arbitrary inhumane state power trained primarily on those seen as outsiders to the empire-state. In this milieu, anti-Muslim, anti-Arab, and anti–South Asian racisms are embedded in both the domestic and global contexts of US empire. This reality necessitates a relational approach that addresses US militarism and foreign policies that target these groups with state violence and other forms of militarized oppression overseas and with domestic forms of carcerality, including entrapment, confinement, depor-tation, and surveillance across a range of institutional sites within the US.

On Trump's ascent, many critics take the long view of waning US in-fluence, noting an attrition in US global power throughout the twenty-first century. The US's authority to assert itself on the global stage has changed dramatically, notwithstanding Trump's swift dismantling of the postwar lib-eral internationalist order. As Alfred McCoy writes, "after 70 years of global dominion, America's geopolitical command of the axial ends of Eurasia—the central pillars of its world power—seems to be crumbling in a matter of months."[10] And yet the forever war and its legacies will endure. How might we capture the scope, scale, ambition, and impact of the US military empire and its everlasting forever wars of security and terror? How can we recon-cile that a military intervention that began in Afghanistan nearly two de-cades ago, after the attacks of September 11, 2001, has now bloomed into a

wide network of military conflicts that stretches over no less than seventy-six countries and has had an estimated cost of $6 trillion (as of late 2018), to say nothing of the literal trillions of dollars that reportedly are unaccounted for by the Pentagon?[11] A queer calculus indeed. It will take lifetimes to calm these catastrophic storms and halt these forever wars.

In this context, the search for alternative imaginaries and anti-imperialist designs could not be more urgent. This is the vital work of insurgent aesthetics alongside a broader constellation of radical acts and freedom dreams: to imagine dissident modes of refusal, ungovernability, and fugitivity as the bases for a revitalized insurgency against the forces of neoliberal security and warfare. This book has shown how culture and aesthetics participates in critical and transformative knowledge about America's global war-making within and outside the borders of the United States. These aesthetic works can inspire social movements laboring to dismantle oppressive regimes of racism, heteropatriarchy, Islamophobia, empire, and class exploitation that are at the root of inequality, precarity, materialism, and violence in its many forms. And yet, as queer theorist Juana Maria Rodríguez reminds us, "getting to the work of changing the world is not without its own hauntings. The paths of insurrection are well-trodden ground; the dusty layers of still visible tracks push through the surface of our political imaginations. Leaders, living and dead, have left us cartographies of insurgency. The comfort of a map is its tangibility, its promise of reaching the end of the journey. Maps are useful guides, but they are site-specific ideological constructions and are quickly dated by the earthquakes of history."[12]

What maps and sensuous visions of insurgency guide us now amid today's "earthquakes of history"? As I was completing this book in midsummer 2018, a few radical glimpses caught my eye. First, hundreds of thousands of protestors marched across London's streets to resist President Trump's boorish arrival to the UK. Facing imminent dissolution from its own #Brexit fiasco and an upsurge in radical-right nativism, the embattled conservative government of Prime Minister Theresa May reluctantly welcomed President Trump to Great Britain for a "working visit" in mid-July 2018. In London, the response to his voyage and retrograde global vision resounded. Protestors launched a giant inflated balloon depicting Trump as a screaming orange baby with a smartphone in hand (figures E.1–E.4). The aerial balloon baby was authorized by London's mayor Sadiq Khan, the city's first ethnic minority (and Muslim) leader, and it offered an apt rejoinder to the toxic atmospheres of white supremacy, heteropatriarchy, and xenophobia vitalized by Trumpism. Before the day's end, the internet was replete with memes of

FIGS E.1–E.4 Screen grabs of "Trump Angry Baby Balloon" protest, Trafalgar Square, London, July 13, 2018.

the president's image substituted by that giant inflated balloon baby in scenes with the prime minister, the first lady, and the queen of England. While the real Trump was busy fumbling his way through diplomatic spectacles of the US-UK "special relationship" and literally upstaging the queen, the inflated balloon baby version towered buoyantly above demonstrators in London's Trafalgar Square.[13]

The images (both real and photoshopped) of the angry orange baby offered a moment of much-needed levity in calamitous times. But the giant balloon reminds me of other atmospheric objects that limn the distance between air, spectrum, and ground, including not only today's armed unmanned aerial vehicles but also the first unmanned hot air balloon flight

The six-metre high caricature is a very visual symbol of anti-Trump sentiment in the UK

demonstrations above Versailles during the reign of Louis XVI in the late eighteenth century.[14] As detailed in Caren Kaplan's magisterial history of the "cosmic view from above," aerial imagery has profoundly reshaped how people perceive their worlds. For Kaplan, these world-making, panoramic views are tied to the times and places of war. New conjoined technologies of flight and photography posed a set of "new imaginative possibilities and embodied experiences" that were activated from modernity's bird's-eye views.[15] As *Insurgent Aesthetics* also has demonstrated, the contemporary field of vision is itself constituted through the war-making violence of security and furthermore is privileged by the state as the fundamental center of data and knowledge. My discussion of Larissa Sansour's speculative visualities in chapter 4 outlines the multiple vertical scales through which both US war-making and insurgent aesthetics manifest and abound.

FIG E.5 Patricia Okoumou scaling the Statue of Liberty base in protest of President Trump's border policies, New York City, July 4, 2018.

In fact, the Trump UK protest was the second time in two weeks where collective insurgencies against the violent global security order surfaced and were cast up in the sky. The first came a little over a week earlier, on the Fourth of July, when Congolese American activist Therese Patricia Okoumou fearlessly scaled the skirts of the Statue of Liberty in New York City to protest Trump's policies of family separation and zero-tolerance prosecution of migrants along the US-Mexico border (figure E.5). A personal trainer and activist living in Staten Island, New York, Okoumou migrated to the US from the Republic of Congo in 1994. She was part of a small contingent of Rise and Resist, a New York City–based activist group that had unfurled earlier that day a banner from the stone pedestal of the Statue of Liberty that read "Abolish ICE," referring to the Immigration and Customs Enforcement agency most associated with Trump's virulent border policies. Okoumou decided to take her solo protest even farther up, lingering in the thin copper folds of the Statue of Liberty to abscond from view and avert capture by the local police. After a four-hour standoff with the police, she was charged with, and ultimately convicted on, three federal misdemeanors (trespassing, disorderly conduct, and interfering with government functions).[16]

At the press conference following her sleepless night in federal custody, Okoumou emerged sporting a black T-shirt reading "White Supremacy Is Terrorism" (figures E.6 and E.7). In her moving remarks, with her fist in the air, she said, "Michelle Obama, our beloved First Lady who I care so much

FIGS E.6–7 Patricia Okoumou's press conference with lawyer Rhiya Trivedi,
July 5, 2018.

about, said, 'When they go low, we go high,' and I went as high as I could."
Her statement was a glorious declaration of the scalar and three-dimensional
world-making potential of insurgent acts of protest. Of course, as we know,
the Obama administration also "went high" through its disproportionate
use of drones. But Okoumou's South Asian Canadian lawyer Rhiya Trivedi
took a more hopeful tact, noting the irony of celebrating freedom and US
independence on Liberty Island. She said, "There are times when justice
demands that we transcend the law. I can think of no better time than the
4th of July, nor no better way to draw attention to the violence being done
in the name of borders, than to physically transcend those hallowed words

at the base of the Statue of Liberty—Give me your tired, your poor, your huddling masses."[17] Okoumou's gripping and gutsy protest called attention to unremitting state-sanctioned terror and border violence, as immigrants and refugees are divided and held indefinitely in detention centers. But she also visually asserted her own Black immigrant body at the center of this debate. In fact, Black immigrants (both refugees and asylees) are one of the fastest growing demographics in the US, and they routinely experience what writer Shamira Ibrahim calls "the dual threat of bias in the criminal-justice system and cruelty in the immigration and deportation system."[18] Okoumou offers us a complex model of Black migrant femme fugitivity—a method of insurrectionary and transcendent trespass that rejects the perverse calculus of the forever war.

I conclude this book with a reflection on that grainy aerial image of Okoumou crouched atop the base of the Statue of Liberty in her bright pink running shoes on the Fourth of July (figure E.8). In the midst of all the calamities and fresh horrors that surround us, Okoumou was calm and composed throughout the four-hour siege. She said that she feared the police would shoot or tranquilize her. She shouted to the officer that "my life doesn't matter to me now, what matters to me is that in a democracy we are holding children in cages."[19] A queer calculus indeed. Her standoff with police ended as the officers eventually edged around the statue's base and seized her body, leading to her arrest and detention in federal custody. That night in confinement, she says she experienced "a strange tranquility": "'I felt peaceful, that I was with those children in spirit. I could feel their isolation and their cries being answered only by four walls.'"[20] Through it all, Okoumou inhabited a critical praxis of the Wild.[21] How else to interpret her defiant feat of scaling Lady Liberty than as a return to the wilds brought on by the vicissitudes of imperial decline? The vision of wildness and wilding that she gives us here is not a recourse to some mythic past or disconnected future, but a queer recognition in the here and now that the world we inhabit is unrelenting and not enough. Okoumou's solitary perch on the Statue of Liberty's pedestal effectively asserted her utopian refusal to come down until the world had been transformed (figures E.9 and E.10). Because she knows that reformist gestures continuously fail to address the violences of the state, she adopts an anarchic approach that charts another path. This is a solo return to the remote spaces of the unknown wilderness in response to the *known violences* of the colonial present and the criminal disorder of things. The present moment of crisis is giving us these riotous visions and sensations of the wild. If only we would respond to their call with our collective energies.

FIGS E.8–10 Patricia Okoumou scaling the Statue of Liberty base in protest of President Trump's border policies, New York City, July 4, 2018.

This wayward return to the wild and wild things is not unpolluted. As queer critics Jack Halberstam and Tavia Nyong'o write, "We live in wild times; we bear witness to wild and ruinous places. No history of wildness can be pure or clean. The idea inheres to colonial fantasies of the primitive. It spurs pioneer dreams of unpopulated space; it fuels eugenic fantasies of social control. It emerges as the other to fascist principles of order, symmetry, and blood purity . . . [and] there are still multiple ways in which the wild remains a potent location in a febrile colonial and antiblack imaginary."[22] And yet, wildness can equally conjure an "anarchic longing" "for those who have been forcibly gathered under its sign."[23] This is an exemplary illustration of why the messy and contaminated forms of insurgency, freedom, fantasy, and flight that I have sought to prioritize in this queer decolonial account of the forever war are so consequential for transforming the dystopian here and now. What remains to be seen is how the contradictions of the present historical conjuncture of imperial decline and imperial expansion will assemble new techniques of security expertise and practices of gendered and racialized governance that alter the dominant calculus of life and death on this planet. I have suggested here that the insurgent cultural forms that emanate from this moment of global political crisis and instability offer powerful clues that signal a necessary moment of collective reckoning and an opening to imagine outside and beyond the stranglehold of US empire and its forever wars.

This book has centered the expansive world-making knowledge practices of Arab, Muslim, and South Asian diasporic multimedia artists and activists who hail from societies beset by war but who live and labor in the heart of empire in order to rethink the strategies, technologies, geographies, and strategic ambitions of contemporary US neoliberal security and warfare. It has pursued a queer feminist fugitive critique of the US military's desire for "full spectrum dominance," with a slantwise relation to the multiple disparate scales and sites of the body, land, air, spectrum, and sky, as well as affective and sensuous experiences that exceed the visual frame. My hope is that this close engagement with the insurgent creative practices of these conceptual artists will allow us to "disrupt neat narratives of freedom and escape" and compel us to think, feel, and imagine otherwise about the manifold violences of the social world.[24] It may also help us reckon with and reimagine anew our own intimate affective relation and collusion with the militarized surveillance and securitization projects of US empire. If we follow the visionary lead of Okoumou, Sansour, Ghani, Ganesh, and the many other creative

practitioners convened in these pages, we might be able to peer down at the ground queerly and with fresh perspective. We might begin to train our gaze on and stimulate our other senses with the felicitous cracks and folds and lines of flight in what the forever war has waged and to begin once again the work of exploiting and amplifying forms of fugitivity, refusal, and rebellion that take us as far and as high as we all can go.

INTRODUCTION

1. The history of drone technologies and airpower stretches across the long twentieth century and has deep roots in European colonial modernity. First developed for military reconnaissance, surveillance, and intelligence gathering, drone technologies emerge out of the history of British colonial administration and policing and have become the preferred tool for twenty-first-century US military and security planners across South Asia, Africa, and the Greater Middle East. See my extended discussion of the genealogies and geopolitics of drone technologies in chapter 1. See also Bashir and Crews, *Under the Drones*; M. Benjamin, *Drone Warfare*; Chamayou, *A Theory of the Drone*; Gregory, "Drone Geographies"; Grosscup, *Strategic Terror*; Gusterson, *Drone*; C. Kaplan, *Aerial Aftermaths*; Parks and Kaplan, *Life in the Age of Drone Warfare*; Scahill, *The Assassination Complex*; Shaw, *Predator Empire*; Turse and Engelhardt, *Terminator Planet*.

2. Shaw, "Scorched Atmospheres," 690; Gregory, "Drone Geographies."

3. Bumiller and Shanker, "War Evolves With Drones"; Sell, "From Blimps to Bugs"; Wilcox, "Drones, Swarms, and Becoming-Insect."

4. In this book, I adopt the regional designation of the "Greater Middle East" to describe the primary geopolitical sites of US global war-making in the twenty-first century. I do so with some critical hesitation, given the term's area studies and military origins and imperfect capture of the proliferating sites of counterterrorism and counterradicalization across the African continent. This phrase resurfaced in the early 2000s in critical security studies circles to describe a regional imperial cartography that encompasses, according to historian Andrew J. Bacevich, "a vast swath of territory stretching from North and West Africa to Central and South Asia," from Morocco to the western edge of China (Bacevich, *America's War for the Greater Middle East*, xxii). See also Yambert, *Security Issues in the Greater Middle East*. Other cartographic terms attempt to delimit or describe US military intervention and security planning in this contiguous region, including MENASA (Middle East, North Africa, and South Asia) or SSWANA (South and Southwest Asia and North Africa). The latter in particular emerges out of progressive diasporic political and cultural spaces that sought to interrogate the historical and social contexts of empires, colonialism, independence, authoritarianism, Islamism, secularism, and revolution. Scholars and activists have also grappled with the "naming problem" to index the post–9/11 formation and consolidation of the "new and terribly broad racial category, which can only be described along the lines of 'Arab-Middle Eastern-South Asian-Muslim'" (Naber, *Arab America*, 252).

5. Cavallaro et al., *Living under Drones.* "Af-Pak" refers to an imperial cartography and cross-border region historically occupied by the Pashtun ethnic group. White House strategist Richard Holbrooke coined the term in 2008. The Af-Pak designation is interesting both for its regional geopolitical implications and for area studies knowledge projects more generally. In popular use, Pakistan has increasingly become disentangled from South Asia and newly sutured to the Middle East, given its renewed importance as a "failed state" and reluctant collaborator in the US global war on terror over the past two decades. Pakistan is a particularly vital geostrategic ally to the US in its global war on terror, and the two countries have maintained a long-standing, if fragile, patron-client relationship (tied to antiterror and antidrug campaigns, militarism, and international migration). Political theorist Kiren Aziz Chaudhry's essay on US militarism in Af-Pak succinctly describes the changing geopolitical dimensions of the region. See Chaudhry, "Dis(re)membering \Pä-ki-'stän\." See also Rana, "The Globality of Af-Pak"; and Tahir, "The Containment Zone."

6. Shaw and Akhter, "The Unbearable Humanness of Drone Warfare in FATA, Pakistan."

7. Rafiq ur Rehman, "Please Tell Me, Mr. President, Why a US Drone Assassinated My Mother," *Guardian*, October 25, 2013, https://www.theguardian.com /commentisfree/2013/oct/25/president-us-assassinated-mother.

8. Reprieve, the British human rights group, together with Brave New Foundation, helped the Rehman family travel to Washington. The hearing was attended by only five members of Congress. Those attending were all Democrats: Rush Holt of New Jersey, Jan Schakowsky of Illinois, John Conyers of Michigan, Rick Nolan of Minnesota, and Alan Grayson, the Florida Democrat who invited the family to Washington and held the hearing.

9. Karen McVeigh, "Drone Strikes: Tears in Congress as Pakistani Family Tells of Mother's Death," *Guardian*, October 29, 2013, https://www.theguardian.com /world/2013/oct/29/pakistan-family-drone-victim-testimony-congress (accessed June 21, 2018).

10. McVeigh, "Drone Strikes."

11. Mahwish Chishty is a contemporary visual artist of Pakistani origin who has exhibited nationally and internationally at venues such as University of Technology (UTS Gallery), Sydney, Australia; Boghossian Foundation, Villa Empain, Brussels, Belgium; Utah Museum of Contemporary Art; Museum of Contemporary African Diasporan Arts (MOCADA), Brooklyn, New York; Imperial War Museum, London, UK; and Gandhara Art Gallery, Karachi, Pakistan. See more of her work online at http://www.mahachishty.com/ (accessed June 11, 2018).

12. On the history of Pakistani truck art (and the use of paintings, calligraphy, ornamental décor such as mirror work, wooden carvings, chains, and pendants), see Paracha, "The Elusive History and Politics of Pakistan's Truck Art."

13. See Khong, "Mahwish Chishty."

14. See, e.g., Mughal, "Pakistan's Indigenous Art of Truck Painting."

15. See images from Chishty's *Drone Art* series online at http://www.mahachishty .com/drone-art-series/ (accessed June 11, 2018).

16. My use of "the forever war" in this book also echoes the 1974 science fiction novel and ultimate series by American author Joe Haldeman inspired by his experience serving in the US Vietnam War as well as the 2009 nonfiction work by investigative war correspondent Dexter Filkins on US wars in Afghanistan and Iraq. See Haldeman, *The Forever War*; and Filkins, *The Forever War*. See also Danner, *Spiral*; and the Editorial Board, "America's Forever Wars," *New York Times*, October 22, 2017, https://www.nytimes.com/2017/10/22/opinion/americas-forever-wars.html.

17. See "Quadrennial Defense Review Report," February 6, 2006, http://archive.defense.gov/pubs/pdfs/QDR20060203.pdf (accessed January 9, 2019). See also Bacevich, *The Long War*; N. Singh, *Race and America's Long War*.

18. I credit Sora Y. Han for this critical formulation. See Han, *Letters of the Law*.

19. Engelhardt, "Mapping a World from Hell." On US and Israeli permanent warfare, see K. Feldman, *A Shadow over Palestine*; and N. Singh, *Race and America's Long War*.

20. For broad overviews on the costs and consequences of US war-making across the long twentieth century in the Greater Middle East, see Bacevich, *America's War for the Greater Middle East*; Dower, *The Violent American Century*; Engelhardt, *Shadow Government*; O. Khalil, *America's Dream Palace*; McCoy, *In the Shadows of the American Century*.

21. Engdahl, *Full Spectrum Dominance*; Shaw, *Predator Empire*, 22.

22. Gregory, "The Everywhere War."

23. See, e.g., Engelhardt, *Shadow Government*; A. Feldman, "Securocratic Wars of Public Safety"; C. Johnson, *Sorrows of Empire*; A. Kaplan, "Where is Guantánamo?"; Parks and Kaplan, *Life in the Age of Drone Warfare*; Lubin, "The Disappearing Frontiers of US Homeland Security"; Medovoi, "Dogma-Line Racism" and "Global Society Must Be Defended"; Mirzoeff, *The Right to Look*; Shaw, *Predator Empire*; Vine, *Base Nation*.

24. S. Dillon, *Fugitive Life*, 22. My use of "fugitivity" is informed most centrally by works on the afterlives of slavery in Black studies. See, e.g., Campt, *Image Matters* and *Listening to Images*; Gumbs, *Spill*; Harney and Moten, *The Undercommons*; Hartman, *Scenes of Subjection* and *Lose Your Mother*; and Moten, *In the Break*.

25. My use of "freedom dreams" is inspired by Robin D. G. Kelley's evocative phrase in his treatment of the twentieth-century Black radical imagination in domains of communism, surrealism, and radical feminism. See Kelley, *Freedom Dreams*.

26. The term "empire" has various theoretical and historical genealogies, which I cannot elaborate fully here, but this book provides an analysis of empire as a key framework for understanding the political and cultural shifts before and after 9/11. Recent scholarship on the cultural and political dimensions of modern US empire, particularly works oriented toward the Greater Middle East and South Asia, are crucial to my theorization of the queer calculus of the forever war. Culled from the last twenty-five years of innovations at the nexus of American studies and postcolonial criticism, these scholarly works examine the material and ideological dimensions of US empire. While this study emphasizes the role of race and racism in the

historical emergence of the US in the international order, I want to underscore my commitment to advancing scholarship that attends to the intersectional logics of race, gender, sexuality, class, religion, citizenship, and ability. These social markers are enduring categories within American studies and related fields of critical ethnic studies, queer studies, gender and women's studies, and disability studies, among others. Intersectional feminist and queer of color theorizing perhaps has gone furthest in detailing the importance of analyzing multiple social determinations. My use of "intersectionality" aims to convey not "multiple identities" but convergent and diverse modes of recognition and particularity. As evidenced by several recent cultural histories of the domestic and international context of empire, imperial race-making was a deeply gendered process. Gender and sexuality are constitutive to European and US forms of imperialism not only as allegories for the politics of dominance but as concrete material organizations of power, including practices and ideologies of race, which centrally sustain colonial projects both within the metropole and colony. The following works advance intersectional analyses of race, gender, class, sexuality, and citizenship in imperial formations that serve as exemplars for the present study: Briggs, *Reproducing Empire*; Lowe, *Immigrant Acts*; McClintock, *Imperial Leather*; Morgan, *Laboring Women*; Renda, *Taking Haiti*; Saldaña-Portillo, *Indian Given*; N. Shah, *Contagious Divides*; N. Silva, *Aloha Betrayed*; A. Smith, *Conquest*; Stoler, *Carnal Knowledge and Imperial Power*; and Weinbaum, *Wayward Reproductions*.

27. On the centrality of visuality and war-making, see, e.g., J. Butler, *Frames of War*; Chow, *Age of the World Target*; Dawson, "Drone Executions"; A. Feldman, *Archives of the Insensible*; K. Feldman, "Empire's Verticality"; Hochberg, *Visual Occupations*; C. Kaplan, *Aerial Aftermaths*; Kozol, *Distant Wars Visible*; Mirzoeff, *The Right To Look*; W. J. T. Mitchell, *Cloning Terror*; Parks, *Rethinking Media Coverage*; Virilio, *War and Cinema*. See also chapter 1 of this book.

28. My invocation of the "Muslim world" (as something other than an abstract geographic term performing a racial Orientalism) is informed by anthropologist Zareena Grewal's assertion that "rather than a foreign region, the Muslim world is a global community of Muslim locals, both majorities and minorities who belong to the places where they live and who, in their totality, exemplify the universality of Islam." See Grewal, *Islam Is a Foreign Country*, 6–7. See also Aydin, *The Idea of the Muslim World*.

29. My use of "contrapuntal" is indebted to the postcolonial work of Edward Said, who, borrowing from music, described the dialectic between literary and cultural narratives set in the European metropole at the height of empire and the colonies upon which the great powers depended for their wealth. See Said, *Culture and Imperialism*.

30. For representative works examining liberal empires and late modern warfare broadly defined, see, e.g., Amar, *Security Archipelago*; J. Butler, *Frames of War*; Dillon and Reid, *Liberal Way of War*; Dower, *The Violent American Century*; Grewal, *Saving the Security State*; C. Kaplan, *Aerial Aftermaths*; Khalili, *Time In the Shadows*; Maira, *Missing*; Martin, *An Empire of Indifference*; Masco, *Theater of Operations*; McCoy, *A Question of Torture*; Mirzoeff, *The Right to Look*; Neocleous, *War Power, Police*

Power; M. Nguyen, *Gift of Freedom*; Reddy, *Freedom with Violence*; N. Singh, *Race and America's Long War*.

31. This book joins the growing scholar activist effort to expose the ideological and material links between various sites of contemporary US global state violence. Throughout, I place the global concept of "homeland security" in dialogue with seemingly more domestic concepts such as "mass incarceration" and "police violence." I do so to underscore the blurring between the domestic and foreign fronts in the US forever war and to call attention to the imaginative forms of coalitional activism that have emerged in response. I use the concept of the homeland to describe a broader constellation of interests and ideologies that extend beyond the sovereign borders of the state. Following scholars such as Amy Kaplan and Alex Lubin, "the homeland" refers to a transnational space that can include urban US cities and distant battlefields in the global war on terror. In a similar fashion, "military urbanism" refers to the militarization of urban spaces. The idea explains how Western militaries and security forces have come to perceive all urban terrain as a conflict zone inhabited by lurking shadow enemies. Thus, if war, terrorism, and security are now the grammar through which collective social life is viewed and regulated across urban spaces in the United States, one of the central tasks of this book is to explore how insurgent artists and cultural producers have begun to resist and reimagine these militarized frames of war and the manifold forms of violence enacted in their name. On the homeland, see A. Kaplan, *Anarchy of Empire*; and Lubin, "The Disappearing Frontiers of Homeland Security." On military urbanism, see Graham, *Cities under Siege*.

32. Paglen, *Blank Spots on the Map*.

33. The "human terrain" was a controversial US Army Training and Doctrine Command program (2005–15) aimed at counteracting the intelligence communities' perceived inadequate cultural and historical knowledge and cultural interpretive capacities in counterinsurgency operations in the Global South. It involved "embedding" anthropologists, sociologists, linguists, and other social scientists with combat brigades to better "interpret" and "understand" local cultures. The idea of the "human terrain" stretches back nearly fifty years to the infamous US House Un-American Activities Committee (HUAC) report about the perceived threat of Black Panthers and other so-called militant groups. As such, the HTS program has a much longer genealogy of US domestic counterinsurgencies that predates the post–9/11 global war on terror. See González, *American Counterinsurgency*; and Kelly et al., *Anthropology and Global Counterinsurgency*.

34. Khalili, *Time in the Shadows*, 7.

35. Amin, Musser, and Pérez, "Queer Form," 227.

36. On critical race/queer/feminist formalist approaches to minoritarian aesthetics and corporeal modes of knowing, see, e.g., Amin et al., "Queer Form"; Getsy, "Queer Relations"; Leigh, Ganesh, and McMillan, "Alternative Structures." See also Alvarado, *Abject Performances*; Bradley, "Other Sensualities" and *Resurfaced Flesh*; Doyle, *Hold It Against Me*; Fleetwood, *Troubling Vision* and *Marking Time*; Halberstam, *Queer Art of Failure*; Harper, *Abstractionist Aesthetics*; Holland, Ochoa,

and Tompkins, "On the Visceral"; Horton-Stallings, *Funk the Erotic*; Lee, *Exquisite Corpse of Asian America*; McMillan, *Embodied Avatars*; Muñoz, *Cruising Utopia*; S. Ngai, *Ugly Feelings*; Nyong'o, *Afro-Fabulations*; J. Rodriguez, *Sexual Futures*; See, *Decolonized Eye* and *Filipino Primitive*; C. Smith, *Enacting Others*.

37. For more on the efflorescence of radical political fervor in 1990s South Asian and Arab diasporic arts and activism in the US, see, e.g., Das Gupta, *Unruly Immigrants*; Kapadia et al., "Artist Collectives in Post-2001 New York"; Maira, *Desis in the House*; Mathew, *Taxi*; Naber, *Arab America*; Prashad, *Karma of Brown Folk*; Sudhakar et al., "Crafting Community."

38. Formative sources for my analysis of body politics in critical race, queer, feminist, and postcolonial theory include Ahuja, *Bioinsecurities*; P. Anderson, *So Much Wasted*; Balce, *Body Parts of Empire*; D. Brooks, *Bodies in Dissent*; J. Butler, *Bodies That Matter*; Casper and Moore, *Missing Bodies*; E. E. Edwards, *The Modernist Corpse*; Espiritu, *Body Counts*; Fleetwood, *Troubling Vision*; Halberstam, *In A Queer Time and Place*; McSorley, *War and the Body*; Muñoz, *Disidentifications*; Nash, *Black Body in Ecstasy*; Pérez, *A Taste for Brown Bodies*; Rosenberg and Fitzpatrick, *Body and Nation*; Salamon, *Assuming a Body*; Scarry, *The Body in Pain*; Schalk, *Bodyminds Reimagined*; Sedgwick, *Touching, Feeling*; Serlin, *Replaceable You*; Shah, *Contagious Divides*; Stoler, *Haunted By Empire*; Tompkins, *Racial Indigestion*; and Wilcox, *Bodies of Violence*.

39. See Chuh, *The Difference Aesthetics Makes*; Fleetwood, *Marking Time*; Lloyd, *Under Representation*; See, *Filipino Primitive*; Weheliye, *Habeas Viscus*.

40. Sharpe, *In the Wake*, 14. See also Chuh, *Imagine Otherwise*.

41. The interdisciplinary field of critical security studies focuses on the role of interpretation in the articulation of danger, expanding the field's traditional emphases on the international system and the nation-state and its military capacities. More recent objects of study that push past the state-centrism of political scientific approaches to security include global health, the environment, human rights, peacebuilding efforts, media, popular culture, and technology. Representative works in critical security and international relations studies include Amar, *The Security Archipelago*; Booth, *Critical Security Studies and World Politics*; Burke, *Beyond Security, Ethics and Violence*; Campbell, *Writing Security*; Crandall and Armitage, "Envisioning the Homefront"; Cowen, *Deadly Life of Logistics*; Croser, *The New Spatiality of Security*; Der Derian, *Virtuous War*; Dillon and Reid, *Liberal Way of War*; Dillon and Lobo-Guerrero, "Biopolitics of Security in the 21st Century"; Foucault, *Security, Territory, Population*; Graham, "Laboratories of War"; Ochs, *Security and Suspicion*; Price-Smith, *Contagion and Chaos*; Qureshi and Sells, *New Crusades*; Reid, *Biopolitics of the War on Terror*; Shalhoub-Kevorkian, *Security Theology, Surveillance, and the Politics of Fear*; K. Silva, *Brown Threat*; Thomas, *Empires of Intelligence*.

42. For an influential post–9/11 political treatise that builds on the work of German theorist Carl Schmitt to theorize the emergency suspension of law for preserving the juridical order, see Agamben, *State of Exception*. For works that link the expansion of the national security state to neoliberal capitalism, see, e.g., Camp, *Incarcerating the Crisis*; Camp and Heatherton, *Policing the Planet*; Clarno, *Neoliberal*

Apartheid; Davis, *Abolition Democracy* and *Freedom Is a Constant Struggle*; Friedman, *Covert Capital*; Gilmore, *Golden Gulag*; Gonzales, *Reform Without Justice*; Grewal, *Saving the Security State*; Hall et al., *Policing the Crisis*; Hardt and Negri, *Empire*; Kelley, "Thug Nation"; Loyd, Mitchelson, and Burridge, *Beyond Walls and Cages*; Sudbury, *Global Lockdown*; Rana, *Terrifying Muslims*; Wacquant, *Punishing the Poor*.

43. Historians of the twentieth-century United States periodize the emergence of the national security state to the National Security Act of 1947. Passed by Congress under President Harry Truman, this law radically restructured the US government's military and intelligence agencies and policing power after World War II. On the origins of the national security state, see Hogan, *A Cross of Iron*. Aside from the military reorganization and the creation of the Air Force and the Defense Department, the National Security Act of 1947 established the National Security Council (NSC), a center of coordination for national security policy in the executive branch, and the Central Intelligence Agency (CIA), the US's first peacetime nonmilitary intelligence agency, originally imagined as a clearinghouse for foreign policy intelligence and analysis. Under the chairmanship of the president, the NSC coordinates domestic, foreign, and military policies with the secretaries of state and defense, and reconciles diplomatic and military commitments and requirements. By contrast, the CIA reports to the director of national intelligence (since the 2004 creation of the Intelligence Reform and Terrorism Prevention Act) and is charged with gathering and analyzing national security information from around the world, primarily through the acquisition of human intelligence (HUMINT). Unlike the Federal Bureau of Investigation (FBI), a domestic security service, the CIA has no law enforcement function and has primarily operated overseas, including its long-standing covert paramilitary operations throughout the Cold War and its twenty-first-century expansion of global militarized activities since the September 11 attacks. For instance, since early 2017, the Trump administration has reversed an Obama-era policy of giving more responsibility for terrorist drone strikes in Af-Pak to the Pentagon. The CIA has resumed charge for not only generating intelligence but also conducting drone strikes across the Greater Middle East. See David Welna, "Trump Restores CIA Power to Launch Drone Strikes," *NPR: All Things Considered*, March 14, 2017, https://www.npr.org/2017/03/14/520162910/trump-restores-cia-power-to-launch-drone-strikes/.

44. Marxist-inflected historiography has periodized the crisis of Fordism in the 1970s as a decisive turning point in the history of capitalism. On how capital and the state's response to the crisis produced a new historical conjuncture now captured under the sign of "neoliberalism," see, e.g., Arrighi, *The Long Twentieth Century*; Duggan, *Twilight of Equality?*; Hardt and Negri, *Empire*; and Harvey, *A Brief History of Neoliberalism* and *Condition of Postmodernity*.

45. N. Singh, *Race and America's Long War*, xiii.

46. Grewal, *Saving the Security State*, 2. See also Jelly-Schapiro, *Security and Terror*; and Schotten, *Queer Terror*.

47. N. Singh, *Race and America's Long War*, xi.

48. Murakawa, *First Civil Right*.

49. N. Singh, *Race and America's Long War*, xiii.

50. Camp, *Incarcerating the Crisis*.

51. Camp, *Incarcerating the Crisis*, 15.

52. Camp, *Incarcerating the Crisis*, 5.

53. Camp, *Incarcerating the Crisis*, 13.

54. On how these penal and policing transformations signal the latest period in a long history of US government warfare and state violence against domestic populations of color, see M. Alexander, *The New Jim Crow*; Berger, *Captive Nation*; Camp, *Incarcerating the Crisis*; Childs, *Slaves of the State*; A. Davis, *Abolition Democracy*; Dayan, "Due Process and Lethal Confinement"; Dillon, *Fugitive Life*; Forman, *Locking Up Our Own*; Gilmore, *Golden Gulag*; Guenther, *Solitary Confinement*; Hames-Garcia, *Fugitive Thought*; Hanhardt, *Safe Space*; Hinton, *From the War on Poverty to the War on Crime*; James, *Warfare in the American Homeland*; Meiners, *For The Children?*; Murakawa, *First Civil Right*; Muhammad, *Condemnation of Blackness*; D. Rodriguez, *Forced Passages*; Seigel, *Violence Work*; Spade, *Normal Life*; Sudbury, *Global Lockdown*; Stanley and Smith, *Captive Genders*; Wacquant, *Punishing the Poor*.

55. Centre for Contemporary Cultural Studies, *Empire Strikes Back*; Hall et al., *Policing the Crisis*.

56. McClintock, *Imperial Leather*, 5. See also Crenshaw, "Mapping the Margins."

57. See also J. Butler, "Merely Cultural"; and Duggan, *Twilight of Equality?*

58. For critical surveillance studies approaches, see Beauchamp, *Going Stealth*; Browne, *Dark Matters*; Camp, *Incarcerating the Crisis*; Camp and Heatherton, *Policing the Planet*; I. Feldman, *Police Encounters*; Fernandes, *Targeted*; Finn, *Capturing the Criminal Image*; Kumar, *Islamophobia and the Politics of Empire*; Kundnani, *The Muslims Are Coming!*; Lyon, *Electronic Eye* and *Surveillance Society*; Masco, *Theater of Operations*; McCoy, *Policing America's Empire*; Monahan, *Surveillance in the Time of Insecurity*; N. Nguyen, *Curriculum of Fear*; Puar, *Terrorist Assemblages*; Rana, *Terrifying Muslims*; Rodriguez, *Suspended Apocalypse*; Selod, *Forever Suspect*; Shapiro, *Cinematic Geopolitics*; Sohi, *Echoes of Mutiny*; Theoharis, *Abuse of Power*.

59. Kundnani and Kumar, "Race, Surveillance, and Empire."

60. Hong, "Neoliberalism," 64n6. On the long history of social movements and political contestations around the racialized and imperialist functions of capital, see Lenin, *Imperialism*; James, *State Capitalism and World Revolution*; E. Williams, *Capitalism and Slavery*; Robinson, *Black Marxism*; Rodney, *How Europe Underdeveloped Africa*; Lowe, *Immigrant Acts*.

61. On warfare/military studies, see Adey, Whitehead, and Williams, *From Above*; Al-Ali and Al-Najjar, *We Are Iraqis*; Bacevich, *Long War* and *America's War for the Greater Middle East*; Cowen, *Military Workfare*; Farish, *Contours of America's Cold War*; Friedman, *Covert Capital*; Gillem, *America Town*; Gusterson, *People of the Bomb*; N. Singh, *Race and America's Long War*.

62. The Centre for Contemporary Cultural Studies (CCCS) at the University of Birmingham was inaugurated in 1964 as a postgraduate interdisciplinary research institute under the directorship of Richard Hoggart. The Centre is credited with

founding "modern" British cultural studies, which developed in the late 1950s and early 1960s out of efforts by the New Left to challenge assumptions held by the Old Left. See, in particular, the work of Raymond Williams (*Marxism and Literature*). Especially in the 1970s, the Birmingham Centre drew on works by Adorno, Benjamin, Althusser, and Gramsci as they were translated and published in *New Left Review*. CCCS sought to distinguish "popular" culture as a mode of textual and everyday practice from "mass" or "consumerist" culture. By exploring culture and the media anthropologically and discursively as lived experiences, this mode of scholarship, like that of the Frankfurt school, rejected the economic determinism of earlier Marxist formulations of culture, giving "voice" to the disempowered in terms of class, and later of gender, race, and migration. Unlike the Frankfurt school, however, the Birmingham school attempted to understand mass cultural consumption from the vantage point of consumers rather than producers. This approach is particularly legible in the transformations of the Centre under the directorship of Stuart Hall. CCCS appropriated Gramsci's insights on the "national-popular" to make sense of the new Thatcher regime's "great moving right show" and the changes in British working-class subcultures. This is evident in Stuart Hall's influential essays on Thatcherism, which isolate how the media constructed and built up the crime of "mugging" and the social type of the "mugger," thus conflating these notions with racial minorities and wider social ills. Hall et al.'s *Policing the Crisis* laid the groundwork for the early interventions of Hazel Carby and Paul Gilroy in *The Empire Strikes Back*, the pioneering study of the centrality of race and migration in the crisis of popular Labourism in the aftermath of Thatcher's 1979 victory and the race riots of the early 1980s. See Centre for Contemporary Cultural Studies, *The Empire Strikes Back*; Hall, *Cultural Studies 1983*; Hall et al., *Policing the Crisis*. For a compilation of the pioneering intellectual works (by Stuart Hall, Paul Gilroy, Hazel Carby, and Kobena Mercer) that emphasized the need to reexamine British racism in relation to its specific historical and social manifestations, rather than viewing it as a universal constant across the range of human encounters, see Baker, Diawara, and Lindeborg, *Black British Cultural Studies*.

63. On the Black radical tradition, see Robinson, *Black Marxism* and *Forgeries of Memory and Meaning*. See also Carby, *Reconstructing Womanhood*; Davis, *Abolition Democracy*; Gilmore, "Abolition Geography and the Problem of Innocence"; Gilroy, *Black Atlantic*; Gordon, *Keeping Good Time*; Johnson and Lubin, *Futures of Black Radicalism*; Kelley, *Freedom Dreams*; Morse, "Capitalism, Marxism, and the Black Radical Tradition"; Moten, *In the Break*; McKittrick, *Demonic Grounds* and *Sylvia Wynter*; Ransby, *Ella Baker and the Black Freedom Movement*; Redmond, *Anthem*; N. Singh, *Black Is a Country*.

64. Lowe and Lloyd, *The Politics of Culture in the Shadow of Capital*, 32n37.

65. Lowe, *Immigrant Acts*, 22. For an extension of this critical cultural materialist tradition in ethnic, queer, and feminist studies, see Ahuja, *Bioinsecurities*; Chuh, *Imagine Otherwise*; Ferguson, *Aberrations In Black*; Gopinath, *Impossible Desires*; Hong, *Ruptures of American Capital* and *Death Beyond Disavowal*; Hong and Ferguson, *Strange Affinities*; Jodi Kim, *Ends of Empire*; Melamed, *Represent and Destroy*;

Reddy, *Freedom With Violence*; Williams, *Divided World*. See also Duggan, *Twilight of Equality?*; Muñoz, *Cruising Utopia*; J. Rodriguez, *Queer Latinidad*; Saldaña-Portillo, *Revolutionary Imagination*.

66. Hong, *Ruptures of American Capital*, xxiv, xxxi.

67. For a sampling of works on the cultures of US imperialism in American studies, see Kaplan and Pease, *Cultures of United States Imperialism*; Dawson and Schueller, *Exceptional State*; Edwards, *After the American Century*; Grewal, *Transnational America* and *Saving the Security State*; Hoganson, *Fighting for American Manhood*; Imada, *Aloha America*; Kaplan, *Aerial Aftermaths*; Lowe, *Immigrant Acts* and *Intimacies of Four Continents*; Lye, *America's Asia*; McAlister, *Epic Encounters*; Renda, *Taking Haiti*; Schueller, *U.S. Orientalisms*; Shah, *Contagious Divides*; and Wexler, *Tender Violence*.

68. For ethnographic reflections of the gray areas between life and death, where people endure a difficult present without any recourse to a redeeming future, see Wool and Livingston, "Collateral Afterworlds."

69. Queer "world-making," following José Esteban Muñoz, and via the artwork of Carmelita Tropicana and Jack Smith, describes how "performances—both theatrical and everyday rituals—have the ability to establish alternate views of the world. . . . They are oppositional ideologies that function as critiques of oppressive regimes of 'truth' that subjugate minoritarian people." See Muñoz, *Disidentifications*, 195. Of such a "world-making project" in queer politics of the early 1990s, Lauren Berlant and Michael Warner also wrote, "We are trying to promote this world-making project, and a first step in doing so is to recognize that queer culture constitutes itself in many ways other than through the official publics of opinion culture and the state, or through the privatized forms normally associated with sexuality. *Queer and other insurgents* have long striven, often dangerously or scandalously, to cultivate what good folks used to call criminal intimacies. We have developed relations and narratives that are only recognized as intimate in queer culture. . . . Queer culture has learned not only how to sexualize these and other relations, but also to use them as a context for witnessing intense and personal affect while elaborating a public world of belonging and transformation. Making a queer world has required the development of kinds of intimacy that bear no necessary relation to domestic space, to kinship, to the couple form, to property, or to the nation. These intimacies do bear a necessary relation to a counterpublic-an indefinitely accessible world conscious of its subordinate relation. They are typical both of the inventiveness of queer world making and of the queer world's fragility" (Berlant and Warner, "Sex in Public," 558; emphasis mine).

70. Cline, *A Calculating People*; McKittrick, "Mathematics Black Life," 17. See also Morgan, "Accounting for 'The Most Excruciating Torment.'"

71. Works in the vibrant fields of queer of color, queer diaspora, and queer Native/Indigenous studies are by now too vast to name comprehensively here, but for a collection of several major insights and interventions into the field of queer studies, see Eng, Halberstam, and Muñoz, eds., "What's Queer about Queer Studies Now?" For key works in queer of color critique, see Cohen, "Punks, Bulldaggers, and Welfare Queens"; Ferguson, *Aberrations in Black*; Fiol-Matta, *Queer Mother for the Nation*;

Holland, *Erotic Life of Racism*; Keeling, *Witch's Flight*; Muñoz, *Disidentifications*; Pérez, *A Taste for Brown Bodies*; Reddy, *Freedom with Violence;* Rodriguez, *Queer Latinidad*; Soto, *Reading Chican@ Like a Queer.* For queer diasporic critique (and its refusal to reify notions of home, nation, and diaspora), see M. J. Alexander, *Pedagogies of Crossing*; Eng, *Racial Castration* and *Feeling of Kinship*; Gopinath, *Impossible Diasporas* and *Unruly Visions*; Manalansan, *Global Divas*; Puar, *Terrorist Assemblages*; Tinsley, *Thiefing Sugar* and *Ezili's Mirrors*; Tongson, *Relocations*; Walcott, *Queer Returns.* On queer Native/Indigenous studies, see Barker, *Critically Sovereign*; Byrd, *Transit of Empire*; Driskill et al., *Queer Indigenous Studies*; Morgensen, *Spaces Between Us*; Rifkin, *Settler Common Sense*; and Tatonetti, *Queerness of Native American Literature.*

72. See Elia et al., *Critical Ethnic Studies.*

73. Reddy, *Freedom with Violence*; Hong and Ferguson, *Strange Affinities.*

74. See Duggan, "Making it Perfectly Queer"; Harper et al., "Queer Transexions of Race, Nation, and Gender"; and Eng et al., "What's Queer about Queer Studies Now?"

75. Farsakh et al., "Queering Palestine."

76. See, e.g., Agathangelou, Bassichis, and Spira, "Intimate Investments"; Amin, *Disturbing Attachments*; Haritaworn, *Queer Lovers*; Mikdashi and Puar, "Queer Theory and Permanent War"; Morgensen, *Spaces Between Us*; Puar, *Terrorist Assemblages.*

77. See, e.g., Dillon, *Fugitive Life*; Gandhi, *Affective Communities*; Halberstam, *The Queer Art of Failure*; Muñoz, *Disidentifications* and *Cruising Utopia*; Horton-Stallings, *Funk the Erotic*; Musser, *Sensational Flesh*; S. Ngai, *Ugly Feelings*; J. Rodriguez, *Sexual Futures*; Vargas, "Ruminations"; Gumbs, *Spill* and *M Archive*; L. Simpson, *As We Have Always Done.*

78. For a canonical work in feminist security studies, see Enloe, *Bananas, Beaches and Bases.* For more recent intersectional feminist, queer, and trans* treatments of state security and surveillance, see, e.g., Ahuja, *Bioinsecurities*; Beauchamp, *Going Stealth*; J. Butler, *Precarious Life* and *Frames of War*; Dubrofsky and Magnet, *Feminist Surveillance Studies*; Grewal, *Saving the Security State*; Hanhardt, *Safe Space*; C. Kaplan, *Aerial Aftermaths*; Puar, *Terrorist Assemblages* and *The Right to Maim*; Terry, *Attachments to War*; Wilcox, *Bodies of Violence.*

79. Tompkins, "Intersections of Race," 174.

80. Martin, *Empire of Indifference*, 16.

81. Martin, *Empire of Indifference*, 16. For a posthumanist queer critique of the drive toward mastery in anticolonial politics and postcolonial studies, see J. Singh, *Unthinking Mastery.*

82. For a sample of influential works on the archival impulse across critical race, postcolonial, queer, and feminist studies, see Amin, *Disturbing Attachments*; Arondekar, *For the Record*; Arondekar et al., "Queering Archives"; Balce, *Body Parts of Empire*; Baucom, *Specters of the Atlantic*; J. Butler, *Frames of War*; Cvetkovich, *An Archive of Feelings*; Derrida, *Archive Fever* and *Specters of Marx*; Freccero, "Queer Spectrality"; Fuentes, *Dispossessed Lives*; Gray and Gómez-Barris, *Toward a Sociol-*

ogy of the Trace; A. Gordon, *Ghostly Matters* and *Hawthorn Archive*; Halberstam, *In a Queer Time and Place*; Luk, *Life of Paper*; Manalansan, "The 'Stuff' of Archives"; Muñoz, *Cruising Utopia*; Weld, *Paper Cadavers*.

83. Muñoz, "Ephemera as Evidence." See also Ahmed, *Living a Feminist Life*.

84. Muñoz, "Ephemera as Evidence," 10.

85. Muñoz, "Gesture, Ephemera, and Queer Feeling," 423. See also Luciano and Chen, "Queer Inhumanisms"; and Muñoz, "Theorizing Queer Inhumanisms."

86. Muñoz, "Ephemera as Evidence," 7.

87. Muñoz, "Ephemera as Evidence," 6.

88. Hong, "Ghosts of Transnational American Studies," 38.

89. Hong, "Ghosts of Transnational American Studies," 38.

90. A. Gordon, "Some Thoughts on Haunting and Futurity."

91. A. Gordon, *Ghostly Matters*, 200.

92. For discussions of "contagion" in relation to US national forms of racialized and sexualized citizenship, see Ahuja, *Bioinsecurities*; W. Anderson, *Colonial Pathologies*; Chen, *Animacies*; N. Shah, *Contagious Divides*; and Wald, *Contagious*.

93. Simon, *Governing Through Crime*, 263.

94. Deer, "Ends of War and the Limits of War Culture," 1, emphasis mine.

95. Mirzoeff, *Right to Look*, 278.

96. Mirzoeff, *Right to Look*, 300.

97. J. Butler, *Frames of War*, ix.

98. The increasingly abundant and diverse strands of critical race, ethnic, queer, feminist, postcolonial, STS, posthumanist, nonhuman, and new materialist approaches to affect and cultural theory are far too vast to summarize here. Let me pause briefly to elaborate on the terminological slippage that often occurs within these studies and that also informs my approach. Feeling, emotion, affect, and perception all capture different concepts, and it would be useful to distinguish between terms without becoming overly didactic. "Emotion" (from the Latin *emovere*) conventionally means "to move out," whereas "affect" is linked to acting or acting on: "affect refers to the effects of actions on one, on how one has been affected" (Flatley, *Affective Mapping*, 200n3). Emotion is psychological insofar as it requires at least a minimally interpretive experience whose physiological aspect is named "affect." Some theorists, for example, Rei Terada (*Feeling in Theory*) consider "feeling" the most capacious term because it combines physical sensations (affects) with psychological states (emotions). It is, in effect, a way of emphasizing the common ground between the physiological and the psychic. I am drawn to Terada's work not only because she attends to the nonsubjective aspects of emotion, but also because she is skeptical of the "surge in academic study of feeling" (14–15). She wonders "where the attraction to emotion comes from and why it comes just now. . . . Historically, the idea of emotion has been activated to reinforce notions of subjectivity that could use the help. They also suggest that people deploy emotion in *epistemologically defensive* ways. Criticism's newfound thematization of emotion may be no exception; rising feeling may acknowledge and ward off antinomies in institutional life and thought. *Conversation about emotion often attempts to supply a sense of substantial-*

ity and purpose where there is and sometimes should be none" (15; emphasis mine). Brian Massumi's *Parables for the Virtual* addresses the slippages between theorizing affect and emotion (along with their attendant narratives of sensation and perception). Instead of focusing on subject formation, Massumi believes that the body itself is the site of affect and resistance. Affect is thus impersonal (preontological; in fact, "ontogenetic"). Finally, Jasbir K. Puar departed from emergent scholarship in queer studies of the early 2000s through her embrace of accounts of affect inspired by Gilles Deleuze and Brian Massumi. Puar's work is important in that it attends to the reactionary aspects of the incorporation of minoritarian subjectivities in national democratic formations and agendas, specifically the articulation of apparently queer political themes and concerns within the discourses of the war on terror, what she terms "homonationalism." In her account of turbaned Sikh bodies, Puar troubles analyses of affect as inhering within the minoritarian subject (and thus functioning, for José Muñoz and others, as a mode of connectivity among various historically coherent groups). Puar's book epilogue offers perhaps the most succinct, if slightly reductive, mapping of the "split genealogy" emerging within recent scholarship under the "affective turn" in poststructuralist theory (206–7). This spectrum of writing is marked, on one hand, by "spheres of techno-science criticism" situated in a Deleuzian frame (Massumi, Hardt, Hardt and Negri, Clough, Parisi, De Landa) and, on the other, "queer theory on emotions and tactile knowings" that follows from Raymond Williams's seminal work on "structures of feeling" (Muñoz, Ahmed, Sedgwick, Cvetkovich, Flatley, Gopinath). While the latter prioritizes modes of communal belonging, views affect as sutured to the subject, and remains "interchangeable with emotion, feeling, expressive sentiment," the former theorizes affect as a "physiological and biological phenomenon, signaling why bodily matter *matters*, what escapes or remains outside of the discursively structured and thus commodity forms of emotion, of feeling" (207). The scholarly stakes are far more variegated than this quick sketch allows, but Puar's analysis does reveal the problem scholars encounter when navigating the genealogies and trajectories of contemporary affect studies. What follows is a nonexhaustive list of works that influence my reading of embodiment and the senses emerging from literary/performance studies: Berlant, *Queen of America Goes to Washington City* and *Cruel Optimism*; Bradley, "Other Sensualities"; Chen, *Animacies*; Cvetkovich, *Archive of Feelings*; Doyle, *Hold It Against Me*; Eng, *Racial Castration* and *Feeling of Kinship*; Flatley, *Affective Mapping*; Gandhi, *Affective Communities*; Gopinath, *Unruly Visions*; Horton-Stallings, *Funk the Erotic*; H. Love, *Feeling Backward*; Luciano and Chen, "Queer Inhumanisms"; McMillan, "Introduction: Skin, Surface, Sensorium"; Muñoz, *Disidentifications* and *Cruising Utopia*; S. Ngai, *Ugly Feelings*; J. Rodriguez, *Sexual Futures*; Sedgwick, *Touching, Feeling*; Tadiar, *Things Fall Away*; R. Williams, *Marxism and Literature*. For anthropology, see Mahmood, *Politics of Piety*; Masco, *Theater of Operations*; Povinelli, *Empire of Love*; Stewart, *Ordinary Affects*; Stoler, *Along the Archival Grain*. For philosophy (including psychoanalytic work on trauma*)*, see Ahmed, *Cultural Politics of Emotion* and *Queer Phenomenology*; Brennan, *Transmission of Affect*; J. Butler, *Precarious Life*; Ioanide, *Emotional Politics of Racism*; Massumi, *Parables for the Virtual*; Protevi, *Political Af-*

fect; Puar, *Terrorist Assemblages*; Rancière, *Dissensus*; J. Singh, *Unthinking Mastery*; Terada, *Feeling in Theory*. For key anthologies, see Clough and Halley, *The Affective Turn*; Clough and Willse, *Beyond Biopolitics*; Gregg and Seigworth, *The Affect Theory Reader*; and Staiger, Cvetkovich, and Reynolds, *Political Emotions*.

99. See J. Butler, *Frames of War*; C. Kaplan, *Aerial Aftermaths*; Mirzoeff, *The Right to Look*; Parks, *Rethinking Media Coverage*. On music in torture, see, e.g., Daughtry, "Thanatosonics"; Goodman, *Sonic Warfare*.

100. Casper and Moore, *Missing Bodies*, 16.

101. Muñoz, *The Sense of Brown*.

102. Deer, "Ends of War," 1.

103. Rana, *Terrifying Muslims*, 93.

104. Martin, *Empire of Indifference*, 5

105. Martin, *Empire of Indifference*, 5.

106. Volpp, "The Citizen and the Terrorist."

107. On the "naming problem" plaguing the range of groups profiled (both racially and politically) in the post–9/11 backlash and beyond, see Maira, *The 9/11 Generation*, 14–15.

108. For notable exceptions and critical interventions in Asian American studies, see, e.g., Afzal, *Lone Star Muslims*; Ameeriar, *Downwardly Global*; Chan-Malik, *Being Muslim*; Grewal, *Islam Is a Foreign Country*; Maira, *Missing* and *The 9/11 Generation*; Rana, *Terrifying Muslims*; Razack, *Casting Out*; Selod, *Forever Suspect*.

109. Maira, *Missing*, 9.

110. Chow, *Age of the World Target*; Mohanty, *Feminism without Borders*; Shohat, *Taboo Memories*. For foundational contributions to understanding the role of culture in colonial modernity, see Said, *Orientalism* and *Culture and Imperialism*. Said's work has been instrumental in the academic formation of colonial discourse analysis, but unsurprisingly, many scholars have since developed nuanced critiques of his analysis and its applicability to US imperialism. For an elaboration of the perceived functionalism, problematic mapping of gendered colonial metaphors, and lack of historicity in Said's work, see Kramer, *Blood of Government*, 5; Lowe, *Immigrant Acts*, 178n7; McAlister, *Epic Encounters*, 11; Miyoshi and Harootunian, *Learning Places*; Shohat, *Taboo Memories*, 364–79; and Stoler, *Carnal Knowledge and Imperial Power*.

111. Select works in the interdisciplinary fields of Arab/Muslim/South Asian/Middle Eastern diaspora studies that inform this book's approach include Abufarha, *The Making of a Human Bomb*; L. Abu-Lughod, "Do Muslim Women Really Need Saving"; Asad, *On Suicide Bombing*; Bayoumi, *How Does It Feel To Be A Problem?*; Cainkar and Maira, "Targeting Arab/Muslims/South Asian Americans"; J. Cole, *Engaging the Muslim World*; Das Gupta, *Unruly Immigrants*; Daulatzai, *Black Star, Crescent Moon*; Grewal, *Transnational America* and *Saving the Security State*; Gopinath, *Impossible Desires* and *Unruly Visions*; A. Gordon, "Abu Ghraib"; Husain, *Voices of Resistance*; A. Kaplan, "Where is Guantánamo?"; Maira, *Missing* and *The 9/11 Generation*; Maira and Shihade, "Meeting Asian/Arab American Studies"; Mahmood, "Feminism, Democracy, and Empire"; Mani, *Aspiring to Home*; McClintock, "Paranoid Empire"; Menon, "Where is West Asia in Asian America?"; Mishra, *Desis*

Divided; Naber, *Arab America*; Prashad, *Karma of Brown Folk* and *Uncle Swami*; Puar, *Terrorist Assemblages* and *The Right to Maim*; Rana, *Terrifying Muslims*; and Volpp, "The Citizen and the Terrorist."

112. This study identifies differential modes of sensuous affiliation that have been deemed illicit, illegitimate, unthinkable, or, as in Gayatri Gopinath's formulation, "impossible." See Gopinath, *Impossible Desires* for an account of the non-nuclear forms of kinship and nonreproductive modes of diasporic belonging that she names "queer diasporas." The emphasis here is less on "locating" homosexuals historically or same-sex-desiring subjects and more on attending to the modes of communal belonging, emotion, and economies of desire that together constitute one of the basic ways of establishing value, of assessing and adjudicating the world. See also Flatley, *Affective Mapping*; Gandhi, *Affective Communities*; and Muñoz, *Cruising Utopia*.

113. Povinelli, *Empire of Love*, 24. For queer and/or anticolonial approaches to intimacy, see Chen, *Animacies*; Eng, *Feeling of Kinship*; Gopinath, *Impossible Desires*; Kunzel, *Criminal Intimacy*; Lowe, *Intimacies of Four Continents*; Mendoza, *Metroimperial Intimacies*; Povinelli, *Empire of Love*; and N. Shah, *Stranger Intimacy*.

114. J. Butler, *Frames of War*, xxx.

115. On the long history of US imperial security governance, see Jelly-Schapiro, *Security and Terror*. For an elaboration of how the current global war on terror is connected to histories of European imperial expansion, see E. Ho, "Empire through Diasporic Eyes." For a comparative account of imperialisms that investigates the "subterranean stream" linking imperialism in Asia and Africa with the emergence of genocidal, totalitarian regimes in Europe, see Arendt, *Origins of Totalitarianism*. Arendt was among the first to claim that European theories of racial superiority (and their totalitarian ends) were in part produced by the economic expansion into, and exploitation of, much of the darker nations, as well as the development of global white settler colonies. While Black diasporic intellectuals such as W. E. B. Du Bois, Aimé Césaire, and Frantz Fanon long assailed the links between colonialism and fascism in their works, seeing colonial racism in Black Africa and racism in metropolitan Europe and the US as twin violences; no other postwar white European critic of totalitarianism or fascism other than Hannah Arendt indicted the European imperial encounter as part of their analysis of totalitarianism. While many historians on the left now see Arendt's work as an outmoded or problematic Cold War polemic that is used to defend democratic liberalism, her (admittedly schematized) "Boomerang Thesis" in part two of *Origins* allows us to understand better how imperialism and colonialism played crucial roles in creating the conditions of possibility for totalitarianism in Europe (*Origins of Totalitarianism*, 206–21). In other words, it proffers a way of characterizing the link between empire and the European heartland, a situation in which she says the "stage seemed to be set for all possible horrors. Lying under anybody's nose were many of the elements which gathered together could create a totalitarian government on the basis of racism" (221). For a critique of the limitations of Arendt's analysis for her inability "to reckon the deeply skewed, racially exclusionary character of US democracy," see N. Singh, "Afterlife of Fascism," 81. For work that builds on Arendt's innovative conception of "origins" and locates the uniqueness of

fascism in the crystallization of the West's various forms of violence, see Traverso, *Origins of Nazi Violence*.

116. For critical scholarly accounts of US national/security that inform this study, see Amar, *Security Archipelago*; Cainkar, *Homeland Insecurity*; Camp, *Incarcerating the Crisis*; Camp and Heatherton, *Policing the Planet*; Cowen, *Deadly Life of Logistics*; Feldman, *Police Encounters*; Gonzales, *Reform Without Justice*; Grewal, *Saving the Security State*; Hevia, *Imperial Security State*; Jelly-Schapiro, *Security and Terror*; C. Kaplan, *Aerial Aftermaths*; O. Khalil, *America's Dream Palace*; Khalili, *Time in the Shadows*; Kumar, "National Security Culture"; Martin, *Empire of Indifference*; Masco, *Theater of Operations*; F. Scott, *Outlaw Territories*; Shaw, *Predator Empire*; N. Singh, *Race and America's Long War*; Terry, *Attachments to War*; Wacquant, *Punishing the Poor*. For more journalistic and popular accounts, see Engelhardt, *Shadow Government*; Fernandes, *Targeted*; Giroux, *Public in Peril*; Greenberg, *Rogue Justice*; Greenwald, *No Place to Hide*; Johnson and Weitzman, *The FBI and Religion*; Priest and Arkin, *Top Secret America*.

117. Grewal, *Saving the Security State*.

118. On the intensification of anti-Arab, anti-Muslim, anti–South Asian, and anti-Palestinian racisms in the United States after 9/11, see Alsultany, *Arabs and Muslims in the Media*; Bayoumi, *How Does It Feel to Be a Problem?* and *This Muslim American Life*; Bazian, "The Islamophobia Industry and the Demonization of Palestine"; Cainkar, *Homeland Insecurity*; Chan-Malik, *Being Muslim*; Daulatzai and Rana, *With Stones in Our Hands*; Kumar, *Islamophobia and the Politics of Empire*; Kundnani, *The Muslims are Coming!*; E. Love, *Islamophobia and Racism in America*; Maira, *Missing* and *The 9/11 Generation*; Naber, *Arab America*; Rana, "The Racial Infrastructure of Terror-Industrial Complex" and *Terrifying Muslims*; Salaita, *Anti-Arab Racism in the U.S.A.* and *Uncivil Rites*; Selod, *Forever Suspect*; Sheehi, *Islamophobia*. For pedagogical approaches to the study of anti-Muslim racism in the United States, see "Islamophobia is Racism," https://islamophobiaisracism.wordpress.com/.

119. Recent exceptions to the absence of sustained scholarship on contemporary art, performance, and visual culture in relation to war and empire in studies of Arab/Muslim/South Asian diasporas include Cable, "Cinematic Activism"; Gopinath, *Unruly Visions*; Mameni, "Dermopolitics"; Mani, *Haunting Visions*; Patel, *Productive Failure*; and Schlund-Vials, *War, Genocide, and Justice*.

120. I am inspired by the critical utopian impulse in works such as brown and Imarisha, *Octavia's Brood*; Chuh, *Imagine Otherwise*; Gumbs, *Spill*; Halberstam, *The Queer Art of Failure*; Harney and Moten, *The Undercommons*; Horton-Stallings, *Funk the Erotic*; Kelley, *Freedom Dreams*; Muñoz, *Cruising Utopia*; See, *Decolonized Eye*; and L. Simpson, *As We Have Always Done*.

121. Key works in contemporary Arab/Muslim American studies that inform my study include Abdul Khabeer, *Muslim Cool*; Alsultany, *Arabs and Muslims in the Media*; Bayoumi, *This Muslim American Life;* Bayoumi, *How Does It Feel To Be a Problem?*; Cainkar, *Homeland Insecurity*; Chan-Malik, *Being Muslim*; Fadda-Conrey, *Contemporary Arab-American Literature*; Daulatzai, *Black Star, Crescent Moon*; K. Feldman, *A Shadow Over Palestine*; Grewal, *Islam Is a Foreign Country*; Gual-

tieri, *Between Arab and White*; Iyer, *We Too Sing America*; Jarmakani, *An Imperialist Love Story*; Lubin, *Geographies of Liberation*; E. Love, *Islamophobia and Racism in America*; Maira, *The 9/11 Generation*; Naber, *Arab America*; Pennock, *Rise of the Arab American Left*; Puar, *Terrorist Assemblages*; Rana, *Terrifying Muslims*; Shaheen, *Reel Bad Arabs*.

122. E. Ahmad, "Counterinsurgency," 36–37.

123. One vivid example of the bleeding effect of US counterterror and counter-insurgency policies is the dramatic growth in carceral strategies directed at other migrant populations during the homeland security era. For the impact on US Latinx/Latin American politics, see, e.g., Buff, *Against the Deportation Terror*; De Genova and Peutz, *Deportation Regime*; Gonzales, *Reform Without Justice*; Macías-Rojas, *From Deportation to Prison*; Márquez, "Juan Crow"; Schreiber, *Undocumented Everyday*.

124. E. Ahmad, "Counterinsurgency," 37.

125. Mamdani, *Good Muslim, Bad Muslim*. As Sunaina Maira adds, "the template for the War on Terror was manufactured in the 1980s to demonize those resisting US hegemony and US allies in the Middle East, particularly Israel, and led to the 'sutur-ing of Israel and the US as defenders of 'Western' values against 'Islamic fanaticism' (Kundnani 2014, 45). So Zionist ideology and the Palestine question have long been a 'shadow' in US imperial culture and race matters even if they have not always been acknowledged as constitutive of debates about 'liberal freedom and colonial vi-olence' and key to U.S. domestic as well as foreign policies in relation to Arabs, Mus-lims, and anticolonial resistance, as argued by Keith Feldman (2015, 2). . . . [Maira's] book recenters the question of Palestine in theorizing the long War on Terror and the politics of solidarity with the Palestinians as a crucial site for the production of an anti-imperial politics" (Maira, *The 9/11 Generation*, 5).

126. Razack, *Casting Out*. On the "Muslim International" and the policing of the "Muslim," see, e.g., Bayoumi, *This Muslim American Life*; Daulatzai, *Black Star, Crescent Moon*; Daulatzai and Rana, *With Stones in Our Hands*; Kumar, *Islamopho-bia and the Politics of Empire*; Kundnani, *The Muslims Are Coming!*; Rana, *Terrifying Muslims*.

127. Daulatzai and Rana, "Writing the Muslim Left," xi.

128. Daulatzai and Rana, *With Stones in Our Hands*.

129. The discourse of American exceptionalism, and its attendant disavowal of empire, haunts every period of US historiography. Put simply in the terms of Robert Vitalis, "exceptionalism" contrasts "one's own nation's distinctiveness to every other people's sameness—to general laws and conditions governing everything but the special case at hand" (*America's Kingdom*, 280n5). Vitalis notes that the term "can be traced back to a particular academic paradigm at the onset of the Cold War and its embrace by professional history writing and those social science frameworks that look like history writing" (280n5). But the tradition of exceptionalism gained cur-rency much earlier, first through the mobilization of key documents in the history of the early republic, including George Washington's "Farewell Address" in 1796 and the Monroe Doctrine of 1823 (Rowe, *Post-Nationalist American Studies*, 3). These docu-

ments have been read as signaling a clean break from the darker history of Europe, "specifically the history of feudalism, class stratification, imperialism and war" (3). Thomas Jefferson's "Empire of Liberty" and Frederick Jackson Turner's classic "frontier thesis" represent later elaborations (1893). The work of New Western historians in the 1980s significantly challenged Turner's thesis. Exceptionalism later morphed again when commentators argued that the US receded into isolationism after World War I. The Cold War and post–9/11 periods also witnessed significant resurgences of the exceptionalist charge. For divergent explications of American exceptionalism and its implications for US history writing, see Asad, *On Suicide Bombing*; Dawson and Schueller, *Exceptional State*; Rodgers, *Atlantic Crossings*; and Westad, *The Global Cold War*.

130. Daulatzai and Rana, "Writing the Muslim Left," xi. Hatem Bazian defines Islamophobia as "a contrived fear or prejudice fomented by the existing Eurocentric, postcolonial, and orientalist global power structures. It is directed at a constructed global Muslim threat, which is used to maintain and extend existing disparities in economic, political, social, and cultural relations." See Bazian, "The Islamophobia Industry and the Demonization of Palestine," 1064n3.

131. J. Singh, *Unthinking Mastery*, 20.

132. Weheliye, *Habeas Viscus*, 2. On the differentiation between "Man" and "human," in the work of Sylvia Wynter, where "Man" refers to the particularly Western, secular, imperial instantiation of the human, see McKittrick, *Sylvia Wynter*. See also Jackson, "Animal"; and Warren, *Ontological Terror*.

133. Gilmore, "Abolition Geography and the Problem of Innocence," 237. My approach to insurgent consciousness is further inspired by Guha, *Elementary Aspects of Peasant Insurgency in Colonial India* and "The Prose of Counter-Insurgency." For other formative sources, see, e.g., E. Ahmad, "Counterinsurgency"; Center for Contemporary Cultural Studies, *The Empire Strikes Back*; Camp, *Incarcerating the Crisis*; Hall et al., *Policing the Crisis*; Harney and Moten, *Undercommons*; James, *Warfare in the American Homeland*; Kelley, *Hammer and Hoe*; Khalili, *Time in the Shadows*. My approach to insurgent knowledge further conjures Michel Foucault's concept of "subjugated knowledges," which he defined as "a whole series of knowledges that have been disqualified as nonconceptual knowledges, as insufficiently elaborated knowledges: naive knowledges, hierarchically inferior knowledges, knowledges that are below the required level of erudition and scientificity" (Foucault, *Power/ Knowledge*, 81–82).

134. Prashad, *Darker Nations*.

135. On Native North American and Native Pacific studies critiques of the long history of the US (settler) state, see Day, *Alien Capital*; Dunbar-Ortiz, *An Indigenous People's History of North America*; Goldstein, *Formations of United States Colonialism*; Hernández, *City of Inmates*; Ross, *Inventing the Savage*; Shigematsu and Camacho, *Militarized Currents*; Saranillio, *Unsustainable Empire*; and Stark, "Criminal Empire."

136. For works that trace the political, philosophical, and historical genealogies of security and terror across the long history of the US/North America, see, e.g.,

Dunbar-Ortiz, *An Indigenous People's History of North America*; Jelly-Schapiro, *Security and Terror*; Lowe, *Intimacies of Four Continents*; Razack, *Casting Out*; and N. Singh, *Race and America's Long War*.

137. Lowe, *Intimacies of Four Continents*. Lowe's account of the problem of narrating synchronous histories of racialization and colonization is worth quoting at length: "Because ongoing settler projects of seizure, removal, and elimination are neither analogous to the history and afterlife of racial slavery, nor akin to the racialized exploitation of immigrant laborers, the discussion of settler colonialism cannot be simply folded into discussions of race without reckoning with the difference. Jodi A. Byrd observes that 'Racialization and colonization have worked simultaneously to other and abject entire peoples so they can be enslaved, excluded, removed, and killed in the name of progress and capitalism,' but cautions that we do not 'obfuscate the distinctions the two systems of dominance and the coerced complicities amid both.' In other words, liberalism comprises a multi-faceted, flexible, and contradictory set of provisions that at once rationalizes settler appropriation and removal differently than it justifies either the subjection of human beings as enslaved property, or the extraction of labor from indentured emigrants, however much these processes share a colonial past and an ongoing colonial present. In this book, I stress that the differentially situated histories of indigeneity, slavery, industry, trade, and immigration give rise to linked, but not identical, genealogies of liberalism. I focus on relation across differences rather than equivalence, on the convergence of asymmetries rather than the imperatives of identity" (Lowe, *Intimacies of Four Continents*, 10–11).

138. Given that one of the central themes of this book is how war is felt on the flesh, the path-breaking work of Black feminist scholars such as Hortense Spillers and Saidiya Hartman is crucial to understanding how gendered racial and imperial power has been imprinted onto the body. On Blackness as/and terror in African American studies, see Browne, *Dark Matters*; Campt, *Listening to Images*; E. Edwards, "The Other Side of Terror"; Kendi, *Stamped from the Beginning*; Sharpe, *In the Wake*; Warren, *Ontological Terror*; Weheliye, *Habeas Viscus*; and C. Young, "Black Ops." Much of this newer Black queer feminist work builds on the scholarly legacy of Spillers and Hartman, as well as that of Katherine McKittrick, Fred Moten, and Sylvia Wynter, cited throughout.

139. Maira, *The 9/11 Generation*, 5. See, e.g., Alsultany, *Arabs and Muslims in the Media*; Bayoumi, *This Muslim American Life*; Daulatzai, *Black Star, Crescent Moon*; Grewal, *Saving the Security State*; R. Khalidi, *Sowing Crisis*; Kumar, *Islamophobia and the Politics of Empire*; Maira, *The 9/11 Generation*; Mamdani, *Good Muslim, Bad Muslim*; Naber, *Arab America*; Rana, *Terrifying Muslims*; Razack, *Casting Out*; N. Singh, *Race and America's Long War*.

140. On the pre–9/11 repression of Arab American activism, see Kadi, *Food for Our Grandmothers*; Naber, *Arab America*; Shakir, *Bint Arab*.

141. Naber, *Arab America*, 61; Maira, *Missing*, 23.

142. See Mamdani, *Good Muslim, Bad Muslim*; and R. Khalidi, *Sowing Crisis*. This demand for historicity is heavily influenced by the emergent literature on the "global cold war." See Westad, *Global Cold War*; Suri, "The Cold War, Decoloniza-

tion, and Global Social Awakenings"; Jodi Kim, *Ends of Empire*; and Yoneyama, *Cold War Ruins*. It is also fueled by the insistence of Arab American studies scholars on rejecting the "entrapment" narrative of the field's formation as if it were an "entirely new, exceptional, post–September 11 moment" and is grounded in the "wide range of studies about the relationship between US empire and Arab diasporas that Arab American studies scholars had been developing long before September 11, 2001." See Naber, *Arab America*, 61, for an extended account of this scholarly debate.

143. The field of Asian Pacific American studies, and in particular, Filipino, Vietnamese, and Southeast Asian American studies, has been a formative site for the proliferation of studies on diasporic literature, performance, and aesthetics as forms of resistance, knowledge, and critique to twentieth- and twenty-first-century war and empire. Recent key works in this quickly proliferating field include Bahng, *Migrant Futures*; Balance, *Tropical Renditions*; Balce, *Body Parts of Empire*; Chambers-Letson, *A Race So Different*; D. Cruz, *Transpacific Femininities*; Day, *Alien Capital*; Espiritu, *Body Counts*; T. Ho, *Romancing and Human Rights*; Hong, *Death beyond Disavowal*; Imada, *Aloha America*; Isaac, *American Tropics*; Jodi Kim, *Ends of Empire*; J. Y. Kim, *The Racial Mundane*; Lee, *Exquisite Corpse of Asian America*; Lim, *Brown Boys and Rice Queens*; Lowe, *Immigrant Acts* and *Intimacies of Four Continents*; Lye, *America's Asia*; Machida, *Unsettled Visions*; Mendoza, *Metroimperial Intimacies*; Min, *Unnamable*; M. Nguyen, *Gift of Freedom*; Paik, *Rightlessness*; Pelaud, Duong, and Lam, *Troubling Borders*; Ponce, *Beyond the Nation*; Rafael, *Motherless Tongues*; San Pablo Burns, *Puro Arte*; Schleitwiler, *Strange Fruit of the Black Pacific*; Schlund-Vials, *War, Genocide, and Justice*; See, *Decolonized Eye* and *Filipino Primitive*; Shigematsu and Camacho, *Militarized Currents*; Tadiar, *Things Fall Away*; Yoneyama, *Cold War Ruins*.

144. Jodi Kim, *Ends of Empire*; Lowe, *Immigrant Acts*; Maira, *The 9/11 Generation*; McAlister, *Epic Encounters*; Naber, *Arab America*; Reddy, *Freedom With Violence*; Shigematsu and Camacho, *Militarized Currents*; Yoneyama, *Cold War Ruins*; Yuh, "Moved By War."

145. Maira, *The 9/11 Generation*.

146. Bald et al., *The Sun Never Sets*; Grewal, *Transnational America* and *Saving the Security State*; Maira, *Missing* and *The 9/11 Generation*; Mani, *Aspiring to Home*; Naber, *Arab America*; Puar, *Terrorist Assemblages*; Rana, *Terrifying Muslims*; Razack, *Casting Out*.

147. I thank my anonymous reader for generously enabling this critical formulation by parsing the distinction between artists caught within differential orders of gendered racialization in the US and Europe and the nonwestern societies addressed by the US as military objects and targets.

148. Khalili, *Time in the Shadows*, 6.

ONE. Up in the Air

1. On the decade-long "hunt" to kill bin Laden and the spectacular nature of the 2011 special forces operation, see Bowden, *The Finish*. The dominant US account of the murder (of which Bowden's work is one among many) has been challenged most

notably by famed investigative reporter Seymour M. Hersh. For his alternative account of the raid and its aftermath, which raises more speculative questions than answers, see Hersh, *The Killing of Osama Bin Laden*. See also Jonathan Mahler, "What Do We Really Know About Osama bin Laden's Death?," *New York Times*, October 15, 2015. For more on the legal dimensions of statelessness in relation to contemporary counterterrorist operations, see Li, "Hunting the 'Out-of-Place Muslim.'"

2. K. Feldman, "Empire's Verticality," 326.

3. Mirzoeff, *The Right to Look*, 289.

4. C. Kaplan, "Viewing the Aerial Images of bin Laden's Compound," *Mind's Eye*, May 7, 2011, http://aerialvisualculture.blogspot.com/2011/05/viewing-aerial-images-of-bin-ladens.html (accessed February 6, 2016). Kaplan's work on the long history of aerial surveillance and cartographic representations from above provides a formative source for my analysis in this chapter. See C. Kaplan, *Aerial Aftermaths*; "Dead Reckoning"; and "Mobility and War." See also Parks and Kaplan, *Life in the Age of Drone Warfare*.

5. Mirzoeff, *The Right to Look*, 290.

6. J. Butler, *Frames of War*, xii.

7. Butler, quoted in Stauffer, "'Peace Is a Resistance to the Terrible Satisfactions of War.'"

8. My understanding of "race-making" draws on French sociologist Loïc Wacquant's formulation of the single "carceral continuum" connecting US histories of racial slavery and present-day mass incarceration. See Wacquant, "From Slavery to Mass Incarceration." The term focuses on institutions that "do not simply process an ethnoracial division that would somehow exist outside of and independently from them. Rather, each produces (or co-produces) this division (anew) out of inherited demarcations and disparities of group power and inscribes it at every epoch in a distinctive constellation of material and symbolic forms" (54). For diverse critiques of Wacquant's thesis on the rise of mass incarceration in the US alongside the formation of a neoliberal state, see Berger, *Captive Nation*; Camp, *Incarcerating the Crisis*; Murakawa, *First Civil Right*; N. Singh, *Race and America's Long War*.

9. Jodi Kim, *Ends of Empire*, 241.

10. Mirzoeff, *The Right to Look*, 277.

11. Famously coined by publisher Henry Luce in *Life Magazine*, this phrase was meant to index the emergence of the US on the global stage after World War II as "the most prosperous, powerful and influential nation in the world." Dower, *Violent American Century*, ix. As Jodi Kim notes further, the concept of "the 'American Century' also strategically repressed or attempted to contain the gendered racial formations of the Cold War." See Jodi Kim, *Ends of Empire*, 231. On the early development of the American capitalist world system and the twentieth-century emergence of the US as global power, see Arrighi, *Long Twentieth Century*; Harvey, *A Brief History of Neoliberalism*. This scholarship recounts how the US rationalized and exceptionalized its mode of global economic, political, and military power in the postwar world. The US sought to amass the military superiority, economic supremacy, and ideological predominance required to dictate the terms of the postwar economic internation-

alism and to secure access to raw materials and markets. Often cloaked in moralistic and exceptionalist terms, US postwar global governance involved the elaboration of multinational institutions and a prevailing discourse of anti-Communism—characterized by the rhetoric of peace, freedom, and development. As the self-described "dove in the face of transparent atrocities," US democratic liberal capitalism was certainly not without competition. This period witnessed the emergence of a rival universalism in state socialism, thus launching what historian Michael Denning terms the "age of three worlds," with the globe now triangulated into capitalist, socialist, and decolonizing domains. See Denning, *Culture in the Age of Three Worlds*; Medovoi, "Global Society Must Be Defended"; and Westad, *Global Cold War*.

12. Such an approach understands how the US has borrowed from and refashioned the past and present military and security thinking of other warfare states and their allies. The concept of "race war" comes from the work of Michel Foucault. In his lectures, Foucault expands on his earlier ideas in *Discipline and Punish* (1995) to argue that the production of "docile bodies" and the defense of vitality ("making live") had in fact begun as a military project. This perpetual war was about properly maintaining and supporting the capabilities and potentialities of the newly defined nation. Emphasizing the capabilities of the modern biopolitical state, Foucault described the conditions that produce and condone the state's exclusionary practices and murderous functions, defining "race" as the creation of "caesuras" in human populations by state powers. See Foucault, *Society Must Be Defended*, 253–54. Under the logics of biopower, race became the essential way to make sense of the distribution of life and death. State racism emerged as an administrative practice at the core of the state and societal processes of normalization and regularization, thus breaking the unified field of "the human." Foucault assessed the conditions of possibility for power's emergence rather than offering us a theory of power as such, suggesting that power passes through various "divisions of reason," including sexuality. See Foucault, *History of Sexuality* and *Power/Knowledge*. For essential critiques of Foucault's genealogies of "race," see Stoler, *Race and the Education of Desire*; see also Mbembe, "Necropolitics"; Puar, *Terrorist Assemblages*; and Weheliye, *Habeas Viscus*. For critical reformulations of "race war," see Kramer, *Blood of Government*; and Medovoi, "Global Society Must Be Defended."

13. See Sarah Sewall's introduction and tacit endorsement in the *US Army and Marine Corps Counterinsurgency Field Manual*, li–xliii. The literature that identifies with the dominant perspective of counterinsurgency is far too massive to cite here, but for one exemplary perspective from this tradition, see Cassidy, *Counterinsurgency and the Global War on Terror*.

14. Deer, "The Ends of War and the Limits of War Culture," 3.

15. Mirzoeff, *The Right to Look*, 278.

16. See, e.g., Balce, *Body Parts of Empire*; Kramer, *Blood of Government*; McCoy, *Policing America's Empire*. As Mirzoeff argues, "the Cold War was always already a counterinsurgency, from Algeria to Indochina, Latin America, and now the Middle East" (*The Right to Look*, 278).

17. Camp, *Incarcerating the Crisis*; Schrader, *Badges without Borders*; N. Singh, *Black is a Country*. Key texts that provide critical and relational approaches to US counterinsurgency warfare include Ahmad, "Counterinsurgency"; Amar, *Security Archipelago*; Balce, *Body Parts of Empire*; Camp, *Incarcerating the Crisis*; González, *American Counterinsurgency*; Guha, "The Prose of Counter-Insurgency"; Kramer, *The Blood of Government*; Kelly et al., *Anthropology and Global Counterinsurgency*; Khalili, *Time in the Shadows*; Masco, "'Sensitive but Unclassified'"; Mirzoeff, "War Is Culture"; McCoy, *Policing America's Empire*; Owens, *Economy of Force*; Schrader, *Badges without Borders*; and the Network of Concerned Anthropologists, *Counter-Counterinsurgency Manual*. For an analysis of counterinsurgency's changing contours in urban spaces of the Global South, see Graham, *Cities Under Siege*; and Scott, *Outlaw Territories*.

18. The last twenty years has seen an explosive growth in historical accounts that take up these global interventions. For region-specific works on the Cold War in Latin America, see Grandin, *The Last Colonial Massacre*; and Saldaña-Portillo, *Revolutionary Imagination*. For the Caribbean and Africa, see Gleijeses, *Conflicting Missions*; Mamdani, *When Victims Become Killers*; and Horne, *Cold War in a Hot Zone*. For Asia and the Pacific, see Espiritu, *Body Counts*; Jodi Kim, *Ends of Empire*; M. Kim, *The Interrogation Rooms of the Korean War*; Klein, *Cold War Orientalism*; Man, *Soldiering through Empire*; McCoy, *Policing America's Empire*; Mendoza, *Metroimperial Intimacies*; M. Nguyen, *Gift of Freedom*; Toor, *State of Islam*; Yoneyama, *Cold War Ruins*; and M. Young, *Vietnam Wars*. For the Middle East, see K. Feldman, *A Shadow Over Palestine*; O. Khalil, *America's Dream Palace*; R. Khalidi, *Sowing Crisis*; Mamdani, *Good Muslim, Bad Muslim*; McAlister, *Epic Encounters*; T. Mitchell, *Rule of Experts*; and Vitalis, *America's Kingdom*.

19. Westad, *Global Cold War*.

20. Jodi Kim, *Ends of Empire*; Yoneyama, *Cold War Ruins*.

21. While the term "Third World" does not adequately account for the distinct conditions among nations of Asia, Africa, the Middle East, and Latin America, I use it genealogically here to name the political project, rather than fixed geographical place, that emerged during this period. See also Denning, *Culture in the Age of Three Worlds*; Okihiro, *Third World Studies*; Prashad, *Darker Nations*; Shohat, *Taboo Memories*; C. Young, *Soul Power*.

22. See Mamdani, *Good Muslim, Bad Muslim*; and Westad, *Global Cold War* for US–Middle East relations dating back to the late Cold War. See R. Khalidi, *Sowing Crisis*; and Vitalis, *America's Kingdom* for US interventionism since the early 1930s, with the signing of Aramco's exclusive oil deal with Ibn Saud, the king of Saudi Arabia. On the "global cold war," see Westad, *Global Cold War*; Suri, "The Cold War, Decolonization, and Global Social Awakenings"; Jodi Kim, *Ends of Empire*; and Yoneyama, *Cold War Ruins*.

23. The long twentieth century (roughly 1898 to the present) was defined by one uninterrupted chain of American wartime violences in the global Asias and the Greater Middle East, from the fin-de-siècle wars in the Pacific and the Caribbean,

the perpetual contestations of the Cold War, the demise of formal European empires, the expansion of US global capital, and the emerging ideological force of area studies programs, as well as multiple forms of insurgent internationalisms, or alternate modes of sensuous affiliation, that emerged in excess of (or across, below, through, and beyond) the nation-state. This spree of military violence directly contradicts the "long peace" that some US apologists such as John Gaddis would suggest about the postwar decades, "even to the point of trumpeting a precipitous decline in global violence since 1945." As John Dower notes, by contrast, "the global landscape of death and devastation makes the label 'Cold War' a cruel and parochial joke. This so-called post war peace, was, and still is, saturated in blood and wracked with suffering" (Dower, *Violent American Century*, xii, 2).

24. See Mamdani, *Good Muslim, Bad Muslim*; R. Khalidi, *Sowing Crisis*.

25. See Gaddis, *Long Peace* and *Cold War*. Against conventional Cold War historiography, such as the work of Gaddis, which heralds the triumphalist vision and success of America's performance in the now-finished Cold War, scholars of US empire have debated how to periodize and adjudicate the violence of the era alongside its antecedents and afterlives. The standard account locates the onset of the Cold War to 1945, when a liberal interpretation of American foreign policy ideology remade "World War Two and its aftermath a laboratory for global reform" (Westad, *Global Long War*, 20). Others highlight 1941, which marks the formal entry of the US military into World War II after the Japanese attack on Pearl Harbor. Some political economists look to the interwar period of the 1920s and 1930s as the origins of the meteoric rise of American economic power throughout the world. The Great Depression, they argue, is when the US first established itself as the "epitome of modernity, conveying ideas that undermined existing concepts of status, class, and identity" (19). Still others cite 1917 as the golden year, because it marked the Bolshevik Revolution and the rise of an alternative form of modernity rivaling that of the US. Finally, some historians of colonialism insist on even earlier temporal markers, emphasizing the need to examine imperial histories of the US and Russia to best locate the confrontations of the postwar period. These varied approaches distill the importance of situating the Cold War amid ongoing debates within international history to effect different kinds of arguments. For more on the perils of periodization, see Westad, *Global Cold War*. For more on Cold War Americanism, see Bacevich, *Long War*; Chomsky, *Towards a New Cold War*; N. Singh, *Race and America's Long War*.

26. Mamdani, *Good Muslim, Bad Muslim*.

27. Mamdani, *Good Muslim, Bad Muslim*, 98–99.

28. Mamdani, *Good Muslim, Bad Muslim*, 95. LIC was effectively terrorism by another name. As Mamdani shows, "the revolutions of 1979 had a profound influence on the conduct of the Afghan War. The Iranian Revolution led to a restructuring of relations between the United States and political Islam. Prior to it, America saw the world in rather simple terms: on one side was the Soviet Union and militant Third World nationalism, which America regarded as a Soviet tool; on the other side was political Islam, which America considered an unqualified ally in the struggle against the Soviet Union. Thus, the United States supported the Sarekat-i-Islam against Su-

karno in Indonesia, the Jamaat-i-Islami against Zulfiqar Ali Bhutto in Pakistan, and the Society of Muslim Brothers against Nasser in Egypt. The expectation that political Islam would provide a local buffer against secular nationalism was also broadly shared by U.S. allies within the region, from Israel to conservative Arab regimes" (120–21).

29. Mamdani, *Good Muslim, Bad Muslim*, 96.

30. Mamdani, *Good Muslim, Bad Muslim*, 97.

31. Mamdani, *Good Muslim, Bad Muslim*, 11, 103.

32. Mamdani, *Good Muslim, Bad Muslim*, 12.

33. R. Khalidi, *Sowing Crisis*.

34. Wegner, *Life between Two Deaths, 1989–2001*.

35. As Mamdani elaborates, the two-decade-long proxy war in the Greater Middle East provides a vital backdrop for understanding the 2003 invasion of Iraq. From the Iraq-Iran War of the 1980s to the regime of UN sanctions, which Mamdani calls a "vicious low-intensity, high-casualty campaign conducted through the offices of the UN . . . nothing short of an officially conducted and officially sanctioned genocide, primarily of children, most under five," these proxy wars suggest a novel development in US regional strategy (*Good Muslim, Bad Muslim*, 181). Mamdani argues that Clinton-era foreign policy of militarized humanitarianism in Iraq was "waged in the entirely novel form of a multilateral proxy, taking the form of UN sanctions, mitigated by an 'oil-for-food' program, justified in the language of humanitarian intervention but at a cost of hundreds of thousands of innocent children's lives. After 9/11, Iraq, more than Afghanistan, became the real launching pad for a brazen U.S. intervention undertaken in the midst of international opposition, including in the halls of the UN" (179). For more on US-Iraq alliance during the late Cold War era (which ended with Saddam Hussein's invasion of Kuwait and the 1991 Gulf War), see Mamdani, *Good Muslim, Bad Muslim*, 178–228.

36. Mamdani, *Good Muslim, Bad Muslim*, 12.

37. Mamdani, *Good Muslim, Bad Muslim*, 178–79.

38. R. Khalidi, *Sowing Crisis*, 236.

39. Since the 1993 release of Amy Kaplan and Donald Pease's classic volume, *Cultures of United States Imperialism*, scholars in American studies have traced the centrality of imperialism to shaping US national self-conception. Crystallizing a paradigm shift in American studies, *Cultures* rejected the "denial of empire" at the heart of decades of scholarship that bolsters the myth of "American exceptionalism," a distorting vision of US imperial conquest as historically aberrant and exclusively confined to the fleeting territorial control of overseas colonies during the early part of the twentieth century. Instead, the editors, who were writing during the first Persian Gulf war, argued that imperialism, understood as continental and interna-tional expansion, conquest, and resistance, has always been central to the construc-tion of US national culture and identity. *Cultures* has been a touchstone for scholars deploying a number of "post-exceptionalist" approaches in American studies to the study of empire, borders, transnationalism, neocolonialism, and war over the past twenty-five years. This "New Americanist" interdisciplinary project denoted a clear shift in the early 1990s: through a rigorous engagement with the tools of postcolonial-

ism, American studies scholars became better equipped to locate the United States in a wider hemispheric (and global) map of cultural and popular arrangements. This work promoted a transnational framework for American studies, contextualizing the US within the legacies of imperialism, colonialism, and global capitalism. Of course, New Americanist scholars of the early 1990s were not the first to pursue work on US empire. Progressive historians and materialists writing around World War I insisted on viewing the US in terms of unequal global economic processes and forces, and exclusionary nationalist and racial models had long been assailed by intellectuals such as W. E. B. Du Bois and José Martí. These interventions considerably predated the institutionalization of US ethnic studies programs in the 1960s and 1970s and colonial discourse analysis in the 1980s. Coterminous with these later developments during the years of détente was a newer generation of revisionist historians, led by William Appleman Williams. Emboldened by anti-imperialist responses to Vietnam, these diplomatic historians attempted to bring empire back into discussions of US diplomacy. The "Wisconsin school" and related anti-imperialist scholarly interventions stressed the importance of political economy for formulations of US foreign policy. They examined US expansion and imperialism within capitalism, as a mode of production that transformed the material and social organization of the world and the international system at the turn of the twentieth century. And yet, the subsequent result of the work of New Americanists in the 1990s has been a transformed vision for the field in the twenty-first century—one that is less insular and parochial and more internationalist and comparative in its design. Their work is especially foundational for the present study, as it attempts to trace contemporary permutations of US race, war, and empire in the post "post–Cold War" period, connecting lessons from histories of US imperialism to the ongoing colonial present.

40. Medovoi, "Global Society Must Be Defended," 65–66. See also N. Singh, *Race and America's Long War*.

41. On the intimacies of US imperial warfare and racialization abroad, see, e.g., Jung, *Coolies and Cane*; Khalili, *Time in the Shadows*; Kramer, *Blood of Government*; Lowe, *Intimacies of Four Continents*; Man, *Soldiering through Empire*; T. Mitchell, *Rule of Experts*; Puar, *Terrorist Assemblages*; Rana, *Terrifying Muslims*; Vitalis, *America's Kingdom*. On the centrality of race thinking to the calculus of the domestic US nation-state, see, e.g., Friedman, *Covert Capital*; Gilmore, *Golden Gulag*; Goldstein, *Poverty in Common*; HoSang, *Racial Propositions*; W. Johnson, *River of Dark Dreams*; Molina, *How Race Is Made in America*; M. Ngai, *Impossible Subjects*; Reddy, *Freedom with Violence*; Saldaña-Portillo, *Indian Given*; Self, *American Babylon*; N. Shah, *Contagious Divides*; N. Singh, *Race and America's Long War*.

42. T. Mitchell, *Rule of Experts*, 7.

43. On the nexus of American Studies and postcolonial theory, see Rowe, *Post-Nationalist American Studies*. For critiques of the internationalization of American studies and US history, see Sharpe, "Is the United States Postcolonial?" See also M. Young, "The Age of Global Power," which warns historians of US empire to avoid "the historiographic rearticulation of imperial processes" by examining the

voices of those affected by US power. These works collectively provide deeper reflection on the strengths and weaknesses of appropriating critical terminology from postcolonial and subaltern studies to analyze the racially excluded populations of the US/North America.

44. Simon, *Governing Through Crime*, 264.

45. Simon, *Governing Through Crime*, 265.

46. Martin, *Empire of Indifference*, 14. See also Camp, *Incarcerating the Crisis*; and Kundnani and Kumar, "Race, Surveillance, and Empire."

47. Simon, *Governing Through Crime*, 270–71.

48. Martin, *Empire of Indifference,* 9.

49. Martin, *Empire of Indifference*, 9.

50. Reddy, *Freedom With Violence*, 11.

51. Mirzoeff, *The Right to Look*, 302.

52. N. Singh, *Race and America's Long War*, 183.

53. Adam Liptak and Michael D. Shear, "Trump's Travel Ban Is Upheld by Supreme Court," *New York Times*, June 26, 2018.

54. Kelley, "After Trump."

55. In his introduction to *Freedom with Violence*, Reddy offers an expert deconstruction of the 2010 version of the NDAA, which, in addition to appropriating $680 billion to the Department of Defense "during the worst recession and job market in the United States since the end of the Great Depression and the Second World War," created an amendment clause to the original bill: the Matthew Shepard and James Byrd, Jr. Hate Crime Prevention Act. As Reddy beautifully details, this legislation consolidated a strange interface between (putatively progressive) civil rights groups and (violent, racially ordered, and excessive forms of) national security. This is the "felicitous conjunction" he evocatively calls a "freedom with violence." See Reddy, *Freedom with Violence*, 2, 5, 11.

56. Kassem, "The Militarisation of 'War on Terror' in the US."

57. Lander, "After Struggle on Detainees, Obama Signs Defense Bill."

58. One of the most significant components of the US forever war involves the use of long-term detention facilities to house so-called enemy combatants. These communications management units (CMUS) were created to segregate and isolate certain prisoners, specifically Muslim prisoners, from the general federal prison population. See Center for Constitutional Rights, *Communications Management Units*.

59. Kassem, "The Militarisation of 'War on Terror' in the US." https://www.aljazeera.com/indepth/opinion/2011/12/20111220103624967465.html.

60. On this notion of "blowback," see Arendt, "Home to Roost."

61. See, e.g., Gilmore, *Golden Gulag*, which provides a political economic analysis to explain how California prison expansion developed from surpluses of finance capital, labor, land, and state capacity.

62. Rana, *Terrifying Muslims*, 153. On Arab American racialization as "Muslims," see Gualtieri, *Between Arab and White*; and Jamal and Naber, *Race and Arab Americans before and after 9/11*.

63. Rana, *Terrifying Muslims*, 158.

64. For more on the nexus of prison abolition and immigration, see Loyd, Mitchelson, and Burridge, *Beyond Walls and Cages*. See also D. Rodriguez, "'I Would Wish Death on You'"; Macías-Rojas, *From Deportation to Prison*; and Vimalassery, "Antecedents of Imperial Incarceration." These works inform this book's emphasis on how "post–9/11" practices of the global security state (including migrant detention practices and extraordinary renditions), once situated within the political context of forced occupation and imperial expansion, represent particular instances in a much longer continuum of US carceral violence and racialized governance.

65. S. Shah, "A Decade of Detention."

66. American Immigration Council, "The Criminal Alien Program (CAP): Immigration Enforcement in Prisons and Jails," fact sheet, August 1, 2013, https://www.americanimmigrationcouncil.org/research/criminal-alien-program-cap-immigration-enforcement-prisons-and-jails (accessed January 13, 2018).

67. S. Shah, "A Decade of Detention." For updated statistics on for-profit prison lobbying, see the "Open Secrets" website of the Center for Responsive Politics, a nonpartisan, independent, and nonprofit organization that tracks money in US politics and its effect on elections and public policy: "For-Profit Prisons," OpenSecrets.org, https://www.opensecrets.org/industries/totals.php?cycle=2018&ind=G7000. Accessed Jan. 10, 2019. For more on the nexus of business profiteering and immigration enforcement, see Fernandes, *Targeted*; and Kamat, "Punishment and Profits."

68. For more on the manufactured crisis that unfolded at the border during summer 2018 as a result of the Trump administration's policies of detention and deportation, see ACLU, "Trump's Family Separation Crisis," https://www.aclu.org/families-belong-together.

69. See Buff, *Against the Deportation Terror*; Das Gupta, *Unruly Immigrants*; De Genova and Peutz, *Deportation Regime*; and Macías-Rojas, *From Deportation to Prison*.

70. Reddy, *Freedom with Violence*, 14; emphasis mine. Likewise, Jodi Kim has argued that twentieth-century Asian migration to the United States can only be understood as a product of the imperial violence of the decades-long Cold War in Asia. Following historian Ji-Yeon Yuh's reconceptualization of post–World War II Asian migration to the United States as "refuge migration," Kim argues, "also highlights the contradictions of seeking 'refuge' in a country that created, in the first place, the very conditions from which you are seeking refuge. This is to articulate the mantra that 'We are here because you were there,' that 'first you destroy our country, and then you rescue [us and] our children.' Or, from the perspective of America, 'We had to destroy the village in order to save it.'" See Jodi Kim, *Ends of Empire*, 238; Lowe, *Immigrant Acts*; Nguyen, *The Gift of Freedom*.

71. US policies targeting migrants, immigrants, refugees, and those classified as "enemy aliens" have a long history. The use of detention and deportation in US immigration history is also long and varied, and includes the Alien and Sedition Acts of 1798, the Chinese Exclusion Act of 1882, the early twentieth-century Palmer Raids that targeted suspected anarchists (most of whom were immigrants), the internment

of Japanese immigrants and Japanese Americans during World War II, Operation Wetback in 1954 that sought to remove Mexican nationals from the US border, Joseph McCarthy's Red Scare in the 1950s, and the Special Registration program installed after the events of 9/11 (detailed in chapter 3).

72. See O. Khalil, *America's Dream Palace* for an elaboration of the post–Cold War interplay between education and national security, and specifically the outstretched impact of privatized knowledge of think tanks such as Brookings, WINEP, and AEI on US foreign policy formation and implementation in the Middle East (while more conventional university-based Middle East studies centers and programs continue to struggle with reduced federal funding).

73. The concept of HTS was first developed in a military paper in 2005. See McFate and Jackson, "An Organizational Solution for DOD's Cultural Knowledge Needs." See the official US Military website for the HTS program: http://hts.army.mil/Default.aspx (accessed July 13, 2012).

74. O. Khalil, *America's Dream Palace*, 268.

75. González, *American Counterinsurgency*, 22.

76. American Anthropological Association, "AAA Opposes US Military's Human Terrain System Project." News accounts often ignored the ethical questions prompted by these missions, which were further complicated by the fact that HTS teams often comprised US military contractors. For instance, BAE Systems, a private corporation and one of Europe's largest military contractors for the program, is not subject to the Uniform Code of Military Justice, which González notes as the foundation of military law.

77. Kipp, quoted in US Department of the Army, *US Army and Marine Corps Counterinsurgency Field Manual*, 25.

78. US Department of the Army, *US Army and Marine Corps Counterinsurgency Field Manual*, 79–135.

79. See websites for the Minerva Research Initiative (https://minerva.defense.gov/) and the Pat Roberts Intelligence Scholars Program (https://www.intelligencecareers.gov/ODNI/ResourceCenter/Student_Opportunities.pdf). For a wholesale critique of the HTS Program, see O. Khalil, *America's Dream Palace.*

80. González, *American Counterinsurgency*, 19.

81. González, *American Counterinsurgency*, 26.

82. González, *American Counterinsurgency*, 27.

83. Mirzoeff, *The Right to Look*, 298.

84. On the notion of "weaponizing anthropology," see Price, *Weaponizing Anthropology*; and R. Davis, "Culture as a Weapon." On the reliance of the Bush II administration on privatization and outsourcing to collect local knowledge about Afghans and Iraqis during the military occupations of the early twenty-first century, see O. Khalil, *America's Dream Palace*, 267–68.

85. Mayer, "The Predator War." Journalistic accounts of the military transition toward airpower as a surrogate for combat troops in Iraq dates back to at least 2005. See Hersh, "Up in the Air."

86. "Af-Pak" refers to a cross-border region historically occupied by the Pashtun

ethnic group. White House strategist Richard Holbrooke coined the term in 2008. The Af-Pak designation is interesting both for its regional geopolitical implications and for area studies knowledge projects more generally. In popular use, Pakistan has increasingly become disentangled from South Asia and newly sutured to the Middle East, given its renewed importance as a "failed state" and reluctant collaborator in the US "global war on terror" over the past two decades. Political theorist Kiren Aziz Chaudhry's essay on US militarism in Af-Pak describes the changing geopolitical dimensions of the region. See Chaudhry, "Dis(re)membering \Pä-ki-ʻstän\."

87. On critical invocations of the "Muslim World," see Aydin, *Idea of the Muslim World*; Grewal, *Islam Is a Foreign Country*.

88. Gusterson, *Drone*; Mirzoeff, *The Right to Look*; and Shaw, *Predator Empire*.

89. Adey, Whitehead, and Williams, *From Above*; Lindqvist, *A History of Bombing*; and C. Kaplan, *Aerial Aftermaths*. See also Satia, *Spies in Arabia*; Satia, "The Defense of Inhumanity"; Satia, "Attack of the Drones"; and Satia, "Drones."

90. Benjamin, *Drone Warfare*; Chamayou, *A Theory of the Drone*; Cohn, *Drones and Targeted Killing*; Engelhardt, "Air War, Barbarity and Collateral Damage"; Parks and Kaplan, *Life in the Age of Drone Warfare*; Turse and Engelhardt, *Terminator Planet*; and Woods, *Sudden Justice*.

91. Journalists began actively reporting on the "double-tap" phenomenon in 2012. See the groundbreaking work of the London-based Bureau of Investigative Journalism on covert drone wars here: https://www.thebureauinvestigates.com/projects/drone-war/.

92. Shaw and Akhter, "The Dronification of State Violence."

93. Arendt, "Home to Roost."

94. In August 2016, the ACLU revealed that the Baltimore Police Department had been subjecting that city to a vast and covert apparatus of aerial surveillance—one of a number of recent instances that demonstrate how the tactics and technologies of US global counterinsurgency have been adopted for domestic social control. See Jay Stanley, "Baltimore Police Secretly Running Aerial Mass-Surveillance Eye in the Sky," August 24, 2016, https://www.aclu.org/blog/free-future/baltimore-police-secretly-running-aerial-mass-surveillance-eye-sky.

95. See, e.g., Amazon's "Prime Air" delivery service first launched on December 7, 2016 (https://www.amazon.com/b?node=8037720011). For additional information, see https://www.theguardian.com/technology/2018/may/10/apple-microsoft-uber-drones-approved-testing-amazon.

96. The vastly proliferating deployment of drones should be contextualized in light of debates about the renewed importance of global counterinsurgency campaigns worldwide. Aerial bombardment is by no means a new phenomenon; its history stretches across British, French, and American occupations and late colonial wars. Recent scholarship has documented that aerial counterinsurgency was in fact invented by the British Royal Air Force in Iraq and the Afghanistan-Pakistan borderlands in the 1920s. Iraq was a target again in the early 1990s under Saddam Hussein's regime, when bombing campaigns were crucial to the US Persian Gulf War.

See Parks and Caplan, *Life in the Age of Drone Warfare*; Satia, *Spies in Arabia*; Sherry, *Rise of American Air Power*; and Weart, *Nuclear Fear*.

97. Mayer, "The Predator War"; and Hersh, "Up in the Air."

98. Shaw, "Predator Empire," 10.

99. Miller, "Plan for Hunting Terrorists Signals US Intends to Keep Adding Names to Kill Lists," *Washington Post*, October 23, 2012. See also the ACLU's archive on targeted killings: "Targeted Killing," https://www.aclu.org/issues/national -security/targeted-killing?redirect=national. On the "disposition matrix," see Shaw, "Predator Empire."

100. Martin, *Empire of Indifference*, 10.

101. Martin, *Empire of Indifference*, 13, 12.

102. On the "Revolution in Military Affairs," see Martin, *Empire of Indifference*. On "Predator Empire," see Shaw, *Predator Empire*. The terms *"small wars," "irregular warfare," "asymmetrical warfare,"* and *"fourth-generation warfare"* (4GW) all express anxiety within the military establishment about the blurring between civilians and soldiers in contemporary wars of the Global South. Coined in 1989, at the end of the Cold War, by William S. Lind to describe the nation-state's loss of monopoly over the use of violence and signaling the emergence of the violent "nonstate actor," some scholars suggest that these terms merely signify a rebranding of the (counter)insurgencies of the "homeland security" era.

103. "UN Investigator Decries US Use of Killer Drones," *Reuters*, June 19, 2012. On the centrality and power of the secret to the contemporary US security state, see Masco, *Theater of Operations*.

104. Hussain, *Jurisprudence of Emergency* and "Counterinsurgency's Comeback."

105. Shaw, *Predator Empire*; and Roblyer, "Beyond Precision." As Sunaina Maira contends, Obama's "open hand" to the so-called Muslim World "concealed his administration's escalation of war and covert operations in Pakistan and Afghanistan; extrajudicial assassinations of terrorist suspects, including U.S. citizens; continuing sanctions on Iran; persistent support for Israeli violence and dispossession in Palestine; and expanded surveillance at home" (Maira, *The 9/11 Generation*, 240).

106. There has been scant formal investigative journalism on the Pakistani government's collusion with the US secret drone war campaign to date. See Steve Coll, "The Unblinking Stare"; Adam Entous, Siobhan Gorman, and Evan Perez, "U.S. Unease over Drone Strikes," *Wall Street Journal*, September 26, 2012, https://www.wsj.com/articles/SB10000872396390444100404577641520858011452 (accessed August 27, 2017). For more details, see also Minhas and Qadir, "The US War on Terror and the Drone Attacks on FATA, Pakistan"; Shaw and Akhter, "The Dronification of State Violence"; Tahir, Memon, and Prashad, *Dispatches from Pakistan*; and Woods, *Sudden Justice*, as well as his writings at the Bureau of Investigative Journalism: https://www.thebureauinvestigates.com/stories/2012–09–28/pakistan -categorically-rejects-claim-that-it-tacitly-allows-us-drone-strikes.

107. The majority of drone attacks launched in Pakistan (with their leaders' tacit support) during both the Bush and Obama administrations have been on Pashtun villages in North and South Waziristan in the Federally Administered Tribal Areas

along the Afghan border. See the work of Worldfocus, which has produced a dev-
astating Google map outlining US-led drone attacks in Pakistan since 2004: http://
maps.google.com/maps/ms?ie=UTF8&hl=en&t=h&msa=0&msid=11392370833855164
1006.00047caa42cb2374421e4&ll=33.031693,70.587158&spn=1.611824,3.295898&z=8&so
urce=embed. See also Tahir, Memon, and Prashad, *Dispatches from Pakistan*.

108. Holbrooke, quoted in Safire, "Wide World of Words."

109. For an exploration of how European colonial knowledge administrations and
information systems link long-standing traditions of imperial security and intelli-
gence to the contemporary US wars in the Greater Middle East, see, e.g., Hevia, *Impe-
rial Security State*; Khalili, *Time in the Shadows*; and Thomas, *Empires of Intelligence*.
Thomas's magisterial comparative study of early twentieth-century French and Brit-
ish colonial intelligence in the interwar Arab world argues that intelligence gathering
is a primary weapon of occupying power. Thomas coins the term "intelligence states"
to describe this form of colonial administration and to capture how state surveil-
lance was a historic outgrowth of scientific modernism, not just an "instrument of
repressive control" (4). Thomas's work builds on Bayly's classic study of empire and
information in nineteenth-century India, and on Satia's concurrently published
study of Britain's "covert empire" in the Middle East. Bayly, *Empire and Information*;
and Satia, *Spies in Arabia*.

110. Shaw and Akhter, "The Unbearable Humanness of Drone Warfare in FATA,
Pakistan."

111. Mirzoeff, *The Right to Look*, 279.

112. González, *American Counterinsurgency*.

113. Masco, *Theater of Operations*, 197.

114. Glenn Greenwald, "Trump's War on Terror Has Quickly Become as Bar-
baric and Savage as He Promised," *Intercept*, March 26, 2017, https://theintercept
.com/2017/03/26/trumps-war-on-terror-has-quickly-become-as-barbaric-and-savage
-as-he-promised/; and Benjamin Hart, "Report: US Air Strikes Killing Far More
Civilians Under Trump," *New York Magazine*, July 17, 2017, http://nymag.com/daily
/intelligencer/2017/07/u-s-air-strikes-are-killing-far-more-civilians-under-trump
.html.

115. As Nicholas Mirzoeff aptly points out, the use of "revolution" was not acciden-
tal: "For the military have been devoted readers of revolutionary and guerilla theory
ranging from the French and Indian Wars of colonial North America to Mao and the
Zapatistas. . . . The RMA was designed to give the military the advantages of speed
and surprise usually held by guerilla and revolutionary groups." See Mirzoeff, *The
Right to Look*, 284.

116. Mirzoeff, *The Right to Look*, 21.

117. Gregory, quoted in Prasse-Freeman, "Droning On."

118. For a nonexhaustive list of scholarly sources, see K. Feldman, "Empire's Ver-
ticality"; Gregory, "From a View to a Kill"; Parks and Kaplan, *Life in the Age of Drone
Warfare*; and C. Kaplan, *Aerial Aftermaths*.

119. On the nexus of visuality and war, see Virilio, *War and Cinema*. See also
J. Butler, *Frames of War*; Chow, *Age of the World Target*; Der Derian, *Virtuous War*;

C. Kaplan, *Aerial Aftermaths*; Mirzoeff, *The Right to* Look; W. J. T. Mitchell, *Cloning Terror.*

120. Rey Chow, *Age of the World Target*, 30–31.

121. McClintock, "Paranoid Empire," 91.

122. Racialization describes the process of abstraction that hierarchically ascribes social value to bodies on the basis of intersectional forms of racial difference. See HoSang, LaBennett, and Pulidio, eds., *Racial Formation in the Twenty-First Century*; Cacho, *Social Death.*

123. Taylor, "Outrage at CIA's Double Tap Drone Attacks."

124. Cavallaro, Sonnenberg, and Kuckey, *Living under Drones*, 74. See also Columbia Law School Human Rights Clinic and Sana'a Center for Strategic Studies, *Out of the Shadows: Recommendations to Advance Transparency in the Use of Lethal Force*, June 2017, https://www.outoftheshadowsreport.com/ (accessed February 3, 2019); and Gregory, "From a View to a Kill."

125. Shaw and Akhter, "Dronification of State Violence."

126. N. Singh, *Race and America's Long War*, 184.

127. Cavallaro et al., *Living under Drones*. For up-to-date analysis of drone civilian casualties, see the *Intercept*'s "The Drone Papers," a cache of secret documents provided by a whistleblower detailing the US military's assassination program in Afghanistan, Yemen, and Somalia: https://theintercept.com/drone-papers/. See also Devereaux, "Manhunting in the Hindu Kush."

128. K. Feldman, "Empire's Verticality," 338.

129. On the biopolitical dimensions of US aerial warfare, see C. Kaplan, *Aerial Attachments*; Parks and Kaplan, *Life in the Age of Drone Warfare*; and Shaw, *Predator Empire.*

130. Sepoy Mutiny, "Waziristan, US," *Chapati Mystery*, April 16, 2014.

131. Cavallaro et al., *Living under Drones*, 76.

132. Cavallaro et al., *Living under Drones*, 93.

133. Cavallaro et al., *Living under Drones*, 98.

134. Cavallaro et al., *Living under Drones*, 99.

135. Hussain, "Counterinsurgency's Comeback," 80–81.

136. Cavallaro et al., *Living under Drones*, 99.

137. Tahir, quoted in Pasternack, "The Story of Drones."

138. Puar, *The Right to Maim.*

139. Cavallaro et al., *Living under Drones*, 90.

140. Kandaswamy, "Stop Urban Shield, Stop Violence against Our Communities."

141. James, *Imprisoned Intellectuals.*

142. Camp, *Incarcerating the Crisis*; Naber, *Arab America*; Pennock, *Rise of the Arab American Left*; Schrader, *Policing Revolution*; C. Young, *Soul Power.*

143. Loyd et al., *Beyond Walls and Cages.*

144. Maira, *The 9/11 Generation*, 258.

145. Williams, *Divided World*, xxxii.

146. McClintock, "Paranoid Empire," 103.

TWO. On the Skin

1. Bilal and Lydersen, *Shoot an Iraqi*, 67.

2. The threat of military service was often a method of selective, state-imposed disappearance for young Iraqis. Bilal laments that he did not want to be one of those who "vanished and then returned a broken man, an example for others" (Bilal and Lydersen, *Shoot an Iraqi*, 68).

3. "Punishing Saddam," *60 Minutes*, May 12, 1996. On the genocidal sanctions regime imposed on Iraq in the 1990s, see Mamdani, *Good Muslim, Bad Muslim*, 178–228.

4. J. Butler, *Frames of War*, 22.

5. Mayer, "The Predator War"; McKelvey, "Inside the Killing Machine"; and Hastings, "The Rise of the Killer Drones."

6. I thank Haytham Bahoora for the reminder that US security discourse during the 1991 war laid equal claim to the idea of a "clean war," with "surgical strikes" and unprecedented levels of precision in targeting enemy combatants. There are many historical antecedents to contemporary US security discourse on precision warfare in the ongoing conflicts in Iraq and Af-Pak, as I elaborated in chapter 1.

7. See J. Butler, *Frames of War*.

8. For a psychoanalytic account of the skin, see Anzieu, *Skin Ego*.

9. Camp, *Incarcerating the Crisis*; Al-Ali and Al-Najjar, *We Are Iraqis*.

10. A. Gordon, "The Prisoner's Curse," 19.

11. For more on Mathaf: Arab Museum of Modern Art and its 2011 inaugural collections, see "Mathaf: Arab Museum of Modern Art," *Nafas Art Magazine*, August 2011, http://u-in-u.com/nafas/articles/2010/mathaf-arab-museum-of-modern-art/.

12. Bilal's piece resonates closely with *Tracking Transience*, Bangladeshi American media artist and university professor Hasan Elahi's virtual surveillance art project. See http://trackingtransience.net/.

13. Orden, "Sir, There's a Camera in Your Head"; and Rymer, "An NYU Professor Will Reinstall a Webcam in the Back of His Head."

14. See Alvarado, *Abject Performances*; Anderson, *So Much Wasted*, and note 35.

15. Rawlings, "Remote Repercussions."

16. I borrow the evocative phrase "machinic assemblage" from Puar, *Terrorist Assemblages*, 175. On the history of prosthetics in postwar America, see Serlin, *Replaceable You*.

17. For more on bioart as art activist intervention, see daCosta and Philip, *Tactical Biopolitics*. See also Marks, *Enfoldment and Infinity*; Mondloch, *Capsule Aesthetic*; and Thacker, *Biomedia*.

18. In his analysis of global Muslim racial formations, anthropologist Junaid Rana describes Bilal's *Domestic Tension*, following Butler, as an "aesthetic of grievability." See Rana, "More than Nothing."

19. See A. Kaplan, "Homeland Insecurities."

20. Rawlings, "Remote Repercussions."

21. Bilal and Lydersen, *Shoot an Iraqi*, 17. Paintball games and videogames are, in fact, central to US military and marine trainings. In his discussion of counterinsurgency's visual logics, for instance, Nicholas Mirzoeff confirms that soldiers often

refer to action in war as like a video game. Bilal not only metaphorizes these war relations but directly reproduces their formal components: "The counterinsurgent feels as in control of the situation as a player in a first-person-shooter videogame. . . . This experience is sufficiently real that videogames are now being used as behavioral therapy for psychologically damaged soldiers. . . . Re-performing the war can restore mental equilibrium in the 'shell-shocked' patient by dint of repetition. The medium-resolution 3-D digital videogame experience is indistinguishable from the 'reality' of counterinsurgency" (Mirzoeff, *The Right to Look*, 297). These insights are reflected further in Bilal's own experimentations with the accessibility and openness of videogames in his (ultimately censored) videogame installation at Rensselaer Polytechnic Institute called *Virtual Jihadi* (2005). There, Bilal hacked a version of the 2003 American game *A Quest for Saddam*, which was itself allegedly hacked by Al-Qaeda and transformed into a quest for George W. Bush called *Night of Bush Capturing*. For more on this controversy, see Kamat, "Interview with Iraqi Artist Wafaa Bilal."

22. Rawlings, "Remote Repercussions."

23. Rawlings, "Remote Repercussions." One of the explicit influences Bilal names for this project is his discovery of the remote nature of twenty-first-century US military technologies. This includes the fact that US Air Force operators now fly drone planes from military sites in Nevada and Colorado, far removed from the official "battle spaces" and "conflict zones" of war in the Middle East. This makes it much easier to fight multiple wars simultaneously, according to the artist, "because psychologically it doesn't affect the soldiers as much as if they had to be on the ground" (Bilal, quoted in Kamat, "Interview with Iraqi Artist Wafaa Bilal," 326). Bilal's performance works bring attention to the ethical and affective implications of these twenty-first-century technological transformations, including the discourse of "soldier disinterestedness."

24. Multiple scholars have critiqued the gendered and sexualized underpinnings of Orientalist and racist modes of contemporary US imperial violence. For one especially strident account, see Puar and Rai, "Monster, Terrorist, Fag."

25. Quoted in Bilal and Lydersen, *Shoot an Iraqi*, 78–81.

26. Muñoz, "The Vulnerability Artist," 200.

27. Quoted in Bilal and Lydersen, *Shoot an Iraqi*, 134.

28. See S. Ngai, *Ugly Feelings*.

29. For a feminist political history of women in postcolonial Iraq, see Al-Ali, *Iraqi Women*; and Al-Ali and Pratt, *What Kind of Liberation?*

30. Becker, quoted in Bilal and Lydersen, *Shoot an Iraqi*, xv–xvi; emphasis mine.

31. Becker, quoted in Bilal and Lydersen, *Shoot an Iraqi*, xix. On "radical passivity" in performance art, see Halberstam, *Queer Art of Failure*, 136.

32. Becker, quoted in Bilal and Lydersen, *Shoot an Iraqi*, xx.

33. Becker, quoted in Bilal and Lydersen, *Shoot an Iraqi*, xix.

34. Bilal and Lydersen, *Shoot an Iraqi*, 146; emphasis mine.

35. For a selection of queer feminist visual and performance studies approaches to pain, humiliation, and violent subjugation as minoritarian forms of pleasure, self-sacrifice, or subjectivity, see Alvarado, *Abject Performances*; Anderson, *So Much*

Wasted; A. Cruz, *The Color of Kink*; Doyle, *Hold It Against Me*; Fleetwood, *Troubling Vision*; Halberstam, *The Queer Art of Failure*; Horton-Stallings, *Funk the Erotic*; Musser, *Sensational Flesh*; Nash, *The Black Body in Ecstasy*; H. Nguyen, *A View from the Bottom*; Rodriguez, *Sexual Futures*; Weiss, *Techniques of Pleasure*.

36. Alvarado, *Abject Performances*; Muñoz, "The Vulnerability Artist"; Doyle, *Hold It Against Me*; Halberstam, *The Queer Art of Failure*, 136.

37. Halberstam, *The Queer Art of Failure*, 137. This resonates with Muñoz's account of Nao Bustamante's *Sans Gravity* (2000) in which multiple balloons are affixed to the artist and audience members are asked to "prick" her balloon-body with needles and knives that have been laid out on surgical trays. Her piece stages the threat of injury and simultaneous relief. As Bustamante becomes "unburdened," she becomes, for Muñoz, a "living cascade sculpture, spilling out onto the world" (Muñoz, "The Vulnerability Artist," 196).

38. Halberstam, *The Queer Art of Failure*, 137.

39. Halberstam, *The Queer Art of Failure*, 135. Halberstam argues that few feminist scholars—aside from notable exceptions such as Linda Hart and Gayle Rubin—have critically engaged with traditions of masochism and sadomasochism as powerful analytics for "considering the relation between self and others, self and technology, self and power in queer feminism" (135). For a definitive analysis of Ono's work, see Bryan-Wilson, "Remembering Yoko Ono's Cut Piece." For more recent queer feminist criticism that takes up Halberstam's call, see note 35.

40. Critical works in new materialist philosophy (especially at the nexus of feminist studies, posthumanist studies, and Black studies) advance the question of flesh and fleshiness in productive and promising new directions. Building on the foundational Black feminist and postcolonial undoing of the subject and the category of the human in works by Hortense Spillers and Sylvia Wynter, these later projects seek to reorient Western epistemologies from the perspective of those never considered human in the first place. See, e.g., Spillers, "Mama's Baby, Papa's Maybe"; Wynter, "Unsettling the Coloniality of Being/Power/Truth/Freedom"; and more recently, Chen, *Animacies*; Jackson, "Animal"; McKittrick, *Sylvia Wynter*; Musser, *Sensational Flesh* and *Sensual Excess*; J. Singh, *Unthinking Mastery*; Weheliye, *Habeas Viscus*.

41. Halberstam, *The Queer Art of Failure*, 139.

42. Halberstam, *The Queer Art of Failure*, 144.

43. Bilal and Lydersen, *Shoot an Iraqi*, 75.

44. Bilal and Lydersen, *Shoot an Iraqi*, 75. Bilal constructs in his memoir an apparently self-conscious indexical relationship between his self-mutilation performance practices and his childhood recollections of the violence of Shia religious rituals in Iraq. Bilal tells stories from his youth about the annual celebration of Ashura, the most important Shia holiday, that took place in the holy cities of Kufa, Najaf, and Karbala. The festival was later "banned and forced underground by Saddam" (24).

45. Halberstam, *The Queer Art of Failure*, 140.

46. See J. Butler, *Precarious Life*; Mack, *Sexagon*; Puar, *Terrorist Assemblages*; Rana, *Terrifying Muslims*.

47. Bilal and Lydersen, *Shoot an Iraqi*, 110–11.

48. The precise circumstances surrounding Haji Bilal's death remain elusive. He was killed in April 2004 by an explosion caused by an American air-to-ground missile. In a 2010 interview with English broadcast journalist Laura Flanders, Wafaa Bilal recounted how his brother had become the primary provider for the Bilal family after Wafaa fled into exile. Haji had a gravel and sand business near the fertile agrarian valley known as the Sea of Najaf. American soldiers needed materials, and Muktada al-Sadr, one of the most influential Shiite clerics in Iraq, raised questions about why Haji was working with American soldiers. al-Sadr's supporters tried to label Haji Bilal a collaborator with the Americans. To protect his family, one day Haji carried weapons and stood outside Kufa, in an effort to display his loyalty to the al-Sadr regime. At that precise moment, US military forces were advancing and a drone ostensibly arrived overhead, prompting his friends to run away. Before Haji could escape, the drone sent a missile to the checkpoint, which ultimately killed him. See Laura Flanders, "Wafaa Bilal."

49. See Tadiar, "The War to Be Human/Becoming Human in a Time of War," 92.

50. For a foundational study of the place of pain and bodily injury in war and torture, see Scarry, *Body in Pain*. See also McSorley, *War and the Body*; and Wilcox, *Bodies of Violence*.

51. On collateral damage, see Yoneyama, *Hiroshima Traces*; and A. Feldman, "On the Actuarial Gaze" and "The Structuring Enemy and Archival War."

52. On the early Cold War production of spatial knowledge as a weapon of war, see Farish, *Contours of America's Cold War*; and Dalby, "The Pentagon's New Imperial Cartography."

53. Flatley, *Affective Mapping*. A precursor to Flatley's depathologizing of melancholia is Muñoz, *Disidentifications*, especially his chapter on Isaac Julien's *Looking for Langston* (57–74). For Muñoz, melancholia can be understood as a "'structure of feeling' that is necessary and not always counterproductive and negative . . . a melancholia that individual subjects and different communities in crisis can use to map the ambivalences of identification and the conditions of impossibility that shape the minority identities under consideration here" (74).

54. Flatley, *Affective Mapping*, 1.

55. Flatley, *Affective Mapping*, 1. For Sigmund Freud, melancholia was caused by the failure to mourn a loss—by refusing to let the lost object go. Walter Benjamin, in contrast, writes about melancholia not as individual ailment but as "evidence of the historicity of one's subjectivity" (3).

56. Flatley, *Affective Mapping*, 4.

57. My thinking on the alternative epistemological projects of Asian American cultural forms is most directly indebted to Lowe, *Immigrant Acts*. See also Chuh, *Imagine Otherwise*; Gopinath, *Impossible Desires*; and Jodi Kim, *Ends of Empire*.

58. Flatley, *Affective Mapping*, 3.

59. Here I evoke Carolyn Dinshaw's evocative metaphor of touch, which suggests that historical inquiry can be motivated by an affective relation between past and present, rather than mere causalities alone. See Dinshaw, *Getting Medieval*. See also H. Love, *Feeling Backward*.

60. On the haptic, see Marks, *Skin of the Film*; Parisi, *Archaeologies of Touch*.

61. Engelhardt, *The American Way of War*, 29. It is worth noting here that women's bodies traditionally have been deployed to "map" postcolonial national spaces, specifically in relation to the Indian subcontinent. A fuller discussion of the gendered nature of cartographic representational practices related to both dominant and anti-colonial nationalist formations exceeds the critical purchase of this chapter. See, e.g., Ramaswamy, *The Goddess and the Nation*.

62. See M. Ahmad, "The Magical Realism of Body Counts"; and Espiritu, *Body Counts*. The body count provides an entry into thinking about ethical systems of life, death, violence, and war. A major source for this chapter's analysis is the Iraq Body Count (IBC) database: http://www.iraqbodycount.org/. It records violent civilian deaths that resulted from the 2003 military invasion of Iraq and offers a public database of deaths caused by US-led coalition forces and paramilitary or criminal acts by others. IBC has been processing and analyzing the Iraq War Logs released by WikiLeaks on October 22, 2010, which contained over 54,910 records compiled by the US military, noting "109,032 violent deaths between January 2004 and December 2009." See IBC's initial analysis of the document drop at "Iraq War Logs: What the Numbers Reveal," October 23, 2010, http://www.iraqbodycount.org/analysis/numbers/warlogs/. See also http://iraqwarlogs.com which is run by the Bureau of Investigative Journalism, a UK-based organization created on April 26, 2010, to "analyze the secret US military war logs released to us by the whistleblowing internet site WikiLeaks." Finally, for an on-the-ground investigation of US air warfare in Iraq against ISIS, see Khan and Gopal, "The Uncounted."

63. J. Butler, *Frames of War*, xx. I thank Vanessa Agard-Jones for pointing out that this tendency is equally paradoxical given the US military's own reliance on qualitative expertise via its Human Terrain System (HTS) program.

64. J. Butler, *Frames of War*, x.

65. Gray and Gómez-Barris, eds., *Toward a Sociology of the Trace*, 5.

66. Gray and Gómez-Barris, eds., *Toward a Sociology of the Trace*, 4.

67. J. Butler, *Frames of War*, xiii.

68. J. Butler, *Frames of War*, xiii.

69. See Gopinath, *Unruly Visions*.

70. The entire series of paintings can be viewed online at http://www.elinohara slavick.com/bomb-after-bomb.html. For the book with a foreword by Howard Zinn and an interview with the artist by Catherine Lutz, see slavick, *Bomb after Bomb*.

71. slavick, *Bomb after Bomb*, 100.

72. slavick, *Bomb after Bomb*, 100.

73. slavick, *Bomb after Bomb*, 97; emphasis mine.

74. Mamdani, *Good Muslim, Bad Muslim*, 194.

75. Baker, quoted in Graham, *Cities under Siege*, 364. For an analysis of how military forces actually use new control, media, and targeting technologies, see Croser, "Networking Security in the Space of the City." See also Croser, *New Spatiality of Security*.

76. slavick, *Bomb after Bomb*, 102.

77. On social ecologies, see Gómez-Barris, *Extractive Zone*. On the toxic after-maths of US militarized warfare and environmental destruction in Iraq, see Koeppel, "Irradiated Iraq."

78. Kamat, "Interview with Iraqi Artist Wafaa Bilal," 328.

79. Bilal and Lydersen, *Shoot an Iraqi*, 140.

80. Gray and Gómez-Barris, eds., *Toward a Sociology of the Trace*, 6.

THREE. Empire's Innards

1. My account of the post–9/11 expansion of torture practices at US military prison sites such as Abu Ghraib, Guantánamo, and Bagram, and related secret "black sites," in the context of the long history of US racial and imperial state violence is informed by investigative journalism and scholarly accounts alike. See, for instance, Danner, *Torture and Truth*; Davis, *Abolition Democracy*; Dayan, *The Story of Cruel and Unusual*; Engelhardt, *Shadow Government*; Evans and Scarry, "The Intimate Life of Violence"; Fault Lines, "The Dark Prisoners"; R. Gordon, *Mainstreaming Torture*; Greenberg, *The Least Worst Place* and *Rogue Justice*; Greenwald, *No Place to Hide*; Hajjar, *Torture*; Hersh, *Chain of Command*; Khalili, *Time in the Shadows*; Maira, *The 9/11 Generation*; McCoy, *A Question of Torture*; McKelvey, *Monstering*; Scahill, *Dirty Wars*; Scarry, *Body in Pain*. See also the "CIA Torture Report," more formally known as "The Committee Study of the Central Intelligence Agency's Detention and Inter-rogation Program," a report compiled by the bipartisan United States Senate Select Committee on Intelligence about the CIA's Detention and Interrogation Program and its use of various forms of torture ("enhanced interrogation techniques" in US government parlance) on detainees between 2001 and 2006 during the war on terror. The final report was approved on December 13, 2012, and a heavily redacted 525-page portion of the report, with key findings and an executive summary of the full report, was ultimately released to the public on December 9, 2014. See also "The Rendi-tion Project," a UK-based research collaboration between academics Ruth Blakeley and Sam Raphael founded in 2011; this project works with the legal action charity Reprieve and the Bureau of Investigative Journalism to bring scholarly research ex-pertise to bear on the CIA's rendition, detention, and interrogation program; https://www.therenditionproject.org.uk/.

2. Key works that inform my analysis of the politics of racialized (im)migrant detention, deportation, and forced removal include Camacho, *Migrant Imaginar-ies*; Chávez, *Queer Migration Politics*; Daulatzai, "Protect Ya Neck"; De Genova and Peutz, *Deportation Regime*; De Genova, "Queer Politics of Migration"; Golash-Boza, *Deported*; A. Gordon, "Abu Ghraib"; D. Hernández, "Undue Process"; K. Hernández, *City of Inmates* and *Migra!*; Kanstroom, *Deportation Nation*; A. Kaplan, "Where is Guantánamo?"; Khalili, *Time in the Shadows*; M. Kim, *Interrogation Rooms of the Korean War*; Loyd and Mountz, *Boats, Borders, and Bases*; Luibhéid, *Entry Denied*; Macías-Rojas, *From Deportation to Prison*; Mountz, *Seeking Asylum*; Maira, *Missing*;

M. Ngai, *Impossible Subjects*; Paik, *Rightlessness*; Razack, *Dying from Improvement*; Vimalassery, "Antecedents of Imperial Incarceration"; White, "Archives of Intimacy and Trauma."

3. The hunger striking and force-feeding of detainees at Guantánamo, not to mention the prison rebellions and barbarous conditions at multiple carceral and detention facilities within the US homeland and at its securitized borders, offer one stark example of this fact. See Charlie Savage, "Number of Hunger Strikers Surges at Guantánamo," *New York Times*, March 20, 2013; and Wil S. Hylton, "The Shame of America's Family Detention Camps," *New York Times*, February 4, 2015.

4. Recent scholarship on surveillance art is by now too vast to cite comprehensively, but for one such survey at the start of the Obama era, see Brighenti, "Artveillance." As I described in more detail in chapter 1, rather than roll back President George W. Bush's global war on terror, the Obama administration largely amplified the legal, security, surveillance, and military dragnet characterizing the Bush II era. Mass disappearances, detentions without trial, summary deportations, shuttering of Muslim nonprofits and bans on remittances, and secret FBI Muslim Surveillance and Entrapment Programs all distinguished the Obama administration, which, statistically, oversaw more deportations than the sum of all presidential administrations in the twentieth century combined, and which led some to describe Obama as the "deporter-in-chief." Between 2009 and 2015, the Obama administration removed more than 2.5 million people through immigration orders, not including the number of people who "self-deported," were turned away at the border by US Customs and Border Protection (CBP), or returned to their home country. See Marisa Franco and Carlos Garcia, "The Deportation Machine Obama Built for President Trump," *Nation*, June 27, 2016.

5. Bayat, quoted in Maira, *The 9/11 Generation*, 261.

6. One notable exception that garnered international recognition in late 2017 was *Ode to the Sea: Art from Guantánamo Bay*, an art exhibition on display from October 2, 2017, to January 26, 2018, at the John Jay College of Criminal Justice in Manhattan. The exhibit was curated by Erin L. Thompson, Paige Laino, and Charles Shields and featured thirty-six paintings, drawings, and sculptures made by eight men who were being held at the Guantánamo Bay detention center in Cuba (including Abdualmalik [Alrahabi] Abud, Ammar Al-Baluchi, Ahmed Rabbani, Djamel Ameziane, Ghaleb Al-Bihani, Khalid Qasim, Moath Al-Alwi, and Muhammad Ansi). Four of the men have since been released. See "Ode to the Sea," https://www.artfromguantanamo.com/. For a digital version of the exhibition catalogue released by *Postprint Magazine*, featuring essays by Jericho Brown, Somaz Sharif, Trevor Paglen, and others, see the special edition issue online at http://www.postprintmagazine.com/special-edition-ode-to-the-sea-art-from-guantanamo/. For more on the political and ethical controversies emerging out of the exhibition, including the Pentagon's decision to abandon years-long precedent of releasing security-screened prisoner art to the public and now calling that art US government property, see Fortin, "Who Owns Art from Guantánamo Bay?"; Hopkins, "I Can Get My Soul Out of Prison"; Rosenberg, "After Years of Letting Captives Own Their Artwork, Pentagon Calls It Property";

and Thompson, "The Art of Keeping Guantánamo Open." For comprehensive documents and research related to the roughly 780 people who have been sent to Guantánamo Bay prison since 2002, see "The Guantánamo Docket" in the *New York Times*; https://www.nytimes.com/interactive/projects/guantanamo/detainees. Finally, for speculative analyses of Guantánamo's futures under the Trump administration, see Greenberg, "Guantánamo's Last 100 Days" and "Guantánamo's Living Legacy in the Trump Era."

7. For more on the efflorescence of radical political fervor in 1990s South Asian and Middle Eastern diasporic arts and activism in the US, see, e.g., Das Gupta, *Unruly Immigrants*; Kapadia et al., "Artist Collectives in Post-2001 New York"; Maira, *Desis in the House*; Mathew, *Taxi*; Naber, *Arab America*; Prashad, *Karma of Brown Folk*; Sudhakar et al., "Crafting Community."

8. For a sample of formative influences for my approach to the archival impulse in critical race, postcolonial, queer, and feminist studies, see note 82 in this book's introduction. See also A. Feldman, *Archives of the Insensible*; Giannachi, *Archive Everything*; Spieker, *Big Archive*.

9. Ghani, "Divining the Question."

10. See, for instance, Browne, *Dark Matters*; J. Butler, *Frames of War*; Chow, *Age of the World Target*; C. Kaplan, *Aerial Aftermaths*; Mirzoeff, *The Right to Look*; Parks and Kaplan, *Life in the Age of Drone Warfare*; Shaw, *Predator Empire*; Virilio, *War and Cinema*.

11. I borrow this evocative phrase from Gregory, *Colonial Present*, to capture a sense of the complex historical trajectories of European and American colonialisms that shadow the violent here and now of US militarism in the Greater Middle East (specifically, as the book's subtitle suggests, in Afghanistan, Palestine, and Iraq). On the long-standing centrality of Islam and Muslims to an imperial system of racism, see also Daulatzai and Rana, *With Stones in Our Hands*.

12. Howell and Shyrock, "Cracking Down on Diaspora." See also Cainkar, *Homeland Insecurity*; Jamal and Naber, *Race and Arab Americans before and after 9/11*; Maira, *Missing*; Puar, *Terrorist Assemblages*; Rana, *Terrifying Muslims*; Razack, *Casting Out*; Selod, *Forever Suspect*; Volpp, "The Citizen and the Terrorist."

13. Buff, *Against the Deportation Terror*.

14. Amar, *Security Archipelago*; Camp, *Incarcerating the Crisis*; Daulatzai, *Black Star, Crescent Moon*; A. Davis, *Abolition Democracy*; A. Gordon, *Ghostly Matters*; Loyd, Mitchelson, and Burridge, *Beyond Walls and Cages*; Macías-Rojas, *From Deportation to Prison*; Rana, *Terrifying Muslims*; D. Rodriguez, *Forced Passages*; Sudbury, "A World Without Prisons."

15. Daulatzai, "Protect Ya Neck," 140–41. See also Kumar; *Islamophobia and the Politics of Empire*; Kundnani, *The Muslims Are Coming!*; Rana, *Terrifying Muslims*.

16. On the "human terrain," see the discussion in chapter 1 and González, *American Counterinsurgency*; Gregory, "The Rush to the Intimate"; Kelly et al., *Anthropology and Global Counterinsurgency*.

17. Balce, *Body Parts of Empire*, 161.

18. Balce, *Body Parts of Empire*, 161.

19. Balce, *Body Parts of Empire*, 9.

20. Hong, *Ruptures of American Capital*, xxxi. In her haunting theorization of the symbolic logics of life and death in the wake of the relentless disavowal of difference that characterizes neoliberalism, Grace Kyungwon Hong evokes the writing of James Baldwin and his final published book, *The Evidence of Things Not Seen* (1985), on the 1981 "Atlanta Child Murders" case. This important, if not particularly well-received, meditation on early 1980s US race relations attempts to make sense of the 1979–81 Atlanta killing spree in which twenty-eight Black children and adults were murdered. A young Black man named Wayne Williams was ultimately tried and convicted of the final two crimes. From his expatriate home in Paris, Baldwin speculates on the case's indeterminacy of guilt while commenting on Atlanta, the US South, and racist legacies of government neglect of Black life. In his indictment of state violence against Black children, Baldwin evokes "the evidence of things not seen," part of the New Testament definition of faith (Hebrews 11:1). This concept challenges extant representational and epistemological frames—what we might call, following Judith Butler, "the sensuous parameters of reality itself" (see J. Butler, *Frames of War*, xi). Baldwin critiques ascendant representational systems of the time that accounted for race, imprisonment, and the devaluation of Black life. These systems control "what can be seen and what can be heard" in public war discourses, even when the wars do not entail overt militarized operations but rather the routine, banal, and brutal policing of domestic populations of color (xi). Baldwin challenges policing and punishment logics that both make Black male bodies hypervisible as "criminal" and disappear those bodies as victims of interpersonal and state violence. I invoke Hong's treatment of Baldwin's account of "the evidence of things not seen" in my theorization of "warm data" because his approach to dominant archives resonates with the core philosophical and methodological challenge at the heart of this chapter. See Hong, *Death beyond Disavowal*. See also Holland, *Raising the Dead*.

21. Visible Collective's members were Naeem Mohaiemen, Anandaroop Roy, Jee-Yun Ha, Donna Golden, Aimara Lin, Vivek Bald, Kristofer Dan-Bergman, J. T. Nimoy, Sehban Zaidi, Anjali Malhotra, Aziz Huq, Sarah Olson, and Ibrahim Quraishi. Beginning in 2006, Visible Collective went into what Mohaiemen describes as "slow retirement," although it continues to occasionally respond to small requests, such as a project at Institut le'Monde Arabe and a book with artist and critic Doug Ashford on the utility of collectives in hypermarket times. For an archive of their works, see "Disappeared in America," http://www.disappearedinamerica.org/. Naeem Mohaiemen is an artist and scholar of Bangladeshi origin who merges essays, films, and installations in order to research South Asia's two postcolonial markers and partitions of 1947 and 1971. His projects on the 1970s revolutionary left have been exhibited internationally at documenta 14, at the Venice Biennale, and across Asia, Europe, the Middle East, and North America. See also Mohaiemen, "Tracing the Index" and "When an Interpreter Could Not be Found."

22. On the 2005 QMA group show curated by Abichandani and Reddy, see "Fatal Love: South Asian American Art Now," https://www.queensmuseum.org/2015/11 /fatal-love-south-asian-american-art-now. For an archive of the brochure, see http://

www.queensmuseum.org/wp-content/uploads/2017/03/Fatal%20Love.pdf (accessed June 9, 2018).

23. On recent transformations of the global art market, see Zarobell, *Art and the Global Economy.*

24. Kapadia et al., "Artist Collectives in Post-2001 New York," 294. In my interview with the Collective, I asked how informal social networks among diverse cultural producers laid the groundwork for forging newer collaborations and alliances that then went on to enable later social and political struggles for social justice.

25. For more on Project Row Houses, see "About PRH," https://projectrowhouses.org/about/about-prh/.

26. Jasbir Puar argues that this type of cultural work reinstates a problematic liberal binary between "public" and "private" spaces, in addition to the Orientalized assumptions that surround the profile of a Muslim extended family. She notes how feminists of color, specifically Ananya Bhattacharjee, have critiqued the white liberal feminist "disregard [of] the vicissitudes of state racism that permeate the domestic private domains of women of color and immigrant women." The private/public split is thus an inadequate paradigm for "immigrant women, especially those who are undocumented and for whom the state is inescapable even in the private, the presence of which most often transpires as state racism" (Puar, *Terrorist Assemblages*, 164).

27. The 2011 film *Enemy Alien* (dir. Konrad Aderer) chronicles Abdel-Muhti's life and details the abuse he experienced in solitary confinement. For over eight months, he was denied vital thyroid medication and continually threatened with deportation. The Palestinian-born activist was subject to a deportation order in 1995. He overstayed his visa, was deported, and reentered the country twice afterward. Originally, his story about where he was born was inconsistent: first he said he was a US citizen born in Puerto Rico, then he told officials that he was born in Palestine. He had a few run-ins with the criminal justice system, including a notable guilty plea of attempted assault on his wife in 1993, a fact that is conspicuously absent in the documentary. This silence implies the need to conform to the "innocence vs. guilt" binary that structures the majority of liberal civil rights and human rights legal advocacy related to incarceration and immigrant detention.

28. In an interesting twist of fate, and despite his long-standing criticism of the Guantánamo facilities, James Yee later became a delegate to the 2008 Democratic National Convention from the Washington 9th Congressional District, casting a nominating ballot in support of President Barack H. Obama. See Associated Press, "Ex-Army Chaplain Cleared in Gitmo Spy Case is Obama Delegate," *Yahoo News*, May 20, 2008 (accessed May 20, 2008, no longer active). See also the epilogue to Parikh, *An Ethics of Betrayal.*

29. A kurta is a long collarless shirt commonly worn by men throughout South Asia.

30. See Finn, *Capturing the Criminal Image.*

31. Puar, *Terrorist Assemblages*, 145. See also 267n89 for an extended discussion of how liberal and progressive criticism of detention and deportation frequently relies on notions of the heteronormative family, a theme that is further explored in Reddy, *Freedom with Violence.*

32. Min, "Tonal Disturbances," 61.

33. For important interventions in the social and cultural analysis of African American Muslims, see Abdul Khabeer, *Muslim Cool*; Chan-Malik, *Being Muslim*; Curtis, *Muslims in America*; Daulatzai, *Black Star, Crescent Moon*; Marable and Aidi, *Black Routes to Global Islam*; McCloud, *African American Islam*; Turner, *Islam in the African American Experience*. For more on the relation between African Americans and South Asian Americans, and specifically the forms of both anti-Black racism and antiracist global consciousness that inaugurated South Asian diasporic racial identities in the US across the twentieth century, see Bald, *Bengali Harlem*; Prashad, *Karma of Brown Folks*; Rana, *Terrifying Muslims*; Sharma, *Hip Hop Desis*.

34. Daulatzai, "Protect Ya Neck," 141.

35. Abdul-Khabeer, *New Muslim Cool*; Browne, *Dark Matters*; Puar, *Terrorist Assemblages*; Rana, *Terrifying Muslims*.

36. Puar, *Terrorist Assemblages*, 174.

37. See Kumar and Kundnani, "Race, Surveillance, and Empire."

38. See Ashford and Mohaiemen, "Collectives in Atomised Times."

39. I am persuaded by Manu Vimalassery's forceful critique of (South Asian) diaspora studies for failing to wrestle with Indigenous critique, thereby facilitating "ongoing imperial projects that erase claims and enactments of indigenous sovereignty and autonomy." See Vimalassery, "Antecedents of Imperial Incarceration," 351. Engaging the thought and politics of indigenous sovereignty in the context of US carceral practices is, as he puts it, "vital to any thoroughgoing critique of US imperialism" (351). For other works that bring native/Indigenous critique to Asian American studies, see Day, *Alien Capital*; Fujikane and Okamura, *Asian Settler Colonialism*; Jafri, "Ongoing Colonial Violence in Settler States"; Karuka, *Empire's Tracks*; Lowe, *Intimacies of Four Continents*; Patel, Moussa, and Upadhyay, "Complicities, Connections, and Struggles"; Saranillio, *Unsustainable Empire*; and Upadhyay, "Pernicious Continuities."

40. Alsultany, *Arabs and Muslims in the Media*; Bayoumi, *This Muslim American Life*; Cainkar, "Special Registration" and *Homeland Insecurity*; Grewal, *Transnational America*; Jamal and Naber, *Race and Arab Americans before and after 9/11*; Maira, *Missing*; Puar, *Terrorist Assemblages*; Rana, *Terrifying Muslims*; Sheikh, *Detained Without Cause*.

41. For more on how the incoherent category of "the Muslim" has been made into a "legible racial category" in order to better serve the interests of the national security state, see Rana, *Terrifying Muslims*, 80; and Puar, *Terrorist Assemblages*, 160–61. See also Cainkar and Maira, "Targeting Arab/Muslims/South Asian Americans"; Daulatzai and Rana, *With Stones In Our Hands*; Kundnani, *The Muslims Are Coming!*; Maira, *Missing* and *The 9/11 Generation*; Volpp, "The Citizen and the Terrorist."

42. As Sunaina Marr Maira explains, "The use of 'the disappeared' by civil and immigrant rights activists was intended to evoke the human rights violations associated with the (much larger scale) abduction, secret detention, and torture of innocent civilians (the *desaparecidos*) during the 'dirty wars' in Argentina in 1976–83, as part of the campaign against left-wing 'terrorists.' By May 2003, the U.S. government had

also detained over 1,000 foreign nationals under the Absconder Apprehension Initiative, which prioritized deportation of 6,000 Arabs and Muslims from the pool of over 300,000 immigrants with outstanding deportation orders (Cole 2003, 25)." See Maira, *Missing*, 70.

43. Puar, *Terrorist Assemblages*, 150–51.

44. M. Ngai, *Impossible Subjects*.

45. Ngai's work attests to the centrality of the law in studies of US racialization and state formation. What is unique about this period, according to Ngai, is that governmentality through immigration law became thoroughly racialized, but not visibly so. The construction of racist exclusions did not rely on an explicit discourse of race (or similar social markers of inferiority, such as disease and sexual deviance). Instead, the quota system masked the dominant racial logic inscribed within the law and appeared as a purely formal, rational mechanism for adjudicating people's life chances. Immigration restriction is thus a powerful site for thinking about the complexities and vagaries of twentieth-century state-making and race-making processes. As the leader in implementing this new administrative system, the US offers a central case study in the century's global restructuring of emergent nation-states. Ngai implicitly argues that immigration control had a crucial impact on the emergence of the nation-state, and that US sovereignty (its territorial integrity and mobility restrictions) formed within a racist/colonialist frame. One wonders how Ngai's argument would be enhanced if she had pursued the "otherworldliness" connecting the history of US immigration to the experiences of US native-born racialized populations (M. Ngai, *Impossible Subjects*, 27). In other words, I ask what it would mean to tell immigrant, Native, and African American history concurrently. A newer cohort of interdisciplinary scholars have taken up this question by connecting the historical "coincidences" of Ngai's immigration story to the legacies of nineteenth- and twentieth-century US Black and Indigenous struggles. See, e.g., Field, *Growing Up with the Country*; Karuka, *Empire's Tracks*; King, *Black Shoals*. See also Byrd, *Transit of Empire*; K. Hernández, *City of Inmates*; Lowe, *Intimacies of Four Continents*; N. Singh, *Race and America's Long War*.

46. See Grewal, *Transnational America*.

47. On INS Special Registration's quotidian afterlife in New York City, see Manalansan, "Race, Violence, and Neoliberal Spatial Politics in the Global City"; and Rana, "Policing Kashmiri Brooklyn."

48. Puar, *Terrorist Assemblages*, 187.

49. A chador is a large piece of cloth draped around the head and body, leaving only the face exposed; chadors are particularly worn by Muslim women.

50. The postcolonial feminist scholarly and popular literature on veiling practices among Muslim women in the West is far too vast to cite here, but for a sample of key interventions, see, e.g., L. Abu-Lughod, "Do Muslim Women Really Need Saving?"; Bucar, *Pious Fashion*; Lewis, *Muslim Fashion*; J. Scott, *Politics of the Veil*; Toor, "Gender, Sexuality, and Islam under the Shadow of Empire."

51. Puar, *Terrorist Assemblages*, 148.

52. Puar, *Terrorist Assemblages*, 146. For a compelling narrative detailing the now

decades-long seizure of immigrant Muslim male heads of household, and specifically related to the story of Sami Al-Arian, a Palestinian Muslim professor at the University of South Florida who was indicted on fifty-three counts of supporting the Palestinian Islamic Jihad, see Al-Arian, "When Your Father is Accused of Terrorism."

53. Puar, *Terrorist Assemblages*, 146. For an extended discussion of how immigration law both demands and regulates heteronormativity, see Reddy, "Asian Diasporas, Neo-liberalism and the Critique of Gay Identity"; and Queers for Economic Justice, "Queers and Immigration." For an earlier review of the literature, see Luibhéid, "Heteronormativity and Immigration Scholarship."

54. See Ameeriar, *Downwardly Global*.

55. For more on the Index of the Disappeared, see "Index of the Disappeared— Documents + Documentation," www.kabul-reconstructions.net/disappeared, (accessed January 10, 2019).

56. Ghani is a Brooklyn-based artist whose work in video, installation, new media, photography, text, and public dialogue performance investigates how history is constructed and reconstructed as narrative in the present, particularly in the border zones and political spaces of transition, where past, present, and future emerge as stories told in translation, contest, and counterpoint. Notably, her father, Ashraf Ghani Ahmadzai, has served as the president of Afghanistan since 2014. For more on her work, see her website; http://www.mariamghani.com/ (accessed January 19, 2019). Ganesh is a Brooklyn-based artist who works across a range of media (drawings, paintings, installation, animation, and new media) and has exhibited internationally and received numerous awards, including the Guggenheim Fellowship in the Creative Arts (2012). For more on her work, see her website: http://www.chitraganesh .com/ (accessed January 19, 2019).

57. Ganesh and Ghani, "Roundtable 2: Impossible Archives," Tracing the Index, nyu Kevorkian Center Library, March 3, 2008. For archives of their work, see "Index of the Disappeared (Ongoing)," http://www.mariamghani.com/work/626, and "Index of the Disappeared—Documents + Documentation," www.kabul-reconstructions .net/disappeared.

58. See "Afterlives of Blacksites I: The Seen Unseen," http://www.chitraganesh .com/portfolio/afterlives-of-blacksites-i-the-seen-unseen/ (accessed June 8, 2018).

59. González, *American Counterinsurgency*; Kelly et al., *Anthropology and Global Counterinsurgency*.

60. Ghani, "Divining the Question."

61. For critiques of humanitarian spectatorship and human rights visuality, see K. Feldman, "#NotABugSplat"; and Hesford, *Spectacular Rhetorics*.

62. Khalili, *Time in the Shadows*, 238.

63. On predictive policing, algorithmic criminology, and the racial surveillance of Muslim Americans, see Amoore and Piotukh, *Algorithmic Life*; Bayoumi, *This Muslim American Life*; Browne, *Dark Matters*; Halpern, *Beautiful Data*; Johnson and Weitzman, *The fbi and Religion*; Kundnani and Kumar, "Race, Surveillance, and Empire"; K. Silva, *Brown Threat*; Striphas, "Algorithmic Culture."

64. Paglen, *Blank Spots on the Map*, xii–xiii.

65. Paglen, *Blank Spots on the Map*, xiii.

66. Paglen, *Blank Spots on the Map*, 5.

67. Arondekar, *For the Record*, 17.

68. Ghani, "Divining the Question."

69. Ghani, "Divining the Question."

70. A. Gordon, *Ghostly Matters*, 79. On the significance of self-representation by undocumented migrants, mostly Mexicans and Central Americans, and their use of documentary media in the context of intensified regimes of state surveillance, see Schreiber, *The Undocumented Everyday*.

71. Solomon-Godeau, "Torture and Representation," 126.

72. Ganesh and Ghani, "Impossible Archives." On the "pornotropic," see Spillers, "Mama's Baby, Papa's Maybe."

73. Ganesh and Ghani, "Impossible Archives."

74. Kahlon, "A Time for Breaking Laws."

75. See "The Rendition Project," www.therenditionproject.org.uk.

76. See Kahlon's images online at "Did You Kiss the Dead Body?" http://www.didyoukissthedeadbody.com. The title of the work—*Did You Kiss the Dead Body?*—references the last line of Harold Pinter's poem "Death," read during his 2005 Nobel Prize acceptance speech, which was notable for its sharp criticism of US foreign policy and the military occupation of Iraq.

77. Kahlon, "Did You Kiss the Dead Body?"

78. R. Hall, "Of Ziploc Bags and Black Holes," 323.

79. R. Hall, "Of Ziploc Bags and Black Holes," 323.

80. On biometric surveillance, see Browne, *Dark Matters*; Caplan and Torpey, *Documenting Individual Identity*; Gates, *Our Biometric Future*; R. Hall, *Transparent Traveler*; Lyon, *Surveillance Society*; Magnet, *When Biometrics Fail*; Mongia, *Indian Migration and Empire*; K. Silva, *Brown Threat*.

81. Stoler, *Along the Archival Grain*; Thomas, *Empires of Intelligence*.

82. Stoler, *Along the Archival Grain*, 100.

83. R. Hall, "Of Ziploc Bags and Black Holes," 321.

84. R. Hall, "Of Ziploc Bags and Black Holes," 323.

85. R. Hall, "Of Ziploc Bags and Black Holes," 323.

86. McClintock "Paranoid Empire," 51.

87. Daulatzai, "Protect Ya Neck," 135.

88. My argument here resonates with that in Tina Campt's recent work on the grammar of Black feminist futurity ("that which will have had to happen, hasn't yet happened but must"). Campt calls attention to a genre of "identification photography": ostensibly mute images that are often encountered only in relation to the state or to science, including passport photos, mugshots, and prison albums. By tracing how Black communities have repurposed these visual archives against the grain, a methodological engagement that she terms "listening to images," Campt's work provides an important resource for my efforts here in conjuring "warm data" in archives of US global military and carceral detention. See Campt, *Listening to Images*. See also Balce, *Body Parts of Empire*; Finn, *Capturing the Criminal Image*; Fleetwood, "Pos-

ing in Prison"; Hartman, "Anarchy of Colored Girls"; Mongia, *Indian Migration and Empire*; Pegler-Gordon, *In Sight of America*.

89. Glisson, quoted in Solomon–Godeau, "Torture and Representation," 334n16.

90. Solomon-Godeau's analysis of Jenny Holzer's *Redaction Paintings* is a key resource for my analysis of Kahlon and the Index of the Disappeared. Solomon-Godeau describes the French Situationists' concept of *detournement*: "appropriating images, texts, advertisements, and so forth, to subvert, alter, derail, or transfigure their original meaning. The new meanings unleashed or enabled thus function as tactical unveilings of what the image or text in its official guise operates to mystify, occlude, disavow" (Solomon-Godeau, "Torture and Representation," 126).

91. "Epistemic anxieties" alludes to Stoler's *Along the Archival Grain*, which is a formative source for theorizing the nexus of reason and affect in colonial administrations and imperial bureaucracies.

92. Kahlon, *Aesthetic Justice Seminar*.

93. Kahlon, "Did You Kiss the Dead Body?"

94. Kahlon, "Did You Kiss the Dead Body?"

95. Kahlon, "Did You Kiss the Dead Body?"

96. A. Gordon, *Ghostly Matters*, 80.

97. D. Taylor, *Disappearing Acts*.

98. Stoler, *Along the Archival Grain*, 70. See also Campt, *Listening to Images*; Finn, *Capturing the Criminal Image*; Fleetwood, "Posing in Prison"; Pegler-Gordon, *In Sight of America*.

99. Razack, *Dying from Improvement*, 28. Razack's study of Canadian state-sponsored attacks on Indigenous communities, as "remnants [who] are not expected to contest their disappearance" (8), is a vital source for my understanding of death and disappearance in the forever war.

100. Balce, *Body Parts of Empire*, 161.

101. Kahlon, *Aesthetic Justice Seminar*. See also Hong, *Death beyond Disavowal*; Holland, *Raising the Dead*.

102. Sharpe, *In the Wake*, 20, 139n28.

103. Stoler, *Along the Archival Grain*, 237.

104. Kahlon, "Did You Kiss the Dead Body?"

105. Email correspondence with the author, March 18, 2014.

106. Amar, *Security Archipelago*.

107. Kahlon, "Did You Kiss the Dead Body?"

108. Kahlon, "Did You Kiss the Dead Body?"

109. Kahlon, "Did You Kiss the Dead Body?"

110. A. Gordon, *Ghostly Matters*; Hong, *Death beyond Disavowal*.

111. Espiritu, *Body Counts*, 107.

112. Ganesh and Ghani, "Chitra Ganesh Talks to Mariam Ghani about *The Trespassers* for the sbx Catalogue."

113. For an excerpt of "The Trespassers," see http://vimeo.com/23004157.

114. For an abc news report on field interpreters, who are called "perps," see

Mosk, "Whistleblower Claims Many US Interpreters Can't Speak Afghan Languages." See also Rafael, *Motherless Tongues*.

115. Hoogslag, "Interview with Mariam Ghani"; emphasis mine.

116. Hoogslag, "Interview with Mariam Ghani."

117. For more on "actionable intelligence" in government interrogations, see M. Kim, *Interrogation Rooms*; McCoy, *A Question of Torture*; Mirzoeff, *The Right To Look*.

118. McClintock, "Paranoid Empire," 51.

119. McClintock, "Paranoid Empire," 51.

120. Shachtman, "Unlimited Talk, Only $679 Million."

121. Hoogslag, "Interview with Mariam Ghani."

122. Maira, *The 9/11 Generation*.

123. Hoogslag, "Interview with Mariam Ghani."

124. On these temporary mock villages and US Army training camps, see Bowman, "In Mock Village." See also González, *American Counterinsurgency*, 38–39.

125. On the Human Terrain System (HTS), see González, "The Rise and Fall of the Human Terrain System"; O. Khalil, *America's Dream Palace*, 267–68; and Price, *Weaponizing Anthropology*.

126. See Parikh, *An Ethics of Betrayal*.

127. On military multiculturalism, see Melamed, "The Spirit of Neoliberalism"; and McAlister, *Epic Encounters*, chapter 6.

128. A. Gordon, *Ghostly Matters*; Ganesh and Ghani, "Chitra Ganesh talks to Mariam Ghani about The Trespassers for the SBX Catalogue."

129. Nicholas Fandos, "Senate Confirms Gina Haspel to Lead C.I.A. Despite Torture Concerns." *New York Times*, May 17, 2018.

130. McClintock, "Paranoid Empire," 59.

FOUR. Palestine(s) in the Sky

1. On Palestine/Gaza (and settler colonial regimes more generally) as propitious "laboratories" for US/Israeli militarized technologies, see, e.g., Esmeir, "Colonial Experiments in Gaza"; I. Feldman, *Police Encounters*; A. Gordon, "The Bruise Blues"; Graham, "Laboratories of War"; Greenwald, "Cash, Weapons, and Surveillance"; Khalili, "The Location of Palestine in Global Counterinsurgencies" and *Time in the Shadows*; Li, "The Gaza Strip as Laboratory"; Matar and Tawil-Souri, *Gaza as Metaphor*; and Puar, *The Right to Maim*.

2. To date, the prevailing scholarly discourse on verticality in Palestine focuses on the verticality of settler construction rather than Indigenous alternatives. See, e.g., Graham, *Vertical*; Lambert, *Weaponized Architecture*; Weizman, *Hollow Land* and "Introduction to the Politics of Verticality."

3. On "full-spectrum dominance" and atmospheric warfare, see Shaw, *Predator Empire*. On queer "world-making," see Muñoz, *Disidentifications*, 195; and Berlant and Warner, "Sex in Public," 558. See also Kondo, *Worldmaking*.

4. I use the language of "queer feminist" rather than "queer and feminist"

throughout this chapter to call attention to the convivial (rather than hostile) political and theoretical genealogies of queer, feminist, and diaspora studies that inspire and enable my reading of Sansour's insurgent aesthetics. For more on contemporary "queer feminist criticism" that builds off of the influential writing of Eve Kosofsky Sedgwick and Gayle Rubin to analyze the affective in temporal terms, and vice versa, see Wiegman, "The Times We're In." For more on the shared genealogies between queer and femme, and between nonwhite, nonwestern, and nonheteronormative subjectivities, desires, and structures, see also, e.g., Ahmed, *Promise of Happiness*; M. J. Alexander, *Pedagogies of Crossing*; Berlant, *Cruel Optimism*; Cvetkovich, *An Archive of Feelings*; Ferguson, *Aberrations in Black*; Freeman, *Time Binds*; Gopinath, *Impossible Desires*; Halberstam, *Queer Art of Failure*; H. Love, *Feeling Backward*; Rodriguez, *Queer Latinidad*; Sedgwick, *Touching, Feeling*; Tinsley, *Ezili's Mirrors*.

5. Farsakh, Khanaaneh, and Seikaly, eds., "Queering Palestine," 7. On feminist and queer critiques of Israeli Zionist colonial violence and the question of Palestine, see Alqaisiya, "Decolonial Queering"; Bhandar, "Some Reflections on BDS and Feminist Political Solidarity"; Elia, "The Burden of Representation" and "Justice Is Indivisible"; Farsakh et al., "Queering Palestine"; Hochberg, "Queer Politics and the Question of Palestine/Israel"; Kouri-Towe, "Textured Activism"; Lloyd, "It Is Our Belief That Palestine Is a Feminist Issue"; Naber, Desouky, and Baroudi, "The Forgotten '-Ism'"; Naber et al., "On Palestinian Studies and Queer Theory"; Olwan, "On Assumptive Solidarities in Comparative Settler Colonialisms"; Schotten, *Queer Terror* and "To Exist Is to Resist"; Shalhoub-Kevorkian, "Palestinian Feminist Critique and the Physics of Power"; Schulman, *Israel/Palestine and the Queer International*; Sharoni et al., "Transnational Feminist Solidarity in Times of Crisis"; and Stelder, "Other Scenes of Speaking."

6. Farsakh et al., "Queering Palestine," 10–11.

7. Mikdashi, quoted in Naber et al., "On Palestine Studies and Queer Theory," 66. On "homonationalism," see Puar, *Terrorist Assemblages*; and Mikdashi and Puar, "Queer Theory and Permanent War."

8. Mikdashi, quoted in Naber et al., "On Palestine Studies and Queer Theory," 66. Building on the work of Jodi Byrd, Jasbir Puar, and others, Mikdashi adds that this decolonial and antiracist queer project routed through Palestine studies might entail "thinking through the intimacies and recursions of settler-colonial and anti-Black praxis within transnational and diasporic discourses and practices of the Global War on Terrorism—a framework that both the U.S. and Israeli states have imposed (and succeeded at imposing) on the Palestinian national anti-colonial struggle" (67). See also Byrd, *Transit of Empire*; Puar, *The Right to Maim*.

9. Farsakh et al., "Queering Palestine," 11. As Nadine Naber elegantly summarizes in the roundtable discussion, this "anti-racist and decolonial queer scholarship and activism can help clarify that just as homophobia and transphobia (both outcomes of nationalist demands for heteronormativity) will not liberate Palestine, 'coming out of the closet' and fighting for a singular concept of 'gay rights' will not liberate gender-nonconforming Palestinians. Indeed, Palestine studies has a great deal to contribute to how scholars and activists are envisioning decolonization beyond nationalism and

heteronormativity while challenging the alliance between liberal LGBTQ activism and colonial discourses on indigenous sexualities" (Naber et al., "On Palestine Studies and Queer Theory," 63).

10. Farsakh et al., "Queering Palestine," 11.

11. Farsakh et al., "Queering Palestine," 11.

12. K. Feldman, "Zionism and Anti-Zionism," 1068. On "contrapuntalism" in postcolonial cultural critique, see Said, *Culture and Imperialism*. For a crystallization of the intellectual and political mapping that characterizes this historical and contemporary relation since at least the late 1970s (via the work of Edward Said), see Abdulhadi and Olwan's edited forum in *American Quarterly*, "Shifting Geographies of Knowledge and Power: Palestine and American Studies," from which Feldman's essay is drawn. See also Gregory, *Colonial Present*; J. L. Kelly, "Locating Palestine within American Studies"; R. Khalidi, *Brokers of Deceit*; McAlister, *Epic Encounters*; Lubin, "American Studies, the Middle East, and the Question of Palestine"; Puar, *The Right to Maim*; Said, *The Question of Palestine*; Salaita, *Intern/Nationalism*; Tabar and Desai, "Decolonization Is a Global Project."

13. This collective project, led by Indigenous studies scholars of North America and the Pacific, has challenged the field's earlier glorification of the "founding fathers" and US exceptionalisms and has forwarded radical critiques of US empire and settler colonialism. For a sample of these de-exceptionalist approaches in Native North American feminist and queer studies, see Barker, *Critically Sovereign*; Byrd, *Transit of Empire*; Goeman, *Mark My Words*; Morgensen, *Spaces between Us*; Rifkin, *Settler Common Sense*; Ross, *Inventing the Savage*; N. Silva, *Aloha Betrayed*; A. Simpson, *Mohawk Interruptus*; and Simpson and Smith, *Theorizing Native Studies*.

14. I thank Lila Sharif for the reminder that Palestinian return is fraught for a myriad of reasons, not least of all the class cleavages that emerge from new and rapid forms of gentrification in Palestine/Israel, including sites such as Jaffa, where rising rents displace long-term residents from historic coastal cities and beyond. See, e.g., Léopold Lambert, "Palestine Report Part 5: The Colonial and Gentrifying Violence of Architecture in Jaffa," *Funambulist*, August 7, 2017, https://thefunambulist .net/architectural-projects/palestine-report-part-5-colonial-gentrifying-violence -architecture-jaffa. See also Rotbard, *White City, Black City*.

15. The mode of Arabfuturism I trace in Sansour's work helps to expand, interrogate, and add new contrapuntal geographies to Black and Native/Indigenous studies and their aesthetic movements against US settler colonialism and racial capitalism. I locate and harness one aspect of the visionary fictive and futurist dimension of contemporary Arab/Palestinian diasporic visual art to illustrate how artists are adopting the spatial and temporal coordinates of science fiction to propose parallel worlds and social fictions, even as some of these thought experiments cannot be fully subsumed under the sign of the "insurgent" or oppositional. And yet, these utopian and dystopian projects are, as cultural theorist Ramzi Fawaz rightly contends, "always conceived of in relation to a particular historical moment—that is, as a response to what is happening in a specific place and time—utopias do not unfold in a linear succession but rather accumulate or expand in number . . . the invention of utopias can

more accurately be understood as a ceaseless accumulation of ideas, experiments, and possibilities projected into an indefinite future." Fawaz, Hall, and Kinsella, "Discovering Paradise Islands," 7.

16. There are several popular and scholarly accounts of settler colonialism, a term first emanating from Native/Indigenous studies but now circulating widely in the fields of anthropology, geography, comparative literature, history, American studies, critical ethnic studies, Palestine/Middle Eastern studies, and beyond. For various itineraries and genealogies of the concept of settler colonialism in North American Native studies, see Goldstein, *Formations of United States Colonialism*; Goldstein and Lubin, "Settler Colonialism"; Kauanui, "'A Structure, Not an Event'"; Morgensen, *Spaces between Us*; Olwan, "On Assumptive Solidarities in Comparative Settler Colonialisms"; Razack, *Race, Space, and the Law*; A. Simpson, *Mohawk Interruptus*; Simpson and Smith, *Theorizing Native Studies*; Wolfe, "Settler Colonialism and the Elimination of the Native"; and Veracini, *Settler Colonialism*. For Asian American settler colonial studies, see Day, *Alien Capital*; Fujikane and Okamura, *Asian Settler Colonialism*; Lowe, *Intimacies of Four Continents*; and Saranillio, *Unsustainable Empire*. For a small sample of works that have advanced the settler colonial paradigm in the field of Palestine studies, see Abu El-Haj, *Facts on the Ground*; Abunimah, *Battle for Justice in Palestine*; K. Feldman, *Shadow Over Palestine*; Gregory, *Colonial Present*; Khalili, *Time in the Shadows*; Kotef, *Movement and the Ordering of Freedom*; Ochs, *Security and Suspicion*; Nitzan-Shiftan, *Seizing Jerusalem*; Olwan, "On Assumptive Solidarities in Comparative Settler Colonialisms"; Pappé, *Forgotten Palestinians*; Pateman and Mills, *Contract and Domination*; Peteet, *Space and Mobility in Palestine*; Qutami, "Rethinking the Single Story"; Rodinson, *Israel*; Salaita, *Inter/Nationalism*; Sayegh, *Zionist Colonialism in Palestine*; Shafir, *Land, Labor, and the Origins of the Israeli-Palestinian Conflict*.

17. K. Feldman, *Shadow Over Palestine*, 1. See also Abunimah, *Battle for Justice in Palestine*; and Khalili, *America's Dream Palace*. From 1948 to 2013, the US provided $233.7 billion in financial aid to Israel (adjusting for inflation) and an additional $19 billion in loan guarantees. See Ora Coren and Nadan Feldman, "U.S. Aid to Israel Totals $233.7b Over Six Decades," *Haaretz*, March 20, 2013. In the waning months of the Obama administration in 2016, the US finalized an additional $38 billion package of military aid for Israel (including financing for its missile defense shield) over the next ten years, the largest of its kind in history. See Peter Baker and Julie Hirschfield Davis, "U.S. Finalizes Deal to Give Israel $38 Billion in Military Aid," *New York Times*, September 13, 2016. Under the Trump administration, the US recognized Jerusalem as Israel's capital and moved its embassy there in May 2018, on the seventieth anniversary of the formation of the state of Israel. This sparked widespread demonstrations and protests, leading Israel to kill dozens of Palestinians at the Gaza border. This diplomatic move, among others by the Trump administration, has been read widely by the international community as a transformative moment in America's Israel policy into completely unconditional, "blank check" support. See Oliver Holmes and Hazem Balousha, "Israel Faces Outcry Over Gaza Killings during Jerusalem Embassy Protests," *Guardian*, May 14, 2018. See also Zack Beauchamp, "Trump, Gaza,

and the 'Blank Check' Approach to Israel," *Vox*, May 15, 2018. For analysis of the Jerusalem decision and shifts in US policy on Palestine under Trump, see R. Khalidi, "And Now What?"

18. On the "post" in post-Oslo, see R. Khalidi, *Brokers of Deceit*; Peteet, *Space and Mobility in Palestine*, 209n8; and Clarno, *Neoliberal Apartheid*, which argues the Oslo peace process has "entrenched rather than reversed settler colonialism in Palestine/Israel" (7). The Oslo Accords refers to the September 1993 peace agreement brokered by President Bill Clinton on the White House lawn between Israeli Prime Minister Yitzhak Rabin and Chairman of the Palestine Liberation Organization (PLO) Yasser Arafat. The Oslo peace process was imagined as a hopeful moment of transformation in Palestine/Israel, but it had a remarkably different impact on the political freedom of Palestinians, as the State of Israel remained a settler colonial state with full sovereign control over the entire territory of Palestine, with the formation of the Palestinian Authority, and with occupied Palestinian territories fragmented into zones of different political jurisdiction (areas A, B, and C, and later H1 and H2, with differentiated levels of Israeli and Palestinian presence, sovereignty, and control). In the post-Oslo reconfiguration of "peace," as Clarno outlines further, "Palestinians in the West Bank and Gaza Strip are *subjects* of Israeli military rule; Palestinians from East Jerusalem have tenuous *residency* rights; 1948 Palestinians have formal *citizenship* in Israel; and Palestinian refugees confront an enforced *absence* in the diaspora. Although subject to different forms of rule, every fragment of the Palestinian population confronts the same Israeli colonial project" (Clarno, *Neoliberal Apartheid*, 37). Moving forward, I follow Peteet's invocation of "post-Oslo" to signal "the period since the second intifada in 2000, when it became clear to Palestinians that Israel would not abide by the Oslo agreements" (Peteet, *Space and Mobility in Palestine*, 209n8).

19. U. Davis, *Apartheid Israel*; W. Khalidi, *All That Remains*; Pappé, *Forgotten Palestinians*; and Sa'di and Abu-Lughod, *Nakba*. On the uses and limits of metaphor, see Collins, *Global Palestine*; K. Feldman, "Zionism and Anti-Zionism"; Olwan, "On Assumptive Solidarities in Comparative Settler Colonialisms"; Rifkin, "Indigeneity, Apartheid, Palestine"; Salaita, *Inter/Nationalism*; and Salamanca et al., "Past Is Present." Rifkin importantly troubles the concurrent usage (or "conceptual collapse") of the political metaphors of apartheid and settler colonialism in the context Palestine/Israel. He notes that when these two terms are used to refer to the same thing in transit, "the notion of indigeneity tends to vanish, in that the political goal for Indigenous peoples gets envisioned as full belonging within the nation-state rather than as acknowledgement of their distinct mode of sovereignty and self-definition. That process of conceptual collapse . . . significantly truncates the meaning of indigenous self-determination in ways that not only have implications for thinking Palestinian peoplehood(s) but for engaging Indigenous peoples more broadly, given the ways that the case of Israel/Palestine (like that of South Africa before it) itself transits transnationally and comes to serve as a prism through which to view other political struggles" (25–26). See also Salaita, *Inter/Nationalism*. On "transit" as metaphor for the circulation/traffic in theoretical frameworks like indigeneity, see Byrd, *Transit of Empire*; and Salaita, *Holy Land in Transit*.

20. Rifkin, "Indigeneity, Apartheid, Palestine."

21. Peteet, *Space and Mobility in Palestine*, 4.

22. Peteet, *Space and Mobility in Palestine*, 3. She continues: "Now that settler colonialism is a fairly standard term of reference, it is time for a shift in English from 'settlements' to 'colonies' and from 'settlers' to 'colonists.' I use the terms settlements and colonies interchangeably, as part of an ongoing shift in terminology in the academic scholarship on Palestine-Israel. *Settlement* usually implies making population inroads in one's own territory into an uninhabited frontier and the maintenance of ties with and support from the state. A *colony* includes these features but also points to a territory not under state sovereignty and to moving the home country's population into it" (4).

23. Rifkin, "Indigeneity, Apartheid, Palestine," 31; Clarno, *Neoliberal Apartheid*, 6. Zionism refers to a violent, racist, supremacist imperial/colonial ideology originating in nineteenth-century Europe. For critical formulations of its history, see J. Butler, *Parting Ways*; K. Feldman, "Zionism and Anti-Zionism"; Rose, *The Question of Zion*; Said, "Zionism from the Standpoint of Its Victims"; and Sayegh, *Zionist Colonialism in Palestine*.

24. On atmospheric warfare, see Shaw, *Predator Empire* and "The Great Wall of Enclosure." On historical and contemporary analyses of the Israeli security and surveillance state, see I. Feldman, *Police Encounters*; Hajjar, *Courting Conflict*; Hochberg, *Visual Occupations*; Kanaaneh, *Birthing the Nation* and *Surrounded*; R. Khalidi, *Brokers of Deceit*; Ochs, *Security and Suspicion*; Shalhoub-Kevorkian, *Security Theology*; Tawil-Souri, "Surveillance Sublime"; Zureik, *Israel's Colonial Project in Palestine*; and Zureik, Lyon, and Abu-Laban, eds., *Surveillance and Control in Israel/Palestine*.

25. On US-Israeli security, police, and military transfers, see Bhungalia, "Managing Violence"; Esmeir, "Colonial Experiments in Gaza"; K. Feldman, "Zionism and Anti-Zionism"; Gregory, *Colonial Present*; Greenwald, "Cash, Weapons, and Surveillance"; Hajjar, "Comparing American and Israeli Ways of War"; R. Khalidi, "The United States and the Palestinians"; O. Khalil, *America's Dream Palace*; Khalili, *Time in the Shadows*; Lubin, *Geographies of Liberation*; Naber, "Anti-Imperialism and Black-Palestinian Solidarity"; Puar, *The Right to Maim*; and Salaita, *Inter/Nationalism*. On the shared conditions of colonial violence and complex relations between Black freedom struggles in the US and the question of Palestine, see K. Feldman, *Shadow over Palestine*; and Lubin, *Geographies of Liberation*. See also Yotam Feldman's 2013 documentary film *The Lab*, on the Israeli arms industry and Palestine as the staging ground for experimentations with military technologies, and Jewish Voice for Peace's nascent campaign on "Deadly Exchange," which traces the dangerous collusions and police exchange programs of "worst practices" between the US/Trump and Israeli/Netanyahu regimes to "bring together police, ICE, border patrol, and FBI from the US with soldiers, police, border agents, etc. from Israel." See Jewish Voice for Peace, "Deadly Exchange," https://deadlyexchange.org/.

26. See, e.g., Byrd, *Transit of Empire*; Lowe, *Intimacies of Four Continents*.

27. Building on Sherene H. Razack's metaphor of the Indigenous body as frontier in the North American settler colonial context in *Dying from Improvement* (2015),

Chandni Desai shows how "Zionist frontier relations" between Zionist settler colonizers and Palestinians persist even when Palestinians are exiled to other diasporic geographies, including Canada and the US. See Desai, "'We Teach Life.'"

28. My account of future-oriented radical, liberationist, and decolonial transnational imaginaries is informed most acutely by Gandhi, *Affective Communities*; Kelley, *Freedom Dreams*; Lubin, *Geographies of Liberation*; Mignolo, *Local Histories/Global Designs*; Prashad, *Darker Nations*; and C. Young, *Soul Power*.

29. Rifkin, *Settler Common Sense*. On this language of "native Indigenous Palestinian Arab," see U. Davis, *Apartheid Israel*; and Rifkin, "Indigeneity, Apartheid, Palestine." For a postcolonial, ecofeminist ethnography that engages questions of displacement, materiality, and the ethics of war survival, see Rubaii, "Concrete and Livability in Occupied Palestine." Rubaii's multispecies and new materialist feminist analysis of concrete resonates with this chapter's focus on infrastructures of violence and resistance. For more on how Israeli settler colonialism operates through a form of "eco-occupation" that Europeanizes the Palestinian indigenous landscape through the planting of nonnative trees to resemble European landscapes and the appropriation of the natural habitat to expand colonial settlement, see Sharif, "Vanishing Palestine."

30. Bouarrouj, "'Bethlehem Bandolero.'" Sansour's father, Anton, was a math professor and one of the founders of Bethlehem University, previously a Roman Catholic seminary. The Sansours trace their ancestral claims back to the Najajreh Clan, one of the oldest Palestinian Roman Catholic families from their native city of Bethlehem. See Andre Dabdoub, "History of Bethlehem Families," http://www.dabdoub.ps/history/Bethlehem_History.HTM (accessed June 17, 2017).

31. Bouarrouj, "'Bethlehem Bandolero.'" Sansour has staged solo exhibitions of her work internationally in Liverpool, Nottingham, Turku, Madrid, Copenhagen, New York City, Hiroshima, Salt Lake City, Stockholm, Istanbul, Dubai, Jerusalem, and Palestine, and she is represented by art galleries in Dubai, Madrid, and Rome. For more on her work, see her website: http://www.larissasansour.com/ (accessed February 10, 2019).

32. Additional images and text of the project are available on Sansour's website: http://www.larissasansour.com/nation_estate.html. See the virtual advertisements Sansour created for the *Nation Estate* video project: "Nation Estate: Elevator Advertisements," http://www.ibraaz.org/projects/32. See also K. Brooks, "Exploring the Fate of the Palestinian Territories with Science Fiction."

33. My use of "arrivant" follows Byrd's notion of racialized non-natives, distinct from white settlers, who inhabit Indigenous lands while still experiencing colonial and racial subjugation. See Byrd, *Transit of Empire*, 2.

34. Peteet, *Space and Mobility in Palestine*, 24.

35. On the concept of breathing and its centrality to stories of escape and flight from circum-Atlantic enslavement and its afterlives, see Crawley, *Blackpentecostal Breath*.

36. The iconic 1936 Zionist propaganda poster "Visit Palestine" was designed by Israeli graphic designer Franz Kraus and commissioned by the Tourist Development

Association of Palestine, a Zionist development agency charged with recruiting Jews to migrate to Historic Palestine. The poster was rediscovered and reprinted in 1995 by Tel Aviv graphic artist David Tartakover in the swell of (short-lived) optimism following the Oslo peace process. Conceived as part of a Zionist propaganda campaign in pre-Israel Palestine, the poster has taken on an unlikely new meaning in the past two decades, as unauthorized reprints have become best-selling symbols of Palestinian resistance, whose supporters point out the ironies "embodied in the provenance of *Visit Palestine* [and] . . . thumb their noses at the Israeli government that for decades claimed there had never been such a place." For more on the Palestine Poster Project Archives, see Davis and Walsh, "'Visit Palestine'"; and the Palestine Poster Project Archives, "Visit Palestine–Original," http://www.palestineposterproject.org/poster/visit-palestine-original.

37. I thank Keith Feldman and Jenny Kelly for the astute reminder that the visual architecture of Palestinian refugee camps and towns is similarly and literally orchestrated vertically, even as that sprawl is continually constrained for certain Palestinians (e.g., in Area C, where residents rarely if ever receive permits to build homes). For more on the architecture of refugee camps, see Peteet, *Landscape of Hope and Despair.* For a comparative analysis of exclusionary landscapes emerging across time and space (from the English countryside and colonial America to present-day Palestine-Israel), see Fields, *Enclosure.* For an interactive multimedia project that details the Israeli demolition of Palestinian homes in East Jerusalem, see "Broken Homes," *Al Jazeera*, https://interactive.aljazeera.com/aje/2017/jerusalem-2016-home-demolitions/index.html.

38. I thank Alexis Lothian for reminding me of the resonance of Sansour's skyscraper fantasy with this news account. For more on the Grenfell Tower fires, see Lynsey Hanley, "Look at Grenfell Tower and See the Terrible Price of Britain's Inequality," *Guardian*, June 16, 2017, https://www.theguardian.com/commentisfree/2017/jun/16/grenfell-tower-price-britain-inequality-high-rise; and Skylar Baker-Jordan, "Racism and Classism Killed the Residents of Grenfell Tower," *HuffPost UK*, The Blog, June 15, 2017, http://www.huffingtonpost.co.uk/skylar-bakerjordan/grenfell-fire_b_17104044.html.

39. On the Nation Estate's lobby placard listing each floor: -3 is marked dead sea. -2 energy and sanitation. -1. souq. o. main lobby 1. diplomatic —2. aid and development. 3. ngo - 4. government hq 5. permits and passports 6. vertical urban planning 7. schools & universities 8. hospital 9. heritage museum 10. national archives 11. wildlife reserve 12. olive grove 13. jerusalem, 14. ramallah, 15. nablus 16. gaza city, . . . 21. bethlehem.

40. Sansour, quoted in Debatty, "Nation Estate."

41. Gabsi, "Fiction and Art Practice," 118.

42. On the political-economic significance of olive trees for Palestinians (and their ecological destruction by Israeli settler colonial projects), see Sharif, "Vanishing Palestine."

43. Lawrie Shabibi is a prominent contemporary art gallery in Dubai that focuses on the development of young international contemporary artists from the Middle

East and North Africa. For a press release from Sansour's 2013 solo exhibit, "Science Faction," see http://www.lawrieshabibi.com/usr/documents/exhibitions/press _release_url/30/press-release-larissa-sansour.pdf; for an overview on Sansour, see https://www.lawrieshabibi.com/artists/72-larissa-sansour/overview/.

44. N. Khalil, "Surreal State."

45. On the modern realist film tradition, see Dabashi, *Dreams of Nation*; and Gertz and Khleifi, *Palestinian Cinema*.

46. brown and Imarisha, *Octavia's Brood*; Bloch, *Utopian Function of Art and Literature*.

47. Imarisha, "Rewriting the Future."

48. Bloch, *Utopian Function of Art and Literature*. My theorization of utopia and its relation to subjugated knowledges in this chapter follows most closely from the work of José Esteban Muñoz and his theoretical debts to Bloch and Fredric Jameson, whose powerful reconsideration of utopianism in the genre of science fiction as a political weapon for dialectical critique also provided the useful framework of "the future as disruption." See Muñoz, *Cruising Utopia*; and Jameson, *Archaeologies of the Future*, xx. For a broader genealogy of utopia and utopian thought across the socialist, Marxist, and Black radical traditions, see A. Gordon, *Hawthorn Archive*.

49. Select formative sources for my interest in both speculative fiction and future imaginaries across a range of Black, Native/Indigenous, Latinx, Asian Americanist, critical ethnic, queer, and feminist studies include Bahng, *Migrant Futures*; R. Benjamin, *Captivating Technology*; J. Brown, "Black Utopias"; a. brown, *Emergent Strategy*; Carrington, *Speculative Blackness*; G. Dillon, *Walking the Clouds*; Fawaz, *New Mutants*; Ellis, *Territories of the Soul*; Gumbs, *Spill*; Jameson, *Archaeologies of the Future*; Kelley, *Freedom Dreams*; Lothian, *Old Futures*; Lothian and Brown, "Speculative Life"; Marez, *Farm Worker Futurism*; Merla-Watson, Josefina, and Olguin, eds., *Altermundos*; Muñoz, *Cruising Utopia*; Nelson, "Afrofuturism"; Nyong'o, *Afro-Fabulations*; Schalk, *Bodyminds Reimagined*; Streeby, *Imagining the Future of Climate Change*; Womack, *Afrofuturism*.

50. Nixon, "Visual Cultures of Indigenous Futurisms." See also Dillon, *Walking the Clouds*.

51. I deploy this militarized language against the grain of a dominant calculus of Palestine as a "testing ground" for Israel settler colonial state's weaponry in the here and now.

52. See Le Guin, *The Dispossessed*; and O. Butler, *Parable of the Sower*. My formulation of "oppose and propose" is borrowed from Cornell, *Oppose and Propose*.

53. Imarisha, "Rewriting the Future."

54. Muñoz, *Cruising Utopia*, 1.

55. Cvetkovich, *Depression*, 161.

56. Muñoz, *Cruising Utopia*, 1.

57. Muñoz, *Cruising Utopia*, 3

58. Muñoz, *Cruising Utopia*, 22.

59. While "facts-on-the-ground" refers colloquially to extant and verifiable mate-

rial circumstances in a given time and place, my use here signals both the expanded scope of illegal Israeli settlements in what has become known as the Occupied Palestinian Territories (OPTs) and Nadia Abu El-Haj's *Facts on the Ground*, a foundational touchstone for my analysis of Sansour's visual art works in this chapter. Abu El-Haj details how practices of archaeology became vital tools for the cultural and political (re)visions and reshaping of modern Israeli colonial governance and Zionist national identity. See also Ben-Naftali, Sfard, and Viterbo, *The ABC of the OPT*.

60. A. Gordon, "The Bruise Blues," 199–200; emphasis mine.

61. Palestine studies scholarship has historically emphasized resistance literature by poets such as Ghassan Kanafani and Mahmoud Darwish, the work of political cartoonist Naji al-Ali, and contemporary hip-hop performances by Palestinian youth. See, e.g., Harlow, *Resistance Literature*; Maira, *Jil Oslo*; and Stein and Swedenburg, *Palestine, Israel, and the Politics of Popular Culture*. For the first international history of the Palestinian liberation struggle drawing on Arabic language sources, see Chamberlin, *Global Offensive*. For a comprehensive analysis of the collective poetry and media campaigns composed by the Palestinian deportees of the Camp of Return at Marj al-Zuhur during the First Intifada in southern Lebanon, see Drumsta and Feldman, "We Deportees." For a full-length monograph that treats the marginal aspects of contemporary transnational Palestinian visual art in the post-Oslo period through the optic of poetry, see Rahman, *In the Wake of the Poetic*.

62. Peteet, *Space and Mobility in Palestine*, 11. As Peteet describes, this post-Oslo policy of *closure* refers to "Israeli restrictions on the movement of Palestinian goods, labor, and people into Jerusalem, in and between the Gaza Strip and the West Bank, and between them and Israel. For Palestinians, closure and separation have resulted in fragmentation, economic devastation, social fracturing, and a deep sense of isolation and abandonment." Peteet, *Space and Mobility in Palestine*, 10. As the Middle East Research and Information Project (MERIP) reports, "The number of Palestinians arrested by Israel since 1967 is now approaching 1 million. Hundreds of thousands of the arrestees have been jailed, some without trial (administratively detained), but most after being prosecuted in the Israeli military court system. More than 40 percent of the Palestinian male population has been imprisoned at least once." See Middle East Research and Information Project, "Primer on Palestine, Israel and the Arab-Israeli Conflict," https://merip.org/palestine-israel-primer/. On the broader Israeli apparatus of control and restriction of mobility in the OPTs, see Kotef, *Movement and the Ordering of Freedom*.

63. A. Gordon, *Hawthorn Archive*, 41.

64. Sansour, quoted in Bouarrouj, "'Bethlehem Bandolero.'" On the development of a new Palestinian museum in Birzeit curated by Reem Fadda, see Vartanian, "A Garden of Possibilities at the Palestinian Museum."

65. See Alloula, *Colonial Harem*; Chaudhury, *Afterimage of Empire*; Rangan, *Immediations*.

66. Sansour, quoted in K. Brooks, "Exploring the Fate of the Palestinian Territories with Science Fiction."

67. I thank Nada Elia and Jenny Kelly for helping me to articulate this point more

succinctly. See also Abunimah, *Battle for Justice in Palestine*; Azeb, "The No-State Solution"; and Estefan, Kuoni, and Raicovich, *Assuming Boycott*.

68. Leila Sansour is founder and CEO of Open Bethlehem, an NGO foundation promoting the life and heritage of Bethlehem city, the birthplace of Jesus Christ. The work of the Sansour sisters also resonates with the ongoing cultural and artistic practice of fellow Bethlehem-based contemporary Palestinian visual artist Emily Jacir. A former winner of the Venice Biennale's Gold Lion award for an artist under the age of forty and the Guggenheim Museum's Hugo Boss Award, Jacir most recently has been raising funds for *Dar Jacir*, a project that will transform her ancestral family home in the West Bank into an international arts center for visual art and cinema. *Dar Jacir* will also house a research center focusing on the Jacir Ottoman archives, a rare collection of photos and texts documenting the Ottoman Empire from the late nineteenth and twentieth centuries. Jacir further plans to launch a small residency program and a series of educational talks and activities for the local community, organized in collaboration with the Institute for Palestinian Studies, Bethlehem University, and the arts nonprofit Alrowwad. The house was originally built by Jacir's great-great-grandfather—the *Mukhtar* (village head) of Bethlehem—in 1890. Today, it stands on the front lines of the Israeli occupation, just steps away from the West Bank barrier wall. See Neuendorf, "Palestinian Artist Emily Jacir Plans to Transform Her Family Home into a West Bank Art Center."

69. Sansour, quoted in Debatty, "Nation Estate."

70. My invocation of "(outer-)planetarity" resonates with Paul Gilroy's notion of "planetary humanism" and Gayatri Spivak's idea of planetarity in her critique of comparative literature and search for alternate theoretical frameworks outside of humanism in the era of post–Cold War globalization. See Gilroy, *Against Race*; and Spivak, *Death of a Discipline*. On the notion of "worldliness" as a form of secular criticism grounded in, but not overly determined by, historical conditions, see Said, *The World, the Text, and the Critic*.

71. Sansour, quoted in Gabsi, "Fiction and Art Practice," 115.

72. Sansour, quoted in Debatty, "Nation Estate."

73. Paglen, "Some Sketches on Vertical Geographies," 1.

74. Paglen, "Some Sketches on Vertical Geographies," 1.

75. Graham, *Vertical*. Additional key sources for my analysis of architectures of violence and verticality include C. Kaplan, *Aerial Aftermaths*; Parks and Kaplan, *Life in the Age of Drone Warfare*; Parks, *Rethinking Media Coverage*; Scott, *Outlaw Territories*.

76. This is so despite Israel's claim that it has "withdrawn" from the Gaza Strip because it pulled its soldiers and settlers out, because by controlling the borders as well as air and maritime space, it of course remains the occupying power, according to the UN and international law.

77. Peteet, *Space and Mobility in Palestine*, 60.

78. Peteet, *Space and Mobility in Palestine*, 11, 18. See also Li, "The Gaza Strip as Laboratory."

79. Weizman, "Introduction to the Politics of Verticality"; *Forensic Architecture*;

and *Hollow Land*. Notably, Weizman and Sansour both lost prizes for which they were initially recognized. Weizman won an architectural award from the Israel Association for United Architects (IAUA) in 2002, and as discussed at length later in this chapter, Sansour was taken off the list of finalists for the Lacoste Elysée Prize in 2011, a Swiss photography honor, for her project *Nation Estate*.

80. Weizman, "Politics of Verticality."

81. Decolonizing Architecture Art Residency is an art and architecture studio and residency program founded in 2007 by Sandi Hilal, Alessandro Petti, and Eyal Weizman in Beit Sahour, a Palestinian town east of Bethlehem under the administration of the PA. For more on the work of the collective and its critical imaginings of "the morning after revolution," see Lambert, *Weaponized Architecture*; and Petti, Hilal, and Weizman, eds., *Architecture after Revolution*.

82. Weizman, "Politics of Verticality."

83. Shaw, *Predator Empire*, 12. As British political theorist Mark Neocleous argues further, the contemporary concept of a "no-fly zone" over embattled terrain represents a form of international police power, but the legal contest over territory ("Who controls the air?") dates back at least to the early seventeenth century. Neocleous cites a series of court cases in English law (by Chief Justice Edward Coke and Sir William Blackstone in 1598 and 1610, respectively) where landowners successfully sued their neighbors for building houses that overhung the line of their properties. He notes how the word "land" in these cases referred "not only to the face of the earth, but everything under it, or over it" (Neocleous, "Police Power," 2). The key doctrine that emerged from these late sixteenth- and early seventeenth-century British court cases over land disputes is, *Cujus est solum ejus est usque ad coelum*: "whoever owns the land owns it up to the sky," or "whoever owns the soil, it is theirs all the way up to Heaven." This dictum later would become central to twentieth-century elaborations of air power. Neocleous develops a genealogy for understanding the tension between contemporary no-fly zones and air power/bombing campaigns—we can think of modern-day Libya and Syria as examples. He notes, for instance, how in the post–World War II period, "sovereignty was extended into the sky" (4). Yet "outer space" remained the "province of all mankind"—"a space that exists somewhere *above territory* and *beyond sovereignty*" (5). See also Neocleous, *War Power, Police Power*.

84. See N. Gordon, *Israel's Occupation*.

85. The ongoing Gaza energy crisis is the product of a clash of authority and escalating tension between Hamas (which oversees Gaza) and the Palestinian Authority/Fatah (which rules the West Bank). All of this is exacerbated by the ongoing land, air, and sea blockade of the Gaza Strip by Israel and Egypt since 2007. See "Gaza on Verge of Collapse as Israel Sends 2.2M People 'Back to Middle Ages' in Electricity Crisis."

86. Peteet, *Space and Mobility in Palestine*, 11, 61.

87. D. Brooks, *Bodies in Dissent*; Muñoz, *Cruising Utopia*; Chuh, *Imagine Otherwise*.

88. A. Brown, *Black Skyscraper*. See also Graham, "Vanity and Violence."

89. T. Smith, *Architecture of Aftermath*, 97. I thank Caren Kaplan for sharing this insightful formulation and reference. See also the introduction to C. Kaplan, *Aerial Aftermaths*.

90. Parks, "Drones, Vertical Mediation, and the Targeted Class," 232. On vertical mediation, see also Parks, *Rethinking Media Coverage*.

91. Caren Kaplan, Respondent Remarks for the Newberry Library Gender and Sexuality Seminar, Chicago, IL, November 10, 2017. I am grateful to Kaplan and all of the participants for their powerful insights during the Newberry Library workshop and seminar.

92. Al-Maria, quoted in Olah, "'Gulf Futurism' Is Killing People."

93. Al-Maria, quoted in Olah, "'Gulf Futurism' Is Killing People." See also Parikka, "Middle East and Other Futurisms."

94. Peteet, *Space and Mobility in Palestine*, 10.

95. New Art Exchange, "Larissa Sansour: In the Future They Ate from the Finest Porcelain," http://www.nae.org.uk/exhibition/larissa-sansour-in-the-future -they-ate/96/.

96. Emery, "Review: Larissa Sansour."

97. Abu El-Haj, *Facts on the Ground*.

98. Sansour, quoted in Bouarrouj, "'Bethlehem Bandolero'" and Debatty, "Nation Estate."

99. Sansour, quoted in Debatty, "Nation Estate."

100. Abu El-Haj, *Facts on the Ground*.

101. N. Khalil, "Surreal State."

102. The June 1967 war marked a crucial historical flashpoint in the settler colonization of Palestine as Israel used the brutal war to launch "what became a 'permanently temporary' military and administrative occupation of the West Bank, the Gaza Strip, the Sinai Peninsula, and the Golan Heights." See K. Feldman, *Shadow Over Palestine*, 3. See also I. Abu-Lughod, *Arab-Israeli Confrontation of 1967*; Erakat, "Taking the Land without the People"; Weizman, *Hollow Land*.

103. "Resolution 194," United Nations Relief and Works Agency for Palestine Refugees in the Near East (UNRWA), https://www.unrwa.org/content/resolution-194. For an analysis of UN Resolution 194, see LeVine, "Why Palestinians Have a Right to Return Home."

104. On the struggle for Palestinian statehood, see R. Khalidi, *Iron Cage* and *Brokers of Deceit*. As Sheety plainly observes, the notion of a Palestine/Israel "conflict" (as opposed to asymmetrical warfare funded by the world's largest superpower) is "a corporate media abstraction used to cover up and obfuscate the continuing destruction of Palestine by creating a false balance and ethical equivalency between the colonisers and the colonised where no such balance and equivalency exists to begin with." See Sheety, "An Alternative Dictionary for the Palestine/Israel 'Conflict.'"

105. On November 29, 2012, in a 138–9 vote (with 41 abstaining), the UN General Assembly resolution 67/19 passed, upgrading Palestine to "non-member observer state" status in the UN. The new status equates Palestine's with that of the Holy See and provides "de facto recognition of the sovereign state of Palestine." Voting "no"

were Canada, the Czech Republic, Israel, the Marshall Islands, the Federated States of Micronesia, Nauru, Palau, Panama, and the United States of America. See Charbonneau and Nichols, "Palestinians Win De Facto U.N. Recognition of Sovereign State."

106. See A. Simpson, *Mohawk Interruptus*; Goldstein, *Formations of United States Colonialism*; and Povinelli, *Empire of Love*.

107. Erakat and Rabbani, *Aborted State?*; Makdisi and Prashad, *Land of Blue Helmets*.

108. On the uses, limits, and disidentificatory embrace of human rights frameworks by racialized and minoritarian peoples in the US, see Atanasoski, *Humanitarian Violence*; Parikh, *Writing Human Rights*; R. Williams, *Divided World*.

109. Massad, "Recognizing Palestine, BDS, and the Survival of Israel." See also Abunimah, "Why I Want Obama to Veto Abbas' UN Resolution on Palestine" and *Battle for Justice in Palestine*.

110. By using the frameworks of Indigenous sovereignty and futurisms in relation to Palestine, I am also critiquing implicitly any nationalist or inclusionary aspects of Arab/South Asian/Muslim diasporic creative organizing in the US discussed earlier in the book. In so doing, I hope to forward an analysis of indigeneity and Palestine that expands the forms of critique I pursue here, rather than relying on the US-Israeli security power nexus alone.

111. Abunimah, "French Clothing Firm Lacoste Censors, Expels Palestinian Artist Larissa Sansour"; and N. Khalil, "Surreal State."

112. In 2014, the Musée de l'Elysée reinstated the prize after entering into a new partnership with watchmaker Parmigiani Fleurier. The relaunched "Prix Elysée" photography contest was, according to press releases at the time, "open to photographers and artists of all nationalities irrespective of theme or preference for genre or technique." See Laurent, "Musée de l'Elysée Relaunches Major Photography Award Following 2011 Lacoste Controversy."

113. For more on censorship struggles within contemporary circuits of Palestinian film festivals, see Cable, "Cinematic Activism." On an important earlier moment in the censorship of Palestinian photography, see Said, *After the Last Sky*.

114. The historical conjoining of South African and Palestinian struggles recalls Rifkin's cogent analysis and rethinking of the analytic limits of the political metaphor of "apartheid," which is drawn from the South African freedom movement, for adjudicating calls for Indigenous self-determination in Palestine. Rifkin argues that forging an analogous relation to South Africa's system of racist domination—to understand Israel's denial of Palestinian rights and land—often forecloses greater understanding of "modes of Palestinian collective self-representation, inhabitance, and self-governance not reducible to fuller participation in the nation-state." See Rifkin, "Indigeneity, Apartheid, Palestine," 30. This critique is especially apt because, unlike in the South African context, so many Palestinians are living in diaspora as a result of the Nakba, and Israel (with backing from the Great Powers) was able to establish its own settler colonial nation-state carved atop and out of Indigenous Arab Palestinian territory. This contradicts the South Africa case, where a white minority class ruled over the Black majoritarian population in the same country. Rifkin's

intervention here is prescient both in the Native North American context and for Palestine/Israel, where Indigenous claims to territory and self-governance often supersede an interest in pluralist recognition from and inclusion into racist liberal settler states. Indeed, Rifkin's intervention asks how we might reimagine the life of the settler state "through a sustained engagement with extant modes of indigeneity," rather than "cordoning off indigenous peoples, principles, and political formations into a segregated part of state lands and policy, divorcing them from the rest of the state's populations, practices, and philosophies" (55). In this way, Rifkin argues, "indigenous self-determination functions less as exception than inspiration, not so much marking a caesura in normative political philosophies as providing a guide for them" (55–56). Important related works on Palestine/Israel that complicate my understanding of solidarity politics include Atshan and Moore, "Reciprocal Solidarities"; Clarno, *Neoliberal Apartheid*; K. Feldman, *Shadow Over Palestine*; J. L. Kelly, "Asymmetrical Itineraries"; Lubin, *Geographies of Liberation*; Morgensen, "A Politics Not Yet Known"; Naber, "Anti-Imperialism and Black-Palestinian Solidarity"; Olwan, "Assumption Solidarities"; Prashad, *Darker Nations*; Qutami, "Rethinking the Single Story"; Tabar and Desai, "Decolonization Is a Global Project."

115. See Palestinian BDS National Committee, "What Is BDS?," https://bdsmove ment.net/what-is-bds. For more on the academic and cultural boycott aspects of BDS, see Abdulhadi and Olwan, "Introduction: Shifting Geographies"; Barghouti, *BDS*; Duggan, "Circuits of Influence"; Estefan et al., *Assuming Boycott*; Maira, *Boycott!*; Maira and Tadiar, "The Academic Boycott Movement"; Mullen and Dawson, *Against Apartheid*; and documents from the Palestinian Campaign for the Academic and Cultural Boycott of Israel (PACBI): Palestinian BDS National Committee, "Results for: PACBI Key Documents," https://bdsmovement.net/tags /pacbi-key-documents.

116. Palumbo-Liu, "BDS Opponents Threaten Academic Associations with 'Ultra Vires' Lawsuits, but Fail Big in First Attempt." As Palumbo-Liu explains, "'Lawfare' is a common weapon used by the powerful to drain financial and other resources from organizations which they can out-lawyer and out-resource. *Ultra vires* suits in particular are used to leverage fear and extreme caution. This case has challenged academic groups on their broader commitments to academic freedom, free speech and public engagement, and in this instance, the challenge has been met, and met in ways that free others [*sic*] organizations to think of taking more assertive positions, especially when it comes to Palestinian rights. At a moment when the Trump White House is openly hostile to BDS (in addition to many forms of political protest), and hostile to education as well, academic organizations need more than ever to exercise their academic freedom, and put to use their critical, intellectual and persuasive powers to educate." On the proposed 2017–18 US Senate Bill 720, the "Israel Anti-Boycott Act," sponsored by the Israel lobby group AIPAC (American Israel Public Affairs Committee), see Levitz, "43 Senators Want to Make It a Federal Crime to Boycott Israeli Settlements." On the criminalization of BDS and related liberationist tactics, see Bazian, "The Islamophobia Industry and the Demonization of Palestine"; and Deeb and Winegar, *Anthropology's Politics*. For a broader account of how Palestine/

Israel has affected US academic politics, see Chatterjee and Maira, *Imperial University*; Deeb and Winegar, *Anthropology's Politics*; Lockman, *Contending Visions of the Middle East*; Maira, *Boycott!*; and Said, *Question of Palestine*.

117. On ethnographic refusal, see Ortner, "Resistance and the Problem of Ethnographic Refusal." On the limits of recognition in liberal governance and the politics of refusal as modes of living in racist settler states for Palestinians, see Meari, "*Sumud*"; for African Americans, see Campt, *Listening to Images*; Harney and Moten, *Undercommons*; and Quashie, *Sovereignty of Quiet*; for Native/Indigenous peoples, see Barker, "The Specters of Recognition"; Coulthard, *Red Skin, White Masks*; Povinelli, *An Empire of Love*; L. Simpson, *As We Have Always Done*; and A. Simpson, *Mohawk Interruptus*; and for queer/trans peoples, see Aizura, "Unrecognizable"; Beauchamp, *Going Stealth*; Halberstam, *Queer Art of Failure*; and Spade, *Normal Life*. On how settler colonialism operates as a logic of Indigenous erasure sustained in and through antiblackness, see King, "New World Grammars"; and Leroy, "Black History in Occupied Territory."

118. For more on Salaita's case, see Salaita, "American Indian Studies and Palestine Solidarity" and *Uncivil Rites*; Deeb and Winegar, *Anthropology's Politics*; and Jewish Voice for Peace, *Stifling Dissent*. For the case of Odeh, see Erakat, "When You Come for Rasmea"; Naber, "Justice for Rasmea Odeh"; and Odeh's legal solidarity campaign website, "About the Case," http://justice4rasmea.org/about/. See also the work of Palestine Legal, founded in 2012 as the only legal organization in the US expressly dedicated to supporting the movement for Palestinian rights: http://palestinelegal.org/. On the post–9/11 targeting of Middle East studies scholars and Title VI funding of Middle East studies centers by Daniel Pipes and his "Campus Watch" website, see Lockman, *Contending Visions*, 255–56. Importantly, US Jewish anti-Zionist political communities have also grown in recent years as organizations such as Jewish Voice for Peace, the International Jewish Anti-Zionist Network, and Jews for Palestinian Right of Return collectively signal the growth of BDS activism among Jews, the fracture of what Abdulhadi and Olwan call the "almost-blanket support of Israel in US Jewish communities," and "a changing political landscape in which Israel no longer represents a beacon of democracy amid an otherwise troubled region, as it once did in dominant and popular US discourses." See Abdulhadi and Olwan, "Introduction: Shifting Geographies," 995–96. For an important corollary on how US liberal inclusion sometimes sustained Jewish anti-Zionisms in ways that "precluded Palestinian and North American indigenous futures," see K. Feldman, "Zionism and Anti-Zionism," 1072. For pre–9/11 (namely, the mid- to late twentieth century) Arab American movements tied to global struggles for Palestinian national liberation, see Naber, *Arab America*. Finally, for critical queer decolonial analysis of how homonationalism and "pinkwashing" activism continue to exacerbate anti-Muslim and anti-Palestinian racisms, see Darwich and Maikey, "The Road from Antipinkwashing Activism to the Decolonization of Palestine"; Puar, "The Golden Handcuffs of Gay Rights"; and Stelder, "Other Scenes of Speaking."

119. Sansour, quoted in Gabsi, "Fiction and Art Practice," 118.

120. Tabar and Desai, "Decolonization Is a Global Project." For more reporting on

recent BDS-related interventions by artists and intellectuals in the international cultural field, see Mostafa Heddaya, "Over 100 Artists and Intellectuals Call for Withdrawal from Creative Time Exhibition," *Hyperallergic*, June 10, 2014, https://hyperallergic.com/131497/over-100-artists-and-intellectuals-call-for-withdrawal-from-creative-time-exhibition/; and Yates McKee and Andrew Ross, "As Artist-Organizer from Decolonize This Place Is Detained By Israeli Military, Calls For Boycott Grow," *Hyperallergic*, January 15, 2018, https://hyperallergic.com/421525/mohammed-habshe-yossef-decolonize-this-place/.

121. Sansour, quoted in Gabsi, "Fiction and Art Practice," 116–17.

122. Sansour, quoted in Gabsi, "Fiction and Art Practice," 115.

123. Kilgore, *Astrofuturism*.

124. Fawaz, "Space, That Bottomless Pit," 1103.

125. Kelley, *Freedom Dreams*, 17.

126. Fawaz, "Space, That Bottomless Pit," 1120. See also carrington, *Speculative Blackness*.

127. I thank Justin Leroy for generously enabling this formulation by asking me to think through the critical distinctions between Native/Indigenous and Black futurisms.

128. For news accounts on the planning of US and allied space wars, see Billings, "War in Space May Be Closer Than Ever"; Pawlyk, "US Air Force Preparing for War in Space"; and Rogers, "Trump Orders Establishment of Space Force as Sixth Military Branch."

129. Shaw, *Predator Empire*, 23.

130. McCoy, "Beyond Bayonets and Battleships," 2. See also McCoy, *In the Shadows of the American Century* on the multifaceted rise of America as a world power from the 1890s through the Cold War, a US hegemony that McCoy argues was characterized by covert intervention, client elites, psychological torture, and global surveillance.

131. McCoy, "Beyond Bayonets and Battleships," 2.

132. McCoy, "Beyond Bayonets and Battleships," 6.

133. K. Feldman, "Zionism and Anti-Zionism," 1070.

134. Khalili, "The Location of Palestine in Global Counterinsurgencies," 415. For more on Palestine as a critical node in imperial and counterinsurgency campaigns, see Khalili, *Time in the Shadows*; Lubin, *Geographies of Liberation*; Peteet, *Space and Mobility in Palestine*; Puar, *The Right to Maim*; and Hajjar, "Comparing American and Israeli Ways of War."

135. Lubin, "The Disappearing Frontiers of US Homeland Security," 1.

136. Lubin, "The Disappearing Frontiers of US Homeland Security," 2.

137. Tawil-Souri, "'A Space Exodus.'"

138. Tawil-Souri, "'A Space Exodus.'"

139. On "unboundedness" as an animating impulse of the Black radical tradition, see Gilmore, "Abolition Geography and the Problem of Innocence," 237–38.

140. Contemporary queer and feminist criticism/politics and its persuasive attacks on normative claims to evidence, archives, temporalities, and systems of repre-

sentation provides an important animating force for my methodological approach in this chapter. As Muñoz explains, "to call for this notion of the future in the present is to summon a refunctioned notion of utopia in the service of subaltern politics" (Muñoz, *Cruising Utopia*, 49). As I detailed further in this book's introduction, Muñoz's assessment of the politics of evidence-making and queer ephemera proposes an alternative mode of valuation, or "proofing," that is formative to my approach to the queer feminist study of the US forever war. See Muñoz, "Ephemera as Evidence" and *Cruising Utopia*.

141. Muñoz, "Gesture, Ephemera, and Queer Feeling," 432.

142. Muñoz, "Gesture, Ephemera, and Queer Feeling," 431; emphasis mine.

143. Neocleous, "Police Power." On Black and Indigenous feminist forms of fantasy and flight, see Gumbs, *Spill*; and L. Simpson, *As We Have Always Done*.

144. Messeri, *Placing Outer Space*, 192, 196.

145. Muñoz, *Cruising Utopia*, 18.

146. Marks, *Enfoldment and Infinity*; Muñoz, *Cruising Utopia*, 18.

EPILOGUE

1. Between 2001 and 2008, the US government maintained an estimated fifty prisons to hold detainees in twenty-eight countries, in addition to at least twenty-five more prisons in Afghanistan and twenty in Iraq. See ACLU, "Accountability for Torture: Infographic," https://www.aclu.org/issues/national-security/torture /accountability-torture-infographic?redirect=national-security/accountability -torture-infographic (accessed July 14, 2018).

2. "Afterlives of Blacksites I: The Seen Unseen," http://www.chitraganesh.com /portfolio/afterlives-of-blacksites-i-the-seen-unseen/ (accessed July 14, 2018). See also Spencer Ackerman, "The Disappeared: Chicago Police Detain Americans at Abuse-Laden 'Black Site,'" *Guardian*, February 24, 2015.

3. The US and UK militaries use the language of "blackness" to refer to highly classified military or defense projects that are not publicly acknowledged by government, military personnel, and contractors; these include so-called black ops, black sites, and stealth weaponry. On the conditions of blackness in historical and contemporary surveillance, see Browne, *Dark Matters*.

4. The piece was commissioned and produced by Creative Time Reports, the Juncture Initiative at Yale Law School's Schell Center for Human Rights and the Samdani Art Foundation, for the Dhaka Art Summit in early 2016.

5. The phrase read: "His body limp, with bubbles rising from his full and open mouth." See installation views online at "Afterlives of Blacksites I."

6. "Afterlives of Blacksites I."

7. "Afterlives of Blacksites I."

8. C. Kaplan, *Aerial Aftermaths*, 18.

9. Engelhardt, "The Real Meaning of Trump," TomDispatch.com, April 26, 2016, http://www.tomdispatch.com/post/176133/tomgram%3A_engelhardt,_has_the _american_age_of_decline_begun/ (accessed July 31, 2018).

10. McCoy, "The Demolition of US Global Power." See also Dower, *The Violent American Century*; and Giroux, *The Public in Peril*.

11. Neta C. Crawford, "United States Budgetary Costs of the Post–9/11 Wars Through FY2019: $5.9 Trillion Spent and Obligated," Costs of War, November 14, 2018, https://watson.brown.edu/costsofwar/files/cow/imce/papers/2018/Crawford_Costs%20of%20War%20Estimates%20Through%20FY2019.pdf (accessed February 11, 2019). The Costs of War Project at Brown University's Watson Institute for International and Public Affairs has created the first ever global map of military conflicts stemming from the US war on terror. It concluded that seventy-six countries worldwide—that is, 39 percent—are now affected by US military activity related to counterterror wars (between 2015 and 2017). This includes seven through air and drones strikes, fifteen through combat troops, forty-four with US military bases, and fifty-eight via training security forces in counterterrorism. The Costs of War project estimates that the US budgetary costs for post–9/11 US wars in Iraq, Syria, Afghanistan, and Pakistan, and for care for veterans since 9/11 and Homeland Security, totals $5.9 trillion through fiscal year 2019. The latest request for annual defense spending totals more than $700 billion, and Crawford estimates the additional war-related Pentagon spending for fiscal years 2020–2023 to be $808 billion, for a projected total of more than $6.7 trillion spent on US wars since 9/11. See also Neta C. Crawford, "United States Budgetary Costs of Post–9/11 Wars Through FY2018, A Summary of the $5.6 Trillion in Costs for the US Wars in Iraq, Syria, Afghanistan, and Pakistan, and Post–9/11 Veterans Care and Homeland Security," Costs of War, November 2017. On the unaccounted trillions in defense spending, see Marcetic, "Dark Money at the Pentagon."

12. J. Rodríguez, *Queer Latinidad*, 39.

13. Sarah Mervosh, "Trump Walks in Front of Queen Elizabeth, Causing Social Media Frenzy," *New York Times*, July 14, 2018.

14. C. Kaplan, *Aerial Aftermaths*.

15. C. Kaplan, *Aerial Aftermaths*, 12.

16. Esther Wang, "Statue of Liberty Climber Therese Patricia Okoumou Found Guilty," *Jezebel*, December 17, 2018, https://jezebel.com/statue-of-liberty-climber-therese-patricia-okoumou-foun-1831155656 (accessed February 11, 2019).

17. Trivedi is referring to Emma Lazarus's famed sonnet "The New Colossus," which was written to raise funds for the construction of the pedestal to the Statue of Liberty and that in 1903 was cast onto a bronze plaque and mounted inside the pedestal's lower level: "Give me your tired, your poor, Your huddled masses yearning to breathe free, The wretched refuse of your teeming shore. Send these, the homeless, tempest-tossed to me, I lift my lamp beside the golden door!" For a transcript of the full press release, see Apollo Soléy Enki, "#Freeokoumou: Full Press Release Transcript, Therese Patricia Okoumou," July 5, 2018, https://medium.com/@AfroManBlac/freeokoumou-full-press-release-transcript-therese-patricia-okoumou-42c55f97b69f/.

18. Shamira Ibrahim, "Patricia Okoumou and the Dual Threat to Black Immigrants," *New York Magazine*, July 13, 2018. See also, NYU Law Immigrant Rights

Clinic and Black Alliance for Just Immigration, "The State of Black Immigrants," http://www.stateofblackimmigrants.com/assets/sobi-fullreport-jan22.pdf (accessed July 15, 2016).

19. Joanna Walters, "'Are They Going to Shoot Me?': Statue of Liberty Climber on Her Anti-Trump Protest," *Guardian*, July 7, 2018. Walters writes: "During the four-hour stand-off with police, she took a short nap. . . . She awoke to police banging on the inside of the thin copper structure. The island had been evacuated of its Independence Day visitors. The police officer standing at the top of a ladder introduced himself as Brian, she said. 'I said "Don't come up." He said, "I care about you." I said, "No, you don't, you could shoot me the way you shot Claudia Gomez and killed the trans woman,"' she said, referring to Gomez, a 20-year-old Guatemalan woman shot by the border patrol in Texas last month, and Roxana [*sic*] Hernández, from Honduras, who died in ICE custody in May after reportedly spending five days in a form of chilled detention dubbed the ice box."

20. Okoumou, quoted in Walters, "Are They Going to Shoot Me."

21. I thank Nicole R. Fleetwood for helping me articulate this formulation.

22. Halberstam and Nyong'o, "Introduction: Theory in the Wild," 454.

23. Halberstam and Nyong'o, "Introduction: Theory in the Wild," 455.

24. Halberstam and Nyong'o, "Introduction: Theory in the Wild," 455.

Abdul Khabeer, Su'ad. *Muslim Cool: Race, Religion, and Hip Hop in the United States.* New York: New York University Press, 2016.

Abdulhadi, Rabab, and Dana M. Olwan. "Introduction: Shifting Geographies of Knowledge and Power: Palestine and American Studies." *American Quarterly* 67, no. 4 (Dec 2015): 993–1006.

Abu El-Haj, Nadia. *Facts on the Ground: Archaeological Practice and Territorial Self-Fashioning in Israeli Society.* Chicago: University of Chicago Press, 2001.

Abufarha, Nasser. *The Making of a Human Bomb: An Ethnography of Palestinian Resistance.* Durham, NC: Duke University Press, 2009.

Abu-Lughod, Ibrahim, ed. *The Arab-Israeli Confrontation of 1967: Arab Perspectives.* Evanston, IL: Northwestern University Press, 1969.

Abu-Lughod, Lila. "Do Muslim Women Really Need Saving? Anthropological Reflections on Cultural Relativism and Its Others." *American Anthropologist* 104, no. 3 (2002): 783–90.

Abunimah, Ali. *The Battle for Justice in Palestine.* Chicago: Haymarket Books, 2014.

Abunimah, Ali. "French Clothing Firm Lacoste Censors, Expels Palestinian Artist Larissa Sansour from Prestigious Contest." *Electronic Intifada*, December 20, 2011. Accessed June 20, 2017. https://electronicintifada.net/blogs/ali-abunimah/french -clothing-firm-lacoste-censors-expels-palestinian-artist-larissa-sansour/.

Abunimah, Ali. "Owner of Lacoste, Which Censored Palestinian Artist, Is Major Donor to Israel, Zionist Causes." *The Electronic Intifada,* December 22, 2011. Accessed July 11, 2017. https://electronicintifada.net/blogs/ali-abunimah/owner -lacoste-which-censored-palestinian-artist-major-donor-israel-zionist-causes.

Abunimah, Ali. Why I Want Obama to Veto Abbas' UN Resolution on Palestine." *The Electronic Intifada*, December 18, 2014. Accessed July 17, 2017. https:// lectronicintifada.net/blogs/ali-abunimah/why-i-want-obama-veto-abbas-un -resolution-palestine.

Aderer, Konrad, dir. *Enemy Alien.* New York: Life or Liberty/Fractured Atlas, 2011. Film.

Adey, Peter, Mark Whitehead, and Alison J. Williams, eds. *From Above: War, Violence, and Verticality.* London: Hurst, 2013.

Afzal, Ahmed. *Lone Star Muslims: Transnational Lives and the South Asian Experience in Texas.* New York: New York University Press, 2015.

Agamben, Giorgio. *Homo Sacer: Sovereign Power and Bare Life.* Translated by Daniel Heller-Roazen. Stanford, CA: Stanford University Press, 1998.

Agamben, Giorgio. *State of Exception*. Chicago: University of Chicago Press, 2005.

Agathangelou, Anna, Daniel Bassichis, and Tamara Spira. "Intimate Investments: Homonormativity, Global Lockdown, and Seductions of Empire." *Radical History Review* 100 (2008): 120–44.

Ahmad, Eqbal. "Counterinsurgency." In *The Selected Writings of Eqbal Ahmad*. Edited by Carrollee Bengelsdoorf, Margaret Cerullo, and Yogesh Chandani, 36–64. New York: Columbia University Press, 2006.

Ahmad, Muhammad Idrees. "The Magical Realism of Body Counts." *Al Jazeera*, June 13, 2011. Accessed July 11, 2012. http://www.aljazeera.com/indepth/opinion /2011/06/2011613931606455.html.

Ahmed, Sara. *The Cultural Politics of Emotion*. New York: Routledge, 2004.

Ahmed, Sara. *Living a Feminist Life*. Durham, NC: Duke University Press, 2017.

Ahmed, Sara. *The Promise of Happiness*. Durham, NC: Duke University Press, 2010.

Ahmed, Sara. *Queer Phenomenology: Orientations, Objects, Others*. Durham, NC: Duke University Press, 2006.

Ahuja, Neel. *Bioinsecurities: Disease Intervention, Empire, and the Government of Species*. Durham, NC: Duke University Press, 2016.

Aizura, Aren, ed. "Unrecognizable: On Trans Recognition in 2017." Against the Day. *South Atlantic Quarterly* 116, no. 3 (July 2017): 606–11.

Al-Ali, Nadje. *Iraqi Women: Untold Stories from 1948 to the Present*. New York: Zed Books, 2007.

Al-Ali, Nadje, and Deborah Al-Najjar, eds. *We Are Iraqis: Aesthetics and Politics in Times of War*. Syracuse, NY: Syracuse University Press, 2012.

Al-Ali, Nadje, and Nicola Pratt. *What Kind of Liberation? Women and the Occupation of Iraq*. Berkeley: University of California Press, 2009.

Al-Arian, Laila. "When Your Father Is Accused of Terrorism." *The Nation*, June 14, 2012. Accessed July 24, 2017. https://www.thenation.com/article/when-your-father -accused-terrorism/.

Alexander, Michelle. *The New Jim Crow: Mass Incarceration in the Age of Colorblindness*. New York: New Press, 2012.

Alexander, M. Jacqui. *Pedagogies of Crossing: Mediations on Feminism, Sexual Politics, Memory, and the Sacred*. Durham, NC: Duke University Press, 2006.

Alloula, Malek. *The Colonial Harem*. Translated by Myrna Godzich and Wlad Godzich. Minneapolis: University of Minnesota Press, 1986.

Alqaisiya, Walaa. "Decolonial Queering: The Politics of Being Queer in Palestine." *Journal of Palestine Studies* 47, no. 3 (Spring 2018): 29–44.

Alsultany, Evelyn. *Arabs and Muslims in the Media: Race and Representation after 9/11*. New York: New York University Press, 2013.

Alvarado, Leticia. *Abject Performances: Aesthetic Strategies in Latino Cultural Production*. Durham, NC: Duke University Press, 2018.

Amar, Paul. *The Security Archipelago: "Human Security" States, Sexuality Politics, and the End of Neoliberalism*. Durham, NC: Duke University Press, 2013.

Ameeriar, Lalaie. *Downwardly Global: Women, Work, and Citizenship in the Pakistani Diaspora*. Durham, NC: Duke University Press, 2017.

American Anthropological Association. "American Anthropological Association's Executive Board Statement on the Human Terrain System Program," October 31, 2007. Accessed January 10, 2019. http://s3.amazonaws.com/rdcms-aaa/files /production/public/FileDownloads/pdfs/pdf/EB_Resolution_110807.pdf.

Amin, Kadji. *Disturbing Attachments: Genet, Modern Pederasty, and Queer History.* Durham, NC: Duke University Press, 2017.

Amin, Kadji, Amber Musser, and Roy Pérez. "Queer Form: Aesthetics, Race, and the Violences of the Social." Introduction to special issue, *Queer Form.* ASAP/Journal 2, no. 2 (May 2017): 227–39.

Amoore, Louise, and Volha Piotukh, eds. *Algorithmic Life: Calculative Devices in the Age of Big Data.* New York: Routledge, 2016.

Anderson, Patrick. *So Much Wasted: Hunger, Performance and the Morbidity of Resistance.* Durham, NC: Duke University Press, 2010.

Anderson, Warwick. *Colonial Pathologies: American Tropical Medicine, Race, and Hygiene in the Philippines.* Durham, NC: Duke University Press, 2006.

Anzieu, Didier. *The Skin Ego.* Translated by Chris Turner. New Haven, CT: Yale University Press, 1989.

Arendt, Hannah. "Home to Roost: A Bicentennial Address." *New York Review of Books* 22, no. 11 (June 26, 1975).

Arendt, Hannah. *The Origins of Totalitarianism.* New York: Schocken Books, 1951.

Arondekar, Anjali. *For the Record: On Sexuality and the Colonial Archive in India.* Durham, NC: Duke University Press, 2009.

Arondekar, Anjali, Ann Cvetkovich, Christina B. Hanhardt, et al. "Queering Archives: A Roundtable Discussion." *Radical History Review* 122 (May 2015): 211–31.

Arrighi, Giovanni. *The Long Twentieth Century: Money Power, and the Origins of Our Times.* New York: Verso Press, 2010.

Asad, Talal. *On Suicide Bombing.* New York: Columbia University Press, 2007.

Ashford, Doug, and Naeem Mohaiemen. "Collectives in Atomised Time." Barcelona, Spain: Identitat, 2009. https://www.academia.edu/4745033/Visible_Collective _Collectives_in_Atomised_Time.

Atanasoski, Neda. *Humanitarian Violence: The U.S. Deployment of Diversity.* Minneapolis: University of Minnesota Press, 2014.

Atshan, Sa'ed, and Darnell L. Moore. "Reciprocal Solidarity: Where the Black and Palestinian Queer Struggles Meet." *Biography* 37, no. 2 (Spring 2014): 680–705.

Awad, Nadia. "Nostalgia for the Future." *New Inquiry*, March 22, 2015.

Aydin, Cemil. *The Idea of the Muslim World: A Global Intellectual History.* Cambridge, MA: Harvard University Press, 2017.

Azeb, Sophia. "The 'No-State Solution': Decolonizing Palestine Beyond the West Bank and East-Jerusalem." *Funambulist* 10 (March–April 2017), https:// thefunambulist.net/articles/no-state-solution-decolonizing-palestine-beyond -west-bank-east-jerusalem.

Bacevich, Andrew J., ed. *The Long War: A New History of US National Security Policy Since World War II.* New York: Columbia University Press, 2007.

Bacevich, Andrew J. *America's War for the Greater Middle East: A Military History*. New York: Random House, 2016.

Bahng, Aimee. *Migrant Futures: Decolonizing Speculation in Financial Times*. Durham, NC: Duke University Press, 2017.

Baker Jr., Houston A., Manthia Diawara, and Ruth H. Lindeborg, eds. *Black British Cultural Studies: A Reader*. Chicago: University of Chicago Press, 1996.

Balance, Christine Bacareza. *Tropical Renditions: Making Musical Scenes in Filipino America*. Durham, NC: Duke University Press, 2016.

Balce, Nerissa S. *Body Parts of Empire: Visual Abjection, Filipino Images, and the American Archive*. Ann Arbor: University of Michigan Press, 2016.

Bald, Vivek. *Bengali Harlem and the Lost Histories of South Asian America*. Cambridge, MA: Harvard University Press, 2015.

Bald, Vivek, Miabi Chatterji, Sujani Reddy, and Manu Vimalassery, eds. *The Sun Never Sets: South Asian Migrants in an Age of U.S. Power*. New York: New York University Press, 2013.

Barghouti, Omar. *Boycott, Divestment, Sanctions: The Global Struggle for Palestinian Rights*. Chicago: Haymarket Books, 2011.

Barker, Joanne. "The Specters of Recognition." In *Formations of United States Colonialism*. Edited by Alyosha Goldstein, 33–56. Durham, NC: Duke University Press, 2014.

Barker, Joanne, ed. *Critically Sovereign: Indigenous Gender, Sexuality, and Feminist Studies*. Durham, NC: Duke University Press, 2017.

Bashir, Shahzad, and Robert D. Crews, eds. *Under the Drones: Modern Lives in the Afghanistan-Pakistan Borderlands*. Cambridge, MA: Harvard University Press, 2012.

Baucom, Ian. *Specters of the Atlantic: Finance Capital, Slavery, and the Philosophy of History*. Durham, NC: Duke University Press, 2005.

Bayly, Christopher Alan. *Empire and Information: Intelligence Gathering and Social Communication in India, 1780–1870*. London: Cambridge University Press, 2000.

Bayoumi, Moustafa. *How Does It Feel to Be a Problem? Being Young and Arab in America*. New York: Penguin, 2008.

Bayoumi, Moustafa. *This Muslim American Life: Dispatches from the War on Terror*. New York: New York University Press, 2015.

Bazian, Hatem. "The Islamophobia Industry and the Demonization of Palestine: Implications for American Studies." *American Quarterly* 67, no. 4 (Dec 2015): 1057–66.

Beauchamp, Toby. *Going Stealth: Transgender Politics and U.S. Surveillance Practices*. Durham, NC: Duke University Press, 2018.

Benjamin, Medea. *Drone Warfare: Killing By Remote Control*. New York: OR Books, 2012.

Benjamin, Ruha, ed. *Captivating Technology: Race, Carceral Technoscience, and Liberatory Imagination in Everyday Life*. Durham, NC: Duke University Press, 2019.

Ben-Naftali, Orna, Michael Sfard, and Hedi Viterbo. *The ABC of the OPT: A Legal*

Lexicon of the Israeli Control over the Occupied Palestinian Territory. New York: Cambridge University Press, 2018.

Berger, Dan. *Captive Nation: Black Prison Organizing in the Civil Rights Era*. Chapel Hill: University of North Carolina Press, 2014.

Berlant, Lauren. *Cruel Optimism*. Durham, NC: Duke University Press, 2011.

Berlant, Lauren. *The Queen of America Goes to Washington City: Essays on Sex and Citizenship*. Durham, NC: Duke University Press, 1997.

Berlant, Lauren, and Michael Warner. "Sex in Public." *Critical Inquiry* 24, no. 2 (Winter 1998): 547–66.

Bhandar, Brenna. "Some Reflections on BDS and Feminist Political Solidarity." *Feminists@law* 4, no. 1 (2014): 1–14.

Bhungalia, Lisa. "Managing Violence: Aid, Counterinsurgency, and the Humanitarian Present in Palestine." *Environment and Planning A* 47 (2015): 2308–23.

Bilal, Wafaa, and Kari Lydersen. *Shoot an Iraqi: Art, Life and Resistance Under the Gun*. San Francisco: City Lights, 2008.

Billings, Lee. "War in Space May Be Closer Than Ever." *Scientific American*, August 10, 2015. Accessed June 20, 2017. https://www.scientificamerican.com/article/war-in-space-may-be-closer-than-ever/.

Bloch, Ernst. *The Utopian Function of Art and Literature: Selected Essays*. Translated by Jack Zipes and Frank Mecklenburg. Cambridge, MA: The MIT Press, 1988.

Booth, Ken, ed. *Critical Security Studies and World Politics*. Boulder, CO: Lynne Rienner, 2005.

Bouarrouj, Khelil. "'Bethlehem Bandolero': Interview with Larissa Sansour." *Palestine Square*, April 20, 2015. Accessed August 17, 2017, https://palestinesquare.com/2015/04/20/larissa-sansour-on-sci-fi-nostalgia-and-the-staging-of-myth/.

Bowden, Mark. *The Finish: The Killing of Osama Bin Laden*. New York: Atlantic Monthly Press, 2012.

Bowman, Tom. "In Mock Village, A New Afghan Mission Takes Shape." *National Public Radio*, March 1, 2012. Accessed June 14, 2012. http://www.npr.org/2012/03/01/147664674/in-mock-village-a-new-afghan-mission-takes-shape/.

Bradley, Rizvana. "Other Sensualities." Introduction to special issue, *The Haptic: Textures of Performance. Women and Performance: A Journal of Feminist Theory* 24, nos. 2–3 (2015): 129–33.

Bradley, Rizvana. "Resurfaced Flesh: Black Aesthetics Unbound." Unpublished manuscript.

Brennan, Teresa. *The Transmission of Affect*. Ithaca, NY: Cornell University Press, 2004.

Briggs, Laura. *Reproducing Empire: Race, Sex, Science and US Imperialism in Puerto Rico*. Berkeley: University of California Press, 2002.

Brighenti, Andrea Mubi. "Artveillance: At the Crossroads of Art and Surveillance." *Surveillance and Society* 7, no. 2 (2010): 175–86.

Brooks, Daphne. *Bodies in Dissent: Spectacular Performances of Race and Freedom, 1850–1910*. Durham, NC: Duke University Press, 2006.

Brooks, Katherine. "Exploring the Fate of the Palestinian Territories with Science Fiction," *Huffington Post*, November 6, 2013. Accessed June 14, 2017. http://www.huffingtonpost.com/2013/11/06/larissa-sansour_n_4221142.html/.

Brown, Adrienne. *The Black Skyscraper: Architecture and the Perception of Race*. Baltimore: Johns Hopkins University Press, 2017.

brown, adrienne maree. *Emergent Strategy: Shaping Change, Shaping Worlds*. Oakland: AK Press, 2017.

brown, adrienne maree, and Walidah Imarisha, eds. *Octavia's Brood: Science Fiction Stories from Social Justice Movements*. Oakland, CA: AK Press and the Institute for Anarchist Studies, 2015.

Brown, Jayna. *Black Utopias: Speculative Life and the Music of Other Worlds*. Durham, NC: Duke University Press, forthcoming.

Browne, Simone. *Dark Matters: On the Surveillance of Blackness*. Durham, NC: Duke University Press, 2015.

Bryan-Wilson, Julia. "Remembering Yoko Ono's Cut Piece." *Oxford Art Journal* 26, no. 1 (Spring 2003): 99–123.

Bucar, Elizabeth. *Pious Fashion: How Muslim Women Dress*. Cambridge, MA: Harvard University Press, 2017.

Buff, Rachel Ida. *Against the Deportation Terror: Organizing for Immigrant Rights in the Twentieth Century*. Philadelphia: Temple University Press, 2017.

Bumiller, Elisabeth, and Thom Shanker. "War Evolves With Drones, Some Tiny as Bugs." *New York Times*, June 19, 2011.

Burke, Anthony. *Beyond Security, Ethics, and Violence: War against the Other*. New York: Routledge, 2007.

Butler, Judith. *Bodies That Matter*. New York: Routledge, 1993.

Butler, Judith. *Frames of War: When Is Life Grievable?* London: Verso, 2009.

Butler, Judith. "Merely Cultural." *Social Text* 52/53 (Winter 1997): 265–77.

Butler, Judith. *Parting Ways: Jewishness and the Critique of Zionism*. New York: Columbia University Press, 2012.

Butler, Judith. *Precarious Life: The Power of Mourning and Violence*. London: Verso, 2004.

Butler, Octavia E. *Parable of the Sower*. New York: Four Walls Eight Windows, 1993.

Byrd, Jodi A. *The Transit of Empire: Indigenous Critiques of Colonialism*. Minneapolis: University of Minnesota Press, 2011.

Cable, Umayyah. "Cinematic Activism: Film Culture and the Queer Politics of Palestine in North America." Unpublished manuscript.

Cacho, Lisa. *Social Death: Racialized Rightlessness and the Criminalization of the Unprotected*. New York: New York University Press, 2012.

Cainkar, Louise. "Special Registration: A Fervor for Muslims." *Journal of Islamic Law and Culture* 7, no. 2 (Fall/Winter 2003): 73–101.

Cainkar, Louise. *Homeland Insecurity: The Arab American and Muslim American Experience after 9/11*. New York: Russell Sage Foundation, 2009.

Cainkar, Louise, and Sunaina Maira. "Targeting Arab/Muslims/South Asian Ameri-

cans: Criminalization and Cultural Citizenship." *Amerasia Journal* 31, no. 3 (2005): 1–28.

Camacho, Alicia Schmidt. *Migrant Imaginaries: Latino Cultural Politics in the Mexico-U.S. Borderlands.* New York: New York University Press, 2008.

Camp, Jordan T. *Incarcerating the Crisis: Freedom Struggles and the Rise of the Neoliberal State.* Berkeley: University of California Press, 2016.

Camp, Jordan T., and Christina Heatherton, eds. *Policing the Planet: Why the Policing Crisis Led to Black Lives Matter.* New York: Verso Press, 2016.

Campbell, David. *Writing Security: United States Foreign Policy and the Politics of Identity.* Minneapolis: University of Minnesota Press, 1992.

Campt, Tina M. *Image Matters: Archive, Photography, and the African Diaspora in Europe.* Durham, NC: Duke University Press, 2012.

Campt, Tina M. *Listening to Images.* Durham, NC: Duke University Press, 2017.

Caplan, Jane, and John Torpey, eds. *Documenting Individual Identity: The Development of State Practices in the Modern World.* Princeton, NJ: Princeton University Press, 2001.

Carby, Hazel. *Reconstructing Womanhood: The Emergence of the Afro-American Woman Novelist.* London: Oxford University Press, 1989.

Carrington, André M. *Speculative Blackness: The Future of Race in Science Fiction.* Minneapolis: University of Minnesota Press, 2016.

Casper, Monica J., and Lisa Jean Moore. *Missing Bodies: The Politics of Visibility.* New York: New York University Press, 2009.

Cassidy, Robert M. *Counterinsurgency and the Global War on Terror: Military Culture and Irregular War.* Stanford, CA: Stanford University Press, 2008.

Cavallaro, James, Stephan Sonnenberg, and Sarah Kuckey. *Living Under Drones: Death, Injury and Trauma to Civilians from US Drone Practices in Pakistan.* Stanford, CA: International Human Rights and Conflict Resolution Clinic, Stanford Law School, 2012.

Center for Constitutional Rights. CMUs: *The Federal Prison System's Experiment in Social Isolation*, March 31, 2010. Accessed December 29, 2011. http://ccrjustice.org /cmu-factsheet.

Centre for Contemporary Cultural Studies, ed. *The Empire Strikes Back: Race and Racism in 70s Britain.* London: Hutchinson/Centre for Contemporary Cultural Studies, University of Birmingham, 1982.

Chakrabarty, Dipesh. *Provincializing Europe: Postcolonial Thought and Historical Difference.* Princeton, NJ: Princeton University Press, 2000.

Chamayou, Grégoire. *A Theory of the Drone.* Translated by Janet Lloyd. New York: New Press, 2014.

Chamberlin, Paul Thomas. *The Global Offensive: The United States, the Palestine Liberation Organization, and the Making of the Post-Cold War Order.* London: Oxford University Press, 2012.

Chambers-Letson, Joshua Takano. *A Race So Different: Law and Performance in Asian America.* New York: New York University Press, 2013.

Chan-Malik, Sylvia. *Being Muslim: A Cultural History of Women of Color in American Islam*. New York: New York University Press, 2018.

Charbonneau, Louis, and Michelle Nichols. "Palestinians Win De Facto U.N. Recognition of Sovereign State." *Reuters*, November 30, 2012. Accessed August 1, 2017, http://www.reuters.com/article/us-palestinians-statehood-idUSBRE8AR0EG 20121201.

Chatterjee, Piya, and Sunaina Maira, eds. *The Imperial University: Academic Repression and Scholarly Dissent*. Minneapolis: University of Minnesota Press, 2014.

Chaudhry, Kiren Aziz. "Dis(re)membering \Pä-ki-'stän\." *Informed Comment*. April 30, 2010.

Chaudhury, Zahid R. *Afterimage of Empire: Photography in Nineteenth-Century India*. Minneapolis: University of Minnesota Press, 2012.

Chávez, Karma. *Queer Migration Politics: Activist Rhetoric and Coalitional Possibilities*. Urbana: University of Illinois Press, 2013.

Chen, Mel Y. *Animacies: Biopolitics, Racial Mattering, and Queer Affect*. Durham, NC: Duke University Press, 2012.

Childs, Dennis L. *Slaves of the State: Black Incarceration from the Chain Gang to the Penitentiary*. Minneapolis: University of Minnesota Press, 2015.

Chomsky, Noam. *Towards a New Cold War: US Foreign Policy from Vietnam to Reagan*. New York: New Press, 2003.

Chow, Rey. *The Age of the World Target: Self-Referentiality in War, Theory, and Comparative Work*. Durham, NC: Duke University Press, 2006.

Chuh, Kandice. *The Difference Aesthetics Makes: On the Humanities "After Man."* Durham, NC: Duke University Press, 2019.

Chuh, Kandice. *Imagine Otherwise: On Asian Americanist Critique*. Durham, NC: Duke University Press, 2003.

Chuh, Kandice. "It's Not about Anything." *Social Text* 121 32, no. 4 (Winter 2014): 125–34.

Clarno, Andy. *Neoliberal Apartheid: Palestine/Israel and South Africa after 1994*. Chicago: University of Chicago Press, 2017.

Cline, Patricia. *A Calculating People: The Spread of Numeracy in Early America*. New York: Routledge, 1999.

Clough, Patricia Ticineto, and Craig Willse, eds. *Beyond Biopolitics: Essays on the Governance of Life and Death*. Durham, NC: Duke University Press, 2011.

Clough, Patricia Ticineto, and Jean Halley, eds. *The Affective Turn: Theorizing the Social*. Durham, NC: Duke University Press, 2007.

Cohen, Cathy. "Punks, Bulldaggers, and Welfare Queens: The Radical Potential of Queer Politics?" GLQ: *A Journal of Gay and Lesbian Studies* 3, no. 4 (1997): 437–65.

Cohn, Marjorie, ed. *Drones and Targeted Killing: Legal, Moral, and Geopolitical Issues*. Northampton, MA: Interlink Publishing Group, 2014.

Cole, David. *Enemy Aliens: Double Standards and Constitutional Freedoms in the War on Terrorism*. New York: New Press, 2003.

Cole, Juan. *Engaging the Muslim World*. New York: Palgrave Macmillan, 2009.

Coll, Steve. "The Unblinking Stare: The Drone War in Pakistan." *New Yorker*,

November 24, 2014. Accessed August 27, 2016, http://www.newyorker.com/magazine/2014/11/24/unblinking-stare.

Collins, John. *Global Palestine*. New York: Columbia University Press, 2012.

Cornell, Andy. *Oppose and Propose: Lessons from Movement for a New Society*. Oakland, CA: AK Press, 2011.

Coulthard, Glen S. *Red Skin, White Masks: Rejecting the Colonial Politics of Recognition*. Minneapolis: University of Minnesota Press, 2014.

Cowen, Deborah. *The Deadly Life of Logistics: Mapping Violence in Global Trade*. Minneapolis: University of Minnesota Press, 2014.

Cowen, Deborah. *Military Workfare: The Soldier and Social Citizenship in Canada*. Toronto: University of Toronto Press, 2008.

Crandall, Jordan, and John Armitage. "Envisioning the Homefront: Militarization, Tracking and Security Culture." *Journal of Visual Culture* 4, no. 1 (2005): 17–38.

Crawley, Ashon T. *Blackpentecostal Breath: The Aesthetics of Possibility*. New York: Fordham University Press, 2016.

Crenshaw, Kimberlé. "Mapping the Margins: Intersectionality, Identity Politics, and Violence Against Women of Color." *Stanford Law Review* 43, no. 6 (1991): 1241–99.

Croser, Caroline. "Networking Security in the Space of the City: Event-ful Battlespaces and the Contingency of the Encounter." *Theory and Event* 10, no. 2 (2007). https://doi.org/10.1353/tae.2007.0058.

Croser, Caroline. *The New Spatiality of Security: Operational Uncertainty and the US Military in Iraq*. New York: Routledge, 2010.

Cruz, Ariane. *The Color of Kink: Black Women, BDSM, and Pornography*. New York: New York University Press, 2016.

Cruz, Denise. *Transpacific Femininities: The Making of the Modern Filipina*. Durham, NC: Duke University Press, 2012.

Curtis, Edward E. *Muslims in America: A Short History*. New York: Oxford University Press, 2009.

Cvetkovich, Ann. *An Archive of Feelings: Trauma, Sexuality, and Lesbian Public Cultures*. Durham, NC: Duke University Press, 2003.

Cvetkovich, Ann. *Depression: A Public Feeling*. Durham, NC: Duke University Press, 2012.

Dabashi, Hamid, ed. *Dreams of Nation: Palestinian Cinema*. London: Verso Press, 2006.

daCosta, Beatriz, and Kavita Philip, eds. *Tactical Biopolitics: Art, Activism, and Technoscience*. Cambridge, MA: MIT Press, 2008.

Dalby, Simon. "The Pentagon's New Imperial Cartography: Tabloid Realism and the War on Terror." In *Violent Geographies: Fear, Terror, and Political Violence*. Edited by Derek Gregory and Allan Pred, 295–308. New York: Routledge, 2007.

Danner, Mark. *Spiral: Trapped in the Forever War*. New York: Simon and Schuster, 2016.

Danner, Mark. *Torture and Truth: America, Abu Ghraib, and the War on Terror*. New York: New York Review Books, 2004.

Darwich, Lynn, and Haneen Maikey. "The Road from Antipinkwashing Activism to the Decolonization of Palestine." *wsQ: Women's Studies Quarterly* 42, no. 3–4 (Fall/Winter 2014): 281–85.

Das Gupta, Monisha. *Unruly Immigrants: Rights, Activism and Transnational South Asian Publics*. Durham, NC: Duke University Press, 2006.

Daughtry, J. Martin. "Thanatosonics: Ontologies of Acoustic Violence." *Social Text* 119 32, no. 2 (2014): 25–51.

Daulatzai, Sohail. *Black Star, Crescent Moon: The Muslim International and Black Freedom Beyond America*. Minneapolis: University of Minnesota Press, 2012.

Daulatzai, Sohail. "Protect Ya Neck: Muslims and the Carceral Imagination in the Age of Guantánamo." *Souls* 9, no. 2 (2007): 132–47.

Daulatzai, Sohail, and Junaid Rana. "Left." *Critical Ethnic Studies* 1, no. 1 (Spring 2015): 39–42.

Daulatzai, Sohail, and Junaid Rana. "Writing the Muslim Left." In *With Stones in Our Hands: Reflections on Muslims, Racism, and Empire*. Edited by Sohail Daulatzai and Junaid Rana, ix–xxiii. Minneapolis: University of Minnesota Press, 2018.

Daulatzai, Sohail, and Junaid Rana, eds. *With Stones in Our Hands: Reflections on Muslims, Racism, and Empire*. Minneapolis: University of Minnesota Press, 2018.

Davis, Angela. *Abolition Democracy: Beyond Empire, Prisons, and Torture*. New York: Seven Stories Press, 2005.

Davis, Angela. *Freedom Is a Constant Struggle: Ferguson, Palestine, and the Foundations of a Movement*. Chicago: Haymarket Press, 2016.

Davis, Rochelle. "Culture as a Weapon." *Middle East Report* 255 (Summer 2010).

Davis, Rochelle, and Dan Walsh. "'Visit Palestine': A Brief Study of Palestine Posters." *Jerusalem Quarterly* 61 (Winter 2015): 42–54.

Davis, Uri. *Apartheid Israel: Possibilities for Struggle Within*. New York: Zed Books, 2003.

Dawson, Ashley. "Drone Executions, Urban Surveillance, and the Imperial Gaze." In *American Encounters the Middle East*. Edited by Alex Lubin and Marwan M. Kraidy, 241–62. Chapel Hill: University of North Carolina Press, 2016.

Dawson, Ashley, and Malini J. Schueller, eds. *Exceptional State: Contemporary U.S. Culture and the New Imperialism*. Durham, NC: Duke University Press, 2007.

Day, Iyko. *Alien Capital: Asian Racialization and the Logic of Settler Colonial Capitalism*. Durham, NC: Duke University Press, 2016.

Dayan, Colin. "Due Process and Lethal Confinement." *South Atlantic Quarterly* 107, no. 3 (Summer 2008): 485–507.

Dayan, Colin. *The Story of Cruel and Unusual*. Cambridge, MA: MIT Press, 2007.

Debatty, Régine. "Nation Estate, a 'Vertical Solution to Palestinian State.'" *We Make Money Not Art*, March 26, 2014. Accessed July 10, 2017. http://we-make-money-not art.com/larissa_sansour/.

De Genova, Nicholas. "The Queer Politics of Migration: Reflections on 'Illegality' and Incorrigibility." *Studies in Social Justice* 4, no. 2 (2010). http://dx.doi.org/10.26522/ssj.v4i2.997.

De Genova, Nicholas, and Nathalie Peutz, eds. *The Deportation Regime: Sovereignty, Space, and the Freedom of Movement.* Durham, NC: Duke University Press, 2010.

Deeb, Lara, and Jessica Winegar. *Anthropology's Politics: Disciplining the Middle East.* Stanford, CA: Stanford University Press, 2016.

Deer, Patrick. "The Ends of War and the Limits of War Culture." *Social Text* 91 25, no. 2 (Summer 2007): 1–11.

Denning, Michael. *Culture in the Age of Three Worlds.* New York: Verso, 2004.

Der Derian, James. *Virtuous War: Mapping the Military-Industrial-Media-Entertainment.* New York: Routledge, 2001.

Derrida, Jacques. *Archive Fever: A Freudian Impression.* Translated by Eric Prenowitz. Chicago: University of Chicago Press, 1996.

Derrida, Jacques. *Specters of Marx: The Scale of the Debt, the Work of Mourning, and the New International.* Translated by Peggy Kamuf. New York: Routledge, 1993.

Desai, Chandni. "'We Teach Life': Exile, Hip Hop and the Radical Tradition of Palestinian Cultural Resistance." PhD diss., University of Toronto, 2016.

Devereaux, Ryan. "Manhunting in the Hindu Kush: Civilian Casualties and Strategic Failures in America's Longest War." *Intercept*, October 15, 2015. Accessed August 27, 2016. https://theintercept.com/drone-papers/manhunting-in-the-hindu-kush/.

Dillon, Grace L., ed. *Walking the Clouds: An Anthology of Indigenous Science Fiction*, 2nd ed. Tucson: University of Arizona Press, 2012.

Dillon, Michael, and Julian Reid. *The Liberal Way of War: The Martial Face of Global Biopolitics.* New York: Routledge, 2009.

Dillon, Michael, and Luis Lobo-Guerrero. "Biopolitics of Security in the 21st Century: An Introduction." *Review of International Studies* 34 (2008): 265–92.

Dillon, Stephen. *Fugitive Life: The Queer Politics of the Prison State.* Durham, NC: Duke University Press, 2018.

Dinshaw, Carolyn. *Getting Medieval: Sexualities and Communities, Pre- and Post-Modern.* Durham, NC: Duke University Press, 1999.

Dower, John W. *The Violent American Century: War and Terror since World War II.* Chicago: Haymarket Books, 2017.

Doyle, Jennifer. *Hold It Against Me: Difficulty and Emotion in Contemporary Art.* Durham, NC: Duke University Press, 2013.

Driskill, Qwo-Li, Chris Finley, Brian Joseph Gilley, Scott Lauria Morgensen, eds. *Queer Indigenous Studies: Critical Interventions in Theory, Politics, and Literature.* Tucson: University of Arizona Press, 2011.

"The Drone Papers." *Intercept.* Accessed July 17, 2017. https://theintercept.com/drone-papers/.

Drumsta, Emily, and Keith P. Feldman. "We Deportees: Race, Religion, and War on Palestine's No-Man's Land." *Social Text* 129 34, no. 4 (December 2016): 87–110.

Dubrofsky, Rachel E., and Shoshana Amielle Magnet, eds. *Feminist Surveillance Studies.* Durham, NC: Duke University Press, 2015.

Duggan, Lisa. "Making It Perfectly Queer." *Socialist Review* 22, no. 1 (1992): 11–31.

Duggan, Lisa. *Twilight of Equality? Neoliberalism, Cultural Politics, and the Attack on Democracy.* Boston: Beacon Press, 2004.

Duggan, Lisa, ed. "Circuits of Influence: US, Israel, Palestine." Special issue of *Social Text Periscope Blog*, June 17, 2014. Accessed August 5, 2017. https://socialtextjournal .org/periscope_topic/circuits-of-influence/.

Dunbar-Ortiz, Roxanne. *An Indigenous People's History of the United* States. Boston: Beacon Press, 2014.

Edwards, Brian T. *After the American Century: The Ends of U.S Culture in the Middle East*. New York: Columbia University Press, 2017.

Edwards, Erica R. "The Other Side of Terror: Blackness and the Culture of US Empire." Unpublished manuscript.

Edwards, Erin E. *The Modernist Corpse: Posthumanism and the Posthumous*. Minneapolis: University of Minnesota Press, 2018.

Elia, Nada. "The Burden of Representation: When Palestinians Speak Out." In *Arab and Arab American Feminisms: Gender, Violence, and Belonging*. Edited by Rabab Abdulhadi, Evelyn Alsultany, and Nadine Naber. Syracuse, 144–58. Syracuse, NY: Syracuse University Press, 2011.

Elia, Nada. "Justice Is Indivisible: Palestine Is a Feminist Issue." *Decolonization: Indigeneity, Education and Society* 6, no. 1 (2017): 45–63.

Elia, Nada, David M. Hernández, Jodi Kim, Shana L. Redmond, Dylan Rodriguez, Sarita Echavez See, eds. *Critical Ethnic Studies: A Reader*. Durham, NC: Duke University Press, 2016.

Ellis, Nadia. *Territories of the Soul: Queered Belonging in the Black Diaspora*. Durham, NC: Duke University Press, 2015.

Emery, Tom. "Review: Larissa Sansour: In the Future They Ate from the Finest Porcelain." *Art Monthly*, no. 394 (March 2016): 24–25.

Eng, David L. *The Feeling of Kinship: Queer Liberalism and the Racialization of Intimacy*. Durham, NC: Duke University Press, 2010.

Eng, David L. *Racial Castration: Managing Masculinity in Asian America*. Durham, NC: Duke University Press, 2001.

Eng, David L., Jack Halberstam, and José Esteban Muñoz, eds. "What's Queer about Queer Studies Now?" *Social Text* 84–85 23, no. 3–4 (Fall–Winter 2005).

Engdahl, F. William. *Full Spectrum Dominance: Totalitarian Democracy in the New World Order*, 3rd ed. Palm Desert, CA: Progressive Press, 2011.

Engelhardt, Tom. "Air War, Barbarity, and Collateral Damage." In *The American Way of War: How Bush's Wars Became Obama's*, 57–91. Chicago: Haymarket Press, 2010.

Engelhardt, Tom. *The American Way of War: How Bush's Wars Became Obama's*. Chicago: Haymarket Press, 2010.

Engelhardt, Tom. "Mapping a World from Hell: 76 Countries Are Not Involved in Washington's War on Terror." *TomDispatch*, January 4, 2018. Accessed January 26, 2018. http://www.tomdispatch.com/blog/176369/.

Engelhardt, Tom. *Shadow Government: Surveillance, Secret Wars, and a Global Security State in a Single-Superpower World*. Chicago: Haymarket Books, 2014.

Enloe, Cynthia. *Bananas, Beaches and Bases: Making Feminist Sense of International Politics*. Berkeley: University of California Press, 1990.

Erakat, Noura. "Taking the Land Without the People: The 1967 Story as Told By the Law." *Journal of Palestine Studies* 47, no. 1 (Autumn 2017): 18–38.

Erakat, Noura. "When You Come for Rasmea, You Come for All of Us." *Jezebel*, March 24, 2017. Accessed August 5, 2017. http://jezebel.com/when-you-come-for -rasmea-odeh-you-come-for-all-of-us-1793609351.

Erakat, Noura, and Mouin Rabbani, eds. *Aborted State? The UN Initiative and New Palestinian Junctures.* Washington, DC: Tadween Publishing, 2013.

Esmeir, Samera. "Colonial Experiments in Gaza." *Jadaliyya*, July 14, 2014. Accessed July 10, 2017. http://www.jadaliyya.com/pages/index/8482/colonial-experiments -in-gaza.

Espiritu, Yen Lê. *Body Counts: The Vietnam War and Militarized Refugees.* Berkeley: University of California Press, 2014.

Estefan, Kareem, Carin Kuoni, and Laura Raicovich. *Assuming Boycott: Resistance, Agency, and Cultural Production.* New York: OR Books, 2017.

Evans, Brad, and Elaine Scarry. "The Intimate Life of Violence." *Los Angeles Review of Books*, December 4, 2017. Accessed December 9, 2017. https://lareviewofbooks .org/article/histories-of-violence-the-intimate-life-of-violence/.

Fadda-Conrey, Carol. *Contemporary Arab-American Literature: Transnational Re-configurations of Citizenship and Belonging.* New York: New York University Press, 2014.

Farish, Matthew. *The Contours of America's Cold War.* Minneapolis: University of Minnesota Press, 2010.

Farsakh, Leila, Rhoda Khanaaneh, and Sherene Seikaly, eds. "Queering Palestine." Special issue, *Journal of Palestine Studies* 47, no. 3 (2018).

Fault Lines. "The Dark Prisoners: Inside the CIA's Torture Programme," *Al Jazeera*, September 14, 2016. Accessed December 9, 2017. http://www.aljazeera.com /indepth/features/2016/03/dark-prisoners-cia-torture-programme-1603260 51331796.html.

Fawaz, Ramzi. *The New Mutants: Superheroes and the Radical Imagination of American Comics.* New York: New York University Press, 2016.

Fawaz, Ramzi. "Space, That Bottomless Pit: Planetary Exile and Metaphors of Belonging in American Afrofuturist Cinema." *Callaloo* 35, no. 4 (2012): 1103–22.

Fawaz, Ramzi, Justin Hall, and Helen M. Kinsella. "Discovering Paradise Islands: The Politics and Pleasures of Feminist Utopias, a Conversation." *Feminist Review* 116 (2017): 1–21.

Feldman, Allen. *Archives of the Insensible: Of War, Photopolitics, and Dead Memory.* Chicago: University of Chicago Press, 2015.

Feldman, Allen. "On the Actuarial Gaze: From 9/11 to Abu Ghraib." *Cultural Studies* 19, no. 2 (2005): 203–26.

Feldman, Allen. "Securocratic Wars of Public Safety: Globalized Policing as Scopic Regime." *Interventions: International Journal of Postcolonial Studies* 6, no. 3 (2004): 330–50.

Feldman, Allen. "The Structuring Enemy and Archival War." *PMLA* 124, no. 5 (Oct 2009): 1704–13.

Feldman, Ilana. *Police Encounters: Security and Surveillance in Gaza under Egyptian Rule*. Stanford, CA: Stanford University Press, 2015.

Feldman, Keith P. *A Shadow over Palestine: The Imperial Life of Race in America*. Minneapolis: University of Minnesota Press, 2015.

Feldman, Keith P. "Empire's Verticality: The Af/Pak Frontier, Visual Culture, and Racialization from Above." *Comparative American Studies* 9, no. 4 (2011): 325–41.

Feldman, Keith P. "#NotABugSplat: Becoming Human on the Terrain of Visual Culture." In *The Routledge Companion to Literature and Human Rights*. Edited by Sophia A. McClennen and Aelxandria Schultheis Moore, 224–32. New York: Routledge, 2016.

Feldman, Keith P. "Zionism and Anti-Zionism: A Necessary Detour, Not a Final Destination." *American Quarterly* 67, no. 4 (2015): 1067–73.

Feldman, Yotam, dir. *The Lab*. Yoav Roeh and Aurit Zamir. Gun Films, 2013. http://www.gumfilms.com/projects/lab. Film.

Ferguson, Roderick A. *Aberrations in Black: Toward a Queer of Color Critique*. Minneapolis: University of Minnesota Press, 2003.

Fernandes, Deepa. *Targeted: National Security and the Business of Immigration*. New York: Seven Stories Press, 2006.

Field, Kendra Taira. *Growing Up With the Country: Family, Race, and Nation after the Civil War*. New Haven, CT: Yale University Press, 2018.

Fields, Gary. *Enclosure: Palestinian Landscapes in a Historical Mirror*. Berkeley: University of California Press, 2017.

Filkins, Dexter. *The Forever War*. New York: Vintage Books, 2009.

Finn, Jonathan. *Capturing the Criminal Image: From Mug Shot to Surveillance Society*. Minneapolis: University of Minnesota Press, 2009.

Fiol-Matta, Licia. *A Queer Mother for the Nation: The State and Gabriela Mistral*. Minneapolis: University of Minnesota Press, 2001.

Flanders, Laura. "Wafaa Bilal: '. . . and Counting,'" *GRITtv.org*, March 20, 2010.

Flatley, Jonathan. *Affective Mapping: Melancholia and the Politics of Modernism*. Cambridge, MA: Harvard University Press, 2008.

Fleetwood, Nicole R. *Marking Time: Art and Visuality in the Era of Mass Incarceration*. Cambridge, MA: Harvard University Press, forthcoming.

Fleetwood, Nicole R. "Posing in Prison: Family Photographs, Emotional Labor, and Carceral Intimacy." *Public Culture* 27, no. 3 (2015): 487–511.

Fleetwood, Nicole R. *Troubling Vision: Performance, Visuality, and Blackness*. Chicago: University of Chicago Press, 2011.

Forman Jr., James. *Locking Up Our Own: Crime and Punishment in Black America*. New York: Farrar, Straus, and Giroux, 2017.

Fortin, Jacey. "Who Owns Art From Guantánamo Bay? Not Prisoners, U.S. Says." *New York Times*, November 27, 2017.

Foucault, Michel. *Discipline and Punish: The Birth of the Prison*. Translated by Alan Sheridan. New York: Vintage Books, 1995.

Foucault, Michel. "Governmentality." In *The Foucault Effect: Studies in Govern-*

mentality. Edited by Graham Burchell, Colin Gordon, and Peter Miller, 87–104. Chicago: University of Chicago Press, 1991.

Foucault, Michel. *The History of Sexuality: Vol. 1, An Introduction*. Translated by Robert Hurley. New York: Vintage, 1978.

Foucault, Michel. *Power/Knowledge: Selected Interviews and Other Writings, 1972–1977*. Edited by Colin Gordon. New York: Vintage, 1980.

Foucault, Michel. *Security, Territory, Population: Lectures at the College de France, 1977–1978*. Translated by Graham Burchell. New York: Palgrave Macmillan, 2007.

Foucault, Michel. *Society Must Be Defended: Lectures at the College de France, 1975–76*. Translated by David Macey. New York: Picador, 2003.

Freccero, Carla. "Queer Spectrality: Haunting the Past." In *A Companion to Gay, Bisexual, Transgender, and Queer Studies*. Edited by George E. Haggerty and Molly McGarry, 194–213. New York: Blackwell Publishing, 2007.

Freeman, Elizabeth. *Time Binds: Queer Temporalities, Queer Histories*. Durham, NC: Duke University Press, 2010.

Friedman, Andrew. *Covert Capital: Landscapes of Denial and the Making of U.S. Empire in the Suburbs of Northern Virginia*. Berkeley: University of California Press, 2013.

Fuentes, Marcela. *Dispossessed Lives: Enslaved Women, Violence, and the Archive*. Philadelphia: University of Pennsylvania Press, 2016.

Fujikane, Candace, and Jonathan Y. Okamura, eds. *Asian Settler Colonialism: From Local Governance to the Habits of Everyday Life in Hawai'i*. Honolulu: University of Hawai'i Press, 2008.

Gabsi, Wafa. "'Fiction and Art Practice': Interview with Larissa Sansour 'A Space Exodus.'" *Contemporary Practices: Visual Arts from the Middle East* X (March 2012): 114–19.

Gaddis, John Lewis. *The Cold War: A New History*. New York: Penguin, 2006.

Gaddis, John Lewis. *The Long Peace: Inquiries into the History of the Cold War*. New York: Oxford University Press, 1989.

Gandhi, Leela. *Affective Communities: Anticolonial Thought, Fin-De-Siècle Radicalism, and the Politics of Friendship*. Durham, NC: Duke University Press, 2006.

Ganesh, Chitra, and Mariam Ghani. "Chitra Ganesh talks to Mariam Ghani about The Trespassers for the sbx Catalogue," November 2010. Accessed July 17, 2017. http://www.kabul-reconstructions.net/mariam/texts/TrespassersFAQ3.pdf.

Ganesh, Chitra and Mariam Ghani. "Roundtable 2: Impossible Archives." Tracing the Index: 4 Discussions, 4 Venues. nyu Kevorkian Center Library, March 3, 2008. www.kabul-reconstructions.net/disappeared.

Gates, Kelly A. *Our Biometric Future: Facial Recognition Technology and the Culture of Surveillance*. New York: New York University Press, 2011.

"Gaza on Verge of Collapse as Israel Sends 2.2M People 'Back to the Middle Ages' in Electricity Crisis." *Democracy Now*, July 19, 2017.

Gertz, Nurith, and George Khleifi. *Palestinian Cinema: Landscape, Trauma, and Memory*. Indianapolis: University of Indiana Press, 2008.

Getsy, David J. "Queer Relations." *ASAP/Journal* 2, no. 2 (May 2017): 254–57.

Ghani, Mariam. "Divining the Question: An Unscientific Methodology for the Collection of Warm Data." *Viralnet*. Issue "Viralzerosix." Los Angeles: Center for Integrated Media, Cal Arts, 2006.

Ghani, Mariam. "The Translators." *The Trespassers*. Vimeo. May 12, 2012. http://vimeo.com/23004157/.

Giannachi, Gabriella. *Archive Everything: Mapping the Everyday*. Cambridge, MA: MIT Press, 2016.

Gillem, Mark L. *America Town: Building the Outposts of Empire*. Minnesota: University of Minnesota Press, 2007.

Gilmore, Ruth Wilson. "Abolition Geography and the Problem of Innocence." In *Futures of Black Radicalism*. Edited by Theresa Gaye Johnson and Alex Lubin, 223–40. New York: Verso, 2017.

Gilmore, Ruth Wilson. *Golden Gulag: Prisons, Surplus, Crisis, and Opposition in Globalizing California*. Berkeley: University of California Press, 2007.

Gilroy, Paul. *Against Race: Imagining Political Culture beyond the Color Line*. Cambridge, MA: Harvard University Press, 2002.

Gilroy, Paul. *The Black Atlantic: Modernity and Double Consciousness*. Cambridge, MA: Harvard University Press, 1993.

Giroux, Henry A. *The Public in Peril: Trump and the Menace of American Authoritarianism*. New York: Routledge, 2018.

Gleijeses, Piero. *Conflicting Missions: Havana, Washington, and Africa, 1959–1976*. Chapel Hill: The University of North Carolina Press, 2002.

Goeman, Mishuana. *Mark My Words: Native Women Mapping Our Nations*. Minneapolis: University of Minnesota Press, 2013.

Golash-Boza, Tanya. *Deported: Immigrant Policing, Disposable Labor, and Global Capitalism*. New York: New York University Press, 2016.

Goldstein, Alyosha, ed. *Formations of United States Colonialism*. Durham, NC: Duke University Press, 2014.

Goldstein, Alyosha. *Poverty in Common: The Politics of Community Action during the American Century*. Durham, NC: Duke University Press, 2012.

Goldstein, Alyosha, and Alex Lubin, eds. "Settler Colonialism." Special issue, *South Atlantic Quarterly* 107, no. 4 (Fall 2008).

Goldstein, Alyosha, Juliana Hu Pegues, and Manu Vimalassery, eds. "On Colonial Unknowing." Special issue, *Theory and Event* 19, no. 4 (2016).

Gómez-Barris, Macarena. *The Extractive Zone: Social Ecologies and Decolonial Perspectives*. Durham, NC: Duke University Press, 2017.

Gonzales, Alfonso. *Reform without Justice: Latino Migrant Politics and the Homeland Security State*. New York: Oxford University Press, 2014.

González, Roberto J. *American Counterinsurgency: Human Science and the Human Terrain*. Chicago: Prickly Paradigm Press, 2009.

González, Roberto J. "The Rise and Fall of the Human Terrain System." *Counterpunch*, June 29, 2015. Accessed July 17, 2017. http://www.counterpunch.org/2015/06/29/the-rise-and-fall-of-the-human-terrain-system/.

Goodman, Steven. *Sonic Warfare: Sound, Affect, and the Ecology of Fear*. Cambridge, MA: MIT Press, 2009.

Gopinath, Gayatri. *Impossible Desires: Queer Diasporas and South Asian Public Cultures*. Durham, NC: Duke University Press, 2005.

Gopinath, Gayatri. *Unruly Visions: The Aesthetic Practices of Queer Diaspora*. Durham, NC: Duke University Press, 2018.

Gordon, Avery F. "Abu Ghraib: Imprisonment & the War on Terror." *Race and Class* 48, no. 1 (2006): 42–59.

Gordon, Avery F. "The Bruise Blues." In *Futures of Black Radicalism*. Edited by Gaye Theresa Johnson and Alex Lubin, 194–205. New York, Verso, 2017.

Gordon, Avery F. *Ghostly Matters: Haunting and the Sociological Imagination*. Minneapolis: University of Minnesota Press, 1997.

Gordon, Avery F. *The Hawthorn Archive: Letters from the Utopian Margins*. New York: Fordham University Press, 2017.

Gordon, Avery F. *Keeping Good Time: Reflections on Knowledge, Power, and People*. Boulder, CO: Paradigm, 2004.

Gordon, Avery F. "The Prisoner's Curse." In *Toward a Sociology of the Trace*. Edited by Macarena Gómez-Barris and Herman Gray, 17–55. Minneapolis: University of Minnesota Press, 2010.

Gordon, Avery F. "Some Thoughts on Haunting & Futurity." *Borderlands* 10, no. 2 (2011): 1–21.

Gordon, Neve. *Israel's Occupation*. Berkeley: University of California Press, 2008.

Gordon, Rebecca. *Mainstreaming Torture: Ethical Approaches in the Post-9/11 United States*. New York: Oxford University Press, 2014.

Graham, Stephen. *Cities under Siege: The New Military Urbanism*. New York: Verso, 2010.

Graham, Stephen. "Laboratories of War: Surveillance and US-Israeli Collaboration in War and Security." In *Surveillance and Control in Israel/Palestine: Population, Territory, and Power*. Edited by Elia Zureik, David Lyon, and Yasmeen Abu-Laban, 133–52. New York: Routledge, 2011.

Graham, Stephen. "Vanity and Violence: On the Politics of Skyscrapers." *City* 20, no. 5 (Aug 2016): 755–71.

Graham, Stephen. *Vertical: The City from Satellites to Bunkers*. New York: Verso Press, 2016.

Gramsci, Antonio. *Selections from Prison Notebooks*. Edited and translated by Quintin Hoare and Geoffrey Nowell Smith. New York: International Publishers, 1971.

Grandin, Greg. *The Last Colonial Massacre: Latin America in the Cold War*. Chicago: University of Chicago Press, 2004.

Gray, Herman, and Macarena Gómez-Barris, eds. *Toward a Sociology of the Trace*. Minneapolis: University of Minnesota Press, 2010.

Greenberg, Karen J. "Guantánamo's Last 100 Days: The Story That Never Was." *TomDispatch.com*, March 2, 2017. Accessed December 9, 2017. http://www.tom dispatch.com/post/176249/tomgram%3A_karen_greenberg%2C_the_forever _prisoners_of_guantanamo/.

Greenberg, Karen J. "Guantánamo's Living Legacy in the Trump Era." *Truthout*, October 16, 2017. Accessed December 9, 2017, http://www.truth-out.org/opinion/item/42269-enemy-combatants-again-will-washington-never-learn/.

Greenberg, Karen J. *The Least Worst Place: Guantánamo's First 100 Days.* New York: Oxford University Press, 2010.

Greenberg, Karen J. *Rogue Justice: The Making of the Security State.* New York: Crown, 2016.

Greenwald, Glenn. "Cash, Weapons, and Surveillance: The U.S. Is a Key Party to Every Israeli Attack." *Intercept*, August 3, 2014. Accessed August 5, 2017. https://theintercept.com/2014/08/04/cash-weapons-surveillance/.

Greenwald, Glenn. *No Place to Hide: Edward Snowden, the NSA, and the US.* New York: Picador, 2014.

Greenwald, Glenn. "The Sham 'Terrorism Expert' Industry." *Salon Online*, August 15, 2012. Accessed August 17, 2012. http://www.salon.com/2012/08/15/the_sham_terrorism_expert_industry/.

Greenwald, Glenn, and Murtaza Husain, "Meet the Muslim-American Leaders the FBI and NSA Have Been Spying on." *Intercept*, July 9, 2014. Accessed August 9, 2017. https://theintercept.com/2014/07/09/under-surveillance/.

Gregg, Melissa, and Gregory J. Seigworth, eds. *The Affect Theory Reader.* Durham, NC: Duke University Press, 2010.

Gregory, Derek. *The Colonial Present: Afghanistan, Palestine, Iraq.* London: Wiley-Blackwell, 2004.

Gregory, Derek. "Drone Geographies." *Radical Philosophy* 183 (Jan/Feb 2014): 7–19.

Gregory, Derek. "From A View to a Kill: Drones and Late Modern Warfare." *Theory, Culture and Society* 28, nos. 7–8 (2011): 188–215.

Gregory, Derek. "The Everywhere War." *Geographical Journal* 177, no. 3 (2011): 238–50.

Gregory, Derek. "The Rush to the Intimate: Counterinsurgency and the Cultural Turn in Late Modern Warfare." *Radical Philosophy* 150 (2008): 8–23.

Grewal, Inderpal. *Saving the Security State: Exceptional Citizens in Twenty-First Century America.* Durham, NC: Duke University Press, 2017.

Grewal, Inderpal. *Transnational America: Feminisms, Diasporas, Neoliberalisms.* Durham, NC: Duke University Press, 2005.

Grewal, Zareena. *Islam Is a Foreign Country: American Muslims and the Global Crisis of Authority.* New York: New York University Press, 2013.

Grosscup, Beau. *Strategic Terror: The Politics an Ethics of Aerial Bombardment.* New York: Zed Books, 2006.

Gualtieri, Sarah. *Between Arab and White: Race and Ethnicity in the Early Syrian American Diaspora.* Berkley: University of California Press, 2009.

Guenther, Lisa. *Solitary Confinement: Social Death and Its Afterlives.* Minneapolis: University of Minnesota Press, 2013.

Guha, Ranajit. *Elementary Aspects of Peasant Insurgency in Colonial India.* Durham, NC: Duke University Press, 1999.

Guha, Ranajit. "The Prose of Counter-Insurgency." In *Selected Subaltern Studies.* Ed-

ited by Ranajit Guha and Gayatri Chakravorty Spivak, 45–86. New York: Oxford University Press, 1988.

Gumbs, Alexis Pauline. *M Archive: After the End of the World*. Durham, NC: Duke University Press, 2018.

Gumbs, Alexis Pauline. *Spill: Scenes of Black Feminist Fugitivity*. Durham, NC: Duke University Press, 2016.

Gusterson, Hugh. *Drone: Remote Control Warfare*. Cambridge, MA: MIT Press, 2016.

Gusterson, Hugh. *People of the Bomb: Portraits of America's Nuclear Complex*. Minneapolis: University of Minnesota Press, 2004.

Hajjar, Lisa. "Comparing American and Israeli Ways of War." In "Circuits of Influence: US, Israel, Palestine," special issue, *Social Text Periscope*, June 10, 2014. Accessed July 10, 2017. https://socialtextjournal.org/periscope_article/comparing -american-and-israeli-ways-of-war/.

Hajjar, Lisa. *Courting Conflict: The Israeli Military Court System in the West Bank and Gaza*. Berkeley: University of California Press, 2005.

Hajjar, Lisa. *Torture: A Sociology of Violence and Human Rights*. New York: Routledge, 2012.

Halberstam, Judith [Jack]. *In a Queer Time and Place: Transgender Bodies, Subcultural Lives*. New York: New York University Press, 2005.

Halberstam, Judith [Jack]. *The Queer Art of Failure*. Durham, NC: Duke University Press, 2011.

Halberstam, Jack. "Wildness, Loss, Death." *Social Text* 121 32, no. 4 (Winter 2014): 137–48.

Halberstam, Jack, and Tavia Nyong'o. "Introduction: Theory in the Wild." *South Atlantic Quarterly* 117, no. 3 (2018): 453–64.

Haldeman, Joe. *The Forever War*, reprint edition. New York: St Martin's Griffin, [1974] 2009.

Haley, Sarah. *No Mercy Here: Gender, Punishment, and the Making of Jim Crow Modernity*. Chapel Hill: University of North Carolina Press, 2016.

Hall, Rachel. "Of Ziploc Bags and Black Holes: The Aesthetics of Transparency in the War on Terror." *Communication Review* 10, no. 4 (2007): 319–46.

Hall, Rachel. *The Transparent Traveler: The Performance and Culture of Airport Security*. Durham, NC: Duke University Press, 2015.

Hall, Stuart. *Cultural Studies 1983: A Theoretical Legacy*. Edited by Jennifer Daryl Slack and Lawrence Grossberg. Durham, NC: Duke University Press, 2016.

Hall, Stuart. "Cultural Studies and Its Theoretical Legacies." In *Cultural Studies*. Edited by Lawrence Grossberg, Cary Nelson, and Paul Treichler, 277–86. New York: Routledge, 1992.

Hall, Stuart. "New Ethnicities." In *Stuart Hall: Critical Dialogues in Cultural Studies*. Edited by David Morley and Kuan-Hsing Chen, 441–49. London and New York: Routledge, 1996.

Hall, Stuart, Chas Critcher, Tony Jefferson, John Clarke, and Brian Roberts. *Policing the Crisis: Mugging, the State, and Law and Order*. London: Macmillan, 1978.

Halpern, Orit. *Beautiful Data: A History of Vision and Reason since 1945*. Durham, NC: Duke University Press, 2015.

Hames-Garcia, Michael. *Fugitive Thought: Prison Movements, Race, and the Meaning of Justice.* Minneapolis: University of Minnesota Press, 2004.

Han, Sora Y. *Letters of the Law: Race and the Fantasy of Colorblindness in American Law.* Stanford, CA: Stanford University Press, 2015.

Hanhardt, Christina B. *Safe Space: Gay Neighborhood History and the Politics of Violence.* Durham, NC: Duke University Press, 2013.

Hardt, Michael, and Antonio Negri. *Empire.* Cambridge, MA: Harvard University Press, 2001.

Haritaworn, Jin. *Queer Lovers and Hateful Others: Regenerating Violent Times and Places.* Chicago: University of Chicago Press, 2015.

Haritaworn, Jin, Adi Kuntsman, and Silvia Posocco, eds. *Queer Necropolitics.* New York: Routledge, 2014.

Harlow, Barbara. *Resistance Literature.* New York: Routledge, 1987.

Harney, Stefano, and Fred Moten. *The Undercommons: Fugitive Planning and Black Study.* Brooklyn, NY: Minor Compositions (Autonomedia), 2013.

Harper, Phillip Brian. *Abstractionist Aesthetics: Artistic Form and Social Critique in African American Culture.* New York: New York University Press, 2016.

Harper, Phillip Brian, Anne McClintock, José Esteban Muñoz, and Trish Rosen, eds. Special issue, "Queer Transexions of Race, Nation, and Gender." *Social Text*, nos. 52–53 (December 1997).

Hartman, Saidiya. "The Anarchy of Colored Girls Assembled in a Riotous Manner." *South Atlantic Quarterly* 117, no. 3 (2018): 465–90.

Hartman, Saidiya. *Lose Your Mother: A Journey Across the Atlantic Slave Route.* New York: Farrar, Straus and Giroux, 2008.

Hartman, Saidiya. *Scenes of Subjection: Terror, Slavery, and Self-Making in Nineteenth-Century America.* New York: Oxford University Press, 1997.

Harvey, David. *A Brief History of Neoliberalism.* New York: Oxford University Press, 2005.

Harvey, David. *The Condition of Postmodernity: An Inquiry into the Origins of Cultural Change.* Malden, MA: Blackwell, 1990.

Hastings, Michael. "The Rise of the Killer Drones: How America Goes to War in Secret." *Rolling Stone Magazine*, April 16, 2012.

Hernández, David Manuel. "Undue Process: Immigrant Detention and Lesser Citizenship." Unpublished manuscript.

Hernández, Kelly Lytle. *City of Inmates: Conquest, Rebellion, and the Rise of Human Caging in Los Angeles, 1771–1965.* Chapel Hill: University of North Carolina Press, 2017.

Hernández, Kelly Lytle. *Migra!: A History of the US Border Patrol.* Berkeley, CA: University of California Press, 2010.

Hersh, Seymour M. *Chain of Command: The Road from 9/11 to Abu Ghraib.* New York: Harper Collins, 2004.

Hersh, Seymour M. *The Killing of Osama Bin Laden.* New York: Verso, 2017.

Hersh, Seymour M. "Up in the Air: Where is the Iraq War Headed Next?" *New*

Yorker, December 5, 2005. Accessed July 24, 2017. http://www.newyorker.com/archive/2005/12/05/051205fa_fact?currentPage=all/.

Hesford, Wendy. *Spectacular Rhetorics: Human Rights Visions, Recognitions, Feminisms*. Durham, NC: Duke University Press, 2011.

Hevia, James. *The Imperial Security State: British Colonial Knowledge and Empire-Building in Asia*. New York: Cambridge University Press, 2012.

Hinton, Elizabeth Kai. *From the War on Poverty to the War on Crime: The Making of Mass Incarceration in America*. Cambridge, MA: Harvard University Press, 2016.

Hirsh, Michael. "American Ally, American Adversary: Our Worsening Pakistan Problem." *The Atlantic*. May 30, 2012. Accessed July 13, 2012. https://www.theatlantic.com/international/archive/2012/05/american-ally-american-adversary-our-worsening-pakistan-problem/257844/.

Ho, Engseng. "Empire through Diasporic Eyes: The View from the Other Boat." *Society for Comparative Study of Society and History* 46, no. 2 (2004): 210–46.

Ho, Tamara. *Romancing and Human Rights: Gender, Intimacy, and Power between Burma and the West*. Honolulu: University of Hawaiʻi Press, 2015.

Hochberg, Gil Z. *Visual Occupations: Violence and Visibility in a Conflict Zone*. Durham, NC: Duke University Press, 2015.

Hochberg, Gil Z., ed. "Queer Politics and the Question of Palestine/Israel." Special issue, *GLQ: A Journal of Lesbian and Gay Studies* 16, no. 4 (2010).

Hogan, Michael J. *A Cross of Iron: Harry S. Truman and the Origins of the National Security State, 1945–1954*. Cambridge, UK: Cambridge University Press, 2000.

Hoganson, Kristin. *Fighting for American Manhood: How Gender Politics Provoked the Spanish-American and Philippine-American Wars*. New Haven, CT: Yale University Press, 2000.

Holland, Sharon Patricia. *The Erotic Life of Racism*. Durham, NC: Duke University Press, 2012.

Holland, Sharon Patricia. *Raising the Dead: Readings of Death and (Black) Subjectivity*. Durham, NC: Duke University Press, 2000.

Holland, Sharon Patricia, Marcia Ochoa, and Kyla Wazana Tompkins, eds. "On the Visceral." *GLQ: A Journal of Lesbian and Gay Studies* 20, no. 4 (2014): 391–406.

Hong, Grace Kyungwon. *Death beyond Disavowal: The Impossible Politics of Difference*. Minneapolis: University of Minnesota Press, 2015.

Hong, Grace Kyungwon. "The Ghosts of Transnational American Studies: A Response to the Presidential Address." *American Quarterly* 59, no. 1 (March 2007): 33–39.

Hong, Grace Kyungwon. "Neoliberalism." *Critical Ethnic Studies* 1, no. 1 (Spring 2015): 56–67.

Hong, Grace Kyungwon. *Ruptures of American Capital: Women of Color Feminism and the Culture of Immigrant Labor*. Minneapolis: University of Minnesota Press, 2006.

Hong, Grace Kyungwon, and Roderick A. Ferguson, eds. *Strange Affinities: The Gender and Sexual Politics of Comparative Racialization*. Durham, NC: Duke University Press, 2011.

Hoogslag, Nanette. "Interview with Mariam Ghani." Visual Correspondents,

October 24, 2009. Accessed May 11, 2012. http://www.mariamghani.com/docs
/Trespassers_FAQv4+Transcripts.pdf.

Hopkins, Valerie. "'I Can Get My Soul Out of Prison': The Art Made by Guantánamo
Detainees." *Guardian*, October 2, 2017.

HoSang, Daniel. *Racial Propositions: Ballot Initiatives and the Making of Postwar
California*. Berkeley: University of California Press, 2010.

HoSang, Daniel, Oneka LaBennett, and Laura Pulido, eds. *Racial Formation in the
Twenty-First Century*. Berkeley: University of California Press, 2012.

Horne, Gerald. *Cold War in a Hot Zone: The United States Confronts Labor and
Independence Struggles in the British West Indies*. Philadelphia: Temple University
Press, 2007.

Horton-Stallings, LaMonda. *Funk the Erotic: Transaesthetics and Black Sexual Cul-
tures*. Champaign: University of Illinois Press, 2015.

Howell, Sally, and Andrew Shyrock. "Cracking Down on Diaspora: Arab Detroit and
America's 'War on Terror.'" *Anthropological Quarterly* 76, no. 3 (2003): 443–62.

Husain, Sarah, ed. *Voices of Resistance: Muslim Women on War, Faith, and Sexuality*.
New York: Seal Press, 2006.

Hussain, Nasser. "Counterinsurgency's Comeback: Can a Colonialist Strategy Be
Reinvented?" *Boston Review* (Jan/Feb 2010). Accessed June 10, 2011. http://
bostonreview.net/BR35.1/hussain.php/.

Hussain, Nasser. *The Jurisprudence of Emergency: Colonialism and the Rule of Law*.
Ann Arbor: University of Michigan Press, 2003.

Imada, Adria. *Aloha America: Hula Circuits through the U.S. Empire*. Durham, NC:
Duke University Press, 2012.

Imarisha, Walidah. "Rewriting the Future: Using Science Fiction to Re-Envision
Justice." *Bitch Media*, February 11, 2015. Accessed June 15, 2017. https://www.bitch
media.org/article/rewriting-the-future-prison-abolition-science-fiction/.

Ioanide, Paula. *The Emotional Politics of Racism: How Feelings Trump Facts in the
Era of Colorblindness*. Stanford, CA: Stanford University Press, 2015.

Isaac, Allan Punzalan. *American Tropics: Articulating Filipino America*. Minneapo-
lis: University of Minnesota Press, 2006.

Iyer, Deepa. *We Too Sing America: South Asian, Arab, Muslim, and Sikh Immigrants
Shape Our Multiracial Future*. New York: New Press, 2017.

Jackson, Zakiyyah Iman. "Animal: New Directions in the Theorization of Race and
Posthumanism." *Feminist Studies* 39, no. 3 (2013): 669–85.

Jafri, Beenash. "Ongoing Colonial Violence in Settler States." *Lateral: Journal of the
Cultural Studies Association* 6, no. 1 (Spring 2017). http://csalateral.org/issue/6–1
/forum-alt-humanities-settler-colonialism-ongoing-violence-jafri/.

Jamal, Amaney A., and Nadine C. Naber, eds. *Race and Arab Americans before and
after 9/11: From Invisible Citizens to Visible Subjects*. Syracuse, NY: Syracuse Uni-
versity Press, 2008.

James, C. L. R. *State Capitalism and World Revolution*. Written in collaboration
with Raya Dunayevskaya & Grace Lee. Chicago: Charles H. Kerr Publishing, 1986
[1950].

James, Joy, ed. *Imprisoned Intellectuals: America's Political Prisoners Write on Life, Liberation, and Rebellion*. New York: Rowman and Littlefield, 2003.

James, Joy, ed. *Warfare in the American Homeland*. Durham, NC: Duke University Press, 2007.

Jameson, Fredric. *Archaeologies of the Future: The Desire Called Utopia and Other Science Fictions*. New York: Verso, 2005.

Jarmakani, Amira. *An Imperialist Love Story: Desert Romances and the War on Terror*. New York: New York University Press, 2015.

Jelly-Schapiro, Eli. *Security and Terror: American Culture and the Long History of Colonial Modernity*. Berkeley: University of California Press, 2018.

Jewish Voice for Peace. *Stifling Dissent: How Israel's Defenders Use False Charges of Anti-Semitism to Limit the Debate over Israel On Campus*. Executive report, Fall 2015. Accessed August 1, 2017. https://jewishvoiceforpeace.org/stifling-dissent/.

Johnson, Chalmers. *The Sorrows of Empire: Militarism, Secrecy, and the End of the Republic*. New York: Metropolitan Books, 2004.

Johnson, Gaye Theresa, and Alex Lubin, eds. *Futures of Black Radicalism*. New York: Verso, 2017.

Johnson, Sylvester A., and Steven Weitzman. *The FBI and Religion: Faith and National Security before and after 9/11*. Berkeley: University of California Press, 2017.

Johnson, Walter. *River of Dark Dreams: Slavery and Empire in the Cotton Kingdom*. Cambridge, MA: Harvard University Press, 2013.

Jones, Kevin. "Science Faction, Larissa Sansour." *ArtAsiaPacific* 86 (Nov/Dec 2013). Accessed June 20, 2017. http://artasiapacific.com/Magazine/86/LarissaSansour/.

Jung, Moon-Ho. *Coolies and Cane: Race, Labor, and Sugar in the Age of Emancipation*. Baltimore: Johns Hopkins University Press, 2006.

Kadi, Joanna, ed. *Food for Our Grandmothers: Writings by Arab-American and Arab-Canadian Feminists*. Boston: South End Press, 1994.

Kahlon, Rajkamal. *Aesthetic Justice Seminar*, Lambert Foundation, New York City, 2011.

Kahlon, Rajkamal. "Did You Kiss the Dead Body?: Visualizing Absence in the Archive of War." *World Policy Blog*, November 9, 2012. Accessed February 19, 2016. http://www.worldpolicy.org/blog/2012/11/09/did-you-kiss-dead-body-visualizing-absence-archive-war/.

Kahlon, Rajkamal. "A Time for Breaking Laws: The Injustice of NSA Surveillance." *Creative Time Reports*, July 15, 2013. Accessed July 17, 2017. http://creativetimereports.org/2013/07/15/a-time-for-breaking-laws-the-injustice-of-nsa-surveillance/.

Kamat, Anjali. "Interview with Iraqi Artist Wafaa Bilal." *Arab Studies Journal* 18, no. 1 (Spring 2010): 316–29.

Kamat, Anjali. "Punishment and Profits: Immigrant Detention | Fault Lines." *Al Jazeera English*, YouTube, April 10, 2012. Accessed July 24, 2017. https://www.youtube.com/watch?v=mAKL3Rl_Ihc&feature=sh_e_se&list=SL/.

Kanaaneh, Rhoda Ann. *Birthing the Nation: Strategies of Palestinian Women in Israel*. Berkeley: University of California Press, 2002.

Kanaaneh, Rhoda Ann. *Surrounded: Palestinian Soldiers in the Israeli Military*. Stanford, CA: Stanford University Press, 2008.

Kandaswamy, Priya. "Stop Urban Shield, Stop Violence against Our Communities," *SAMAR*, "Identity and the State," no. 44 (September 25, 2014). Accessed July 24, 2017. http://samarmagazine.org/archive/articles/462/.

Kanstroom, Dan. *Deportation Nation: Outsiders in American History*. Cambridge, MA: Harvard University Press, 2007.

Kapadia, Ronak K., Prerana Reddy, Naeem Mohaiemen, Vivek Bald, Aimara Lin, Uzma Z. Rizvi, and Aziz Huq. "Artist Collectives in Post-2001 New York: A Conversation with Visible Collective." *Asian American Literary Review* 2, no. 1.5 (Fall 2011): 294–318.

Kaplan, Amy. *The Anarchy of Empire in the Making of US Culture*. Cambridge, MA: Harvard University Press, 2002.

Kaplan, Amy. "Homeland Insecurities: Some Reflections on Language and Space." *Radical History Review* 85 (2003): 82–93.

Kaplan, Amy. "Where Is Guantánamo?" *American Quarterly* 57, no. 3 (September 2005): 831–58.

Kaplan, Amy, and Donald Pease, eds. *Cultures of United States Imperialism*. Durham, NC: Duke University Press, 1993.

Kaplan, Caren. *Aerial Aftermaths: Wartime from Above*. Durham, NC: Duke University Press, 2018.

Kaplan, Caren. "Dead Reckoning: Aerial Perception and the Social Construction of Targets." *Vectors* 2, no. 2 (January 2007). Accessed June 15, 2011. http://www.vectorsjournal.org/index.php?page=7&projectId=11/.

Kaplan, Caren. "Mobility and War: The Cosmic View of US 'Air Power.'" *Environment and Planning A*, no. 38 (February/March 2006): 395–407.

Kaplan, Caren. "Viewing the Aerial Images of bin Laden's Compound." *Mind's Eye* blog, May 7, 2011. Accessed June 11, 2011. http://aerialvisualculture.blogspot.com/2011/05/viewing-aerial-images-of-bin-ladens.html/.

Karuka, Manu. *Empire's Tracks: Plains Indians, Chinese Migrants, and the Transcontinental Railroad*. Berkeley: University of California Press, 2019.

Kassem, Ramzi. "The Long Roots of the NYPD Spying Program." *Nation*, June 13, 2012. Accessed June 17, 2012. http://www.thenation.com/article/168376/long-roots-nypd-spying-program/.

Kassem, Ramzi. "The Militarisation of 'War on Terror' in the US." *Al Jazeera*, December 22, 2011. Accessed December 23, 2011. http://www.aljazeera.com/indepth/opinion/2011/12/20111220103624967465.html/.

Kauanui, J. Kēhaulani. "'A Structure, Not an Event': Settler Colonialism and Enduring Indigeneity." *Lateral: Journal of the Cultural Studies Association* 5, no. 1 (2016). http://csalateral.org/issue/5-1/forum-alt-humanities-settler-colonialism-enduring-indigeneity-kauanui/.

Keeling, Kara. *The Witch's Flight: The Cinematic, the Black Femme, and the Image of Common Sense*. Durham, NC: Duke University Press, 2007.

Kelly, Jennifer Lynn. "Asymmetrical Itineraries: Militarism, Tourism, and Solidarity in Occupied Palestine." *American Quarterly* 68, no. 3 (September 2016): 723–45.

Kelly, Jennifer Lynn. "Locating Palestine within American Studies: Transitory Field

Sites and Borrowed Methods." In *Theorizing Fieldwork in the Humanities: Methods, Reflections, and Approaches to the Global South*. Edited by Shalini Puri and Debra Castillo, 97–110. New York: Palgrave Macmillan, 2016.

Kelly, John D., Beatrice Jauregui, Sean T. Mitchell, and Jeremy Walton, eds. *Anthropology and Global Counterinsurgency*. Chicago: University of Chicago Press, 2010.

Kelley, Robin D. G. "After Trump." *Boston Review*, November 15, 2016. http://bostonreview.net/forum/after-trump/robin-d-g-kelley-trump-says-go-back-we-say-fight-back/.

Kelley, Robin D. G. *Freedom Dreams: The Black Radical Imagination*. Boston: Beacon, 2002.

Kelley, Robin D. G. *Hammer and Hoe: Alabama Communists during the Great Depression*. Chapel Hill: University of North Carolina Press, 1990.

Kelley, Robin D. G. "Thug Nation: On State Violence and Disposability." In *Policing the Planet: Why the Policing Crisis Led to Black Lives Matter*. Edited by Jordan T. Camp and Christina Heatherton, 15–34. New York: Verso, 2016.

Kendi, Ibram X. *Stamped from the Beginning: The Definitive History of Racist Ideas in America*. New York: Nation Books, 2016.

Khalidi, Rashid. "And Now What? The Trump Administration and the Question of Palestine." *Journal of Palestine Studies* 47, no. 3 (Spring 2018): 93–102.

Khalidi, Rashid. *Brokers of Deceit: How the U.S. Has Undermined Peace in the Middle East*. New York: Beacon Press, 2013.

Khalidi, Rashid. "Introduction: Historical Landmarks in the Hundred Years' War on Palestine." *Journal of Palestine Studies* 185 47, no. 1 (Autumn 2017): 6–17.

Khalidi, Rashid. *The Iron Cage: The Story of the Palestinian Struggle for Statehood*. Boston: Beacon, 2006.

Khalidi, Rashid. "Israel: A Carceral State." *Journal of Palestine Studies* 43, no. 4 (Summer 2014): 5–10.

Khalidi, Rashid. *Sowing Crisis: The Cold War and American Dominance in the Middle East*. Boston: Beacon Press, 2009.

Khalidi, Rashid. "The United States and the Palestinians, 1977–2012: Three Key Moments." *Journal of Palestine Studies* 42, no. 4 (Summer 2013): 61–72.

Khalidi, Walid. *All That Remains: The Palestinian Villages Occupied and Depopulated by Israel in 1948*. Washington, DC: Institute for Palestine Studies, 2006.

Khalil, Nadine. "Surreal State." *Bespoke Magazine* (April/May 2012). Accessed August 3, 2017. http://www.bespoke-magazine.com/70/Article/Surreal-State/.

Khalil, Osamah F. *America's Dream Palace: Middle East Expertise and the Rise of the National Security State*. Cambridge, MA: Harvard University Press, 2016.

Khalili, Laleh. "The Location of Palestine in Global Counterinsurgencies." *International Journal of Middle East Studies* 42, no. 3 (August 2010): 413–33.

Khalili, Laleh. *Time in the Shadows: Confinement in Counterinsurgencies*. Stanford, CA: Stanford University Press, 2012.

Khan, Azmat, and Anand Gopal. "The Uncounted." *New York Times*, November 16, 2017.

Khong, En Liang. "Mahwish Chishty, Imperial War Museum, London–Review."

Financial Times, November 2, 2016. https://www.ft.com/content/891af6ac-a0e9
-11e6-891e-abe238dee8e2/.

Kilgore, De Witt Douglas. *Astrofuturism: Science, Race, and Visions of Utopia in Space*. Philadelphia: University of Pennsylvania Press, 2003.

Kim, Jodi. *Ends of Empire: Asian American Critique and the Cold War*. Minneapolis: University of Minnesota Press, 2010.

Kim, Ju Yon. *The Racial Mundane: Asian American Performance and the Embodied Everyday*. New York: New York University Press, 2015.

Kim, Monica. *The Interrogation Rooms of the Korean War: The Untold History*. Princeton, NJ: Princeton University Press, 2019.

King, Tiffany Lethabo. *The Black Shoals: Abolition, Decolonization, and Conquest*. Durham, NC: Duke University Press, 2019.

King, Tiffany Lethabo. "New World Grammars: The 'Unthought' Black Discourses of Conquest." *Theory and Event* 19, no. 4 (2016).

Klein, Christina. *Cold War Orientalism: Asia in the Middlebrow Imagination, 1945–1961*. Berkeley: University of California Press, 2003.

Koeppel, Barbara. "Irradiated Iraq: The Nuclear Nightmare We Left Behind." *Washington Spectator*, March 30, 2016. Accessed June 6, 2018. https://washington spectator.org/irradiated-iraq-nuclear-nightmare/.

Kondo, Dorinne. *Worldmaking: Race, Performance, and the Work of Creativity*. Durham, NC: Duke University Press, 2018.

Kotef, Hagar. *Movement and the Ordering of Freedom: On Liberal Governances of Mobility*. Durham, NC: Duke University Press, 2015.

Kouri-Towe, Natalie. "Textured Activism: Affect Theory and Transformational Politics in Transnational Queer Palestine-Solidarity Activism." *Atlantis* 37, no. 1 (2015): 23–34.

Kozol, Wendy. *Distant Wars Visible: The Ambivalence of Witnessing*. Minneapolis: University of Minnesota Press, 2014.

Kramer, Paul. *The Blood of Government: Race, Empire, the United States, and the Philippines*. Chapel Hill: University of North Carolina Press, 2006.

Kumar, Deepa. *Islamophobia and the Politics of Empire*. Chicago: Haymarket Books, 2012.

Kumar, Deepa. "National Security Culture: Gender, Race, and Class in the Production of Imperial Citizenship." *International Journal of Communication* 11 (2017): 2154–77.

Kundnani, Arun. *The Muslims Are Coming! Islamophobia, Extremism, and the Domestic War on Terror*. London: Verso, 2015.

Kundnani, Arun, and Deepa Kumar. "Race, Surveillance, and Empire." *International Socialist Review* 96 (Spring 2015). Accessed Janury 4, 2019. https://isreview.org /issue/96/race-surveillance-and-empire/.

Kunzel, Regina. *Criminal Intimacy: Prison and the Uneven History of Modern American Sexuality*. Chicago: University of Chicago Press, 2008.

Lambert, Léopold. *Weaponized Architecture. The Impossibility of Innocence*. New York: Dpr-Barcelona, 2012.

Lander, Mark. "After Struggle on Detainees, Obama Signs Defense Bill." *New York Times*, December 31, 2011. Accessed December 31, 2011. http://www.nytimes.com /2012/01/01/us/politics/obama-signs-military-spending-bill.html?_r=1&hp/.

Laurent, Olivier. "Musée de l'Elysée Relaunches Major Photography Award Following 2011 Lacoste Controversy." *British Journal of Photography*, February 3, 2014. Accessed August 4, 2017. http://www.bjp-online.com/2014/02/musee-de-lelysee -relaunches-major-award-following-lacoste-controversy/.

Le Guin, Ursula K. *The Dispossessed: An Ambiguous Utopia*. New York: Harper and Row, 1974.

Lee, Rachel. *The Exquisite Corpse of Asian America: Biopolitics, Biosociality, and Posthuman Ecologies*. New York: New York University Press, 2014.

Leigh, Simone, Chitra Ganesh, and Uri McMillan. "Alternative Structures: Aesthetics, Imagination, and Radical Reciprocity: An Interview with Girl." *ASAP/Journal* 2, no. 2 (May 2017): 241–52.

Lenin, Vladimir. *Imperialism: The Highest Stage of Capitalism*. London: Penguin Classics, 2010.

Leroy, Justin. "Black History in Occupied Territory: On the Entanglements of Slavery and Settler Colonialism." *Theory and Event* 19, no. 4 (2016).

LeVine, Mark. "Why Palestinians Have a Right to Return Home." *Al Jazeera*, September 23, 2011. http://www.aljazeera.com/indepth/opinion/2011/09 /201192213554o203743.html/.

Levitz, Eric. "43 Senators Want to Make It a Federal Crime to Boycott Israeli Settlements." *New York Magazine*, July 19, 2017. Accessed August 3, 2017. http://nymag .com/daily/intelligencer/2017/07/senate-bill-would-make-it-a-federal-crime-to -boycott-israel.html/.

Lewis, Reina. *Muslim Fashion: Contemporary Style Cultures*. Durham, NC: Duke University Press, 2015.

Li, Darryl. "The Gaza Strip as Laboratory: Notes in the Wake of Disengagement." *Journal of Palestine Studies* 35, no. 2 (2006): 38–55.

Li, Darryl. "Hunting the 'Out-of-Place Muslim.'" *SAMAR*, May 31, 2011. Accessed June 17, 2011. http://samarmagazine.org/archive/articles/355/.

Lim, Eng-Beng. *Brown Boys and Rice Queens: Spellbinding Performance in the Asias*. New York: New York University Press, 2013.

Lindqvist, Sven. *A History of Bombing*. Translated by Linda Haverty Rugg. New York: The New Press, 2003.

Lloyd, David. "It Is Our Belief That Palestine Is a Feminist Issue." *Feminists@law* 4, no. 1 (2014): 1–19.

Lloyd, David. *Under Representation: The Racial Regime of Aesthetics*. New York: Fordham University Press, 2018.

Lockman, Zachary. *Contending Visions of the Middle East: The History and Politics of Orientalism*. London: Cambridge University Press, 2004.

Lothian, Alexis. *Old Futures: Speculative Fiction and Queer Possibility*. New York: New York University Press, 2018.

Lothian, Alexis, and Jayna Brown, eds. Special issue, "Speculative Life." *Social Text*

Online. January 4, 2012. Accessed July 11, 2017. https://socialtextjournal.org
/periscope_topic/speculative_life/.

Love, Erik. *Islamophobia and Racism in America.* New York: New York University
Press, 2017.

Love, Heather. *Feeling Backward: Loss and the Politics of Queer History.* Cambridge,
MA: Harvard University Press, 2007.

Lowe, Lisa. *Immigrant Acts: On Asian American Cultural Politics.* Durham, NC:
Duke University Press, 1996.

Lowe, Lisa. *The Intimacies of Four Continents.* Durham, NC: Duke University Press,
2015.

Lowe, Lisa, and David Lloyd, eds. *The Politics of Culture in the Shadow of Capital.*
Durham, NC: Duke University Press, 1997.

Loyd, Jenna M., and Alison Mountz. *Boats, Borders, and Bases: Race, the Cold War,
and the Rise of Migrant Detention in the United States.* Berkeley: University of
California Press, 2018.

Loyd, Jenna M., Matthew Mitchelson, and Andrew Burridge, eds. *Beyond Walls and
Cages: Prisons, Borders, and Global Crisis.* Atlanta: University of Georgia Press, 2012.

Lubin, Alex. "American Studies, the Middle East, and the Question of Palestine."
American Quarterly Vol. 68, no. 1 (March 2016): 1–21.

Lubin, Alex. "The Disappearing Frontiers of US Homeland Security: Mapping
the Transit of Security across the US and Israel." *Jadaliyya*, February 26, 2013.
Accessed July 10, 2017. http://www.jadaliyya.com/pages/index/10365/the
-disappearing-frontiers-of-us-homeland-security/.

Lubin, Alex. *Geographies of Liberation: The Making of an Afro-Arab Political Imagi-
nary.* Chapel Hill: University of North Carolina Press, 2014.

Lubin, Alex, and Marwan M. Kraidy, eds. *American Studies Encounters the Middle
East.* Chapel Hill: University of North Carolina Press, 2016.

Luciano, Dana, and Mel Y. Chen, eds. "Queer Inhumanisms." Special issue, GLQ:
A Journal of Lesbian and Gay Studies 21, nos. 2–3 (2015).

Luibhéid, Eithne. *Entry Denied: Controlling Sexuality at the Border.* Minneapolis:
University of Minnesota Press, 2002.

Luibhéid, Eithne. "Heteronormativity and Immigration Scholarship: A Call for
Change." GLQ: *A Journal of Lesbian and Gay Studies* 10, no. 2 (2004): 227–35.

Luibhéid, Eithne, ed. "Queer/Migration: An Unruly Body of Scholarship." GLQ: *A
Journal of Gay and Lesbian Studies* 14, nos. 2–3 (2008): 169–90.

Luk, Sharon. *The Life of Paper: Letters and a Poetics of Living beyond Captivity.*
Berkeley: University of California Press, 2017.

Lye, Colleen. *America's Asia: Racial Form and American Literature, 1893–1945.*
Princeton, NJ: Princeton University Press, 2005.

Lyon, David. *The Electronic Eye: The Rise of Surveillance Society.* Minneapolis: Uni-
versity of Minnesota Press, 1994.

Lyon, David. *Surveillance Society: Monitoring Everyday Life.* Maidenhead, Berkshire,
UK: Open University Press, 2001.

Machida, Margo. *Unsettled Visions: Contemporary Asian American Artists and the Social Imaginary.* Durham, NC: Duke University Press, 2009.

Macías-Rojas, Patrisia. *From Deportation to Prison: The Politics of Immigration Enforcement in Post-Civil Rights America.* New York: New York University Press, 2016.

Mack, Mehammed Amadeus. *Sexagon: Muslims, France, and the Sexualization of National Culture.* New York: Fordham University Press, 2017.

Magnet, Shoshana. *When Biometrics Fail: Gender, Race, and the Technology of Identity.* Durham, NC: Duke University Press, 2011.

Mahmood, Saba. "Feminism, Democracy, and Empire: Islam and the War on Terror." In *Women's Studies On the Edge.* Edited by Joan Wallach Scott, 193–215. Durham, NC: Duke University Press, 2008.

Mahmood, Saba. *Politics of Piety: The Islamic Revival and the Feminist Subject.* Princeton, NJ: Princeton University Press, 2011.

Maira, Sunaina. *Boycott! The Academy and Justice for Palestine.* Berkeley: University of California Press, 2018.

Maira, Sunaina. *Desis in the House: Indian American Youth Culture in New York City.* Philadelphia: Temple University Press, 2002.

Maira, Sunaina Marr. *Jil Oslo: Palestinian Hip Hop, Youth Culture, and the Youth Movement.* Washington, DC: Tadween, 2013.

Maira, Sunaina Marr. *Missing: Youth, Citizenship, and Empire after 9/11.* Durham, NC: Duke University Press, 2009.

Maira, Sunaina Marr. *The 9/11 Generation: Youth, Rights, and Solidarity in the War on Terror.* New York: New York University Press, 2016.

Maira, Sunaina Marr, and Magid Shihade. "Meeting Asian/Arab American Studies: Thinking Race, Empire, and Zionism in the U.S." *Journal of Asian American Studies* 9, no. 2 (June 2006): 117–40.

Maira, Sunaina, and Neferti X. M. Tadiar, eds. "The Academic Boycott Movement." *Social Text Periscope*, November 15, 2016. Accessed July 10, 2017. https://socialtext journal.org/periscope_topic/the-academic-boycott-movement/.

Makdisi, Karim, and Vijay Prashad, eds. *Land of Blue Helmets: The United Nations and the Arab World.* Berkeley: University of California Press, 2016.

Mamdani, Mahmood. *Good Muslim, Bad Muslim: America, the Cold War, and the Roots of Terror.* New York: Pantheon, 2004.

Mamdani, Mahmood. *When Victims Become Killers: Colonialism, Nativism, and the Genocide in Rwanda.* Princeton, NJ: Princeton University Press, 2002.

Mameni, Sara. "Dermopolitics: Erotics of the Muslim Body in Pain." *Women and Performance: A Journal of Feminist Theory* 27, no. 1 (2017): 96–103.

Manalansan, Martin F., IV. *Global Divas: Filipino Gay Men in the Diaspora.* Durham, NC: Duke University Press, 2003.

Manalansan, Martin F., IV. "Race, Violence, and Neoliberal Spatial Politics in the Global City." *Social Text* 84–85 23, nos. 3–4 (Fall 2005): 141–55.

Manalansan, Martin F., IV. "The 'Stuff' of Archives: Mess, Migration, and Queer Lives." *Radical History Review* 120 (Fall 2014): 94–107.

Man, Simeon. *Soldiering through Empire: Race and the Making of the Decolonizing Pacific*. Berkeley: University of California Press, 2018.

Mani, Bakirathi. *Aspiring to Home: South Asians in America*. Stanford, CA: Stanford University Press, 2012.

Mani, Bakirathi. *Haunting Visions: South Asian Diasporic Visual and Exhibition Cultures*. Durham, NC: Duke University Press, forthcoming.

Marable, Manning, and Hishaam Aidi, eds. *Black Routes to Global Islam*. New York: Palgrave Macmillan, 2009.

Marcetic, Branko. "Dark Money at the Pentagon." *Jacobin Magazine*, January 24, 2018. https://jacobinmag.com/2018/01/pentagon-budget-government-spending -military/.

Marez, Curtis. *Farm Worker Futurism: Speculative Technologies of Resistance*. Minneapolis: University of Minnesota Press, 2016.

Marks, Laura U. *Enfoldment and Infinity: An Islamic Genealogy of New Media Art*. Cambridge, MA: MIT Press, 2010.

Marks, Laura U. *The Skin of the Film: Intercultural Cinema, Embodiment, and the Senses*. Durham, NC: Duke University Press, 2000.

Márquez, John D. "Juan Crow: Progressive Mutations of the Black-White Binary." In *Critical Ethnic Studies: A Reader*. Edited by Critical Ethnic Studies Editorial Collective, 43–62. Durham, NC: Duke University Press, 2016.

Martin, Randy. *An Empire of Indifference: American War and the Financial Logic of Risk*. Durham, NC: Duke University Press, 2007.

Matar, Dina, and Helga Tawil-Souri, eds. *Gaza as Metaphor*. London: Hurst, 2016.

Masco, Joseph. "'Sensitive but Unclassified': Secrecy and the Counterterrorist State." *Public Culture* 22, no. 3 (2010): 433–63.

Masco, Joseph. *The Theater of Operations: National Security Affect from the Cold War to the War on Terror*. Durham, NC: Duke University Press, 2014.

Massad, Joseph A. "Recognizing Palestine, BDS and the Survival of Israel." *Electronic Intifada*, December 16, 2014. Accessed July 17, 2017. https://electronicintifada.net /content/recognizing-palestine-bds-and-survival-israel/14123/.

Massumi, Brian. *Parables for the Virtual: Movement, Affect, Sensation*. Durham, NC: Duke University Press, 2002.

Mathew, Biju. *Taxi!: Cabs and Capitalism in New York City*. Ithaca, NY: ILR Press, 2008.

Mayer, Jane. "The Predator War: What Are the Risks of the C.I.A.'s Covert Drone Program?" *New Yorker*, October 26, 2009.

Mbembe, Achille. "Necropolitics." *Public Culture* 15, no. 1 (2003): 11–40.

McAlister, Melani. *Epic Encounters: Culture, Media, and US Interests in the Middle East Since 1945*. Berkeley: University of California Press, 2001.

McClintock, Anne. *Imperial Leather: Race, Gender, and Sexuality in the Colonial Conquest*. New York: Routledge, 1995.

McClintock, Anne. "Paranoid Empire: Specters from Guantánamo and Abu Ghraib." *Small Axe* 13, no. 1 (2009): 50–74.

McCloud, Aminah Beverly. *African American Islam*. New York: Routledge, 1995.

McCoy, Alfred W. "Beyond Bayonets and Battleships: Space Warfare and the Future of US Global Power," *TomDispatch.com*, November 8, 2012. Accessed June 27, 2017. http://www.tomdispatch.com/blog/175614/tomgram%3A_alfred_mccoy,_super_weapons_and_global_dominion/.

McCoy, Alfred W. "The Demolition of US Global Power: Donald Trump's Road to Debacle in the Greater Middle East." *TomDispatch.com*, July 16, 2017. Accessed July 24, 2017. http://www.tomdispatch.com/blog/176308/tomgram%3A_alfred_mccoy%2C_trumping_the_empire/.

McCoy, Alfred W. *In the Shadows of the American Century: The Rise and Fall of US Global Power.* Chicago: Haymarket Books, 2017.

McCoy, Alfred W. *Policing America's Empire: The United States, the Philippines, and the Rise of the Surveillance State.* Madison: University of Wisconsin Press, 2009.

McCoy, Alfred W. *A Question of Torture: CIA Interrogation from the Cold War to the War on Terror.* New York: Metropolitan, 2006.

McFate, Montgomery, and Andrea Jackson. "An Organizational Solution to DOD's Cultural Knowledge Needs." *Military Review* (July–Aug 2005): 18–21.

McKelvey, Tara. "Inside the Killing Machine." *Newsweek*, February 13, 2011.

McKelvey, Tara. *Monstering: Inside America's Policy of Secret Interrogations and Torture in the Terror War.* New York: Carroll and Grab, 2007.

McKittrick, Katherine. *Demonic Grounds: Black Women and the Cartographies of Struggle.* Minneapolis: University of Minnesota Press, 2006.

McKittrick, Katherine. "Mathematics Black Life." *Black Scholar* 44, no. 2 (2014): 16–28.

McKittrick, Katherine, ed. *Sylvia Wynter: On Being Human as Praxis.* Durham, NC: Duke University Press, 2015.

McMillan, Uri. *Embodied Avatars: Genealogies of Black Feminist Art and Performance.* New York: New York University Press, 2016.

McMillan, Uri. "Introduction: Skin, Surface, Sensorium." *Women and Performance: A Journal of Feminist Theory* 28, no. 1 (Feb 2018): 1–15.

McSorley, Kevin, ed. *War and the Body: Militarisation, Practice and Experience.* London: Routledge, 2012.

Meari, Lena. "*Sumud*: A Palestinian Philosophy of Confrontation in Colonial Prisons." *South Atlantic Quarterly* 133, no. 3 (Summer 2014): 547–78.

Medovoi, Leerom. "Dogma-Line Racism: Islamophobia and the Second Axis of Race." *Social Text* 30, no. 2 (2012): 43–74.

Medovoi, Leerom. "Global Society Must Be Defended: Biopolitics Without Boundaries." *Social Text* 91 25, no. 22 (Summer 2007): 53–79.

Meiners, Erica R. *For the Children? Protecting Innocence in a Carceral State.* Minneapolis: University of Minnesota Press, 2016.

Melamed, Jodi. *Represent and Destroy: Rationalizing Violence in the New Racial Capitalism.* Minneapolis: University of Minnesota Press, 2011.

Melamed, Jodi. "The Spirit of Neoliberalism: From Racial Liberalism to Neoliberal Multiculturalism." *Social Text* 89 24, no. 4 (2006): 1–24.

Mendoza, Victor Román. *Metroimperial Intimacies: Fantasy, Racial-Sexual Gov-*

ernance, and the Philippines in U.S. Imperialism, 1899–1913. Durham, NC: Duke University Press, 2015.

Menon, Sridevi. "Where is West Asia in Asian America?:'Asia' and the Politics of Space in Asian America." *Social Text* 86 24, no. 1 (Spring 2006): 55–79.

Merla-Watson, Cathryn Josefina, and B. V. Olguin, eds. *Altermundos: Latin@ Speculative Literature, Film, and Popular Culture*. Seattle: University of Washington Press, 2017.

Messeri, Lisa. *Placing Outer Space: An Earthly Ethnography of Other Worlds*. Durham, NC: Duke University Press, 2016.

Mignolo, Walter. *Local Histories/Global Designs: Coloniality, Subaltern Knowledges, and Border Thinking*. Princeton, NJ: Princeton University Press, 2000.

Mikdashi, Maya, and Jasbir K. Puar. "Queer Theory and Permanent War." GLQ: A *Journal of Lesbian and Gay Studies* 22, no. 2(2016): 212–15.

Miller, Greg. "Plan for Hunting Terrorists Signals US Intends to Keep Adding Names to Kill Lists." *Washington Post*, October 23, 2012.

Min, Susette. "Tonal Disturbances." *Social Text* 94 26, no. 1 (Spring 2008): 59–74.

Min, Susette. *Unnamable: The Ends of Asian American Art*. New York: New York University, 2018.

Minhas, Zakir, and Altaf Qadir. "The US War on Terror and Drone Attacks on FATA, Pakistan." *Pakistan Annual Research Journal* 50 (2014): 15–28.

Mirzoeff, Nicholas. *The Right to Look: A Counterhistory of Visuality*. Durham, NC: Duke University Press, 2011.

Mirzoeff, Nicholas. "War Is Culture: Global Counterinsurgency, Visuality, and the Petraeus Doctrine." *PMLA* 123, no. 5 (October 2009): 1737–46.

Mishra, Sangay K. *Desis Divided: The Political Lives of South Asian Americans*. Minneapolis: University of Minnesota Press, 2016.

Mitchell, Timothy. *Rule of Experts: Egypt, Techno-Politics, Modernity*. Berkeley: University of California Press, 2002.

Mitchell, W. J. T. *Cloning Terror: The War of Images, 9/11 to the Present*. Chicago: University of Chicago Press, 2011.

Miyoshi, Masao, and Harry Harootunian, eds. *Learning Places: The Afterlives of Area Studies*. Durham, NC: Duke University Press, 2002.

Mohaiemen, Naeem. "Tracing the Index: Collaboration and Context." *Art in General*, March 26, 2008.

Mohaiemen, Naeem. "When An Interpreter Could Not Be Found." In *The Sun Never Sets: South Asian Migrants in an Age of US Power*. Edited by Vivek Bald et al., 229–37. New York: New York University Press, 2013.

Mohanty, Chandra Talpade. *Feminism without Borders: Decolonizing Theory, Practicing Solidarity*. Durham, NC: Duke University Press, 2003.

Molina, Natalia. *How Race Is Made in America: Immigration, Citizenship, and the Historical Power of Racial Scripts*. Berkeley: University of California Press, 2014.

Monahan, Torin. *Surveillance in the Time of Insecurity*. New Brunswick, NJ: Rutgers University Press, 2010.

Mondloch, Kate. *The Capsule Aesthetic: Feminist Materialisms in New Media Art.* Minneapolis: University of Minnesota Press, 2018.

Mongia, Radhika. *Indian Migration and Empire: A Colonial Genealogy of the Modern State.* Durham, NC: Duke University Press, 2018.

Morgan, Jennifer L. "Accounting for 'the Most Excruciating Torment': Gender, Slavery, and Trans-Atlantic Passages." *History of the Present* 6, no. 2 (Fall 2016): 184–207.

Morgan, Jennifer L. *Laboring Women: Reproduction and Gender in New World Slavery.* Philadelphia: University of Pennsylvania Press, 2004.

Morgensen, Scott L. "A Politics Not Yet Known: Imagining Relationality within Solidarity." *American Quarterly* 67, no. 2 (June 2015): 309–15.

Morgensen, Scott L. *Spaces between Us: Queer Settler Colonialism and Indigenous Decolonization.* Minneapolis: University of Minnesota Press, 2011.

Morse, Chuck. "Capitalism, Marxism, and the Black Radical Tradition: An Interview with Cedric Robinson." *Perspectives on Anarchist Theory* 3, no. 1 (Spring 1999): 1, 6–8.

Mosk, Matthew, Brian Ross, and Joseph Rhee. "Exclusive: Whistleblower Claims Many US Interpreters Can't Speak Afghan Languages." The Blotter. *ABC News*, September 8, 2010. Accessed May 13, 2012. http://abcnews.go.com/Blotter /afghanistan-whistleblower-claims-us-interpreters-speak-afghan-languages /story?id=11578169#.T4HeN5pSSjM/.

Moten, Fred. *In the Break: The Aesthetics of the Black Radical Tradition.* Minneapolis: University of Minnesota Press, 2003.

Moten, Fred. "The New International of Insurgent Feeling." Palestinian Campaign for the Academic and Cultural Boycott of Israel. November 7, 2009. Accessed December 14, 2017. http://www.pacbi.org/etemplate.php?id=1130/.

Mountz, Alison. *Seeking Asylum: Human Smuggling and Bureaucracy at the Border.* Minneapolis: University of Minnesota Press, 2010.

Mughal, Owais. "Pakistan's Indigenous Art of Truck Painting." *All Things Pakistan*, June 18, 2008. Accessed January 26, 2018. https://pakistaniat.com/2008/06/18 /pakistans-indigenous-truck-art/.

Muhammad, Khalil Gibran. *The Condemnation of Blackness: Race, Crime, and the Making of Modern Urban America.* Cambridge, MA: Harvard University Press, 2011.

Mullen, Bill V., and Ashley Dawson, ed. *Against Apartheid: The Case for Boycotting Israeli Universities.* Chicago: Haymarket Books, 2015.

Muñoz, José Esteban. *Cruising Utopia: The Then and There of Queer Futurity.* New York: New York University Press, 2009.

Muñoz, José Esteban. *Disidentifications: Queers of Color and the Performance of Politics.* Minneapolis: University of Minnesota Press, 1999.

Muñoz, José Esteban. "Ephemera as Evidence: Introductory Notes to Queer Acts." *Women and Performance: A Journal of Feminist Theory* 8, no. 2 (1996): 5–16.

Muñoz, José Esteban. "Gesture, Ephemera, and Queer Feeling: Approaching Kevin Aviance." In *Dancing Desires: Choreographing Sexualities On and Off the Stage.* Edited by Jane Desmond, 423–42. Madison: University of Wisconsin Press, 2001.

Muñoz, José Esteban. *The Sense of Brown: Ethnicity, Affect, Performance.* Durham, NC: Duke University Press, n.d.

Muñoz, José Esteban. "Theorizing Queer Inhumanisms: The Sense of Brownness." In "Queer Inhumanisms." Special issue, GLQ: A Journal of Lesbian and Gay Studies 21, nos. 2–3 (2015): 209–10.

Muñoz, José Esteban. "The Vulnerability Artist: Nao Bustamante and the Sad Beauty of Reparation." Women and Performance: A Journal of Feminist Theory 16, no. 2 (2006): 191–200.

Murakawa, Naomi. The First Civil Right: How Liberals Built Prison America. New York: Oxford University Press, 2014.

Musser, Amber Jamilla. Sensational Flesh: Race, Power, and Masochism. New York: New York University Press, 2014.

Musser, Amber Jamilla. Sensual Excess: Queer Femininity and Brown Jouissance. New York: New York University Press, 2018.

Naber, Nadine. Arab America: Gender, Cultural Politics, and Activism. New York: New York University Press, 2012.

Naber, Nadine. "Justice for Rasmea Odeh." MERIP: Middle East Research and Information Project. June 19, 2014. Accessed August 5, 2017. https://merip.org/2014/06 /justice-for-rasmea-odeh/.

Naber, Nadine. "'The U.S. and Israel Make the Connections For Us': Anti-Imperialism and Black-Palestinian Solidarity." Critical Ethnic Studies 3, no. 2 (Fall 2017): 15–30.

Naber, Nadine, Eman Desouky, and Lina Baroudi. "The Forgotten '-Ism': An Arab American Women's Perspective on Zionism, Racism, and Sexism." In Color of Violence: The INCITE! Anthology. Edited by INCITE! Women of Color against Violence, 97–112. Cambridge, MA: South End Press, 2006.

Naber, Nadine, Sa'ed Atshan, Nadia Awad, et al. "On Palestinian Studies and Queer Theory." Journal of Palestine Studies 47, no. 3 (Spring 2018): 62–71.

Nash, Jennifer C. The Black Body in Ecstasy: Reading Race, Reading Pornography. Durham, NC: Duke University Press, 2014.

Nelson, Alondra, ed. "Afrofuturism." Special issue, Social Text 71 20, no. 2 (2002).

Neocleous, Mark. "Police Power, All the Way to Heaven: Cujus Est Solum and the No-Fly Zone." Radical Philosophy 182 (November/December 2013): 5–14.

Neocleous, Mark. War Power, Police Power. Edinburgh: Edinburgh University Press, 2014.

Network of Concerned Anthropologists, ed. The Counter-Counterinsurgency Manual; or, Notes on Demilitarizing American Society. Chicago: Prickly Paradigm Press, 2009.

Neuendorf, Henri. "Palestinian Artist Emily Jacir Plans to Transform Her Family Home into a West Bank Art Center." Artnet, May 23, 2017. Accessed August 4, 2017. https://news.artnet.com/art-world/emily-jacir-community-art-center-969854.

Ngai, Mae. Impossible Subjects: Illegal Aliens and the Making of Modern America. Princeton, NJ: Princeton University Press, 2005.

Ngai, Sianne. Ugly Feelings. Cambridge, MA: Harvard University Press, 2005.

Nguyen, Hoang Tan. A View from the Bottom: Asian American Masculinity and Sexual Representation. Durham, NC: Duke University Press, 2014.

Nguyen, Mimi Thi. *The Gift of Freedom: War, Debt, and Other Refugee Passages*. Durham, NC: Duke University Press, 2012.

Nguyen, Nicole. *A Curriculum of Fear: Homeland Security in U.S. Public Schools*. Minneapolis: University of Minnesota Press, 2016.

Nitzan-Shiftan, Alona. *Seizing Jerusalem: The Architectures of Unilateral Unification*. Minneapolis: University of Minnesota Press, 2017.

Nixon, Lindsay. "Visual Cultures of Indigenous Futurisms." *GUTS Magazine*, May 20, 2016. Accessed May 5, 2017. http://gutsmagazine.ca/visual-cultures/. Minneapolis: University of Minnesota Press, 2017.

Nyong'o, Tavia. *Afro-Fabulations: The Queer Drama of Black Life*. New York: New York University Press, 2018.

Ochs, Juliana. *Security and Suspicion: An Ethnography of Everyday Life in Israel*. Philadelphia: University of Pennsylvania Press, 2011.

Okihiro, Gary Y. *Third World Studies: Theorizing Liberation*. Durham, NC: Duke University Press, 2016.

Olah, Nathalie. "'Gulf Futurism' Is Killing People." *Vice Magazine*, May 15, 2014. Accessed August 8, 2017, https://www.vice.com/read/the-human-cost-of-building-the-worlds-tallest-skyscraper/.

Olwan, Dana M. "On Assumptive Solidarities in Comparative Settler Colonialisms." In "Complicities, Connections, and Struggles: Critical Transnational Feminist Analysis of Settler Colonialism." Special issue, *Feral Feminisms* 4 (Summer 2015): 89–102.

Orden, Erica. "Sir, There's a Camera in Your Head." *Wall Street Journal*, November 16, 2010.

Ortner, Sherry B. "Resistance and the Problem of Ethnographic Refusal." *Comparative Studies in Society and History* 37, no. 1 (1995): 173–93.

Owens, Patricia. *Economy of Force: Counterinsurgency and the Historical Rise of the Social*. London: Cambridge University Press, 2015.

Paglen, Trevor. *Blank Spots on the Map: The Dark Geography of the Pentagon's Secret World*. New York: New American/Penguin, 2010.

Paglen, Trevor. "Some Sketches on Vertical Geographies. *e-flux Architecture*, Superhumanity, October 5, 2016. Accessed August 5, 2017. http://www.e-flux.com/architecture/superhumanity/68726/some-sketches-on-vertical-geographies/.

Paik, A. Naomi. *Rightlessness: Testimony and Redress in U.S. Prison Camps Since World War II*. Chapel Hill: University of North Carolina Press, 2016.

Palumbo-Liu, David. "BDS Opponents Threaten Academic Associations With 'Ultra Vires' Lawsuits, but Fail Big in First Attempt." *Truthout*, April 12, 2017. Accessed August 3, 2017. http://www.truth-out.org/news/item/40170-bds-opponents-threaten-academic-associations-with-ultra-vires-lawsuits-but-fail-big-in-first-attempt/.

Pappé, Ilan. *The Ethnic Cleaning of Palestine*. Oxford: One World Books, 2008.

Pappé, Ilan. *The Forgotten Palestinians: A History of the Palestinians in Israel*. New Haven, CT: Yale University Press, 2011.

Paracha, Nadeem F. "The Elusive History and Politics of Pakistan's Truck Art." *Dawn*, August 19, 2016. Accessed December 15, 2017. https://www.dawn.com/news/1278386/the-elusive-history-and-politics-of-pakistans-truck-art.

Parikh, Crystal. *An Ethics of Betrayal: The Politics of Otherness in Emergent US Literatures and Cultures.* New York: Fordham University Press, 2009.

Parikh, Crystal. *Writing Human Rights: The Political Imaginaries of Writers of Color.* Minneapolis: University of Minnesota Press, 2017.

Parikka, Jussi. "Middle East and Other Futurisms: Imaginary Temporalities in Contemporary Art and Visual Culture." *Culture, Theory, and Critique* 58, no. 4 (2017): 1–19.

Parks, Lisa. *Rethinking Media Coverage: Vertical Mediation and the War on Terror.* New York: Routledge, 2018.

Parks, Lisa. "Drones, Vertical Mediation, and the Targeted Class." *Feminist Studies* 42, no. 1 (2016): 227–35.

Parks, Lisa, and Caren Kaplan, eds. *Life in the Age of Drone Warfare.* Durham, NC: Duke University Press, 2017.

Parisi, David. *Archaeologies of Touch: Interfacing with Haptics from Electricity to Computing.* Minneapolis: University of Minnesota Press, 2018.

Pasternack, Alex. "The Story of Drones, As Told By the People Who Live Under Them." *Motherboard,* October 25, 2013.

Patel, Alpesh Kantilal. *Productive Failure: Writing Queer Transnational South Asian Art Histories.* Manchester: Manchester University Press, 2017.

Patel, Shaista, Ghaida Moussa, and Nishant Upadhyay. "Complicities, Connections, and Struggles: Critical Transnational Feminist Analysis of Settler Colonialism," *Feral Feminisms* 4 (Summer 2015): 5–19.

Pateman, Carol, and Charles Mills. *Contract and Domination.* Cambridge, MA: Polity, 2007.

Pawlyk, Oriana. "US Air Force Preparing for War in Space," *Military.com,* April 4, 2017. Accessed June 20, 2017. http://www.military.com/daily-news/2017/04/04/us-air-force-preparing-war-space.html.

Pegler-Gordon, Anna. *In Sight of America: Photography and the Development of US Immigration Policy.* Berkeley: University of California Press, 2009.

Pelaud, Isabelle Thuy, Lan Duong, and Mariam B. Lam, eds. *Troubling Borders: An Anthology of Art and Literature by Southeast Asian Women in Diaspora.* Seattle: University of Washington Press, 2013.

Pennock, Pamela E. *The Rise of the Arab American Left: Activists, Allies, and Their Fight against Imperialism and Racism, 1960s–1980s.* Chapel Hill: University of North Carolina Press, 2017.

Pérez, Hiram. *A Taste for Brown Bodies: Gay Modernity and Cosmopolitan Desire.* New York: New York University Press, 2015.

Peteet, Julie. *Landscape of Hope and Despair: Palestinian Refugee Camps.* Philadelphia: University of Pennsylvania Press, 2005.

Peteet, Julie. *Space and Mobility in Palestine.* Bloomington: Indiana University Press, 2017.

Petti, Alessandro, Sandi Hilal, and Eyal Weizman, eds. *Architecture after Revolution.* Berlin: Sternberg Press, 2013.

Ponce, Martin Joseph. *Beyond the Nation: Diasporic Filipino Literature and Queer Reading*. New York: New York University Press, 2012.

Povinelli, Elizabeth. *The Empire of Love: Toward a Theory of Intimacy, Genealogy and Carnality*. Durham, NC: Duke University Press, 2006.

Prashad, Vijay. *The Darker Nations: A People's History of the Third World*. New York: New Press, 2007.

Prashad, Vijay. *The Karma of Brown Folk*. Minneapolis: University of Minnesota Press, 2001.

Prashad, Vijay. *Uncle Swami: South Asians in America Today*. New York: New Press, 2012.

Prasse-Freeman, Elliott. "Droning On." *New Inquiry*, February 20, 2015.

Price, David H. *Weaponizing Anthropology: Social Science in Service of the Militarized State*. New York: AK Press, 2011.

Price-Smith, Andrew T. *Contagion and Chaos: Disease, Ecology, and National Security in the Era of Globalization*. Cambridge, MA: MIT Press, 2009.

Priest, Dana, and William M. Arkin. *Top Secret America: The Rise of the New American Security State*. New York: Little, Brown, 2011.

Protevi, John. *Political Affect: Connecting the Social to the Somatic*. Minneapolis: University of Minnesota Press, 2009.

Puar, Jasbir K. "The Golden Handcuffs of Gay Rights: How Pinkwashing Distorts both LGBTIQ and Anti-Occupation Activism." *Feminist Wire*, January 30, 2012. Accessed August 4, 2017. http://www.thefeministwire.com/2012/01/the-golden -handcuffs-of-gay-rights-how-pinkwashing-distorts-both-lgbtiq-and-anti -occupation-activism/.

Puar, Jasbir K. *The Right to Maim: Debility, Capacity, Disability*. Durham, NC: Duke University Press, 2017.

Puar, Jasbir K. *Terrorist Assemblages: Homonationalism in Queer Times*. Durham, NC: Duke University Press, 2007.

Puar, Jasbir K., and Amit Rai. "Monster, Terrorist, Fag." *Social Text* 72 20, no. 3 (Fall 2002): 117–48.

"Punishing Saddam." *60 Minutes*. Season 28, episode 35. Aired May 12, 1996, on CBS.

Quashie, Kevin. *The Sovereignty of Quiet: Beyond Resistance in Black Culture*. New Brunswick, NJ: Rutgers University Press, 2012.

Queers for Economic Justice. "Queers and Immigration: A Vision Statement." 2006. Accessed January 10, 2019. http://sfonline.barnard.edu/immigration /QEJ-Immigration-Vision.pdf.

Qureshi, Emran, and Michael A. Sells, eds. *The New Crusades: Constructing the Muslim Enemy*. New York: Columbia University Press, 2003.

Qutami, Loubna. "Rethinking the Single Story: BDS, Transnational Cross Movement Building, and the Palestine Analytic," *Social Text, Periscope Blog*, July 17, 2014. Accessed August 5, 2017. socialtextjournal.org/periscope_article/rethinking-the -single-story-bds-transnational-cross-movement-building-and-the-palestine -analytic/#sthash.enMJQXB2.dpuf/.

Rafael, Vicente L. *Motherless Tongues: The Insurgency of Language amid Wars of Translation*. Durham, NC: Duke University Press, 2016.

Rahman, Najat. *In the Wake of the Poetic: Palestinian Artists after Darwish*. Syracuse, NY: Syracuse University Press, 2015.

Ramaswamy, Sumathi. *The Goddess and the Nation: Mapping Mother India*. Durham, NC: Duke University Press, 2010.

Rana, Junaid. "The Globality of Af-Pak: U.S. Empire and the Muslim Problem." In *The Routledge Handbook of Asian American Studies*. Edited by Cindy I-Fen Cheng, 233–45. New York, Routledge, 2017.

Rana, Junaid. "More than Nothing: The Persistence of Islamophobia in Post-Racial Racism." *Global Dialogue* 12, no. 2 (2010).

Rana, Junaid. "Policing Kashmiri Brooklyn." In *The FBI and Religion: Faith and National Security before and after 9/11*. Edited by Sylvester A. Johnson and Steven Weitzman, 256–68. Berkeley: University of California Press, 2017.

Rana, Junaid. "The Racial Infrastructure of the Terror-Industrial Complex." *Social Text* 129 34, no. 4 (December 2016): 111–38.

Rana, Junaid. *Terrifying Muslims: Race and Labor in the South Asian Diaspora*. Durham, NC: Duke University Press, 2011.

Rancière, Jacques. *Dissensus: On Politics and Aesthetics*, electronic version. Edited and translated by Steve Corcoran. London: Continuum, 2010.

Rangan, Pooja. *Immediations: The Humanitarian Impulse in Documentary*. Durham, NC: Duke University Press, 2017.

Ransby, Barbara. *Ella Baker and the Black Freedom Movement: A Radical Democratic Vision*. Chapel Hill: University of North Carolina Press, 2005.

Rawlings, Ashley. "Remote Repercussions: Wafaa Bilal." *ArtAsiaPacific* (March/April 2011). Accessed April 25, 2012. http://artasiapacific.com/Magazine/72/Remote RepercussionsWafaaBilal/.

Razack, Sherene H. *Casting Out: The Eviction of Muslims from Western Law and Politics*. Toronto: University of Toronto Press, 2008.

Razack, Sherene H. *Dying from Improvement: Inquests and Inquiries into Indigenous Deaths in Custody*. Toronto: University of Toronto Press, 2015.

Razack, Sherene H., ed. *Race, Space, and the Law: Unmapping a White Settler Society*. Toronto: Between the Lines, 2002.

Reddy, Chandan. "Asian Diasporas, Neo-liberalism and the Critique of Gay Identity: Re-viewing the Case for Homosexual Asylum in the Context of 'Family Rights.'" *Social Text* 84–85 23, nos. 3–4 (Fall 2005): 101–19.

Reddy, Chandan. *Freedom with Violence: Race, Sexuality and the US State*. Durham, NC: Duke University Press, 2011.

Redmond, Shana. *Anthem: Social Movements and the Sounds of Solidarity in the African Diaspora*. New York: New York University Press, 2013.

Reid, Julian. *The Biopolitics of the War on Terror: Life Struggles, Liberal Modernity, and the Defence of Logistical Societies*. Manchester, UK: Manchester University Press, 2006.

Renda, Mary. *Taking Haiti: Military Occupation and the Culture of US Imperialism*. Chapel Hill: University of North Carolina Press, 2000.

Rifkin, Mark. *Beyond Settler Time: Temporal Sovereignty and Indigenous Self-Determination*. Durham, NC: Duke University Press, 2017.

Rifkin, Mark. "Indigeneity, Apartheid, Palestine: On the Transit of Political Metaphors." *Cultural Critique* 95 (Winter 2017): 25–70.

Rifkin, Mark. *Settler Common Sense: Queerness and Everyday Colonialism in the American Renaissance*. Minneapolis: University of Minnesota Press, 2014.

Ritchie, Andrea. *Invisible No More: Police Violence against Black Women and Women of Color*. Boston: Beacon Press, 2017.

Robinson, Cedric J. *Black Marxism: The Making of the Black Radical Tradition*. Chapel Hill: University of North Carolina Press, 2000.

Robinson, Cedric J. *Forgeries of Memory and Meaning: Blacks and the Regimes of Race in American Theater and Film before World War II*. Chapel Hill: University of North Carolina Press, 2007.

Roblyer, Lt. Col. Dwight A. "Beyond Precision: Issues of Morality and Decision Making in Minimizing Collateral Casualties." Arms Control, Disarmament, and International Security (ACDIS) Occasional Paper (April 2004). Accessed January 10, 2019. https://apps.dtic.mil/dtic/tr/fulltext/u2/a424627.pdf.

Rodgers, Daniel T. *Atlantic Crossings: Social Politics in a Progressive Era*. Cambridge, MA: Harvard University Press, 2000.

Rodinson, Maxime. *Israel: A Settler-Colonial State?* Translated by David Thorstad. London: Pathfinder Press, 1973.

Rodney, Walter. *How Europe Underdeveloped Africa*. Baltimore: Black Classic Press, [1972] 2011.

Rodriguez, Dylan. *Forced Passages: Imprisoned Radical Intellectuals and the US Prison Regime*. Minneapolis: University of Minnesota Press, 2006.

Rodriguez, Dylan. "'I Would Wish Death On You . . .': Race, Gender, and Immigration in the Globality of the US Prison Regime." *Scholar and Feminist Online* 6, no. 3 (Summer 2008): 1–9.

Rodriguez, Dylan. *Suspended Apocalypse: White Supremacy, Genocide, and the Filipino Condition*. Minneapolis: University of Minnesota Press, 2010.

Rodríguez, Juana María. *Queer Latinidad: Identity Practices, Discursive Spaces*. New York: New York University Press, 2003.

Rodríguez, Juana María. *Sexual Futures, Queer Gestures, and Other Latina Longings*. New York: New York University Press, 2014.

Rogers, Katie. "Trump Orders Establishment of Space Force as Sixth Military Branch." *New York Times*, June 19, 2018.

Rose, Jacqueline. *The Question of Zion*. Princeton, NJ: Princeton University Press, 2007.

Rosenberg, Carol. "After Years of Letting Captives Own Their Artwork, Pentagon Calls it U.S. Property. And May Burn It." *Miami Herald*, November 16, 2017.

Rosenberg, Emily S., and Shanon Fitzpatrick, eds. *Body and Nation: The Global*

Realm of U.S. Body Politics in the Twentieth Century. Durham, NC: Duke University Press, 2014.

Ross, Luana. *Inventing the Savage: The Social Construction of Native American Criminality*. Austin: University of Texas Press, 1998.

Rotbard, Sharon. *White City, Black City: Architecture and War in Tel Aviv and Jaffa*. Cambridge, MA: MIT Press, 2015.

Rowe, John Carlos, ed. *Post-Nationalist American Studies*. Berkeley: University of California Press, 2000.

Rubaii, Kali. "Concrete and Livability in Occupied Palestine." In "Life on the Frontier: The Environmental Anthropology of Settler Colonialism." *Engagement: A Blog of the Anthropology and Environment Society*, September 20, 2016. Accessed April 11, 2017. https://aesengagement.wordpress.com/2016/09/20/concrete-and-livability-in-occupied-palestine/.

Rymer, Michael. "An NYU Professor Will Reinstall a Webcam in the Back of His Head." *Village Voice*, August 10, 2011.

Sa'di, Ahmad H., and Lila Abu-Lughod, eds. *Nakba: Palestine, 1948, and the Claims of Memory*. New York: Columbia University Press, 2007.

Safire, William. "Wide World of Words." *New York Times*, April 23, 2009.

Said, Edward W. *After the Last Sky: Palestinian Lives*. New York: Columbia University Press, 1999.

Said, Edward W. *Culture and Imperialism*. New York: Vintage Books, 1993.

Said, Edward W. *Orientalism*. New York: Vintage Books, 1979.

Said, Edward W. *The Question of Palestine*. New York: Vintage Books, 1979.

Said, Edward W. *The World, the Text, and the Critic*. Cambridge, MA: Harvard University Press, 1984.

Said, Edward W. "Zionism from the Standpoint of Its Victims." *Social Text* 1, no. 1 (1979): 7–58.

Salaita, Steven. "American Indian Studies and Palestine Solidarity: The Importance of Impetuous Definitions." *Decolonization: Indigeneity, Education and Society* 6, no. 1 (2017): 1–28.

Salaita, Steven. *Anti-Arab Racism in the U.S.A.: Where It Comes from and What It Means for Politics Today*. London: Pluto Press, 2006.

Salaita, Steven. *The Holy Land in Transit: Colonialism and the Quest for Canaan*. Syracuse, NY: Syracuse University Press, 2006.

Salaita, Steven. *Inter/Nationalism: Decolonizing Native America and Palestine*. Minneapolis: University of Minnesota Press, 2016.

Salaita, Steven. *Uncivil Rites: Palestine and the Limits of Academic Freedom*. Chicago: Haymarket Books, 2015.

Salamanca, Omar Jabary, Mezna Qato, Kareem Rabie, and Sobhi Samour, eds. "Past Is Present: Settler Colonialism in Palestine." *Settler Colonial Studies* 2, no. 1 (2012). https://doi.org/10.1080/2201473X.2012.10648823.

Salamon, Gayle. *Assuming a Body: Transgender and the Rhetorics of Materiality*. New York: Columbia University Press, 2010.

Saldaña-Portillo, María Josefina. *Indian Given: Racial Geographies across Mexico and the United States.* Durham, NC: Duke University Press, 2016.

Saldaña-Portillo, María Josefina. *The Revolutionary Imagination in the Americas and the Age of Development.* Durham, NC: Duke University Press, 2003.

San Pablo Burns, Lucy Mae. *Puro Arte: Filipinos on the Stage of Empire.* New York: New York University Press, 2012.

Saranillio, Dean. *Unsustainable Empire: Alternative Histories of Hawai'i Statehood.* Durham, NC: Duke University Press, 2018.

Satia, Priya. "Attack of the Drones." *Nation*, November 9, 2009.

Satia, Priya. "The Defense of Inhumanity: Air Control in Iraq and the British Idea of Arabia." *American Historical Review* 111 (February 2006): 16–51.

Satia, Priya. "Drones: A History from the British Middle East." *Humanity* 5, no. 1 (Spring 2014): 1–31.

Satia, Priya. *Spies in Arabia: The Great War and the Cultural Foundations of Britain's Covert Empire in the Middle East.* Oxford, UK: Oxford University Press, 2008.

Sayegh, Fayez A. *Zionist Colonialism in Palestine.* Beirut, Lebanon: Palestine Liberation Organization Resource Center, 1965.

Scahill, Jeremy. *Dirty Wars: The World Is a Battlefield.* New York: Nation Books (Perseus), 2013.

Scahill, Jeremy and Ryan Devereux. "Watch Commander: Barack Obama's Secret Terrorist-Tracking System, by the Numbers," *Intercept*, August 5, 2014. Accessed August 9, 2017. https://theintercept.com/2014/08/05/watch-commander/.

Scahill, Jeremy, and the Staff of the Intercept. *The Assassination Complex: Inside the Government's Secret Drone Warfare Program.* New York: Simon and Schuster, 2017.

Scarry, Elaine. *The Body in Pain: The Making and Unmaking of the World.* New York: Oxford University Press, 1985.

Schalk, Sami. *Bodyminds Reimagined: (Dis)ability, Race, and Gender in Black Women's Speculative Fiction.* Durham, NC: Duke University Press, 2018.

Schleitwiler, Vince. *Strange Fruit of the Black Pacific: Imperialism's Racial Justice and its Fugitives.* New York: New York University Press, 2017.

Schlund-Vials, Cathy. *War, Genocide, and Justice: Cambodian American Memory Work.* Minneapolis: University of Minnesota Press, 2012.

Schotten, C. Heike. *Queer Terror: Life, Death, and Desire in the Settler Colony.* New York: Columbia University Press, 2018.

Schotten, C. Heike. "To Exist Is to Resist: Palestine and the Question of Queer Theory." *Journal of Palestine Studies* 47, no. 3 (Spring 2018): 13–28.

Schrader, Stuart. *Badges without Borders: How Global Counterinsurgency Transformed American Policing.* Berkeley: University of California Press, forthcoming.

Schreiber, Rebecca M. *The Undocumented Everyday: Migrant Lives and the Politics of Visibility.* Minneapolis: University of Minnesota Press, 2018.

Schueller, Malini Johar. *U.S. Orientalisms: Race, Nation, and Gender in Literature, 1790–1890.* Ann Arbor: University of Michigan Press, 2001.

Schulman, Sarah. *Israel/Palestine and the Queer International*. Durham, NC: Duke University Press, 2012.

Scott, Felicity D. *Outlaw Territories: Environments of Insecurity/Architectures of Counterinsurgency*. New York: Zone Books, 2016.

Scott, Joan Wallach. *The Politics of the Veil*. Princeton, NJ: Princeton University Press, 2010.

Sedgwick, Eve K. *Touching, Feeling: Affect, Pedagogy, Performativity*. Durham, NC: Duke University Press, 2003.

See, Sarita. *The Decolonized Eye: Filipino American Art and Performance*. Minneapolis: University of Minnesota Press, 2009.

See, Sarita. *The Filipino Primitive: Accumulation and Resistance in the American Museum*. New York: New York University Press, 2017.

Seigel, Micol. *Violence Work: State Power and the Limits of Police*. Durham, NC: Duke University Press, 2018.

Self, Robert O. *American Babylon: Race and the Struggle for Postwar Oakland*. Princeton, NJ: Princeton University Press, 2005.

Sell, Rebecca. "From Blimps to Bugs: The Miniaturization of Drone Technology." *New York Times*, Online Interactive. Accessed January 20, 2018. http://www .nytimes.com/interactive/2011/06/20/world/military-tech.html?action=click &contentCollection=World&module=RelatedCoverage®ion=EndOfArticle &pgtype=article/.

Selod, Saher. *Forever Suspect: Racialized Surveillance of Muslim Americans in the War on Terror*. New Brunswick, NJ: Rutgers University Press, 2018.

Sepoy Mutiny. "Waziristan, U.S." *Chapati Mystery*, April 16, 2014.

Serlin, David. *Replaceable You: Engineering the Body in Postwar America*. Chicago: University of Chicago Press, 2004.

Sewall, Sarah. "Introduction." In *The US Army and Marine Corps Counterinsurgency Field Manual*, li–xliii. Chicago: University of Chicago Press, 2007.

Shafir, Gershon. *Land, Labor, and the Origins of the Israeli-Palestinian Conflict, 1882–1914*. London: Cambridge University Press, 1989.

Shah, Nayan. *Contagious Divides: Epidemics and Race in San Francisco's Chinatown*. Berkeley: University of California Press, 2001.

Shah, Nayan. *Stranger Intimacy: Contesting Race, Sexuality and the Law in the North American West*. Berkeley: University of California Press, 2012.

Shah, Silky. "A Decade of Detention: The Post 9/11 Immigrant Dragnet." *SAMAR 37: 9/11 A Decade Later*, September 11, 2011. Accessed January 10, 2019. http://samar magazine.org/archive/articles/376.

Shaheen, Jack. *Reel Bad Arabs: How Hollywood Vilifies a People*. Northampton, MA: Olive Branch Press, 2014.

Shakir, Evelyn. *Bint Arab: Arab and Arab American Women in the United* States. Westport, CT: Praeger, 1997.

Shalhoub-Kevorkian, Nadera. "Palestinian Feminist Critique and the Physics of Power: Feminists between Thought and Practice." *Feminists@law* 4, no. 1 (2014): 1–18.

Shalhoub-Kevorkian, Nadera. *Security Theology, Surveillance, and the Politics of Fear*. New York: Cambridge University Press, 2015.

Sharif, Lila. "Vanishing Palestine." *Critical Ethnic Studies* 2, no. 1 (Spring 2016): 17–39.

Sharma, Nitasha Tamar. *Hip Hop Desis: South Asian Americans, Blackness, and a Global Race Consciousness*. Durham, NC: Duke University Press, 2010.

Sharoni, Simona, Rabab Abdulhadi, Nadje Al-Ali, et al. "Transnational Feminist Solidarity in Times of Crisis: The Boycott, Divestment and Sanctions (BDS) Movement and Justice In/For Palestine." *International Feminist Journal of Politics* 17, no. 4 (2015): 654–70.

Sharpe, Christina. *In the Wake: On Blackness and Being*. Durham, NC: Duke University Press, 2016.

Sharpe, Jenny. "Is the United States Postcolonial? Transnationalism, Immigration, and Race." *Diaspora: A Journal of Transnational Studies*. 4, no. 2 (1995): 181–99.

Shanker, Thom. "To Track Militants, US Has System That Never Forgets a Face." *New York Times*, July 13, 2011.

Shapiro, Michael J. *Cinematic Geopolitics*. New York: Routledge, 2009.

Shaw, Ian G. R. "The Great War of Enclosure: Securing the Skies." *Antipode* 49, no. 4 (2017): 883–906.

Shaw, Ian G. R. *Predator Empire: Drone Warfare and Full Spectrum Dominance*. Minneapolis: University of Minnesota Press, 2016.

Shaw, Ian G. R. "Predator Empire: The Geopolitics of US Drone Warfare." *Geopolitics* 18, no. 3 (2013): 536–59.

Shaw, Ian G. R. "Scorched Atmospheres: The Violent Geographies of the Vietnam War and the Rise of Drone Warfare." *Annals of the American Association of Geographers* 106, no. 3 (2016): 688–704.

Shaw, Ian, and Majed Akhter. "The Dronification of State Violence." *Critical Asian Studies* 26, no. 2 (2014): 211–34.

Shaw, Ian, and Majed Akhter. "The Unbearable Humanness of Drone Warfare in FATA, Pakistan." *Antipode* 44, no. 4 (2012): 1490–509.

Sheehi, Stephen. *Islamophobia: The Ideological Campaign against Muslims*. Atlanta, GA: Clarity Press, 2011.

Sheety, Roger. "An Alternative Dictionary for the Palestine/Israel 'Conflict.'" *Middle East Eye*, September 9, 2014. Accessed August 7, 2017. http://www.middle easteye.net/columns/alternative-dictionary-palestineisrael-conflict-abridged -version-395849147/.

Sheikh, Irum. *Detained without Cause: Muslims' Stories of Detention and Deportation in America after 9/11*. New York: Palgrave Macmillan, 2011.

Sherry, Michael. *The Rise of American Air Power: The Creation of Armageddon*. New Haven, CT: Yale University Press, 1989.

Shigematsu, Setsu, and Keith Camacho, eds. *Militarized Currents: Toward a Decolonized Future in Asia and the Pacific*. Minneapolis: University of Minnesota Press, 2010.

Shohat, Ella. *Taboo Memories, Diasporic Voices.* Durham, NC: Duke University Press, 2006.

Silva, Noenoe K. *Aloha Betrayed: Native Hawaiian Resistance to American Colonialism.* Durham, NC: Duke University Press, 2004.

Silva, Kumarini. *Brown Threat: Identification in the Security State.* Minneapolis: University of Minnesota Press, 2016.

Simon, Jonathan. *Governing Through Crime: How the War on Crime Transformed American Democracy and Created a Culture of Fear.* Oxford: Oxford University Press, 2007.

Simpson, Audra. *Mohawk Interruptus: Political Life across the Borders of Settler States.* Durham, NC: Duke University Press, 2014.

Simpson, Audra, and Andrea Smith, eds. *Theorizing Native Studies.* Durham, NC: Duke University Press, 2014.

Simpson, Leanne. *As We Have Always Done: Indigenous Freedom through Radical Resistance.* Minneapolis: University of Minnesota Press, 2017.

Singh, Julietta. *Unthinking Mastery: Dehumanism and Decolonial Entanglements.* Durham, NC: Duke University Press, 2018.

Singh, Nikhil Pal. "The Afterlife of Fascism." *South Atlantic Quarterly* 105, no. 1 (Winter 2006): 71–93.

Singh, Nikhil Pal. *Black is a Country: Race and the Unfinished Struggle for Democracy.* Cambridge, MA: Harvard University Press, 2004.

Singh, Nikhil Pal. *Race and America's Long War.* Berkeley: University of California Press, 2017.

slavick, elin o'Hara. *Bomb After Bomb: A Violent Cartography.* Milan, Italy: Charta Art Books, 2007.

Smith, Andrea L. *Conquest: Sexual Violence and American Indian Genocide.* Cambridge, MA: South End Press, 2005.

Smith, Andrea L. "Queer Theory and Native Studies: The Heteronormativity of Settler Colonialism." GLQ: *A Journal of Gay and Lesbian Studies* 16, nos. 1–2 (2010): 42–68.

Smith, Cherise. *Enacting Others: Politics of Identity in Eleanor Antin, Nikki S. Lee, Adrian Piper, and Anna Deavere Smith.* Durham, NC: Duke University Press, 2011.

Smith, Neil. *American Empire: Roosevelt's Geographer and the Prelude to Globalization.* Berkeley: University of California Press, 2003.

Smith, Terry. *The Architecture of Aftermath.* Chicago: University of Chicago Press, 2006.

Sohi, Seema. *Echoes of Mutiny: Race, Surveillance, and Indian Anticolonialism in North America.* New York: Oxford University Press, 2014.

Solomon-Godeau, Abigail. "Torture and Representation: The Art of Detournement." In *Speaking About Torture.* Edited by Julie A. Carson and Elisabeth Weber, 115–28. New York: Fordham University Press, 2012.

Soto, Sandra K. *Reading Chican@ Like a Queer: The De-Mastery of Desire.* Austin: University of Texas Press, 2010.

Spade, Dean. *Normal Life: Administrative Violence, Critical Trans Politics and the Limits of the Law.* Cambridge, MA: South End Press, 2011.

Spade, Dean, and Craig Willse. "Sex, Gender, and War in an Age of Multicultural Imperialism." *QED: A Journal in GLBTQ Worldmaking* 1, no. 1 (Spring 2014): 5–29.

Spieker, Sven. *The Big Archive: Art from Bureaucracy.* Cambridge, MA: MIT Press, 2017.

Spillers, Hortense J. "Mama's Baby, Papa's Maybe: An American Grammar Book." *Diacritics* 17, no. 2 (Summer 1987): 64–81.

Spivak, Gayatri Chakravorty. *Death of a Discipline.* New York: Columbia University Press, 2003.

Staiger, Janet, Ann Cvetkovich, and Ann Reynolds, eds. *Political Emotions.* New York: Routledge, 2010.

Stanley, Eric A., and Nat Smith, eds. *Captive Genders: Trans Embodiment and the Prison Industrial Complex.* New York: AK Press, 2011.

Stanley, Eric A., Dean Spade, and Queer (In)Justice. "Roundtable: Queering Prison Abolition, Now?" *American Quarterly* 64, no. 1 (March 2012): 115–27.

Stanley, Jay. "Baltimore Police Secretly Running Aerial Mass Surveillance Eye in the Sky." *ACLU*, August 24, 2016. Accessed August 27, 2016. https://www.aclu.org/blog/free-future/baltimore-police-secretly-running-aerial-mass-surveillance-eye-sky/.

Stark, Heidi Kiiwetinepinesiik. "Criminal Empire: The Making of the Savage in a Lawless Land." *Theory and Event* 19, no. 4, (2016): 1–16.

Stauffer, Jill. "An Interview with Judith Butler: 'Peace Is a Resistance to the Terrible Satisfactions of War.'" *Believer Magazine*, May 1, 2003. https://believermag.com/an-interview-with-judith-butler/.

Stein, Rebecca L., and Ted Swedenburg, eds. *Palestine, Israel, and the Politics of Popular Culture.* Durham, NC: Duke University Press, 2005.

Stelder, Mikki. "Other Scenes of Speaking: Listening to Palestinian Anticolonial-Queer Critique." *Journal of Palestine Studies* 47, no. 3 (Spring 2018): 45–61.

Stewart, Katharine. *Ordinary Affects.* Durham, NC: Duke University Press, 2007.

Stoler, Ann Laura. *Along the Archival Grain: Epistemic Anxieties and Colonial Common Sense.* Durham, NC: Duke University Press, 2010.

Stoler, Ann Laura. *Carnal Knowledge and Imperial Power: Race and the Intimate in Colonial Rule.* Berkeley: University of California Press, 2002.

Stoler, Ann Laura. *Race and the Education of Desire: Foucault's History of Sexuality and the Colonial Order of Things.* Durham, NC: Duke University Press, 1995.

Stoler, Ann Laura, ed. *Haunted By Empire: Geographies of Intimacy in North American History.* Durham, NC: Duke University Press, 2006.

Streeby, Shelley. *Imagining the Future of Climate Change: World-Making through Science Fiction and Activism.* Berkeley: University of California Press, 2018.

Striphas, Ted. "Algorithmic Culture." *European Journal of Cultural Studies* 18, nos. 4–5 (2015): 395–412.

Sudbury, Julia, ed. *Global Lockdown: Race, Gender, and the Prison-Industrial Complex.* New York: Routledge, 2004.

Sudbury, Julia, ed. "A World Without Prisons: Resisting Militarism, Globalized Punishment, and Empire." *Social Justice* 31, nos. 1–2 (2004): 9–30.

Sudhakar, Anantha, Jaishri Abichandani, Vivek Bald, et al. "Crafting Community:

South Asian American Arts and Activism in 1990s New York City." In "Local/ Express: Asian American Arts and Community in 90s NYC." Edited by Curtis Chin, Terry Hong, and Parag Rajendra Khandhar. Special issue, *Asian American Literary Review* (2013): 161–79.

Suri, Jeremi. "The Cold War, Decolonization, and Global Social Awakenings: Historical Intersections." *Cold War History* 6 (August 2006): 353–63.

Tabar, Linda, and Chandni Desai. "Decolonization Is a Global Project: From Palestine to the Americas." *Decolonization: Indigeneity, Education and Society* 6, no. 1 (2017): i–xix.

Tadiar, Neferti X. M. *Things Fall Away: Philippine Historical Experience and the Makings of Globalization*. Durham, NC: Duke University Press, 2009.

Tadiar, Neferti X. M. "The War to Be Human/Becoming Human in a Time of War." In *The Color of Violence: The Incite! Anthology*. Edited by Incite! Women of Color Against Violence, 92–96. Cambridge, MA: South End Press, 2006.

Tahir, Madiha. "The Containment Zone." In *Life in the Age of Drone Warfare*. Edited by Lisa Parks and Caren Kaplan, 220–40. Durham, NC: Duke University Press, 2017.

Tahir, Madiha, dir. *Wounds of Waziristan*. Madiha Tahir and Parergon Films, 2013. Film. http://woundsofwaziristan.com/.

Tahir, Madiha R., Qalandar Bux Memon, and Vijay Prashad, eds. *Dispatches from Pakistan*. Minneapolis: University of Minnesota Press, 2014.

Tatonetti, Lisa. *The Queerness of Native American Literature*. Minneapolis: University of Minnesota Press, 2014.

Tawil-Souri, Helga. "'A Space Exodus': A Truly Palestinian Film." *Jadaliyya*, April 2, 2011. Accessed December 19, 2015. http://www.jadaliyya.com/Details/23863/A -Space-Exodus-A-Truly-Palestinian-Film.

Tawil-Souri, Helga. "Surveillance Sublime: The Security State in Jerusalem." *Jerusalem Quarterly* 68 (Winter 2016): 56–65.

Taylor, Diana. *Disappearing Acts: Spectacles of Gender and Nationalism in Argentina's "Dirty War."* Durham, NC: Duke University Press, 1997.

Taylor, Jerome. "Outrage at CIA's Double Tap Drone Attacks." *Guardian*, September 25, 2012.

Terada, Rei. *Feeling in Theory: Emotion after the "Death of the Subject."* Cambridge, MA: Harvard University Press, 2003.

Terry, Jennifer. *Attachments to War: Biomedical Logics and Violence in Twenty-First-Century America*. Durham, NC: Duke University Press, 2017.

Thacker, Eugene. *Biomedia*. Minneapolis: University of Minnesota Press, 2004.

Theoharis, Athan. *Abuse of Power: How Cold War Surveillance and Secrecy Shaped the Response to 9/11*. Philadelphia: Temple University Press, 2011.

Thomas, Martin. *Empires of Intelligence: Security Services and Colonial Disorder after 1914*. Berkeley: University of California Press, 2008.

Thompson, Erin L. "The Art of Keeping Guantánamo Open: What the Paintings by Its Prisoners Tell Us About Our Humanity and Theirs." *Truthout*, December 4, 2017. Accessed December 10, 2017. http://www.truth-out.org/news/item/42794-the

-art-of-keeping-guantanamo-open-what-the-paintings-by-its-prisoners-tell-us
-about-our-humanity-and-theirs/.

Tinsley, Omise'eke Natasha. *Ezili's Mirrors: Imagining Black Queer Genders*. Durham, NC: Duke University Press, 2018.

Tinsley, Omise'eke Natasha. *Thiefing Sugar: Eroticism between Women in Caribbean Literature*. Durham, NC: Duke University Press, 2010.

Tompkins, Kyla Wazana. "Intersections of Race, Gender, and Sexuality: Queer of Color Critique." In *The Cambridge Companion to Gay and Lesbian Literature*. Edited by Scott Herring, 173–89. New York: Cambridge University Press, 2015.

Tompkins, Kyla Wazana. *Racial Indigestion: Eating Bodies in the 19th Century*. New York: New York University Press, 2012.

Tongson, Karen. *Relocations: Queer Suburban Imaginaries*. New York: New York University Press, 2011.

Toor, Saadia. "Gender, Sexuality, and Islam Under the Shadow of Empire." *Scholar and Feminist Online* 9, no. 3 (Summer 2011). http://sfonline.barnard.edu/religion /print_toor.htm.

Toor, Saadia. *The State of Islam: Culture and Cold War Politics in Pakistan*. New York: Pluto Press, 2011.

Traverso, Enzo. *The Origins of Nazi Violence*. Translated by Janet Lloyd. New York: New Press, 2003.

Turner, Richard Brent. *Islam in the African American Experience*. Indianapolis: Indiana University Press, 1997.

Turse, Nick, and Tom Engelhardt. *Terminator Planet: The First History of Drone Warfare 2001–2050*. New York: Dispatch Books, 2012.

"UN Investigator Decries US Use of Killer Drones." *Reuters*, June 19, 2012. Accessed July 24, 2017. http://www.reuters.com/article/usa-un-drones-idUSL5E8HIJPJ 20120619/.

Upadhyay, Nishant. "Pernicious Continuities: Un/settling Violence, Race, and Colonialism. *Sikh Formations* 9, no. 2 (2013): 263–68.

US Department of the Army. *US Army and Marine Corps Counterinsurgency Field Manual*. Chicago: University of Chicago Press, 2007.

US Department of State, Bureau of International Information Programs, USINFO. "National Security Entry-Exit Registration System." USINFO.state.gov, June 5, 2002. Accessed June 26, 2007, no longer active. http://usinfo.state.gov/is/Archive _Index/EntryExit_Registration_System.html/.

US Department of Homeland Security, US Immigration and Customs Enforcement. "Changes to National Security Entry/Exit Registration System (NSEERS)." ICE.gov, December 1, 2003. Accessed June 26, 2007. http://www.ice.gov/pi/news/factsheets /nseersfs120103.htm/.

Vargas, Deb. "Ruminations on Lo Sucio as a Latino Queer Analytic." *American Quarterly* 66, no. 3 (September 2014): 715–26.

Vartanian, Hrag. "A Garden of Possibilities at the Palestinian Museum." *Hyperallergic*, September 6, 2017. Accessed September 6, 2017. https://hyperallergic.com /397840/palestinian-museum-opens/.

Veracini, Lorenzo. *Israel and Settler Society*. London: Pluto Press, 2006.

Veracini, Lorenzo. *Settler Colonialism: A Theoretical Overview*. New York: Palgrave Macmillan, 2010.

Vimalassery, Manu. "Antecedents of Imperial Incarceration: Fort Marion to Guantánamo." In *The Sun Never Sets: South Asian Migrants in an Age of U.S. Power*. Edited by Vivek Bald et al., 350–73. New York: New York University Press, 2013.

Vine, David. *Base Nation: How U.S. Military Bases Abroad Harm America and the World*. New York: Metropolitan Books, 2015.

Virilio, Paul. *War and Cinema: The Logistics of Perception*. New York: Verso, 1989.

Vitalis, Robert. *America's Kingdom: Mythmaking on the Saudi Oil Frontier*. Stanford, CA: Stanford University Press, 2007.

Volpp, Leti. "The Citizen and the Terrorist." UCLA *Law Review* 49 (2002): 1575–600.

Wacquant, Loïc. "From Slavery to Mass Incarceration: Rethinking the 'Race Question' in the US." *New Left Review* 13 (January-February 2002): 41–60.

Wacquant, Loïc. *Punishing the Poor: The Neoliberal Government of Social Insecurity*. Durham, NC: Duke University Press, 2009.

Walcott, Rinaldo. *Queer Returns: Essays on Multiculturalism, Diaspora, and Black Studies*. Toronto: Insomniac Press, 2016.

Wald, Priscilla. *Contagious: Cultures, Carriers, and the Outbreak Narrative*. Durham, NC: Duke University Press, 2008.

Warren, Calvin L. *Ontological Terror: Blackness, Nihilism, and Emancipation*. Durham, NC: Duke University Press, 2018.

Weart, Spencer. *Nuclear Fear: A History of Images*. Cambridge, MA: Harvard University Press, 1989.

Wegner, Phillip E. *Life between Two Deaths, 1989–2001: U.S. Culture in the Long Nineties*. Durham, NC: Duke University Press, 2009.

Weheliye, Alexander G. *Habeas Viscus: Racializing Assemblages, Biopolitics, and Black Feminist Theories of the Human*. Durham, NC: Duke University Press, 2014.

Weinbaum, Alys. *Wayward Reproductions: Genealogies of Race and Nation in Transatlantic Modern Thought*. Durham, NC: Duke University Press, 2004.

Weiner, Joshua J., and Damon Young. "Introduction: Queer Bonds." GLQ: *A Journal of Lesbian and Gay Studies* 17, no. 2–3 (2011): 223–41.

Weiss, Margot. *Techniques of Pleasure: BDSM and the Circuits of Sexuality*. Durham, NC: Duke University Press, 2011.

Weizman, Eyal. *Forensic Architecture: Violence at the Threshold of Detectability*. New York: Zone Books, 2017.

Weizman, Eyal. *Hollow Land: Israel's Architecture of Occupation*. London: Verso Press, 2007.

Weizman, Eyal. "Introduction to the Politics of Verticality." *Open Democracy*, Part 1 Introduction, April 23, 2002. Accessed June 15, 2017. https://www.opendemocracy.net/ecologypoliticsverticality/article_801.jsp/.

Weld, Kirsten. *Paper Cadavers: The Archives of Dictatorship in Guatemala*. Durham, NC: Duke University Press, 2014.

Westad, Odd Arne. *The Global Cold War: Third World Interventions and the Making of Our Times.* London: Cambridge University Press, 2005.

Wexler, Laura. *Tender Violence: Domestic Visions in an Age of US Imperialism.* Chapel Hill: University of North Carolina Press, 2000.

White, Melissa Autumn. "Archives of Intimacy and Trauma: Queer Migration Documents as Technologies of Affect." *Radical History Review* 120 (Fall 2014): 75–93.

Wiegman, Robyn. "The Times We're In: Queer Feminist Criticism and the Reparative 'Turn.'" *Feminist Theory* 15, no. 1 (2014): 4–25.

Wiegman, Robyn, and Donald E. Pease, eds. *The Future of American Studies.* Durham, NC: Duke University Press, 2002.

Wilcox, Lauren B. *Bodies of Violence: Theorizing Embodied Subjects in International Relations.* New York: Oxford University Press, 2015.

Wilcox, Lauren B. "Drones, Swarms, and Becoming-Insect: Feminist Utopias and Posthuman Politics." *Feminist Review* 116 (2017): 25–45.

Williams, Eric. *Capitalism and Slavery.* Chapel Hill: University of North Carolina Press, 1994.

Williams, Randall. *The Divided World: Human Rights and its Violence.* Minneapolis: University of Minnesota Press, 2010.

Williams, Raymond. *Marxism and Literature.* Oxford, UK: Oxford University Press, 1977.

Williams, William Appleman. *Empire as a Way of Life.* New York: Ig Publishing, [1980] 2007.

Wolfe, Patrick. "Settler Colonialism and the Elimination of the Native." *Journal of Genocide Research* 8, no. 4 (December 2006): 387–409.

Womack, Ytasha L. *Afrofuturism: The World of Black Sci-Fi and Fantasy Culture.* Chicago: Chicago Review Press, 2013.

Woods, Chris. *Sudden Justice: America's Secret Drone Wars.* Oxford, UK: Oxford University Press, 2015.

Wool, Zoë H., and Julie Livingston. "Collateral Afterworlds: An Introduction." *Social Text* 130 35, no. 1 (March 2017): 1–15.

Worldfocus. "US Drone Attacks in Pakistan." *Google Maps,* January 8, 2010.

Wynter, Sylvia. "Unsettling the Coloniality of Being/Power/Truth/Freedom: Towards the Human, after Man, Its Overrepresentation—An Argument." *CR: The New Centennial Review* 3, no. 3 (2003): 257–337.

Yambert, Karl, ed. *Security Issues in the Greater Middle East.* Santa Barbara, CA: Praeger Security International (ABC-CLIO), 2016.

Yoneyama, Lisa. *Cold War Ruins: Transpacific Critique of Justice and Japanese War Crimes.* Durham, NC: Duke University Press, 2016.

Yoneyama, Lisa. *Hiroshima Traces: Times, Space, and the Dialectics of Memory.* Berkeley: University of California Press, 1999.

Young, Cynthia. "Black Ops: Black Masculinity and the War on Terror." *American Quarterly* 66, no. 1 (March 2014): 35–67.

Young, Cynthia. *Soul Power: Culture, Radicalism and the Making of the US Third World Left*. Durham, NC: Duke University Press, 2006.

Young, Marilyn B. "The Age of Global Power." In *Rethinking American History in a Global Age*. Edited by Thomas Bender, 274–94. Berkeley: University of California Press.

Young, Marilyn B. *Vietnam Wars: 1945–1990*. New York: HarperCollins, 1991.

Yuh, Ji-Yeon. "Moved by War: Migration, Diaspora, and the Korean War." *Journal of Asian American Studies* 8, no. 3 (2005): 277–92.

Zarobell, John. *Art and the Global Economy*. Berkeley: University of California Press, 2017.

Zureik, Elia. *Israel's Colonial Project in Palestine: Brutal Pursuit*. New York: Routledge, 2015.

Zureik, Elia, David Lyon, and Yasmeen Abu-Laban, eds. *Surveillance and Control in Israel/Palestine: Population, Territory, and Power*. New York: Routledge, 2011.

detention bed mandates, 125

Detention Watch Network, 59

detournement, 250n90

Dhaka Art Summit, 268n4, **plate 26**; "Mining Warm Data," 188

diaspora studies, 38, 246n39, 251n4

Dinshaw, Carolyn, 239n59

disability, 192, 205n26

disability studies, 205n26

disidentification, 5, 113, 119, 127, 133, 169, 172

disposition matrix, 65

DJ Rekha: Mutiny club night, 110

documenta 14, 244n21

Dome of the Rock, 162

Dower, John, 223n11, 225n23

drones (UAVs), 1, 8–9, 12, 28, 47, 50, 57, 68, 74, 84, 99, 107–8, 136, 173, 197, 203n1, 237n23, 269n11; counterterrorism/counterinsurgency tool, 2, 62–67, 73, 209n43, 232n96; double-tapping, 64, 69–72, 78, 232n91; drone creep, 73; dronification of state violence, 64; General Atomics MQ-1 Predator drone, 65–66, 69; General Atomics MQ-9 Reaper drone, 4, **6–7**, **47**, 69, **plate 1**, **plate 6**; Northrop Grumman X-47B drone, **plate 5**; strikes in Afghanistan, 4, 62–63, 65–67, 72, 77–78, 97, 233n107, 235n127; strikes in Af-Pak, 21, 39–40, 48–49, 62–63, 70–72, 77–79, 90–91, 209n43; strikes in Iraq, 39–40, 48, 65, 77–78, 90–91, 103, 239n48; strikes in Pakistan, **3**, 42, 62–72, 77–78, 233nn105–7

Du Bois, W. E. B., 92, 217n115

Duterte, Rodrigo, 192

dystopian here and now, 2, 8, 41, 152, 157, 170, 184, 191

Egypt, 80, 226n28, 262n85

Elahi, Hasan: *Tracking Transience*, 236n12

Elia, Nada, 260n67

El Salvador, 97

Engelhardt, Tom, 191

England, 258n37; London, 41, 110, 152, 157, 161, 193–94, **194–95**, 232n91. *See also* Great Britain; United Kingdom

England, Lynndie (Lyndie), 84

Erdogan, Recep Tayyip, 192

Espiritu, Yen Lê, 144

ethnic studies, 54, 227n39; critical ethnic studies, 38, 77, 205n26, 254n16

Fanon, Frantz, 33, 217n115

Farsakh, Leila: "Queering Palestine" special issue, 153

fascism, 36, 54, 68, 191, 200, 217n115

Fatah, 262n85

Fawaz, Ramzi, 182, 253n15

Federal Bureau of Investigation (FBI), 57, 119, 209n43, 256n25; Muslim Surveillance and Entrapment Programs, 242n4

Feldman, Keith P., 45, 154, 219n125, 258n37

Feldman, Yotam: *The Lab*, 256n25

feminism, 23, 74, 105, 107, 128, 166–68, 238n39; Black, 14, 88, 221n138, 238n40, 249n88; feminist unbecoming, 90; Indigenous, 14; intersectional, 205n26; Marxist, 20–21; new materialist, 257n29; postcolonial, 25, 30, 40, 49, 91; queer, 10, 13, 14, 16, 28, 32, 35, 38–39, 41, 43, 87, 94, 97, 100, 102, 152–57, 162, 185–86, 190, 200, 251n4; queer feminist visionary aesthetics, 41–42, 151–56, 167–68, 172, 177, 180, 183–84; race radical, 16, 22, 25; radical, 205n25; Third World, 20, 22; transnational, 14, 17, 26, 38; US Third World, 14, 20, 22; white, 245n26; women of color, 14, 20, 22, 25

Ferguson, Roderick, 22

Filkins, Dexter, 205n16

Flanders, Laura, 239n48

Flatfile Galleries, 86

Flatley, Jonathan, 91–92, 214n98, 239n53

Fleetwood, Nicole R., 270n21

Fordism, 209n44

Ford Motor Company, 4

Forward Operating Bases, 188

Foucault, Michel, 123, 220n133, 224n12

France, 97, 177, 223n8, 232n96, 234n109, 234n115, 250n90; Paris, 178, 244n20

Frankfurt school, 210n62

Franklin Street Works, 125

freedom dreams, 9–10, 43, 74, 182, 193, 205n25

Freedom of Information Act (FOIA), 136, 139, 141–42, 144, 146, 150

Freud, Sigmund, 92, 239n55

full-spectrum dominance, 8, 152, 171, 182, 200

Divestment, and Sanctions (BDS) movement
Israel Association for United Architects (IAUA), 261n79

Jacir, Emily: *Dar Jacir*, 261n68
Jacir Ottoman archives, 261n68
Jamaat-i-Islami, 226n28
James, Henry, 92
Jameson, Fredric, 259n48
Japan, 119, 226n25, 230n71; Hiroshima, 97, 257n31; Nagasaki, 97; Tokyo, 88
Jefferson, Thomas, 219n129
Jewish Voice for Peace, 256n25, 266n118
Jews for Palestinian Right of Return, 266n118
jihad, 10, 34, 85, 236n21
Jordan: Amman, 162
Journal of Palestine Studies: "Queering Palestine" special issue, 153

Kafka, Franz, 86–87
Kahlon, Rajkamal, 11, 27, 41, 105, 113, 146, 168, 250n90; *Did You Kiss the Dead Body?*, 136–44, 249n76, **plates 14–18**
Kamat, Anjali, 101
Kanaaneh, Rhoda: "Queering Palestine" special issue, 153
Kanafani, Ghassan, 260n61
Kandaswamy, Priya, 73
Kaplan, Amy, 207n31, 227n39
Kaplan, Caren, 46, 173, 187, 190, 195, 223n4, 263n89
Karuka (Vimalassery), Manu, 246n39
Kassem, Ramzi, 57–58
Kelley, Robin D. G., 57, 182, 205n25
Kelly, Jenny, 258n37, 260n67
Khadr, Omar, **plate 13**
Khalidi, Rashid, 36, 52–54
Khalil, Osamah, 61
Khalili, Laleh, 12, 41, 44, 127, 183
Khan, Sadiq, 193
Kilgore, De Witt, 180
Kim, Jodi, 48, 223n11, 230n70
Kipp, Jacob, 61
Korea, 42, 97, 122; Seoul, 110
Kraus, Franz, 257n36
Kubrick, Stanley: *2001: A Space Odyssey*, 180

Kumar, Deepa, 20
Kundnani, Arun, 20
Kuwait, 76, 227n35

Lacoste Elysée Prize, 177–79, 261n79
Laino, Paige: *Ode to the Sea: Art from Guantánamo Bay*, 242n6
Landstuhl Regional Medical Center (LRMC), 140
Laos, 97
Latin America dirty wars, 141, 246n42
lawfare, 10, 38, 40, 49, 178–79, 191, 265n116
Lawrie Shabibi gallery, 258n43; "Science Faction," 163
Lazarus, Emma: "The New Colossus," 269n17
Lebanon, 32, 53–54, 97, 105, 125, 260n61
Le Guin, Ursula K., 166
Leroy, Justin, 267n127
liberalism, 22, 50, 70, 151, 178, 180, 217n115, 219n125, 264n114; in Cold War, 51, 223n11, 226n25; confinement under, 39, 48; human rights and, 130, 245n27; internationalism and, 52; liberal counterinsurgencies, 41; liberal empire, 10, 31, 175–76; liberal-pluralist distributive order, 17; liberal war, 12, 44, 48, 73; multiculturalism and, 37; race under, 221n137, 245n26
Libya, 2, 42, 45, 62, 65, 262n83
Lin, Aimara, **111**, 244n21. *See also* Visible Collective
Lind, Søren, 157; *In the Future, They Ate From the Finest Porcelain*, 157–58, 174–75, **175**, **plate 23–24**
Lind, William S., 233n102
long peace, 52, 226n23
Lothian, Alexis, 258n38
Louis XVI (king), 195
Lowe, Lisa, 20, 36, 221n137
low-intensity conflict (LIC), 49, 52–53, 73, 226n28, 227n35
Lubin, Alex, 183, 207n31
Luce, Henry, 223n11

Maira, Sunaina Marr, 30, 36, 73, 103, 219n125, 233n105, 246n42
Malhotra, Anjali, **111**, 244n21. *See also* Visible Collective

Palestinian Authority (PA), 172, 176–77, 255n18, 262n85
Palestinian Islamic Jihad, 247n52
Palmer Raids, 230n71
Palumbo-Liu, David, 265n116
Parisi, David, 214n98
Park Avenue Armory, 125
Parker, Sarah Jessica, 110
Parks, Lisa, 173
Parmigiani Fleurier, 264n112
patriarchy, 113, 153, 166; heteropatriarchy, 11, 23, 32–34, 74, 85, 193
Pearl Harbor, 226n25
Pease, Donald, 227n39
Pentagon, 5, 43, 193, 209n43, 242n6, 269n11
Pérez, Roy, 13
performance studies, 14, 32, 77, 87
Persian Gulf, 79, 99, 101, 116, 174, 227n35, 227n39, 232n96
Peteet, Julie, 156, 168, 171–72, 255n18, 256n22, 260n62
Petti, Alessandro, 262n81
Philippine–American War, 33
Philippines, 5, 33, 37, 108, 222n143
pinkwashing, 266n118
Pinter, Harold: "Death," 249n76
Pipes, Daniel: Campus Watch, 266n118
Platonov, Andrei, 92
Poitras, Laura, 104
postcolonialism, 37, 51, 88–89, 108, 169, 205n26, 220n130, 240n61, 244n21; postcolonial feminism, 25, 30, 40, 49, 91
postcolonial studies, 14, 21, 25–26, 30, 38–40, 49, 54, 74, 91, 166, 206n29, 214n98, 227n39, 228n43, 238n40
poststructuralism, 16, 74, 214n98
Povinelli, Elizabeth, 31, 176
Project Row Houses, 110, **112, 121**
Puar, Jasbir, 113, 118, 122–24, 214n98, 236n16, 245n26, 252n8
Puerto Rico, 245n27; Vieques, 97
Putin, Vladimir, 192

Qasim, Khalid, 242n6
Qatar, 174; Doha, 79
Quadrennial Defense Review (QDR), 5
Queens Museum of Art (QMA), 112; "Fatal Love," 110

queer calculus, 10, 28, 75, 77, 100–102, 125, 190–91, 193, 198, 205n26; as critical hermeneutic, 39; definition, 21–24; human rights and, 70; post-9/11 security discourse and, 33; proofing and, 25; race and, 119; sensorial life and, 40, 43, 81, 89–95, 104, 109; settler colonialism and, 172
queer feminist visionary aesthetics, 41–42, 151–56, 167–68, 172, 177, 180, 184
queer of color critique, 22–23
queer reading, 22, 90
queer studies, 22–23, 38, 77, 152–53, 193, 204n26, 214n98; affect in, 214n98; affiliation in, 31; body in, 14; decolonial, 184; methodology of, 14, 21–23; Palestine in, 153–54; utopia in, 166
A Quest for Saddam (video game), 236n21
quiet encroachments, 103, 105
Quraishi, Ibrahim, 40, 105, 109, **111**, 244n21. See also Visible Collective

Rabbani, Ahmed, 242n6
Rabin, Yitzhak, 255n18
race, 14, 81, 95, 136, 138–39, 141, 148, 155, 161, 205n26, 210n62, 219n125, 244n20; astrofuturism and, 180; colonialism and, 149–56, 167–68, 172, 176–79, 182, 184, 217n115, 221n137, 228n43, 253n15, 257n33; in the forever war, 1, 4, 9–10, 16–17, 49–50, 54–64, 63, 67–74, 77–78, 87, 89–90, 104–29, 188–92, 203n4, 228n39; gendered, 11–20, 25–39, 42, 55–56, 78, 84–85, 113, 156, 189–92, 222n147, 223n11, 245n26; in immigration law, 43, 122–23, 247n45; queerness and, 21–23, 153; race-making, 18, 47, 54, 56, 123, 205n26, 223n8, 247n45; race radical tradition, 16, 22, 25, 35, 167; race war, 50, 70, 224n12; racial capitalism, 18, 35, 192, 221n137, 253n15; racialization, definition, 235n122
racism, 25, 35, 73–74, 90, 177, 179, 182, 193, 205n26, 211n62, 256n23, 264n114; colonialism/imperialism and, 54–55, 67, 192, 217n115, 237n24, 247n45; gendered, 11, 20, 34, 84–85, 245n26; hate crimes and, 58; state, 118, 224n12, 244n20, 245n26; structuring the forever war, 31, 32; surveillance and, 19, 118; in US immigration system,

USA PATRIOT Act: Section 412
US area studies, 30
US Army, 40, 113, 149; Field Manual, 125; Special Forces, 44, 51, 57, 67–68; Training and Doctrine Command, 61, 126, 207n33; *US Army and Marine Corps Counterinsurgency Field Manual*, 50. See also Human Terrain System (HTS)
US Congress, 3, 57–58, 119, 204n8, 209n43; Senate CIA Torture Report, 136; Senate Select Committee on Intelligence, 241n1
US Customs and Border Protection (CBP), 60, 242n4
US Department of Defense (DOD), 5, 57, 209n43, 229n55
US Department of Homeland Security (DHS), 57, 59–60, 269n11
US Department of Justice (DOJ), 55, 57
US exceptionalism, 34, 154, 219n129, 223n11, 227n39, 253n13
US global counterinsurgencies (GCOIN), 16, 22, 33, 35, 41, 49–50, 71, 73, 109, 145, 182–83, 232n94, 232n96
US global state violence, 5, 10, 40, 46–47, 49, 74, 105, 115, 207n31
US House Un-American Activities Committee (HUAC), 207n33
US Immigration and Customs Enforcement (ICE), 57, 60, 196, 256n25, 270n19; Secure Communities program, 59
US Immigration and Naturalization Service (INS), 119, 122. See also National Security Entry-Exit Registration System (NSEERS, Special Registration)
US Joint Special Operations Command, 45
US Military Intelligence, 140
US Navy SEALS, 45, 140
US Uniform Code of Military Justice, 231n76
utopia, 161, 198, 259n48; Palestinian liberation and, 41, 152, 154–55, 157, 166–68, 171, 173, 182–85, 253n15; queerness of, 21, 23, 25, 155, 180, 185, 267n140
Uzbekistan, 66

Venice Biennale, 244n21, 261n68
Versailles, 195
vertical mediation, 173–74
Vietnamese studies, 222n143

Vietnam War, 33, 51–53, **96**, 96–97, 108, 205n16, 228n39
Vimalassery, Manu. *See* Karuka (Vimalassery), Manu
Visible Collective, 11, 28, 40, 55, 105, 244n21; *Disappeared in America*, 109–13, **111**, **112**, **114**, **119**, 125; *Driving While Black Becomes Flying While Brown*, 113, 115–19, **116–17**; *Against Empire*, 115, 124; *Invisible Man*, 115; *It's Safe to Open Your Eyes Now*, **121**; *Patriot Story*, **121**
"Visit Palestine" poster, 160, 257n36
visual studies, 27, 38, 45, 173
Vitalis, Robert, 219n129

Wacquant, Loïc, 223n8
wake work, 142. *See also* Sharpe, Christina
Walters, Joanna, 270n19
warm data, 28, 40–41, 103–50, 168, 188–89, 244n20, 249n88
Warner, Michael, 212n69
war on crime, 18, 27, 49, 55–56, 115, 118, 141
war on drugs, 18, 49, 55–57
war on terror, 14, 29, 46, 115, 191, 204n5, 231n86, 242n4; drones in, 1, 66, 68; as forever war, 5, 55–56; homonationalism in, 214n98; human terrain of, 12, 207n33; national security state and, 17, 148; precedents for, 219n125; prisons and, 108; restructuring of homeland in, 57, 207n31; role of artists in, 105; scope of, 269n11; torture in, 241n1. *See also* 9/11
Washington, DC, 1, 3, 8, 51, 63–64, 72, 74, 176, 204n8
Wegner, Phillip E., 53
Weheliye, Alexander G., 34
Weizman, Eyal, 171, 261n79
Westad, Odd Arne, 51–52
White House, 45, 204n5, 231n86, 255n18, 265n116
Whitney Biennial (New York, 2006), 110
WikiLeaks, 80, 104, 140
Williams, Randall, 44, 74
Williams, Raymond, 210n62, 214n98
Williams, Robert, **116**
Williams, Wayne, 244n20
Williams, William Appleman, 227n39
WINEP, 231n72